CLASSICAL GREECE AND THE BIRTH OF WESTERN ART

What was the "Classical Revolution" in Greek art? What were its contexts, aims, achievements, and impact?

This book introduces students to these questions and offers some answers to them. Andrew Stewart examines Greek architecture, painting, and sculpture of the fifth and fourth centuries B.C. in relation to the great political, social, cultural, and intellectual issues of the period. Intended for use in courses in classical civilization, as well as Greek art and archaeology, his book draws on Greek lyric poetry, tragedy, comedy, historiography, oratory, philosophy, medicine, and science to illuminate the art of the period.

- Features 173 color and black-and-white illustrations, more then half of them new and many published here for the first time
- Has a strong focus on political, social, cultural, and intellectual context of art works
- Includes a timeline, biographical sketches, and other reference data

Andrew Stewart is Nicholas C. Petris Professor of Greek Studies at the University of California, Berkeley. A scholar of ancient Mediterranean art and archaeology, he has received fellowships from the American Council of Learned Societies and the Guggenheim and Getty Foundations, and is a member of the American School of Classical Studies in Athens and the Deutsches Archaeologisches Institut. He is the author of *Art, Desire and the Body in Ancient Greece* and most recently of *Attalos, Athens and the Akropolis: The Pergamene "Little Barbarians" and Their Roman and Renaissance Legacy.*

CLASSICAL GREECE AND THE BIRTH OF WESTERN ART

ANDREW STEWART

University of California, Berkeley

CAMBRIDGE
UNIVERSITY PRESS

CAMBRIDGE UNIVERSITY PRESS

Cambridge, New York, Melbourne, Madrid, Cape Town, Singapore, São Paulo, Delhi

Cambridge University Press
32 Avenue of the Americas, New York, NY 10013-2473, USA

www.cambridge.org
Information on this title: www.cambridge.org/9780521618359

First published 2008

Printed in Hong Kong by Golden Cup

A catalog record for this publication is available from the British Library.

Library of Congress Cataloging in Publication Data

Stewart, Andrew F.
Classical Greece and the birth of Western art / Andrew Stewart.
p. cm.
Includes bibliographical references and index.
ISBN 978-0-521-85321-7 (hardback) – ISBN 978-0-521-61835-9 (pbk.)
1. Art, Ancient – Greece. 2. Art, Greek. 3. Greece – Civilization – To 146 B.C.
I. Title.
N5630.S74 2008
709.38–dc22 2007039501

ISBN 978-0-521-85321-7 hardback
ISBN 978-0-521-61835-9 paperback

Here is something I can study all my life, and never understand.

— SAMUEL BECKETT

CONTENTS

MAPS AND FIGURES

PREFACE

J. J. Pollitt's *Art and Experience in Classical Greece* is a hard act to follow. When Cambridge University Press asked me to write a replacement for this best-selling text, because its author was unwilling to revise it, I felt first elation, and then despair. When I reread *Art and Experience* shortly thereafter, the latter feeling only deepened. How could I match it, let alone supplant it?

So I decided to do something different. Instead of Pollitt's broad-brush approach, informed by what little is known or can be conjectured about the individual "experience" of art during the period and about its art theory (Pollitt's own dissertation topic, published in 1974 as *The Ancient View of Greek Art*), I have chosen a less impressionistic and more socially grounded one. Hence my title: *Classical Greece* (history, society, culture, in macrocosm and microcosm, as appropriate) *and the Birth of Western Art*. This is why, for example, each chapter touches on several works of classical Greek literature, and why terms such as *oikos* or household, absent from Pollitt's text, feature prominently in mine. Some readers may also notice that my view of the art of the Peloponnesian War and the fourth century differs markedly from his in some key respects. But to compensate, evocative quotations and borrowings from *Art and Experience* appear at several points in the text, *in pietate*.

Many people have generously contributed their time and expertise to the project. My research assistant, Erin Babnik, has saved me countless hours of bibliographical work and letter writing. Mont Allen, Erin Babnik, Becky Martin, Stephanie Pearson, Peter Schultz, Kristen Seaman, and Jennifer Stager have read the entire text in its various stages of preparation; have suggested many improvements; and have saved me from many errors and infelicities. For all those that remain, *mea culpa*. Therese Babineau, Beryl Barr-Sharrar, Timothy Beutler, Osmund Bopearachchi, Antonio Corso, Jan Eklund, Hans Goette, Mark Griffith, Chris Hallett, Tonio Hölscher, Wolfram Hoepfner, Frank Holt, David Jacobson, Leslie Kurke, Don Mastronarde, Craig and Marie Mauzy, Jari Pakkanen, Olga Palagia, Alain Pasquier, Jim Porter, Peter Schultz, Kim Shelton, and Carson Sieving have generously contributed bibliography,

ideas, suggestions, corrections, and/or pictures. For three decades I have had the enormous pleasure of reading most of the Greek texts I address in the congenial company of the Berkeley Greek Club: I thank its present and past members, Fred Amory, Jock Anderson, Louise Chu, Marcia DeVoe, Mark Griffith, Gary Holland, Sharon James, Leslie Kurke, Kathy McCarthy, Rodney Merrill, Jack Nickel, Amy Russell, Chris Simon, Anne Stewart, Michael Tillotson, and Tom Walsh, for their friendship and invaluable contributions to my understanding of these works.

Beatrice Rehl, my long-suffering editor at Cambridge University Press, has answered innumerable queries and solved numerous problems with her usual geniality and dispatch. Dan Johnston and Julie Wolf digitized many of the pictures, and Lynn Cunningham kindly spent long hours cleaning them up, sizing them, and editing them. Erin Babnik produced almost all of the superb drawings in the book, and Candace Smith one of the maps and the splendid new reconstruction of the Tegea Temple. U.C. Berkeley's Committee on Research provided generous grants for research assistance and for pictures and permissions, as, in the latter case, did Cambridge University Press. And finally, these grateful acknowledgments would not be complete without mention of the warm companionship and support of Darlis, Dinah, Maxie, Poly, and Shadow.

Andrew Stewart
Berkeley
June 2007

INTRODUCTION

CLASSICAL, CLASSIC, THE CLASSICS, AND CLASSICISM

"Classical" is a divisive word. For some, it conjures up stirring images of The Glory That Was Greece (Fig. 1) and The Grandeur That Was Rome. For others, it invokes the tyranny of Dead White Males, of extinct languages force-fed one as a child, and of tweedy pedants poring over dusty remains (Fig. 2).

Both sides have a point. For centuries "the classics" and a classical education *were* used to intimidate, and the legacy of Greece and Rome did cast a long shadow over Western culture. Yet the almost complete disappearance of Greek and Latin from schools and from many universities by the late twentieth century produced an unexpected payoff. It lifted the spell, for good or ill, and made these two cultures seem strange again. Now we can approach them more on their own terms, bearing less inherited baggage than before.

For the Greeks and Romans not only lived in a particularly vibrant period of human history, but also created a unique body of art and literature in response to its challenges. The most thoughtful of them explicitly sought to add to the sum of human understanding – to create a "possession for ever," to quote the historian Thucydides (who will reappear often in the chapters to come). They aimed to leave a legacy that would be both "classic" and socially useful. So if *any* products of the past are worth studying, theirs should be.

The words "classic" and "classical" are not Greek but Roman, however. They derive from the Latin *classicus*, meaning "of a certain class," and thence "in a class of its own." For in addition to conquering the Greeks, the Romans eagerly appropriated their legacy in literature and the arts. They taught their children the Greek literary classics, mostly those of the fifth and fourth centuries B.C. (the period covered by this book); translated them into Latin; and based their own literature upon them. And last but not least, they collected

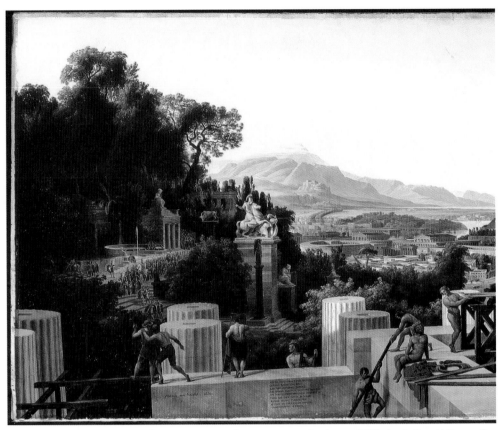

1. *Glimpse of the Golden Age of Greece.* Nineteenth-century copy by August Wilhelm Julius Ahlborn after an original by Karl Friedrich Schinkel painted in 1836, but destroyed in 1945. Berlin, Staatliche Museen, Nationalgalerie. In an idyllic landscape with the Akropolis at center, Athenian craftsmen erect a colonnade including the Parthenon frieze.

Greek masterpieces of sculpture and painting, particularly fifth- and fourth-century ones; copied them; and wrote about them. They considered them to be authoritative, to set a standard that none, probably, could ever surpass. Since so much Greek literature and art has fallen victim to the ravages of time, much of what we know about them is due to this Roman reverence for things Greek.

Today, however, "classical" is often used as shorthand to describe all of Greek and Roman antiquity. This is because from the Renaissance into the nineteenth century, many people thought that *everything* Greek and Roman was exemplary – a towering cultural achievement that could only be imitated, never surpassed. The rise of Romanticism after 1800 even reinforced this belief, because its critics promptly used the Romantics' scandalous lack of restraint, balance, order, and decorum to boost the case for the classics, which were universally held to exhibit such virtues. In academe, at least, the establishment prevailed, and today departments of Classics (i.e., of Greek and Roman studies) are to be found in many universities across the Western world. The

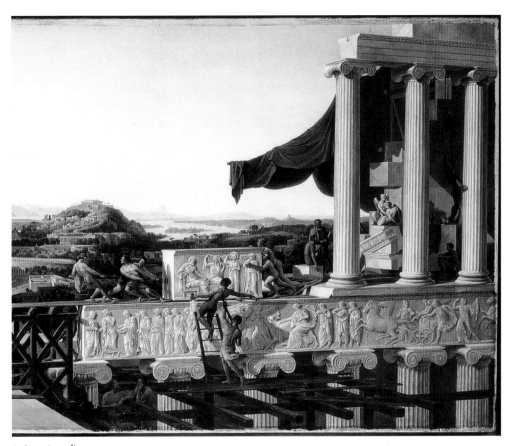

1 (*continued*).

one at Harvard is even called the Department of The Classics, as if no other classics (English, French, Spanish, Arabic, Chinese, . . .) existed at all.

Those classicists who study ancient material culture, from the Parthenon to potsherds, are called classical archaeologists (or classical art historians: the distinction is a false one, rooted in the nineteenth century). Yet they tend to employ the adjectives "classic" and "classical" in a more restrictive way – like the ancient Romans. Often spelling them with a capital C, they use them to refer to the Greek buildings, sculptures, paintings, and luxury crafts of the fifth and fourth centuries B.C.: the period seen as the summit of human cultural achievement by the Romans and by later Greeks too, and the period covered by this book. This practice is also a nineteenth-century one, when scholars divided Greek history and culture into three main phases based on a biological model of birth, maturity, and decline: the "primitive" Archaic (ca. 700–480 B.C.), the "mature" Classic (ca. 480–330 B.C.), and the supposedly "degenerate" Hellenistic (ca. 330–30 B.C).

Confusingly, though, the surviving products (literary and artistic) of what is consequently called Classical Greece include not only those done in true "classical" style – exhibiting the supposedly "classic" stylistic traits of consistency, economy, clarity, balance, restraint, and the supremacy of formal

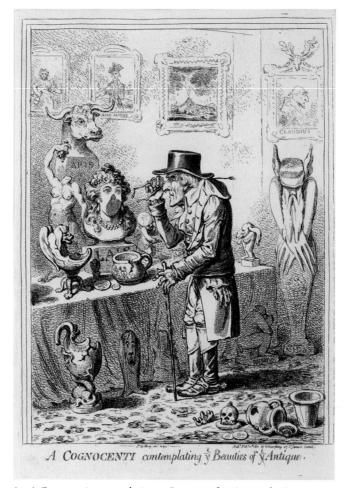

2. *A Cognocenti contemplating ye Beauties of ye Antique* by James
Gillray, ca. 1801. London, National Maritime Museum. An aged
pedant seeks inspiration from the detritus of antiquity.

design – but also others that do not exhibit these traits, or exhibit them only
weakly or partially, if they happen to have been made during the same period.
All the products of this period, regardless of their style, quality, and real or
presumed status as "classics," fall within the scope of the present book.

The term "classicism" is equally treacherous, for it covers more than
the style(s) of the classical period proper. "Periklean classicism," for example,
traditionally describes the sculptural, pictorial, and architectural style(s) dom-
inant in Athens under the leadership of Perikles, from the 450s B.C. to his
death in 429 (see Chapter 3), but similar principles prevailed in other, later
periods as well.

Thus, classicists regularly speak of "Augustan classicism" (under the
emperor Augustus, who ruled from 31 B.C. to A.D. 14) and "Hadrianic classi-
cism" (under Hadrian, A.D. 117–38) and even of "Constantinian classicism"
(under Constantine, A.D. 312–37). Moreover, in 1899 the German scholar

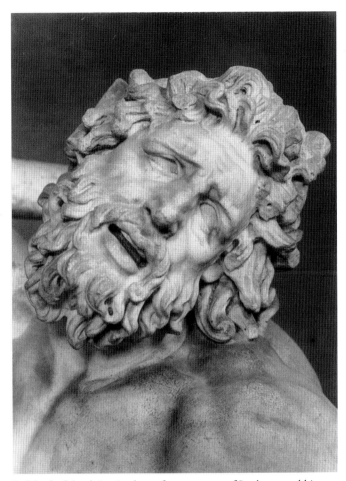

3. Head of the dying Laokoon from a group of Laokoon and his
sons, from Rome, by Hagesandros, Athanodoros, and Polydoros of
Rhodes, ca. 30. Marble; ht. of group 1.84 m (6′). Vatican Museums.

Heinrich Wölfflin published a path-breaking book entitled *Die klassische
Kunst*, soon translated into English as *Classic Art* and still in print in both
languages. But far from being a work on Greece or Rome, it discusses five
"classic" painters of the Italian High Renaissance: Leonardo, Michelangelo,
Raphael, Fra Bartolemmeo, and Andrea del Sarto.

Yet whereas the Augustans and these Renaissance painters decisively
broke new ground, others thus described are often better termed "neoclassic"
(the German alternative, "classicistic," both is a tongue-twister and has an
unpleasant tinkle to it). These individuals include the Roman-period sculptors
who created marble copies of Greek classical statues, and Renaissance sculptors
such as Baccio Bandinelli and the spectacularly named Pier Jacopo di Antonio
Alari-Bonacolsi, helpfully called "Antico" for short, who did the same. Instead
of creatively reinterpreting the classics, they sought merely to reproduce them
as skillfully as they could.

Finally, one recent discussion cheekily turns all this on its head, defining classicism in a purely functional way as "the emulation of any earlier set of visual styles, forms, or iconographies, which in the very fact of their being borrowed are established as in some sense canonical (or classic)." In other words, "a classic is something that sets a standard. It does not matter, for the most part, in what field the standard is set. We are now used to sports commentators talking of a classic horse race, and the notion of 'rock classics' no longer seems as incongruous as it once did."

To this view, not only the Parthenon (Fig. 1; cf. Figs. 60–70), but also the Laokoon (Fig. 3), the early Greek bronzes (Fig. 4) beloved of many modern artists, Picasso's *Demoiselles d'Avignon*, Dali's *Soft Watches*, Jackson Pollock's drip paintings, Craven Walker's original lava lamp, and many Beatles songs are all classics, simply because they have set a standard that people have copied, quoted, adapted, and even parodied over and over again. (In California, where I live, there is even a company called "Classic Party Rentals," though I have yet to discover whether it truly sets a standard!) But it is time to get back to the Greeks.

THE CLASSICAL REVOLUTION

The Greek classical revolution changed the course of Western culture forever. Enshrined by the Greeks themselves, embraced by the Romans, and rediscovered in the Renaissance, it set a standard that altered our planet's intellectual and visual landscape beyond all recognition. (Though by no means all at once. Classical architecture had no impact upon India, China, and Japan, for example, until the late nineteenth century.) Whether we like it or not, its legacy is everywhere, and in art at least we all "know" a classical or neoclassical work when we see one. As a standard textbook remarks, "Greek architecture, sculpture, and painting . . . are immediately recognizable as the direct ancestors of our own . . . A Greek temple reminds us of the bank around the corner, a Greek statue brings to mind countless other statues that we have seen somewhere, and a Greek coin seems as close as the change in our pockets." Yet what did the classical revolution achieve, and what did the classical ideal really consist of?

First and most famously, the classical revolution set the seal on the Greek discovery of the mind, pioneered by Homer and in our period exemplified for all time in those two towering intellectual achievements of fifth-century Athens, namely, tragedy and moral philosophy. In *tragedy*, Aischylos, Sophokles (see Fig. 164), and Euripides explored the complexities of the human condition and Greek society through the refracting lens of heroic myth, whereas in *philosophy*, Sokrates (see Fig. 132) inaugurated the study of ethics, and his fourth-century followers Plato (see Fig. 133) and Aristotle systematized it. Meanwhile, the *comedies* of Aristophanes and others questioned and parodied both, relentlessly probing for weaknesses and mercilessly exposing charlatans and phonies.

But this was not all, and Athens was by no means the only city involved (Aristotle came from the tiny northern Greek town of Stageira, for example).

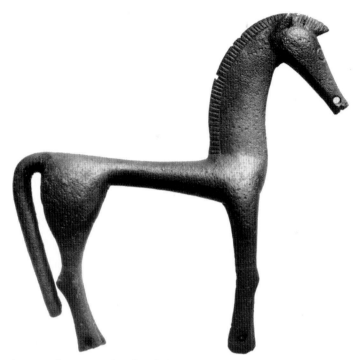

4. Horse from a ring handle of a large tripod caldron at Olympia,
ca. 750–700. Bronze; ht. 11.2 cm (4.4″). Olympia Museum.

The fifth-century quest for knowledge led to the foundation of the exact, biological, social, and human sciences (though these were seldom distinct, at least early on), especially *mathematics* and *geometry*; *physics, astronomy*, and *cosmology*; *biology*; *medicine, psychology*, and *psychiatry*; *political science*; and *geography, ethnography, chronology*, and *historiography*. Many individuals from many different cities were involved in this unique enterprise. We shall encounter some of them in the chapters that follow, including the philosopher–mathematician Pythagoras of Samos, the doctors Alkmaion of Kroton and Hippokrates of Kos, the natural philosophers and cosmologists Parmenides of Elea and Anaxagoras of Abdera, the political theorist and town planner Hippodamos of Miletos, and the historians Hekataios of Miletos, Herodotos of Halikarnassos, and Thucydides of Athens (see Fig. 165).

Finally, to disseminate all this knowledge, much of it disputed among competing pundits and theorists, came *education* and the art of persuasion or *rhetoric*, dominated in the fifth century by the so-called Sophists. Two of them, Protagoras of Abdera and Gorgias of Leontinoi, will appear in Chapters 3 and 5. Simultaneously, and not coincidentally, the period witnessed the great efflorescence of Athenian political and courtroom *oratory* under such men as Perikles (see Fig. 56) and (in the fourth century) Lysias, Demosthenes (see Fig. 173), and Aischines.

In art, to amass a glittering array of lasting classical discoveries (both fifth- and fourth-century) and their discoverers (real or supposed) is easy.

In *architecture*: integrated city planning (Hippodamos of Miletos: Fig. 31); the first theaters (Figs. 18, 163, 167), gymnasia, porticoes, and libraries; the Corinthian architectural style or *Order*[1] (Kallimachos: Compare Figs. 115, 137); classic statements of the Doric and Ionic Orders (by Libon of Elis; and Iktinos and Mnesikles of Athens [?]: Figs. 42, 60, 102; and by Pytheos of Priene); and the invention of the interior as a distinct architectural form (Iktinos and Skopas of Paros: Figs. 115, 137).

In *sculpture*: the civic monument (Kritios and Nesiotes of Athens: Fig. 5); the individualized portrait (Kresilas of Kydonia, Demetrios of Alopeke, Silanion of Athens, Lysippos and Lysistratos of Sikyon: Figs. 37, 56, 132, 133, 156); lifelike representations of the gods (Pheidias and Praxiteles of Athens: Figs. 69, 140) and of the human body (Kritios and Nesiotes, Polykleitos of Argos, Praxiteles, Lysippos: Figs. 71, 140, 141, 154); the invention of *contrapposto* and *sfumato* (Kritios, Polykleitos, Praxiteles: Figs. 5, 34, 71, 140, 141) (see Glossary); and an enhanced polychromy using brilliant metal inlays (Pheidias: Fig. 69) or seductive pastels (Nikias of Athens for Praxiteles: Compare Figs. 145, 146).

And in *painting* and *mosaic*: the framed picture to hang on a wall (Zeuxis of Herakleia, Parrhasios of Ephesos); the still life (Pausias of Sikyon); "encaustic" painting in hot wax (Polygnotos of Thasos, Aristeides of Thebes); the illusionistic devices of perspective and theatrical scene-painting (Polygnotos, Agatharchos of Samos: Figs. 51, 52, 108, 109, 142) and of shading, *chiaroscuro* (see glossary), and luster (Apollodoros of Athens, Zeuxis of Herakleia, Apelles of Kos: Figs. 110, 144–6, 158–60); the exploration of character and emotion, of the interior self (Polygnotos: compare Fig. 52); figured polychrome mosaics; and many of the innovations already listed under sculpture.

As for the classical ideal itself, in 1755 the German scholar Johann Joachim Winckelmann was the first to venture a definition of it: "a noble simplicity and quiet grandeur." As mentioned earlier, others soon proposed a more concrete list of traits, such as consistency, economy, clarity, balance, restraint, and the supremacy of formal design. Yet such definitions are ultimately rather unsatisfying. Somewhat dry and abstract, they are decontextualized (severed from the social realities, concerns, and needs of the Greek city); they fail to tell us why the horse in Fig. 4, for example, should not be called classic despite its manufacture almost three centuries before the "true" classical period begins; they fail to explain the sheer novelty and force of the works discussed in this book; and they overlook four key components of Greek and Roman writing about art.

Good art, the Greeks and Romans believed, should have *vitality, beauty, sensuality,* and *soul.* These traits, already budding in archaic Greek art of the late sixth century B.C., burst suddenly into bloom in the fifth and fourth centuries, creating works that not only *looked* revolutionary (which is why the names of their creators were remembered) but also exuded artistic excellence or *aretē*

1 Note, however, that "Order" is not an ancient term but a Renaissance one, and implies a far greater rigidity than ever existed in practice. In reality, these ancient architectural styles were quite flexible.

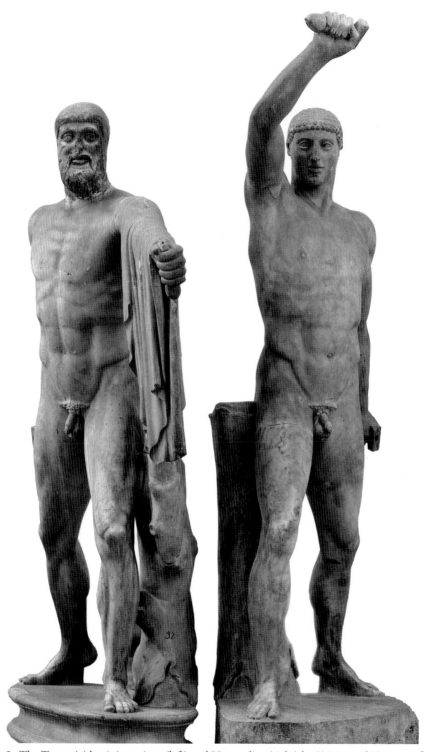

5. The Tyrannicides Aristogeiton (left) and Harmodios (right) by Kritios and Nesiotes of Athens (Roman copy); bronze original, 477/76. Marble; ht. 1.85 m (6′). Naples, Museo Archeologico. The original group stood in the Athenian Agora near the *orchēstra* and was erected to replace a predecessor seized by the Persians in 480; it commemorated the assassination of the tyrant Hipparchos in 514. The assassins' swords are missing; the tree stumps were added by the Roman copyist.

(pl. *aretai*). Aretē is a powerful term that Homer uses to denote the prowess of the hero; thereafter, it betokens excellence in general, and, eventually, moral virtue. In art, it signals technical and expressive distinction: the ability to create a visual wonder. The artist's task was to capture his subject accurately, powerfully, and authoritatively, whether it be god, hero, man, woman, monster, myth, animal, or plant.

Vitality

Vitality was paramount. Wherever possible, materials must sparkle and shine, and buildings, sculptures, and paintings must seem to live and breathe, to engage us and to excite our empathy. Marble, in Greek *marmaros*, comes from the verb for "to sparkle"; bronze, enamel, silver, gold, and ivory are all radiant materials; and a judicious application of wax, paint, and even silver or gold leaf could signally intensify the effect.

Working directly from life, classical sculptors and painters abandoned the old formulaic poses and discovered new, evocatively mobile ones: new *rhythmoi*, as they called them – a word that is as suggestive in Greek as it is in English. Swinging hips, rippling muscles, pulsing veins, parted lips, focused gazes, windblown hair, revealing clothing – all these, rendered with the most precision that the artist could muster, signal a new understanding of the human body not merely as a mechanism, a "robot made by Daidalos," but as a living, breathing organism, active in the here-and-now. These men sought to craft figures so lifelike that viewers would feel that they were about to step off their bases or out of their frames. Architects, too, enlivened their buildings by blending subtle curves into the design to give them bounce and spring, and invented a new, nature-based architectural style: the Corinthian Order.

Beauty

By itself, however, mere liveliness was insufficient. If Sokrates ever had asked any of his long-suffering fellow Athenians what defined good art, his victim would probably have answered, "Beauty." But beauty is culture-specific (in Greece it equaled, quite literally, the gendered civic ideals – masculine and feminine – of the Greek city) and all but impossible to define. How does one characterize, except in metaphor or simile, a beautiful face or torso, let alone a beautiful mouth or eyebrow? The Greeks, famously loquacious about everything, never even tried.

Instead, they chose another route. Beauty, they believed, is appearance informed by geometry. Hence the Greek belief that geometrical forms underlay all natural phenomena, from bodies to drapery folds; hence the horse (Fig. 4) and the korē (Fig. 6); and hence Plato's famous remark that "measure and commensurability are everywhere identified with beauty and excellence." Commensurability of parts or *symmetria* ("measuring together": for convenience, often paraphrased in this book as "proportion") became geometry's ally, the key to creating an ideal *structure*. It linked every part of one's work – building, statue, or painted figure – proportionally (i.e., mathematically) to

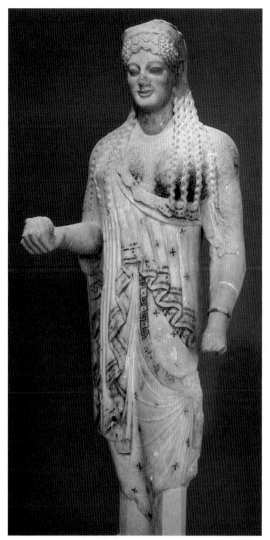

6. Standing girl or *korē* (no. 680) from the Athenian Akropolis, ca. 520–500. Marble; preserved ht. 1.15 m (3′9″). Athens, Akropolis Museum. The girl holds an apple in her right hand; she was vandalized by the Persians in 480 or 479 and buried soon afterward by the returning Athenians.

every other part and to the whole (see Fig. 22). Good proportions not only made an artwork look and feel right, but also could even align it with the structure of the cosmos itself, namely, abstract mathematics, as expressed in the harmonies of the musical scale (see Fig. 23) and the harmony of the spheres.

Sensuality

Beauty, however, appeals not only to the viewer's mind but also to the heart and even to the hand. For Greeks often thought of the eye as a roving searchlight

and vision as long-distance touch (as when we say, "I feel your eyes on me"). Classical Greek sculpture and painting are fundamentally erotic, and even classical Greek architecture has its sensuous appeal.

In the representational arts, not only are males often partially or wholly naked – a custom famously exemplified in real life by the Greek practice of stripping naked to exercise and to compete in the games – but also the clothing of both sexes soon thins out in order to reveal the curves of the body below (see Figs. 17, 62, 63, 104–6). Postures become subtly provocative. Gods, heroes, and athletes become macho icons (see Figs. 5, 21) or even homoerotic ones, and a lowered head and averted glance evoke the reserve that is proper to a well-mannered youth or girl and sets red-blooded men aflame with desire (see Figs. 35, 36, 84, 107). Because ancient society was profoundly sexist – what a surprise! – these erotic gestures were directed primarily at men; and because Greek men were often bisexual, not only unmarried girls but also teenage youths ignited their desire (Harmodios, Fig. 5; see also Fig. 35).

Soul

As mentioned earlier, it is often said that the greatest discovery of the Greeks was the discovery of the mind. It shines from every page of Homer's *Iliad* and *Odyssey*, and in our period Athenian tragedy and moral philosophy take up the torch. Likewise, classical Greek artists discovered how their works could radiate not merely life but soul: A sense of personhood, or what we might call *interiority*. Although the Western mind–body dichotomy is largely Plato's invention, even in the fifth century the Greeks distinguished the physical body on the one hand from *ēthos* (one's innate disposition or character) and *pathos* (any feeling aroused by one's experiences) on the other.

Yet because character and feelings naturally involved the whole person, they manifested themselves on its exterior as bodily signs and – potentially – thus could be read off the body by a sensitive observer. In art, a sober facial expression (see Figs. 5, 17, 21, etc.) now replaced the archaic smile (see Figs. 6, 13). This device encouraged one to project one's own ideas and feelings onto the image, to participate imaginatively in its life, and thus both to enter its world and to coopt it into one's own. Along with a telling posture or gesture selected from the natural repertoire, a raised or lowered head, a slight contraction of lip or brow, and/or a level gaze or downcast eye (see Figs. 5, 17, 20, 21, 29, 35, 36, 50, etc.), it could convincingly convey a sense of interiority. By indicating the presence of a thinking, feeling human being, a person with soul, it could excite the viewer's empathy, hostility, or awe.

ART AND LIFE IN CLASSICAL GREECE

Greek art was a creature of the Greek city-state or *polis* (pl. *poleis*) – for convenience, usually translated in this book simply as "city." Ancient Greece is often described as a culture of images, and indeed, in many larger cities, art was everywhere.

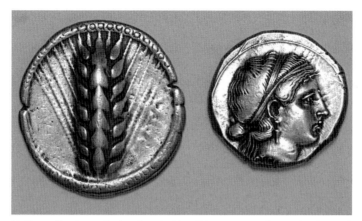

7. Ears of barley and a head probably of Demeter on silver coins (staters) of Metapontum, ca. 520 and ca. 370. Diam. 2.5 and 1.9 cm (1″ and 0.75″). Berkeley, Hearst Museum of Anthropology. The city's economy depended upon cereal production; Demeter is the goddess of cereals.

Our art is created for personal enjoyment in civic centers, museums, offices, and private homes, but Greek (and Roman) art was strictly *functional*. Much of it was broadly religious, intended to charm or placate the gods, the heroes, and the dead; to make them continually present – literally, to *re-present* them – to the living; and to make the living eternally present to the gods. Every city had its sanctuaries, altars, and temples; its cemeteries; its agora; and (increasingly) its public buildings, porticoes, and theater. Local, regional, and international or *Panhellenic* sanctuaries received similar attention, often competitive, from the cities and individuals they served. It is this huge investment in monumental, psychologically uplifting, and basically didactic *display* and the unique culture of images that it fostered that, above all, differentiates the Greeks from their Near Eastern neighbors (some of whom, however, soon began to imitate them) and from the modern world. Through images, the city represented itself to itself and to its neighbors and rivals, and did so for over a thousand years.

Offerings to the gods in sanctuaries included every sort of object imaginable, from pots through statuettes to throngs of life-size or even colossal statues in stone, bronze, and precious metals. Cities began to bustle with images of gods, heroes, statesmen, warriors, and athletes, silently looking over one's shoulder and policing one's behavior. Fifth-century homes were usually modest (and streets mere dusty tracks), but anyone with a decent income could afford red-figured and black-glazed pottery to grace the table, and the tombs that lined the main roads into town often boasted handsome carved gravestones – silent testimonials to the virtues (real or imagined) of the deceased – and offerings of drink and oil deposited in gaily painted flasks. Even the coins jingling in one's purse were miniature works of art, bearing low-relief images of the city's divine and heroic protectors and/or important local products such as horses, grain, flowers, fish, and spices (Fig. 7).

Some of this art, from temples to coins, was commissioned by the state, but most of it was made for families and individuals. Chapter 4 offers a closer look at it from this point of view. Men made virtually all of it, and they made most of it *for* men.[2] With the exception of some specifically women's utensils such as mirrors (see Fig. 97) and vessels made for both sexes such as the water-jar or *hydria* (see Figs. 93, 119; used by women at the well and by men at drinking parties or *symposia*), the consumer/spectator for 99% of Greek art was conventionally gendered male. Yet this did not mean that half the population of Greece was thereby rendered invisible, for classical Greek art was resolutely *anthropocentric*: It focused upon people, or at least upon living things.

From temple sculpture through painted vases to utensil legs in the shape of lions' feet (see Fig. 97), the Greek urge to animate their world, to fill it with lifelike images, with *bodies*, is everywhere. For image and subject were routinely conflated: "This is X," a Greek would say, not "this is a statue of X." Thus, just before the Peloponnesian War, Perikles told the Athenians that they could raise extra cash by "melting down the gold on the goddess herself" – that is, on Pheidias's great gold and ivory statue of Athena Parthenos (see Fig. 69). At some level, too, this urge must connect with Greek polytheism, with the conviction that a god dwelt in every river, a nymph in every tree, and a satyr in every meadow. In ancient Greece, love, hate, strife, and even friendship were gods.

But how did this art relate to the realities of Greek life?

Some of it, of course, represented that life directly – or purported to. Statues of civic heroes or Olympic athletes donning their victory crowns (see Figs. 5, 84) or vases showing revelers (Fig. 8) or young newlyweds (see Fig. 92) all look amazingly realistic. All of them seem to be straightforward, unmediated slices of ancient Greek life. But are they? Everyone's body is perfect; the two heroes are naked but for a single (!) cloak; the athlete looks like every other athlete; the revelers dance in a void and also wear nonfunctional clothing; and Greek men married at 30 or later and in this period always wore beards. The "reality effect" created by Greek naturalism, by the Greek artist's understanding of the living body and unequaled command of the vocabulary of representation, has fooled us.

Although we first hear explicitly of artists using live models around 400 B.C., the relaxed poses and boldly foreshortened limbs of late sixth-century red-figure revelers (Fig. 8), athletes, and others must have been

2 A few late texts mention women painters, most of whom are postclassical, and one vase of around 470 B.C. shows a girl painting or engraving a vessel: John Boardman, *Athenian Red Figure Vases: The Archaic Period* (London 1975), fig. 323. As to consumers, although many Athenian red-figure pots were exported to Etruria and (later) to the north and east, the determining factor was the vessel's shape, not its decoration. See, for example, Christoph Reusser, *Vasen für Etrurien* (Zürich 2002), with English summary, pp. 269–70, and Andrew Stewart and Susan Rebecca Martin, "Attic Imported Pottery at Tel Dor, Israel: An Overview," *Bulletin of the American Schools of Oriental Research* 337 (2005): 79–93. So in general, regardless of where the vases ended up, we may take their pictures as a guide to Athenian taste at the time.

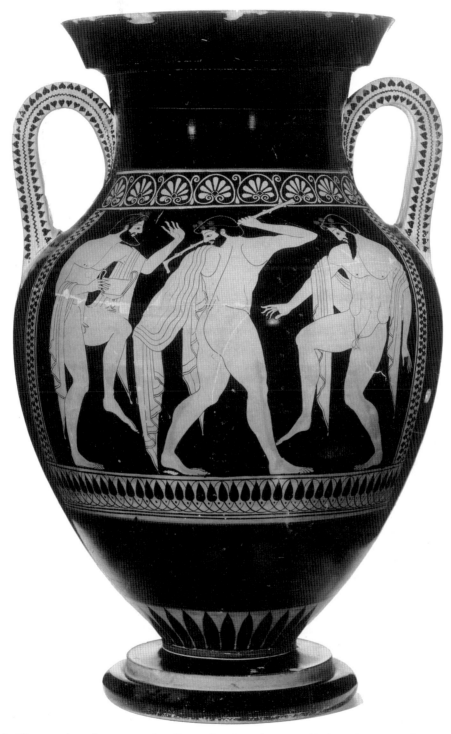

8. Three revelers after a symposion: Komarchos, Hegedemos, and Teles. Athenian red figure wine jar (amphora) from Vulci (Etruria), signed by Euthymides son of Polion "as never Euphronios [could do]," ca. 510. Ht. 60 cm (1′11″). Munich, Antikensammlung.

sketched from life. Some Greek festivals featured beauty contests for men and a few did so for women. Moreover, ancient writers make it clear that leading fourth-century models such as the *hetaira* or courtesan Phryne, who posed nude for the sculptor Praxiteles' Aphrodite of Knidos (see Fig. 140) and the painter Apelles' Aphrodite Rising from the Sea, were unusual only because of their rare beauty and strong characters.

Other artists went further. An anecdote relayed by several writers of the Roman period tells how the virtuoso painter Zeuxis, commissioned by the city of Kroton to paint the fabulously beautiful Helen, could only do his subject justice in what seems to us a most peculiar way. He chose the city's most beautiful girls, asked them to strip, selected the best features of each, and blended them into a single, surpassingly gorgeous figure (Fig. 9). It would be easy to dismiss this tale as a later fantasy if chance remarks by two of Zeuxis's contemporaries did not authenticate it.

Yet however bizarre this procedure seems to us, it points to a deeper, more general truth. For the Greeks were well aware that their art transcended mere human beauty. "Real bodies are uglier than statues"; "no one can make his body resemble statues or paintings"; "only a flatterer tells you that you look like your portrait" – this is how contemporary Greeks saw the artworks illustrated in this book. In fact, excavated skeletons show that Greek men were on average quite stocky; stood only five feet five inches (165 cm) tall; and weighed only 130 lbs (59 kg) – about the same as a modern sixteen-year-old Greek or Turkish boy. What a difference from the Olympia heroes and the six-and-a-half-foot tall Doryphoros (see Figs. 44, 45, 71), let alone a hulking 220-pound American GI or college football player!

Classical Greek art, then, is the product of a sophisticated understanding of the human body and mind in all their power and complexity. A cross section of the best and most beautiful that the city could produce or imagine, it was arrived at by trial and error, filtered through mathematics and geometry, and continually revised: the highest common factor of Greek humanity. This accounts for much of its peculiarly lasting appeal – the unique standard that it has set. For we instinctively feel that it is no ivory tower concoction, no cold and remote abstraction, but a thing of real flesh and blood. It is a product of specific social needs, keen observation, penetrating insight, superlative technique, and sheer hard work. It is our best guide to understanding how this uniquely vital culture saw itself, or (perhaps) saw what – the gods willing – it might become.

So instead of seeing these images as mere reflections of the world, it is better to regard them as intellectualized fantasies or constructs. They represent what the Greeks saw as basic truths about heroes, warriors, athletes, revelers, bridegrooms, and so on.[3] To convey these truths these artists edited their raw

3 It is tempting to say that they have *idealized* them, but to do so conjures up visions of perfection beyond mere space and time – of a *neoclassic* mentality more at home in the nineteenth century A.D. than the fifth and fourth centuries B.C. So for the most part I shall avoid this badly overworked word.

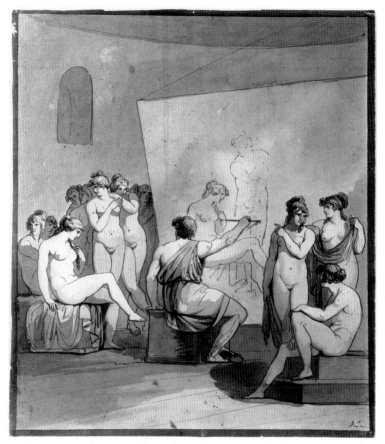

9. *Zeuxis Paints the Beautiful Maidens of Croton* by Angelika Kaufmann, ca. 1800. Basel, Kunstmuseum, Kupferstichkabinett. Zeuxis chooses the city's most beautiful girls and blends their best features to create his picture of the incomparably beautiful Helen of Troy.

material severely but kept their feet firmly on the ground even so.[4] Distilling the essential and typical from people and situations, they sought to present them in the most vivid and compelling manner possible. Always seeking to generalize, they took the city and its life (past and present) as their focus, raw material, and audience, but not as their gospel.

PRESENT AND PAST

Figure 8 is a scene of contemporary life, but the other side of the same pot (Fig. 10) illustrates a myth or legend (the distinction between them is fuzzy,

4 "Heroic nudity" is a purely modern notion. The revelers of Fig. 8, for example, are not heroes but contemporary Athenians, and there is nothing even faintly heroic about the occasion.

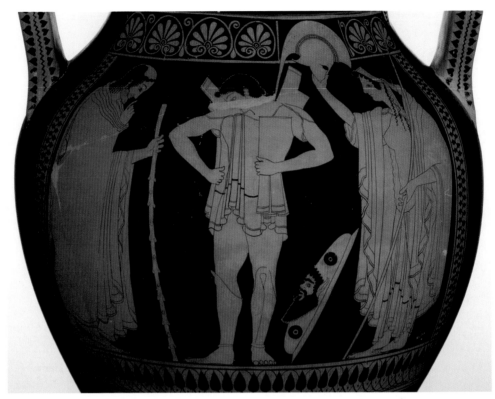

10. Hektor arming, flanked by his father Priam and his mother Hekabe. Obverse of Fig. 8.

and not worth discussing here), namely, the arming of the Trojan hero Hektor. Such stories had furnished the main subject matter of Greek narrative art since the seventh century B.C. Learnt at one's mother's or nurse's knee and at the fireside, anchored in the very topography of Greece, flexible, always evolving, and both local and Panhellenic, they could handily mirror or at least illuminate contemporary life. For they were infinite in number; dealt with every situation conceivable to the Greeks; were rooted both in their past (their history) and in their present (the city and its landscape); were regarded by most as basically true and historical; and were familiar, at least in some form, to everyone. As one comic poet quipped, whereas he and his fellows had to invent their own plots from scratch, the tragedians could mine these stories at will:

> For tragedy's a lucky sort of art:
> The audience knows the plot before you start.
> You've only to remind it. "Oedipus,"
> You say, and all's out: father Laius,
> Mother Jocasta, daughters these, sons those;
> His sin; his coming punishment. Or suppose
> You say "Alkmaion"; in saying that, you've said
> All his sons too, how he's gone off his head
> And killed his mother, and how Adrastos next
> Will enter, exit, and reenter, vexed.

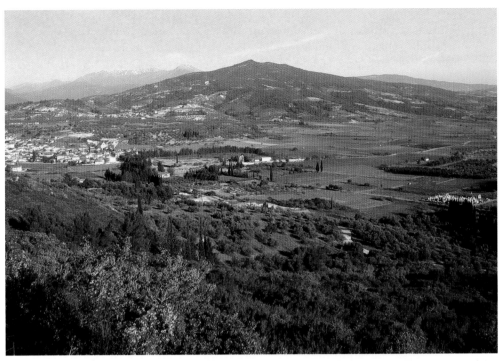

11. The Nemea Valley and its sanctuary of Zeus. Herakles accomplished his first labor, the killing of the Nemean Lion, in this valley; the Temple of Zeus (whose ruins are just visible at center) was built in the late fourth century B.C.

> Then when a playwright's tired of his play,
> And simply can't find any more to say,
> As easy as winking up goes the trapeze,
> And everyone's content with what he sees.

Thus, any Greek passing through the beautiful vale of Nemea in the northern Peloponnese (Fig. 11) would recall that under Athena's aegis Herakles once slew the Nemean lion there – the first of his twelve Labors and the first victory of civilization over beasts and monsters, of culture over nature. Similarly, any fifth-century Athenian looking south from the Akropolis over the Saronic Gulf would recall Theseus's perilous journey around it to the city (see Fig. 76), his recognition as heir to the Athenian throne, and his voyage to Crete to slay the Minotaur (see the far right-hand metope on Fig. 75) and to rescue the monster's annual human meal of fourteen of his city's choice youths and maidens. And if our Athenian turned around, he or she would see Theseus's bones buried in the Agora below, in a shrine resplendent with Mikon's paintings of his exploits, the Cretan one included. More grimly, he or she would also surely recall Theseus's later abduction of the Amazon queen Antiope, her enraged sisters' assault upon the city (see Fig. 39), the hero's last-ditch defense of the Akropolis at Athena's behest (see Fig. 70), and the Persian reenactment of this monstrous invasion (see Fig. 25) – devastating but eventually futile.

19

So myth was a shared cultural resource. It could both entertain and instruct, could furnish precedents and hint at outcomes, could satisfy the demands of piety and politics, could dignify and elevate, and could equally well embellish a temple on a hill, a pot on a table, or a coin in one's purse.

GETTING THERE

In practical terms, how was all this achieved? The keyword is *technē* (pl., *technai*). Basically untranslatable, it is best understood through its two English derivations, technique and technology. Technē is the understanding, ingenuity, and skill that one applies to a problem in order to solve it, or to brute matter in order to make something useful of it.

By the fifth century, the Greeks understood that technē was the driving force behind the advance of civilization, and used it to describe any skill, craft, art, or profession that contributed to this advance. Sailing, agriculture, divination, cooking, medicine, carpentry, metalworking, rhetoric, and politics were all *technai* in this sense. So were sculpture, painting, and architecture. In these occupations, specialized knowledge of stones, alloys, and pigments; skill in drawing, arithmetic, and geometry; understanding of anatomy and the behavior of cloth; dexterity with chisel, brush, ruler, or compass; and (last but not least) a good dose of virtuosity and creativity could give the "expert" sculptor, painter, or architect a distinct edge over the competition. As a fifth-century Corinthian remarked, "in the crafts, new methods drive out old ones"; and as one such craftsman himself noted on his dedication to Athena, the divine patroness of the crafts:

> It's good for skilled men to show their ingenuity according to their *technē*,
> For he who has a *technē* has a better life.

This is why the names of so many classical Greek artists were remembered, indeed celebrated, in the literary tradition. They had made lasting discoveries that enriched not merely Greek art, but Greek – and later, Roman – life. In addition to changing the way that people saw and felt, some of them had changed the way that people lived.

Yet, although classical Greek art had its own momentum, acquired from shared repertoires of techniques, forms, and functions, and a shared pursuit of the goals discussed earlier, this did not mean that its development was preordained and purely mechanical. Although to us it *looks* remarkably consistent and uniform, and so all but predetermined, this is 20/20 hindsight. Not only does the classical period begin with a major rupture, around the year 480, but a generation later, around 450, we find another – less spectacular, to be sure, but still significant – and then two more around 370 and under Alexander (reigned 336–23).

So at any point the artist was confronted with many possible paths to take, in greater or lesser number according to his own skill, the current state of the art, and his customers' openness to innovation. At any point, his own

creativity and/or his clientele's wishes might propel him in a new direction. At any point, life might intervene, directly or indirectly.

SOURCES

All history writing depends upon sources. I could not have written the preceding pages without consulting two kinds of them: *primary sources* and *secondary sources*.

Our *primary sources* are the Greek buildings, sculptures, paintings, and so on that we are discussing, and ancient writings about them. They subdivide into two types: *contemporary* ancient sources and *later* but still ancient ones. The contemporary sources for classical Greek art are the material remains (buildings, artworks, and other objects) of the fifth and fourth centuries B.C. and texts (inscriptions and literary works) written at the same time. The later ancient sources include Hellenistic and Roman copies of (now-lost) classical Greek statues and paintings (Fig. 5) and texts written anywhere from a generation or two after the original artworks were made to centuries later.

These primary sources are the most valuable but unfortunately the least abundant. Medieval builders have deprived us of vast quantities of classical marble architecture, sculpture, and inscriptions, which they broke up for rubble or burned to make lime mortar. Their hunger for metal and fear of paganism also condemned almost all classical gold, silver, and bronze statuary to the melting pot, together with the lead-encased iron clamps and dowels that bonded the joints of cut stone buildings. All the great classical wall and panel paintings have vanished too, though spectacular discoveries of numerous frescoed tombs in Macedonia allow us to regain contact with this art toward the end of our period (see Fig. 160). The handbooks written by classical architects, sculptors, and painters are all lost but for a few quotations, and their contemporaries usually mention art and architecture only in passing, if at all.

But the picture is less bleak than it seems. Many carved votive and funerary reliefs and much architectural sculpture survives, particularly in Athens; ancient wrecks have yielded over a dozen classical bronze statues; and some classical temples and other buildings still stand, albeit in ruin. Bronze and especially terracotta statuettes remain in some quantity. Pots have fared particularly well. Italian and Sicilian tombs have produced thousands of classical red-figured vases (both Athenian and locally made) and tens of thousands of plain black-glazed ones, and the aforementioned Macedonian tombs often contain luxury vessels in bronze, silver, and gold, as well as jewelry. Engraved gems and coins are numerous, many of the latter coming from coin hoards. Finally, many inscriptions and some precious remarks about art by classical Greek writers survive and help us to interpret the material remains.

The later ancient sources also help to fill in some of the gaps. Roman copies of classical sculptures in marble and occasionally bronze are abundant (though not always accurate), and classical panel paintings were often reproduced in Roman houses, though these reproductions vary greatly in detail and in quality. And besides offering valuable observations of their own,

Roman-period authors quoted and paraphrased their Greek sources in their writings about art. Three of these writers stand out, for their works have survived intact:

Vitruvius (ca. 80–20 B.C.), a practicing architect, has left us a ten-book treatise in Latin entitled *On Architecture*. Although most of his sources were postclassical, he transmits a wealth of information about classical Greek architects and their buildings, methods, and writings.

Pliny the Elder (A.D. 23–79) wrote a Latin encyclopedia in 37 books entitled *On the Nature of Things*. Books 34–37 address the representational arts under four heads: metals in book 34, with an emphasis on bronzes; earths, including pigments and paintings, in book 35; stones, especially sculptured marbles, in book 36; and gems in book 37. Basing his work largely on Greek sources and focusing on the classical period, for which he gives an invaluable chronology, he lists several hundred artists and describes many of their works, sometimes in considerable detail. Some of his remarks on Praxiteles and Lysippos are translated in the boxes in Chapters 6 and 7.

Pausanias (ca. A.D. 130–200), a Greek travel writer probably from Asia Minor, wrote a ten-book *Description of Greece*. Although it actually covers only the southern Greek mainland, it is a gold mine of facts, observations, and opinions about everything he saw and heard, from sites and monuments to rituals, customs, legends, myths, and historical events. Also heavily biased toward the classical period, it contains detailed descriptions of several key but now vanished masterpieces, including Pheidias's gold and ivory colossi of Athena Parthenos on the Akropolis (see Fig. 69) and Zeus at Olympia and the great fresco cycles of Polygnotos and his followers at Delphi and Athens.

Our *secondary sources* are the writings of others about all this: A continuous scholarly tradition that began as a trickle in the Renaissance, became a stream during the nineteenth century, and swelled into a torrent in the twentieth. Obviously most of these modern publications are of much less value as *evidence* than the ancient, primary sources. This is why scholars usually cite them after the ancient ones, as in the notes at the end of this book. Yet they make up for their shortcomings as evidence in another way, through their interest as *interpretations*.

The true foundations for understanding ancient art were laid in the eighteenth century. We have already encountered the discipline's founding father, the German humanist Johann Joachim Winckelmann (1717–68). Believing that "good taste was born under the skies of Greece," he began his career by systematically tackling the issue of the sculptural and pictorial models that contemporary eighteenth-century artists should use, predictably endorsing only those that to him exhibited the "noble simplicity and quiet grandeur" of the classical ideal.

Winckelmann's second and most important work, the *History of Ancient Art* (1764), was the first such systematic account ever. He began by examining the preconditions – geography, climate, and history – that had made

Greek art great, and then proceeded to analyze and periodize Greek sculpture and painting, working from the ancient literary sources, especially Pliny. The scheme he devised, essentially still in use today, runs as follows:

Date B.C.	Winckelmann	Current
Before 450	"Older"	Archaic; Early Classic/ "Severe" style
450–400	"High/Sublime"	High Classic
400–330	"Beautiful"	Late Classic
330–Roman	"Imitators"	Hellenistic, Roman

Winckelmann's final book cataloged and classified the ancient sculptures in the main Roman collections by subject. His life's work complete, he promptly got himself murdered the following year.

Winckelmann thus initiated the systematic exploration of the world of ancient art. His work was *critical* (assessing Greek art's value to the contemporary world), *contextual* (addressing its debt to its geographical, historical, and social contexts), *diachronic* (addressing its stylistic development), *thematic* (addressing its subject matter), and *descriptive* (cataloging objects in collections). It announced most of the concerns of subsequent scholarship in the field.

The nineteenth century expanded these horizons in ways that Winckelmann could never have envisaged. A British ambassador to the Sultan of Turkey, Lord Elgin, brought the Parthenon marbles (and much else) to London in 1801–11 (see Figs. 55, 62–67), setting off an "antiquities war" that continued throughout the century. Excavations soon began at Olympia, Delphi, and other major sites, and scholars soon set about classifying, cataloging, researching, interpreting, and publishing the rapidly mounting haul of material. It is an industry that grows exponentially by the decade.

THIS BOOK

At first sight, this book may look quite traditional: a discussion of classical (i.e., fifth- and fourth-century) Greek art in its historical and cultural context that Winckelmann would have had no trouble recognizing, even though he would have found some of its emphases alien and uncongenial. In traditional fashion, it focuses on sculpture, painting, and architecture – partly because it is not an archaeological or anthropological textbook, and partly because these items not only signify more directly and more powerfully than cookware, plowshares, and peasant huts, but also might be more accessible to most readers.

Also it may seem unduly Athenocentric – centered on Athens and its art. This is because Athens both was the leading art center for most of the period and produced most of the extant writing that enables us to contextualize this

art. And because this is not an A-to-Z textbook on Greek art (plenty of those are available) and brute economics forces me to be selective, some major pieces are missing altogether. Students of Greek art will miss the Riace Bronzes, for example (omitted because they totally lack a context), and the Mausoleum at Halikarnassos (omitted because although Halikarnassos was a Greek city and the Mausoleum was built by Greeks, it was built *for* an independently minded Karian satrap of the Persian Empire – a "barbarian" potentate, not a Greek).

Yet this book also challenges some popular assumptions, particularly the notion that art merely *reflects* the events, concerns, and ideas of its time. This notion and its parent, the theory proposed by the German philosopher Georg Wilhelm Friedrich Hegel (1770–1831) that a *Zeitgeist* or Spirit of the Age pervades all the arts of a particular period, are merely more sophisticated versions of an ancient Greek theory of artistic imitation first proposed by Plato. Ironically, it was Greek art's very success in capturing appearances that inspired this theory. In its crudest form, it saw art as a mere mirror of life, relegating it to the purely cosmetic function of reproducing the already lived and already known.

Instead, I prefer to borrow an idea from the social sciences: Classical Greek art participates in a civic *discourse*. Along with classical Greek literature, theater, music, sport, politics, and even warfare, it engages in an ongoing debate about the city or *polis* and its relation to its past, present, and future, to its own inhabitants, and to the outside world. (This is one reason that I have included so much historical and social context and that each chapter also engages some key classical authors.)[5] For these artists and their clients were deeply rooted in the polis. They were citizens of their respective cities, lived and worked in them, and participated in their civic, religious, and social life. Like writers, actors, musicians, doctors, and politicians, they competed for attention from an engaged and opinionated public. They drew on the

5 The featured authors and texts are as follows:

Chapter	Author	Text(s)
1	Pindar	*Isthmian Ode* 5
	Aischylos	*Persians*
2	Aischylos	*Oresteia*
	Pindar	*Olympian Ode* 1
3	Thucydides	*Peloponnesian War* 2
	Sophokles	*Antigone*
4	Sophokles	*Antigone*
	Plato	*Republic* 5
5	Aristophanes	*Peace*
	Euripides	*Iphigeneia among the Taurians*
6	Plato	*Republic* 6
	Euripides	*Bacchae*
7	Aischines	*Against Ktesiphon*
	Demosthenes	*On the Crown*

experiences of this public; reprocessed its ideas, feelings, and agendas; and received its praise and criticism. They were socially engaged.

But their work was – or could be – socially formative. It helped to *create* environments and to *construct* ideologies; it *produced* thoughts and feelings; and it *promoted* continuity or change. As a *form of life*, it contributed actively to the fabric of Greek life. It could sway the soul. Many Greeks held this view, which is why Plato attacked art so savagely in his magisterial *Republic* (see Chapter 6, Box 1). He saw artworks as morally corrupting, as mere secondhand copies of the visible world whose beauty and realism seduced people away from philosophy and the contemplation of true reality: the invisible universals or "Forms."

In the pages that follow, I try to keep at least some of these balls in the air simultaneously. Unfortunately, the surviving classical Greek texts that mention artworks rarely specify causes and effects, usually reducing us to inference of one kind or another. But whenever possible, I try to explain what seems to have gone into a given work of art, what may have come out of it, and what impact it may have had. I try to contextualize the classical Greek "revolution." First, however, I must discuss its origins.

CHAPTER 1

ARCHAIC INTO CLASSICAL: THE GREEK REVOLUTION

GREECE THROUGH THE LOOKING GLASS

"We sit," Sokrates once observed, "like frogs around a pond." Greece is a small country, and the Aegean is not a large sea (see Map 1). Yet imposing mountains and treacherous waters encouraged political and social fragmentation, and mini-states dotted the Greek landscape even in the Bronze Age. When these states collapsed in the twelfth century, the Greek language and a rich array of stories survived the debacle, but little else did. The society that emerged from this "Dark Age" – three long centuries of poverty, insecurity, and isolation – was self-reliant, combative, and obsessed with personal prowess and personal excellence, all summed up in the Greek word *aretē*.

Homer's *Iliad* and *Odyssey* belong to this time and remained the "Bible of the Greeks" throughout antiquity. To Homer, aretē (for convenience, usually translated in this book as "excellence") makes a man stronger than his rivals (who otherwise could kill or enslave him) and entitles him to recognition and honor. Thus, in *Iliad* 1, the great hero Achilles, "peerless in excellence", withdrew from the fighting at Troy because King Agamemnon took away his favorite captive, Briseis, and thus "did no honor to the best of the Achaeans." This mindset helped to generate what historians aptly call the Greek "contest society." Preoccupied with personal honor (and its opposite, shame), the Greeks focused their attention on the self and its attributes: autonomy, strength, prowess, physical beauty, and so on. This may be one reason that Greek art is so *anthropocentric* – so focused on humans and their doings.

In the eighth century, the scattered Dark Age villages began to coalesce into larger units – a development paralleled in the non-Greek cultures of Phoenicia (Lebanon), Etruria in northern Italy, the Latin regions of central Italy, and southern Spain. In Greece, these independent city-states or

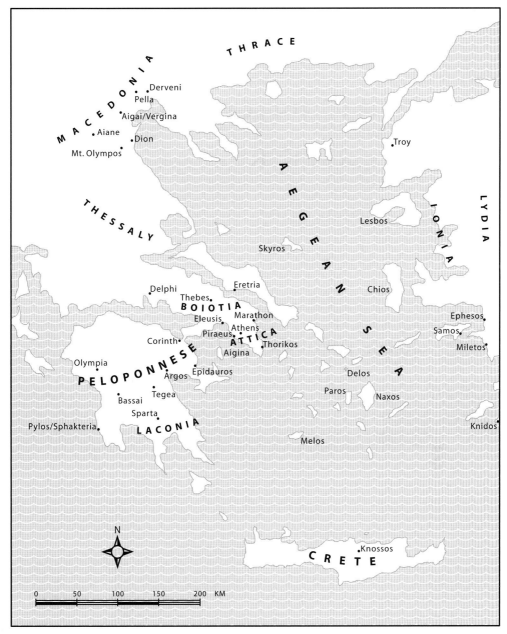

Map 1. Greece and the Aegean. Map drawn by Erin Babnik.

poleis (sing. *polis*) – in this book simply called "cities" – soon began to out-grow their land and resources and to display a quite extraordinary dynamism. Competing for honors and power, often in the guise of demanding justice for themselves and their followers, their inhabitants began to overthrow their hereditary rulers, replacing them with aristocratic cliques (*oligarchies*) or even dictatorships (*tyrannies*), and instituting aggression against other cities. The

losers in these contests often headed overseas to found new cities on the shores of Sicily, Italy, North Africa, and the Black Sea.

CITY AND ELITE

Physically, a typical Greek polis displayed four main features (Fig. 12): a wall for defense; an open space or *agora* inside it where citizens could meet, talk, and trade,[1] and where the city's founding hero or heroes were buried; a sanctuary to its guardian divinity, often sited on a citadel or *akropolis*; and a cemetery or *nekropolis*, usually situated outside the main gate. Most poleis were small, especially compared with the great and teeming cities of the Near East, but proud and hugely jealous of their independence. As one sixth-century Greek remarked:

> Phokylides says this: A polis on a barren rock, small, but settled
> In an orderly fashion, is greater than senseless Nineveh.

As to the elites of these cities, their dominant symbol was the *kouros* (Fig. 13; pl. *kouroi*). Adapted from Egyptian sculpture around 650 B.C.,[2] it showed a smiling youth, beardless and so around 16–18 years old and at the pinnacle of his life, stepping confidently toward us with his left foot forward and his arms by his sides. Kouroi are naked, youthful, beautiful, autonomous, and happy. Indeed, the elite clans of several cities, Athens included, shamelessly flaunted their wealth, power, and consequent felicity by openly calling themselves the "Happy Ones."

As grave-markers or votive offerings to the gods, the kouroi represent the gilded youth of this brazenly elitist society in all its shining splendor. They are the successors of Homer's "long-haired Achaians": the "best of the Achaians," brilliant in peace and glorious in war. The epigram carved on the base of the one illustrated here (Fig. 13) speaks volumes:

> Stay and weep at the tomb of dead Kroisos, whom raging Ares
> Destroyed one day as he fought in the foremost ranks.

Kroisos was so great a warrior, this implies, that it took the war-god Ares himself to destroy him, one glorious but fatal day – a fact to which his magnificent body and soldierly posture still bear silent witness. A moving elegy by Mimnermos glosses this blatantly heroic warrior ethic:

> None could match the strength of him and the pride of his courage.
> Thus the tale told by my father who saw him there
> Breaking the massed battalions of armored Lydian horsemen,
> Swinging the ash-wood spear on the range of the Hermos plain.

1 The Greek words for "speak" (*agoreuō*) and "buy" (*agorazō*) both derive from *agora*, and of course the Greeks themselves were notoriously argumentative.

2 Henceforth, all dates are B.C. unless otherwise stated.

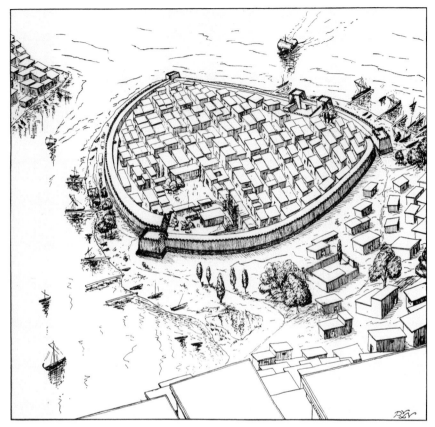

12. Imaginative reconstruction of the polis of Old Smyrna in the seventh century B.C.

> Pallas Athene, goddess of war, would have found no fault with
> This stark heart in its strength, when at the first-line rush
> Swift in the blood and the staggered collision of armies in battle,
> All through the raining shafts he fought out a bitter path.
> No man ever in the strong encounters of battle was braver
> Than he, when he went still in the gleaming light of the sun.

Mimnermos was by no means the only advocate of this militaristic, elitist, and aristocratic point of view. Alkaios, Sappho, and other like-minded poets cheerfully joined the chorus, cozying up to the gods, invoking the Homeric heroes, parading their love of luxury, flaunting their wealth in lavish banquets, weddings, funerals, and "Orientalizing" dedications to the gods, and trying hopefully to mimic the lifestyles of the grandiose kings of nearby Lydia in western Asia Minor (see Map 2). Indeed, the Athenian family who set up the kouros of Fig. 13 even named their son, Kroisos, after the most fabulously wealthy of these Lydian monarchs, King Croesus (reigned ca. 560–46).

These individuals regularly put the interests of their own *oikos* (family/ household; pl. *oikoi*) first, and their socioeconomic networks soon far transcended the Greek cities, reaching out to Lydia, the Etruscan towns of northern

29

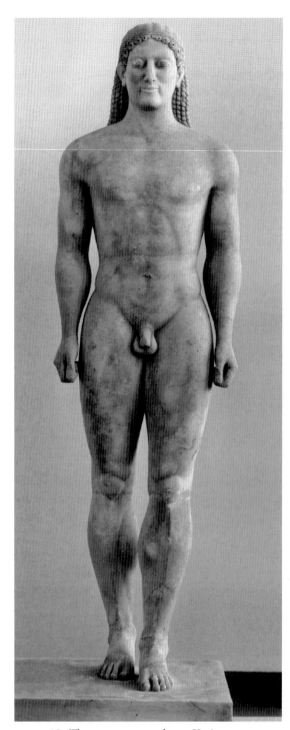

13. The young man or *kouros* Kroisos,
from his tumulus at Finikia near
Anavyssos in Attica, ca. 530. Marble; ht.
1.94 m (6′5″). Athens, National
Museum. The three-stepped base (not
shown) carries an inscribed epitaph
stating that Kroisos fell in battle,
"fighting in the foremost ranks."

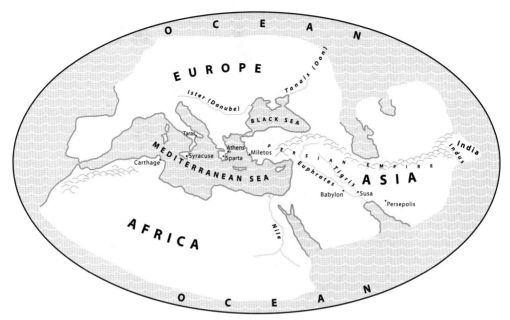

Map 2. The known world in the fifth and fourth centuries B.C. Map drawn by Erin Babnik.

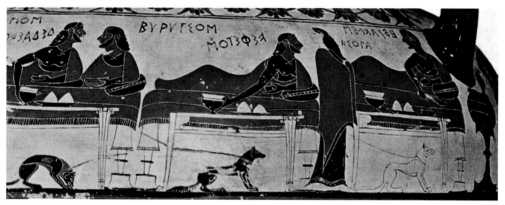

14. A Greek symposion: Herakles feasts in the house of Eurytos. Detail of an early Corinthian mixing bowl (column krater) from Caere (Etruria), ca. 600–575. Ht. 46 cm (1′6″). Paris, Louvre. Herakles, at far right, is attracted by Eurytos's daughter Iole, standing in front of him.

Italy, and beyond. Their major social ritual was the *symposion* (Fig. 14; pl. *symposia*), at which they reclined like Lydian and other near-eastern potentates, drank prodigious quantities of wine, traded stories and jokes, seduced boys and women, and sang the songs of their favorite poets. Their favorite outdoor pastimes were competitive: warfare, hunting, horse racing and chariot racing, and athletics.

By 500, this elite's defining symbols, the muscular, naked kouroi (Fig. 13) and their female counterparts, the comely, brilliantly dressed *korai* (see Fig. 6; sing. *korē*), thronged the sanctuaries, cemeteries, and roadsides of Greece. Although not found uniformly throughout the Greek world, these splendid

BOX 1. *THE PERSIAN WARS*

Persian involvement with the Greek cities began shortly after 547, when they conquered the Lydians and deposed their king, Croesus. The Ionian Greek cities of coastal Asia Minor soon fell under their sway, which by 520 extended to the offshore islands, including Samos, Chios, and Lesbos.

Increasingly restive under Persian rule, the Ionian Greeks revolted against Persia in 499. Athens and Eretria sent twenty-five ships to support them; they helped the rebels to sack the Persian provincial capital, Sardis, and then withdrew, leaving Darius to crush the revolt in 494. In midsummer of 490, he sent a punitive expedition across the Aegean, which sacked Eretria and landed at Marathon for the march on Athens. The Spartans set out too late to help the greatly outnumbered Athenians, and only a gallant detachment from the town of Plataia joined them. Fortunately, in hand-to-hand combat the lightly armored Persians were no match for the bronze-clad Greek spearmen or *hoplites* (see Fig. 15), and the Greek practice of exercising and competing in the games naked, now all but universal, gave them the edge physically as well (Fig. 25). Under the blazing summer sun, the Athenian–Plataian phalanx covered the mile to the Persian line at a run, before the enemy archers could do serious damage. Although the Athenian captain general, Kallimachos, was killed in the ensuing mēlée, the Persians eventually broke and ran for their ships, leaving 6,400 dead on the field to the Athenians' 192.

Darius's plans for retaliation were delayed by a revolt in Egypt; when he died in 486, his son Xerxes took on the task. By 483 he was almost ready, but the gods intervened once more. A revolt in Babylonia tied down Xerxes' army for a year, and Athenian prospectors discovered a rich vein of silver in Attica at Laurion. Themistokles (see Fig. 37), a wily and far-sighted politician, persuaded his fellow citizens not to divide it among themselves but to build a 200-ship fleet with it, arguing that now they could crush their ancient enemy and commercial rival, the nearby island of Aigina. This never happened. In 481, with Xerxes and his huge army massing in Lydia, representatives of thirty-one Greek states met at the Isthmus of Corinth and resolved to postpone their quarrels and to resist the coming invasion. In the spring of 480 the Persians crossed into Europe on a bridge of boats, marched through Macedonia, and descended on central Greece, their left flank protected by a vast fleet.

Victorious at Thermopylai over a heroic defense led by King Leonidas and his legendary 300 Spartans, Xerxes forced the Boiotians to change sides and occupied Athens in early September. Themistokles had already persuaded the Athenians to evacuate; only a few diehards remained on the Akropolis, which Xerxes soon stormed and sacked. Themistokles then convinced the Greek fleet to make a stand at nearby Salamis, whose narrow straits would offset the Persians' huge numerical advantage. Yet though the Greeks were decisively victorious, the enormous Persian army was still intact; even so, the humiliated Xerxes hurried off to Sardis, supposedly to forestall another

revolt in Ionia, leaving his army behind. Meanwhile, the Sicilian Greeks under Gelon, tyrant of Syracuse, had crushed a similar threat from the west, clearly orchestrated to coincide with Xerxes' invasion. Supposedly on the same day as the battle of Salamis, Gelon ambushed a huge Carthaginian force at Himera. He utterly destroyed it, ending the Carthaginian threat for many years.

In September 479, after the frustrated Persians had sacked Athens a second time, the combined Greek armies under the Spartan regent, Pausanias, finally confronted them at Plataia and secured the decisive victory they needed, killing their commander, Mardonios. On the same day, but on the other side of the Aegean, the combined Greek fleet and its marines under the Spartan king Leotychidas annihilated the Persian fleet and garrison of Miletos at the nearby promontory of Mykale, guaranteeing Greek control of Ionia and the seas in between. Finally, in 474, the Syracusans decisively defeated the Etruscans at Cumae in central Italy, effectively ending their threat to the Greek colonies there also.

figures hint strongly at the cultural bonds that now united it. During the Persian Wars of 490 and 480–79, the Athenians neatly summarized them, citing "our common Greek brotherhood, our common language, the altars and sacrifices of which we all partake, and the common character that we bear." In addition, all Greek children had learned the Greek myths – universally accepted as history – at their mothers' knees, and all had thrilled to the tales of Achilles, Agamemnon, Menelaos, Odysseus, and their peers in the *Iliad* and *Odyssey*, which along with other epic sagas were regularly sung at festivals and feasts.

By 500, too, all Greek males were accustomed to exercise naked, and all those who could afford their own heavy armor (see Fig. 15) were trained for

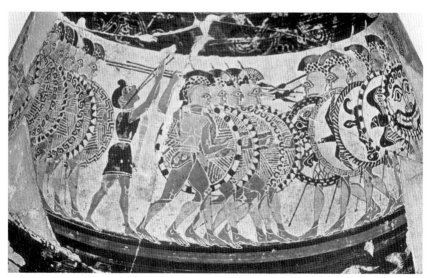

15. Phalanx battle. Detail of a late Protocorinthian wine jug or *olpē* (the so-called Chigi Vase) from Veii (Etruria), ca. 650. Ht. of frieze, 5 cm (1.9″). Paris, Louvre.

the sort of warfare that the Athenians so brilliantly practiced at the battle of Marathon in 490 (see Box 1. *The Persian Wars*), wherein *hoplites* or heavily armored spearmen in dense *phalanx* array fought spear to spear, shield to shield, and eyeball to eyeball until one side broke and ran. Most importantly, and in part owing to the male bonding that athletics and massed phalanx warfare promoted, they had begun to develop a strong sense of civic community, today aptly dubbed "the Greek men's club." For women were excluded from polis citizenship and had no voice in public affairs. Their role was not to be citizens, but to produce them.

THE "MIDDLING" ALTERNATIVE

This sense of community did not emerge all at once, nor was it achieved without struggle. From the dawn of the Greek city in the eighth century a strong tradition of nonelitist and sometimes anti-elitist verse promotes the virtues of hard work, neighborliness, and simple piety and sternly rejects pretension, luxury, and fancy foreign ways. To different degrees, the poets Hesiod, Archilochos, Theognis, Phokylides, and others each stood for this agenda, breaking with the elitism of Mimnermos, Alkaios, Sappho, and their kind. But these men were not revolutionaries, proto-communists, or anarchists. Their roots were in the farming and artisan middle class.

In one poem by Archilochos, a carpenter dismisses the Lydian King Croesus's illustrious ancestor Gyges in a single sentence, flatly rejecting everything the aristocratic elite held dear:

> I don't care for Gyges the Golden's goods,
> And I've never envied him.
> I'm not jealous of the deeds of gods either,
> And I don't lust after a magnificent tyranny.
> These are beyond my sights.

Archilochos's contemporary Phokylides put it more bluntly:

> Phokylides says this: Middling in the city I would be.

These men's response to the elite's individualistic, heroic-style warrior ethic was to mock it and to promote the more egalitarian hoplite phalanx instead. As Archilochos also remarked:

> I don't like a general who's tall, swaggers about,
> Takes pride in his curls, and shaves under his chin.
> I like the one who's short, bandy-legged,
> Stands firmly on his feet, and brims with courage.

So much for Kroisos too (Fig. 13)!

By 500, the elite's grip on many cities was slipping. An economic and demographic expansion had been under way for some time and was creating

repercussions well down the social ladder. In some cities, a growing restiveness on the part of the "middling" hoplite class hastened the collapse of the regime, whether an entrenched aristocracy or one-man rule, called by the Greeks a *tyranny*. This Lydian loan word was originally quite neutral, but soon came to acquire its modern, pejorative connotations as some rulers met their opponents with force and repression. In Samos (522), Athens (508), and an increasing number of other cities the triumph of this newly self-assertive, much broader "Greek men's club" was enshrined in new constitutions whose common slogan was *isonomia* ("equal-law"), meaning both "equality of rights" and "equality under the law" – but only for citizen males and their families.

Elites still dominated city affairs, of course, for they alone had the status bestowed by land and money, the leisure to devote to politics, the networks to build followings, and the speaking skills to promote their agendas. But rudimentary systems of checks and balances now ensured that they could no longer act unilaterally, and new laws aimed at achieving justice put all significant decisions "in the middle" before the collective: the "men's club" or *dēmos* meeting as a voting assembly. The city, in other words, had begun to prevail over the household, the collective over the individual, and the state over kinship. So in essence these cities were now hoplite republics – a giant step toward democracy (*dēmokratia* or "people-power"), but still far from the developed or radical democracies of the mid fifth century. Some of these fledgling republics quickly collapsed, but others – the Athenian one in particular – endured and thrived.

The newly empowered "men's club" soon flexed its muscles. Kouroi had already disappeared in some communities ruled by populist tyrants, but in Athens and Attica (its surrounding territory) it is surely no accident that they vanished, along with fancy carved gravestones, soon after the new republican constitution was adopted in 508. Because Attic kouroi now did duty almost exclusively as grave markers (see Fig. 13), a law curbing aristocratic funerary ostentation is the most likely reason. The best candidate is one recorded half a millennium later by the Roman orator Cicero (*Laws* 2.64–5):

> On account of the enormous tombs that are visible in the Kerameikos [the main Athenian cemetery], a law was passed "that no one should build a tomb that required more than three days work for ten men." It was forbidden, too, to adorn a tomb with stucco and to place on it the so-called herms. Eulogies of the deceased were also forbidden, except at public funerals and by publicly appointed orators. Crowds of mourners were even forbidden, in order to limit the lamentations; for a crowd increases grief.

Always suspicious of elite self-assertion, which elevates the individual and his household above the collective and could signal an aspiring tyrant, the dēmos targets a particular elitist practice and stages a coup, nationalizing and democratizing it – an increasingly familiar pattern. Nor was Athens unique. Throughout Greece, offerings in graves decline precipitately in quantity and quality at this very time, and in the world of the living, houses remain simple

and dress (a telltale marker of social change) becomes simpler too. As the historian Thucydides noted around 400:

> It was the Spartans who first began to dress simply and in accordance with our modern taste, with the rich leading a life that was as much as possible like the lives of ordinary people.

In this newly self-conscious environment, increasingly dominated by egalitarian sentiment and a "middling" behavioral ethic, luxury and conspicuous display were becoming unfashionable. Significantly, though, the leader of this egalitarian movement was Sparta.

THE SPARTAN RESPONSE

A military state headed by two kings but actually run by a council of elders and five elected "overseers," Sparta was a vibrant center of music, poetry, and art for much of the archaic period. It reacted to the winds of change blowing through Greece by turning itself into an armed camp and vigorously crushing populist movements – tyrannies and democracies – within its sphere of influence. In 510, it had been instrumental in ousting the Athenian tyranny, but disliking the republic that followed it, soon tried to install an oligarchy. Fortunately, the attempt failed.

The Spartans ruled about two-fifths of the Peloponnese, a territory comprising their Lakonian homeland in the east and Messenia in the west, conquered in the seventh century. They dominated most of the remainder through the so-called Peloponnesian League, a system of alliances that all but compelled its adherents to follow Spartan policy, and wielded great influence in the rest of Greece also.

All Sparta's full citizens or *Spartiates* (who called themselves "peers" or "equals") were fulltime hoplites, Greece's only professional army. When a child was born, it was the state, not the parents, that determined whether or not it should live. Boys were taken from their parents at age seven, brought up communally, and subjected to an exacting curriculum of military training; and girls practiced sports, dancing, and singing as a preparation for courtship, marriage, the rigors of childbirth, and the demands of motherhood. In peacetime, Spartan men were supposed to live in barracks rather than at home. They shared the same austerely communal lifestyle, were banned from commerce and trade, and deferred to their elders and betters in peace and to the kings in war. To frustrate even the smallest move toward commercialism and a market economy, the Spartans stashed their gold and silver – mostly plunder – at Delphi; banned the use of coinage within their territory; and used heavy iron spits for currency instead. (How did they manage at the ATM?)

These Spartiates, who numbered around nine thousand by the end of the sixth century, lived in five unwalled villages (four composing the town of Sparta itself and one at nearby Amyklai), ringed by sanctuaries that demarcated

them from the rest of the Lakonian population. These folk, who outnumbered the Spartiates many times over, consisted of "peripherals," who were free and also served in the army, but had no civic rights, and serfs or *helots*, who were unfree. The "peripherals" were farmers and craftsmen, and the helots worked the estates that supported the Spartiates in their martial lifestyle. The Spartiates treated the helots like dirt, even ritually declaring war on them every year so that they could kill them at will. Needless to say, the helots bitterly resented their lot. As one observer dryly noted, "they would gladly eat the Spartans raw!"

So the Spartan system was a curiously schizophrenic trade-off between "middling" and elitist, between city and individual, and between polis and oikos. "Within the restricted community of those with full citizen rights, every Spartiate was a middling citizen, a 'peer' or 'equal'; outside that community, every Spartiate was a little Homeric lordling, terrorizing the serfs and affecting a long, heroic hairstyle. When marching out to war they were led by kings, like the Akhaians at Troy; at home they were ruled by elected Overseers and a Council of Elders. Spartans presented themselves to their fellow Greeks and to their subjects as superelitists – eschewing the softness and luxury of their Ionian counterparts, but nonetheless upholding the ancient virtues of their Dorian heroes – even as, among themselves, they promulgated an ideology of egalitarian militarism."[3]

Sparta's very extremism and spectacular success (for a while) made it highly attractive to a certain kind of mind, from Kritias, Xenophon, and (perhaps) Plato in the classical period through Adolf Hitler in the twentieth century. But like many such systems, it harbored the seeds of its own decline. Spartan arrogance and brutality often alienated their allies; their avarice once abroad was legendary; their xenophobia, narrow-mindedness, and fear of helot revolts tended to hobble their foreign policy; and with the men so often absent on maneuvers or on campaign, their birthrate soon began to fall. By 480 the number of true-blue Spartiates had dropped to eight thousand; by 370 to a mere one thousand; and by 244 to only 700.

Despite the Spartans' espousal of the "middling" way, then, after 500 Sparta began to emerge as Athens's political and cultural antitype. Although it would be some time before they actually came to blows, the rift between them would only increase as the fifth century wore on. In essence, the two societies evolved *interdependently*, each pushing the other further and further into the opposite corner of the ring. Indeed, apart from a handful of monuments to their victories over Persia in 479 and Athens in 404, now lost, the Spartans produced almost no architecture, sculpture, painting, literature, or music during the classical period. So Spartan caution and Spartan philistinism will henceforth serve as a foil to Athenian military and cultural hyperactivity. If the symbol of the "glory that was Greece" is the Periklean building program (see Figs. 54, 55, 59–70, 78, 102–5, 111, 112), then Sparta's answer to it was

3 Richard Neer, "Framing the Gift: The Politics of the Siphnian Treasury at Delphi," *Classical Antiquity* 20 (2001): 273–336, at p. 286.

the lowly *kōthōn* (Fig. 16), the simple black-glazed drinking mug that every Spartiate carried on campaign, complete with pinched rim to catch dirt and bugs in the water.

THE THEATER OF THE REAL

To return to Athens, even before the last Attic kouroi were carved, the bases of some of them had begun to carry vivacious scenes of everyday life that contrasted strikingly with the robotlike figures poised above. Many contemporary vases followed suit. Thus, one side of the late sixth-century wine-jar or *amphora* in Fig. 8 shows three revelers capering about after a symposion. The central one is suggestively labeled Hegedemos, "dēmos-leader." Yet its other side (Fig. 10) is quite solemn, even potentially tragic. Also carefully labeled, it shows Hektor standing between his father Priam and his mother Hekabe, putting on his armor (anachronistically, the standard hoplite panoply of helmet, breastplate, and greaves) to go out and fight for his city, Troy – for the last time?

This ominous vignette would have resonated strongly with late sixth-century Athenians. For not only had they been able to see mythical tragedies of this sort enacted on the stage since the 530s, but they now faced the real thing in the flesh. Surrounded by enemies, and in 506 menaced by a three-pronged assault by the Spartans and their allies, their fledgling republic seemed doomed, but Athenian courage and daring won the day. Miraculously, they repulsed their enemies and saved their city. So this pot references both sides of the civic experience: the citizen male "at play" as a symposiast and "at work" as a warrior. We shall encounter these complementary roles often in the pages that follow.

The painter of these scenes even tagged them with a sly dig at a rival, a clear sign that he regarded them as a tour-de-force. Proudly using his full name, in a striking display of the competitiveness that pervaded ancient Greek society in general and its craft production in particular, he spread it right around the pot (though in minuscule letters): "Euthymides son of Polion painted me || as never Euphronios [could do]!"[4]

For Euthymides and his rival Euphronios were both masters of *foreshortening*: the rendering of the appearance of people and things as they project or recede into space. In Fig. 10, one of Hektor's feet projects in foreshortened frontal view, but the symposion scene in Fig. 8 is far bolder. The left-hand reveler angles away from us, his chest and abdomen correctly foreshortened; the magnificent central one twists 180 degrees, the sweeping curve of his spine unifying his movement; and the right-hand one swivels toward him. These three figures mark a crucial step in the conversion of Greek art from the ancient *conceptual* approach that represents people and

4 Because he placed the words "as never Euphronios [could do]" behind the left-hand partygoer, Komarchos or "Lord of the Revel," one could read them as a boast that Komarchos is the best party animal in town; but because the words are not directly connected with the figure, this interpretation seems forced.

16. A Spartan mug or *kōthōn*. Ht. 5.2 cm (2″). The pro-Spartan Kritias remarked: "The Spartan kōthōn is a mug most suitable for military service and easily portable in a kit bag. It's a soldiers' mug, because often they have to drink dirty water; the liquid inside it can't be seen too clearly, and it has a pinched rim to retain any impurities."

objects in their most characteristic aspect, as they are *known* to be (Figs. 4, 14, 15), to an optically based or *perceptual* approach that represents them as they are *seen* or *appear* to be. Signaling the triumph of subjective appearance over inherited tradition, they create what the great French literary critic Roland Barthes once cleverly called (in another context) a *reality effect*.

It may be no coincidence that these experiments often appear in representations of the symposion, a newer and less codified pictorial genre than that of heroic myth (Fig. 14, painted around 580, is the earliest surviving example). The full artistic, social, and intellectual consequences of these innovations would not emerge for many years; we shall explore them in the following chapters.

Another symposion vase, painted somewhat later by the Brygos Painter, has completely assimilated this perceptual approach and treats it with a new intimacy and insight. On one side Dionysos quietly communes with a nymph, while on the other (Fig. 17) Alkaios, a renowned poet of the symposion, sings to his lyre while the poetess Sappho listens to him. (Again, the painter names them both.) The two had lived a century earlier on the island of Lesbos, and probably knew each other. As mentioned earlier, both of them were strong partisans of the elitist, refined, Lydian-style culture of the archaic Greek aristocracy.

Alkaios, elegantly dressed and with his hair foppishly curled and bound with a Dionysiac fillet, stands in profile view; the painter "represents" his song by faint purple arcs that waft from his open mouth. Sappho, just as stylishly attired, has been walking away from him (her body inclines slightly to the right, and the folds of her clothing pick up its movement), but now swivels gracefully around to listen, her own lyre and plectrum at the ready. Her right

foot is frontal and her face shown in three-quarter view. This is the first time that an Athenian painter represents a woman thus, and we shall discover in a moment why he has done so. Moreover, in keeping with the new natural and vivid look, he teasingly sketches the figures' bodies beneath their clothing.

Nineteenth-century scholars were quick to connect this encounter with an incident reported almost two centuries later by Aristotle:

> Men are ashamed to say, to do, or to intend to do shameful things; as when Alkaios once said to Sappho:

> > I want to say something to you, but shame prevents me.

> She replied:

> > If you desired what is honorable and good
> > And your tongue weren't stirring up something bad,
> > Shame wouldn't cover your eyes,
> > But you would set forth your claim.

The anecdote is probably fictitious, but even so the two poets' personal interaction is real and brilliantly staged. This is perhaps the first true conversation piece in western art.

DRAMA, INTERIORITY, ĒTHOS, PATHOS

Figure 17's resemblance to a stage play may not be fortuitous. For these same years saw the first great flowering of Athenian drama. Supposedly invented by Thespis in the 530s and dedicated to the god Dionysos (pictured on the pot's other side), by the 470s the art had evolved considerably. Early drama had employed a single protagonist speaking to a chorus that in effect represented the audience onstage. Aischylos, who made his theater debut in 499 and soon became the first "classic" Athenian tragedian (the other two being Sophokles and Euripides), added a second actor. This not only enabled true dialogue to take place, but also created real dramatic tension and vivid exploration of character and motivation as the two actors engaged each other face-to-face or individually discussed their thoughts and feelings with the chorus. Almost always set in the heroic past, these tragedies explored – like the Hektor scene in Fig. 10 – the city's trials, tribulations, hopes, and fears through the medium of heroic myth.

Such themes compelled the dramatist not merely to explore human character and emotion (the *ēthos* and *pathos* analyzed later by Aristotle) – Homer and other poets had done that brilliantly for centuries – but to *represent* them to a mass audience. The task now was to *externalize* interiority in word and deed. And because all participants were masked and the audience was large and often quite distant, the actors not only had to enunciate emphatically and clearly, but also had to develop the right body language to express their states of mind. They had to turn the familiar and very rich Mediterranean language

17. The poet Alkaios serenades the poetess Sappho on the lyre. Detail of an Athenian red-figure wine cooler (kalathoid *psykter*) from Agrigento (Sicily) attributed to the Brygos Painter, ca. 475. Ht. 25.3 cm (10″). Munich, Antikensammlung. The painter names the two poets; from Lesbos, they lived about a century earlier, but remained popular throughout the period.

of posture and gesture into a medium of artistic expression, to harness and stylize it so that it could bring the script to life. They too had to create a *reality effect*.

These early plays – indeed all Greek tragedies and comedies – were performed in the open air. Theaters were more or less rectangular (Fig. 18)

18. The theater at Thorikos, fifth and fourth centuries B.C. The original theater, built around 500, consisted of a rectangular dancing floor or *orchēstra* only, with the audience sitting on the bare hillside above. In the later fifth century, however, the orchēstra was enlarged and the stone seats visible in the photograph were built. In the late fourth century, twelve more rows of seats (now lost) were added above these, bringing the theater's total capacity to around 6,000. Many of the seats were restored for the 2004 Olympics. The photograph is taken from the ruins of the temple of Dionysos; his altar stood at the far end of the orchestra.

and stayed that way until mid-fourth-century architects invented the clamshell type, familiar today from the great theaters at Athens, Epidauros, and elsewhere (see Figs. 163, 167). This rectangular design was dictated by the chorus, which danced in rectilinear formations (Fig. 19) and thus needed a wide, oblong dancing floor or *orchēstra* in order to do so. Scenery was nonexistent at first, though a simple wooden building behind the orchēstra provided a changing room for the actors, a backdrop for the action, doors for entrances and exits, and a flat roof for divine epiphanies and the like. As in Fig. 18, an altar and temple to Dionysos often completed the ensemble.

The strong reaction to some of these early tragedies shows just how vivid some of them were. Thus, when the Ionian Greeks' revolt from Persian rule was finally crushed in 494, the great city of Miletos was sacked, and its inhabitants were either massacred or enslaved, the Athenian tragedian Phrynichos dramatized the event in a play entitled *The Fall of Miletos*. Shocked and appalled, his audience broke down in tears. Indicting him for "reminding them of their misfortunes," they fined him severely and banned his play forever. (Aischylos was to achieve a similar effect a generation later, though fortunately at no cost to his bank balance. When the dreaded Furies appeared onstage at the beginning of his *Eumenides*, the audience panicked and supposedly women even miscarried in terror.)

In the Brygos Painter's picture (Fig. 17), this sense of theater begins with and is abetted by the red-figure pictorial technique itself, which renders the human body as a light-colored form that stands out, as if illuminated, against its deep black background. Alkaios and Sappho seem to be spotlighted on

19. Chorus dancing at a tomb (?). Athenian red-figure mixing bowl (column krater), ca. 480. Ht. 40.5 cm (1′4″). Basel, Antikenmuseum. The six men dance in rectangular formation. They wear masks, showing that the scene takes place in a theater; the identity of the boy watching them is uncertain.

a stage, as in contemporary theaters where, as we have seen (Fig. 18), the floor was a wide rectangle and the blue Aegean sea and sky often formed the backdrop to the action. Unlike Hektor's leave-taking (Fig. 10), their encounter is not tragic, of course, but it is certainly dramatic, in that each seems to be playing a definite role and uses acting techniques in order to get it across. It is this that gives them their powerful sense of character, of a thinking, feeling person standing before us. So we instinctively weave a narrative around them, project our ideas and feelings upon them, and endow them with thoughts, hopes, and fears like our own. They become, in short, human beings like us. They have a life. Looking at them, one almost feels relieved that at last, Greek artists have discovered the mind.

For the painter captures them in a moment that reveals not only experience and feeling (pathos) but also character (ēthos). Alkaios, simultaneously composing, singing, and playing extempore, shows his absorption in his task and his dissociation from his audience – ourselves – by standing in profile with his head lowered in rapt concentration. Sappho, on the other hand, employs the actor's technique of "cheating out" – of turning her body and head toward us while ostensibly listening to her companion. This pose (which we shall meet again) enables her to convey her polite attention to his words but deftly includes us in the conversation. As a result, in stark contrast to the popular

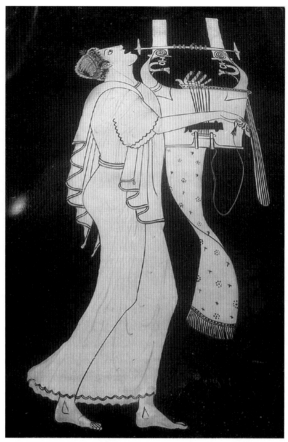

20. Ecstatic kithara-player. Detail of an Athenian
red-figure wine jar (belly amphora) from Nola (Etruria)
attributed to the Berlin Painter, ca. 480. Ht. 42 cm (1′5″).
New York, Metropolitan Museum of Art. For detailed
photo credit see Sources of Illustrations.

image of the poet as an inspired, even manic figure (Fig. 20), the two indi-
viduals emerge as model representatives of their class and station – as refined,
well-bred aristocrats who happen to be accomplished musicians, espied in a
private exchange.

So like Kroisos (Fig. 13) and his fellow kouroi, these are examples of
what has aptly been called the *role portrait*: A portrait "which emphasizes
the public aspect of an individual, his fulfillment of an important role in
society." Catering to the Greek urge to represent the specific in the light of the
generic, such images were now fixtures on the Greek scene, and an interest in
character and emotion as revealed by the silent but eloquent dramatic language
of posture and gesture would soon become an obsession with early classical
Greek artists, particularly the great muralist Polygnotos and his peers (see
Figs. 51, 52).

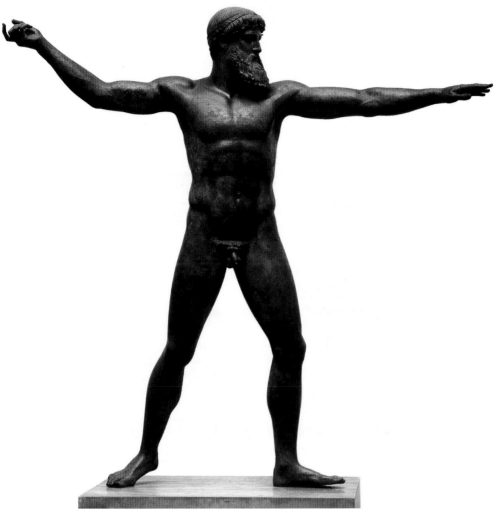

21. God, probably Zeus, from a wreck off Cape Artemision (Greece). Bronze; ht. 2.1 m (6′11″). Athens: National Museum. Zeus's thunderbolt fits better in the hollow of his right hand than Poseidon's trident.

A CALL TO ORDER

Humans may propose, but the gods dispose. Above all, they enforce order. The spectacular bronze recovered in 1926–8 from a shipwreck off Cape Artemision in Greece (Fig. 21) sums all this up and adds much more. Once identified as Poseidon hurling a trident at some unseen foe, he is more likely to be Zeus. For the fingers of his right hand were curled around a thick tubular object with a flange, directed out at a 20-degree angle from the body. Surely this weapon was Zeus's thunderbolt, not Poseidon's trident. For a trident held in this way either would have obscured the god's face with its prongs or, stopping short of his head, would have made him look as if he were committing suicide with it!

Made probably in the 450s, this mighty bronze is often regarded as the very embodiment of the early Classic or *Severe* style in Greek art, with good reason. Not only does the god exemplify perfectly the often-touted classic virtues of consistency, economy, clarity, balance, restraint, and the supremacy of formal design, but he also radiates vitality, beauty, sensuality, and soul. Yet although caught at the very moment of hurling his weapon, he betrays no sign of effort or strain, and little sign even of forward movement. His body is upright, his massive muscles immobile, his neck straight, his head erect, his features impassive, and his gaze level. All this elevates him far above mere human striving. The overall effect is so compelling that one can easily miss the fact that his arms have been deliberately elongated in order to equalize the composition horizontally and vertically: to inscribe it within a square.[5]

So whereas archaic artists had represented the gods either like kouroi or lunging forward in violent action, this one has taken a new tack. He has asked himself, "How do I convey Zeus's uniquely universal power?" Dissatisfied with mere action for its own sake, he has come to view it as a symbol of his subject, as a way of demonstrating Zeus's personality – his status as both the embodiment of divine order and its enforcer. By stilling the god's movement and trapping it within the static boundaries of a square, he has produced an icon of effortless cosmic power and superhuman excellence, to be respected, reverenced, even feared. Starkly silhouetted against the sky, this is the Lord of the Universe, and God help those who cross him: "Zeus who disposes this and that, Zeus the master of everything."

This last quotation comes from Pindar, the great lyric poet of the first half of the fifth century. Pindar bestrides the archaic and classical periods, and his agenda – a moralizing concern with man's relations with his fellow men on the one side and the awesome power of the Olympian gods on the other – has much in common with that of early classical Greek art. This is not surprising, because both he and the artists often catered to the same audiences: the powerful elites of the mainland Greek cities and their colonies abroad. In other words, together they helped to shape a developing *discourse* about man, god, power, and order.

Elsewhere Pindar reflects on this discourse in lines that might have been written in front of this statue:

> God reaches, soon as thought, his ends:
> God, who can catch the winged eagle in the sky
> And overtake the dolphin in the sea.
> He can bring down anyone whose heart is high,
> And to others give unaging splendor.

We have seen that the Artemision Zeus's uncanny aura of self-control derives in part from his immobile muscles and impassive features, and in part from

5 Each axis measures 2.09 m (6′10¼″) or seven Attic feet of 29.5 cm (11.61″), so that if Zeus were to drop his hands to his sides, his fingertips would almost touch his kneecaps!

a careful balance of horizontals and verticals. Yet it also depends upon his balanced posture – upon the particular poise of his limbs. His weight falls on his flexed left leg and his flexed right arm hefts his weapon; his other arm and leg, both of them straight and unburdened, complete the X-shaped pattern, setting up an antithesis or *counterpoise* of engaged and relaxed, flexed and straight, and weight-bearing and free within the composition, thus:

ENGAGED, FLEXED ARM RELAXED, STRAIGHT ARM

RELAXED, STRAIGHT LEG ENGAGED, FLEXED LEG

Called a *chiasmus* because it resembles the Greek letter *chi*, χ, this crisscross compositional device was invented early in the fifth century and soon became a trademark of classical art. Rediscovered in the Italian Renaissance, it was rechristened *contrapposto*. Ancient writers saw it as a special sort of rhythmical, ordered composition or *rhythmos*. Rhythmos (pl. *rhythmoi*) also embraced rhythm in music and dance and its equivalent, meter, in poetry: the antithetical balance of long (–) and short (◡) syllables in a line of Greek verse.

Rhythm is dynamic and temporal, a way of imposing order (*kosmos*) on time and motion. Its static, spatial counterpart is *symmetria* (pl. *symmetriai*) or commensurability of parts: the correct proportioning of all the individual parts of a person, animal, or building to each other *and to the whole*. Together, these two key concepts now regulated the confusing flux of reality and resonated deep in the Greek psyche. For as Plato later intoned, "measure and proportion are everywhere identified with beauty and excellence." For the rest of this chapter and the next two we shall see some very clever men working toward a comprehensive solution of this kind: Libon in his temple of Zeus at Olympia (see Fig. 42), Iktinos in the Parthenon (see Fig. 60), and Polykleitos in his Canon (see Figs. 71, 72).

Analysis of the Artemision Zeus's clay core has shown that it comes from Attica, so probably an Athenian workshop made the statue. Taking the Attic foot of 29.5 cm (11.61 inches) as a module and imposing a half-foot grid over the figure immediately produces some striking results (Fig. 22; the anomalies are due to the distortions created by the dynamic pose and by the camera lens). The sculptor perhaps chose the god's head (minus his beard) and/or his feet, each measuring one Attic foot high/long, as the basis for this grid, which, as mentioned earlier, takes the form of a seven-foot square. The top of Zeus's penis marks its midpoint; his knees are located one and a half feet below this fringe, and his navel, his sternum, the pit of his neck, and his eyes at intervals

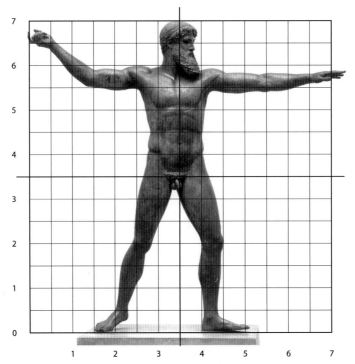

22. Reconstruction of the proportional grid of the Zeus, Fig. 21. Each square measures half an Attic foot (14.75 cm or 5.8″).

of three-quarters of a foot above it; his nipples are one foot apart; and so on. So in this magnificent work, the ruler of the universe (*kosmos* again – the ultimate manifestation of order) now concretely embodies this order himself.

The Greeks' craving for order and their tendency to view life as a clash of opposites were noted in the Introduction and discussed earlier in this chapter. Ancient Greek registers this binary mentality through the two small but powerful particles *men* and *de*, which English clumsily translates as "on the one hand" and "on the other." By the fifth century, the Greeks had formalized these thought patterns in various ways. Chiastic word plays became all the rage, for example, King Croesus's supposed aphorism that "In peace sons bury their fathers, but in war fathers bury their sons."[6] Greek thinkers soon

6 Herodotos 1.87:

"In peace *sons* bury their *fathers*...

χ

... but in war, *fathers* bury their *sons*."

Compare John Fitzgerald Kennedy's "ask not what your *country* can do for *you* – ask what *you* can do for your *country*" or Mae West's classic "it's not the *men* in your *life* that counts, it's the *life* in your *men!*" A stricter type of chiasmus, even more closely comparable to the sculptural variety, avoids repeating the same words: thus Samuel Johnson's "By *day* the *frolic*, and the *dance* by *night*."

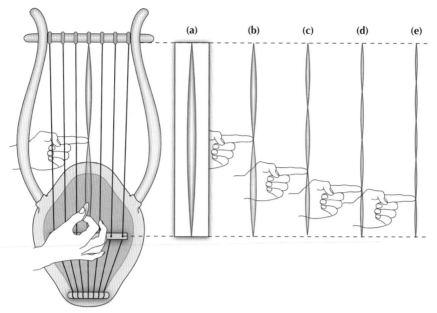

23. The perfect musical intervals as discovered supposedly by Pythagoras of Samos (ca. 550–480). A lyre string (a) is plucked to produce a note. It is then stopped at a half (b), third (c), quarter (d), and fifth (e) of its length (i.e., at ratios of 1:2, 2:3, 3:4, and 4:5) and each time plucked to produce (b) the octave above (a), and then the basic harmonies of (c) the fifth above that, (d) the next fourth above that (i.e., the octave above (b)), and (e) the next third above that. The first three of these intervals above (a), the "perfect" intervals (b), (c), and (d), make up the Pythagorean decad ($1 + 2 + 3 + 4 = 10$).

followed suit, devising antithetically based systems of "elements" such as this famous and very long-lived one:

EARTH WATER

$$\chi$$

FIRE AIR

The boldest of these proposals came from Greek south Italy, whither the thinker Pythagoras of Samos (ca. 560–500) and his followers had fled after the Persian conquest of their homeland in 522. This philosophical sect based its world-view upon a bizarre mixture of mathematics and binarism. For Pythagoras had noticed that stopping a stretched string halfway, one third, and one quarter of the way along its length, and then plucking it, produced the "perfect" intervals of the octave (1:2), the fifth above it (2:3), and the fourth above that (3:4) – that is, the next octave (Fig. 23b–23d). He also substituted two abstract concepts, Limit and the Unlimited, for the four elements.

Arguing that "all is number," the Pythagoreans swiftly elevated these "perfect" ratios to quasi-mystical status as the basis of all reality and combined them in what is called an arithmetic progression to produce the "perfect" number 10 $(1 + 2 + 3 + 4 = 10)$. The two opposites soon proliferated into another table of ten, as follows:

limit	unlimited
odd	even
one	many
right	left
male	female
rest	motion
straight	crooked
light	darkness
good	bad
square	oblong

Soon, Greek doctors began to develop similar theories about the human body, health, and sickness. They came to understand the body as a battleground of opposing forces, whose balance the *technē* or art/craft of medicine was dedicated to maintaining. The most rigorous of them, Alkmaion of Kroton (ca. 500–450), even fashioned the Pythagorean binary system into a theory that folded medicine, politics, and art into a single overarching technology of the body:

> What preserves health is the equality (*isonomia*) of the powers – wet, dry, hot, cold, sweet, and so forth – whereas the domination (*monarchia*) of any one of them engenders disease: for the rule of a single contrary is destructive. The active cause of disease is excess of heat or cold, the occasion of it excess or insufficiency of nourishment, the seat of it blood, marrow, or the brain. Disease may also be engendered by external causes such as water, environment, exhaustion, torture, or the like. Health on the other hand is a proportionate (*symmetron*) mixture of opposites.

Alkmaion's theory represents our first encounter with that peculiarly Greek belief in the unity of the natural world, the social world, the psychological world, and the world of manmade things and the subjugation of all of these to an ideal (preferably mathematical) metaphysic. If the ratio between one's body and head is just so – and likewise the ratios between one's bodily qualities or "humors" (heat, cold, moisture, dryness, etc.); between the notes of the musical scale; between farmers and artisans in the well-run city; between the column height and entablature of the city's temple; and so on – if all these ratios are just right and in harmony with each other, then chaos is kept at bay and all is right with the world.

All this makes it easy to see why Greek sculptors chose a similar path. Being in the business of producing perfect bodies, and attentive to current ideas and fashions, they developed proportional systems to help them create

such bodies and invented counterpoise in composition to give the appearance of perfect bodily control. By imposing order on the flux of human life and on the disorderly movements of figures such as the capering revelers of Fig. 8 or the ecstatic poet of Fig. 20, these techniques signaled a balanced, healthy mind in control of a balanced, healthy body.

So it is perhaps no coincidence that a pioneering artist in this field was a slightly later fellow-countryman of Pythagoras's and (curiously) a namesake of his. This second Pythagoras was also a Samian and also fled his home for Italy, but did so only after the failure of the Ionian Revolt in 494. He was much in demand for bronze statues both in Italy and at Olympia through the 450s, when the Artemision Zeus was also made. Because of these coincidences of name, place, and time, scholars have often speculated that he or his parents may have been followers of the great philosopher Pythagoras. Unfortunately, none of his works survives, but in a tantalizing aside a Roman-period source suggestively credits him as "the first artist to aim at rhythmos and symmetria."

PRUDENCE, HYBRIS, NEMESIS, AND JUSTICE

As in the Brygos Painter's picture (Fig. 17), where the two protagonists display a strong sense of decorum, in the Zeus (Fig. 21) we instinctively sense that he also "knows himself," that he is in complete command of his body and therefore of his soul as well. He is, in fact, a model of prudence, of the self-knowledge that begets a measured self-control. We can imagine his unseen opponent to be some troublesome human or other: one of those "whose heart is high," as Pindar put it in the verses quoted earlier. The Greeks had a word for this kind of individual: a *hybristēs* or man of *hybris* – arrogant, willfully blind, even wantonly violent. Hades was full of them. Fatally lacking prudence, they had overreached themselves, challenged the gods, and lost – terminally.

Yet prudence was not easily achieved. Zeus in particular was a notorious womanizer, and the sixth-century poet Theognis had cheekily taunted him with being unwilling or incapable of enforcing decent behavior on others too. Why does he let people get away with hybris and not visit *nemesis* (retribution) upon them? Why is the god of justice not himself just?

> Dear Zeus, I'm surprised at you. You're lord over all,
> You alone have prestige and great power,
> You know well the mind and heart of every man
> And your rule, O King, is the highest of all.
> How then, son of Kronos, does your mind bear to hold sinners
> And the just man in the same esteem
> Whether men's minds turn to prudence or to hybris,
> When they yield to unjust acts?

Yet by 450 the tide had turned. Vase paintings of Zeus and other gods chasing and abducting defenseless women and boys had all but vanished, and the

great first chorus of Aischylos's tragedy *Agamemnon*, staged in 458, decisively establishes Zeus as prudence's just and stern enforcer:

> Zeus, whose will has marked for man
> The sole way where wisdom lies;
> Ordered one eternal plan:
> *Man must suffer to be wise.*
> Head winds heavy with past ill
> Stray man's course and cloud his heart.
> Sorrow takes the blind soul's part,
> Man grows prudent 'gainst his will.
> For powers who rule from thrones above
> By ruthlessness commend their love.

What had happened in the meantime?

GREEKS AND PERSIANS

While Athens and other Greek cities were beginning their experiment with democracy, a new, autocratic colossus – Persia – was rising in the east.

The Persian Empire was one of the greatest success stories of the ancient world. In a mere twenty years, King Cyrus the Great (reigned 557–30) turned a small nomadic tribe into the lords of the Near East, conquering Media, Lydia, the Babylonian Empire, and central Asia in quick succession. Mopping up the Ionian Greek cities, he and his successors then subdued the adjacent Aegean islands (see Box 1. *The Persian Wars*), and by 500 they had reached across the straits into Europe and across the desert into Egypt.

From the Indus to the Aegean, the Great King now ruled the largest and richest empire ever, comprising over half the known world (Map 2). Across two million square miles of the earth's surface and for many millions of souls, his every word was law. Split into twenty-three provinces or *satrapies*, his vast realm was studded by great and ancient cities and traversed by a Royal Road that ran for 1,500 miles from the imperial center at Susa to the westernmost satrapal seat, the ex-Lydian capital of Sardis. To reach this imperial outpost from the Persian heartland of Iran took a daunting three months, but it was only three days' march from the Aegean.

Together, a foundation inscription and the endless processions of tribute-bearers (Fig. 24) from the palace of King Xerxes (reigned 485–65) at Persepolis signal the breathtaking pretensions and ambitions – to a Greek, the unbridled hybris – of this vast new imperial power:

> Ahuramazda is the great god who gave us this earth, who gave us yonder sky, who gave us mankind, who gave his worshipers prosperity, who made Xerxes the king to rule the multitudes as the only king, and made him alone to command the other kings.

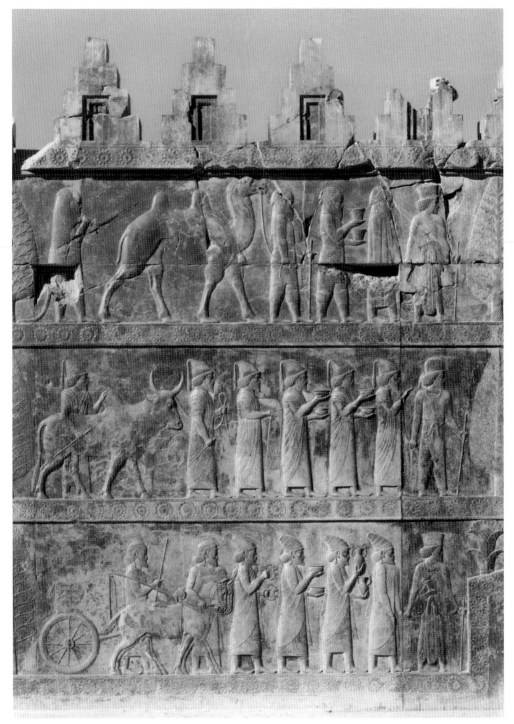

24. Subjects of the Persian Great King bring him tribute, ca. 500–480. Persepolis, palace of Darius and Xerxes, east stair façade of the royal audience hall (Apadana). The building and its reliefs were begun under Darius (reigned 521–486) and completed under Xerxes (reigned, 486–65).

I AM XERXES, the Great King, the king of kings, the king of all coun-
tries which speak all kinds of languages, the king of this entire big and
far-reaching earth, the son of Darius, the Achaemenid, a Persian, son of
a Persian, an Aryan man of Aryan stock.

Thus speaks King Xerxes: "These are the countries – in addition to Persia –
which I rule under the shadow of Ahuramazda, over which I hold sway,
which are bringing their tribute to me – whatsoever I command them,
they do and they abide by my law: [*a long list of subject and tributary
peoples follows*]."

Now tributary empires of this sort divide society into two distinct strata: the
ruled, organized into nominally autonomous communities; and the rulers,
who monopolize all real power and exact tribute from the ruled. The result is
a fundamental contradiction between the individual community's continued
existence and its ongoing negation by the state. So the ruled intrigue incessantly
for freedom and the rulers just as persistently try to stop them, by a policy
of "divide and rule" when possible and by brute force when not. The Persian
Empire and (after 479 and in the Aegean) its Athenian successor were no
exceptions.

So when in 499 the Greek cities of Ionia and the adjacent islands revolted
against Persian rule, Xerxes' predecessor, King Darius, first sought to divide
them and then summarily crushed them. As mentioned earlier, in 494 he
utterly destroyed the great city of Miletos, the rebellion's epicenter, as a lesson
to the others, killing the men and herding the women and children into central
Asia as slaves. This brutal deed sent shock waves across the Greek world, and (as
we have seen) the traumatized Athenians severely punished Phrynichos when
he staged the tragedy in the dramatic competitions of 492. Until this time,
the Greeks had never distinguished themselves consistently and sharply from
the non-Greeks across the seas. This now changed, as the word "barbarian"
leapt to everyone's lips.

The Athenians' fears were justified, for alone among the Greeks they and
the Eretrians of nearby Euboia had sent an expedition to help the Ionian rebels,
which had sailed up river to Sardis and burnt the town. The rest, as they say, is
history (see Box 1. *The Persian Wars*): The Persian punitive expedition of 490
and the stunning Athenian triumph at Marathon; the simultaneous Persian
and Carthaginian invasions of 480 and the great battles of Thermopylai,
Himera, Salamis, and Plataia; the Carthaginian army's abject surrender; and
the Persian army's ignominious retreat to Asia in 479.

Typically, the mainland Greeks attributed their miraculous salvation
from the Persian juggernaut both to the personal excellence of men – the
selfless martyr Leonidas, the canny strategist Themistokles, the clever tactician
Pausanias, and the brave warriors under their command – and to the gods,
who had met the Persians' monstrous hybris with an even bigger and more
devastating dose of nemesis. The bronze-clad or (in art) often naked Greek
(Figs. 15, 25) had defeated the trousered barbarian; the manly spear had

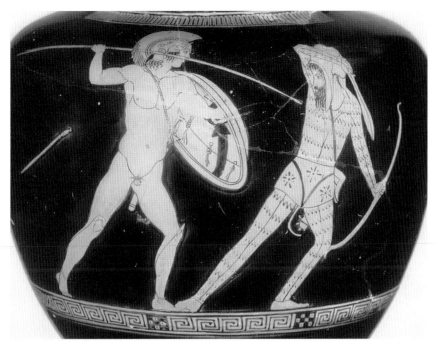

25. A Greek warrior attacks a Persian archer. Detail of an Athenian red-figure pitcher (oinochoe) from Gela (Sicily) attributed to the Chicago Painter, ca. 460. Ht. 24 cm (9.5″). Photograph © Museum of Fine Arts, Boston; for detailed credit see Sources of Illustrations. The Persian has just shot an arrow at the Greek and missed; unrealistically, the painter shows the Greek wearing only helmet and greaves in order to emphasize his athletically fit body, and 'youthens' him by removing his beard.

beaten the cowardly bow;[7] and freedom had triumphed over slavery. Zeus had ensured that justice was done.

Victory odes by leading poets, eulogies and war memorials for the fallen, and Aischylos's tragedy *The Persians* of 472 (funded, in one of those nice historical conjunctions, by the young Perikles) gleefully took up these themes. A new Trojan War had been won – no, was about to reach its climax, for the victors would now move east, chasing the barbarian from the Aegean and liberating the enslaved Ionians from the Persian yoke.

7 On his gold coins or *darics*, Darius is represented as the archer par excellence, and at Thermopylai, Xerxes boasted that the Persians' arrows would darken the sun. The Greeks, on the other hand, thought the bow was cowardly because unlike hoplites, who confronted their foes face to face (Fig. 15), archers did not need to be manly or brave (witness Homer's portrait in the *Iliad* of the cowardly archer Paris), merely accurate and lucky. Shooting from afar, they could pick off the bravest of warriors and run away. Thus the lament of Kallikrates, "the most beautiful man not only among the Spartans, but of the whole Greek army," at Plataia in 479, when a Persian arrow mortally wounded him before battle was joined: "I grieve not because I have to die for my country, but because I haven't lifted my arm against the enemy, nor done any deed worthy of me, for all that I've longed to do so" (Herodotos 9.72).

By popular vote, the Aiginetans had won the prize for valor at Salamis, infuriating their ancient enemies and commercial rivals, the Athenians, who thought (with some justification) that they deserved it instead. Soon after, an Aiginetan called Phylakidas won a crown in the *pankration* (a brutal combination of wrestling and boxing) at the Isthmian Games, and the islanders commissioned Pindar to celebrate it. After introducing Phylakidas and his victory, he says:

> [In Aigina are honored] the greathearted spirits
> Of Aiakos and his sons, who twice in battles
> Sacked the Trojan's city, first
> As followers of Herakles,
> Then with the sons of Atreus. Drive me up from the plain,
> And tell me who slew Kyknos, who slew Hektor
> And the fearless leader of the Ethiopians,
> Memnon the bronze-clad? Who then wounded noble Telephos
> With his spear by the banks of the Kaikos?
>
> Aigina was their homeland, one's lips proclaim,
> That illustrious island. Long ago was she built
> As a bastion for men to scale with lofty prowess.
> My fluent tongue
> Has many arrows to hymn them aloud.
> And recently in war the city of Ajax could attest
> That it was saved by her sailors,
>
> At Salamis, in the murderous storm of Zeus,
> In the hail of blood of men past counting.
> But drench your boast in silence:
> Zeus disposes this and that,
> Zeus the master of everything.

So it is no surprise to find that in these same years the Aiginetans replaced their old temple of Aphaia (burnt probably by the Persians in 480) with a new one whose pediments featured these two Trojan victories (Figs. 26–28). The temple itself (Figs. 26, 27), built in the 470s, is a late archaic gem. Its anonymous designer well understood the necessity for proportion and measure. For example, he repeated the 1:2 ratio of the plan of its colonnade (6 × 12 columns) in the elevation of its façade, where the height of the columns, 16 Doric feet, is double the distance between their axes (8 feet). He also calculated the combined height of the architrave and frieze according to the same formula, doubling the lower diameter of the columns. Yet because these columns are only three feet thick instead of four (as a rigorously comprehensive proportional system would require), the colonnade is more open than usual and the entablature proportionally less heavy, making the building look strikingly advanced for its time.

Yet in Doric architecture, such proportions could *never* be rigorously comprehensive. For the system contained an internal contradiction that could

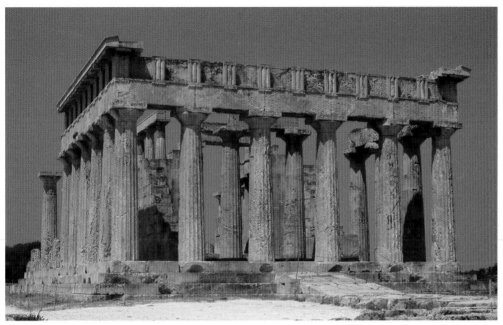

26. The Temple of Aphaia at Aigina, ca. 479–70. Limestone (originally stuccoed); preserved height, 8.3 m (27′2″).

never properly be resolved. The two rules that governed its most distinctive feature, the triglyph–metope frieze, conflicted. These rules were (1) that the triglyphs must be centered above the axes of the columns and the spaces between them; and (2) that the frieze must end with a triglyph, not a half-metope. At the corners, to obey rule (1) meant violating rule (2) and vice versa. In order to finesse this so-called "corner conflict," Doric architects moved the corner columns inward and the last two triglyphs outward, compressing the colonnade and stretching the frieze. Purists predictably condemned this compromise as undermining the whole system, and it remained an irritation for the rest of antiquity.

As mentioned earlier, the Aigina temple was dedicated to Aphaia, a nymph of the island once raped by Zeus. Because divine seed always sprouts, nine months later she produced the Aiginetan hero Aiakos, the very same man whom Pindar celebrates as the sire of those Aiginetans who twice sacked Troy, "first as followers of Herakles, then with the sons of Atreus." This genealogy paid a double dividend. It both linked the Aiginetans who triumphed at Salamis to their glorious heroic ancestors and thus to Father Zeus himself, and presented Troy's twin destructions as precedents for and analogues to the great sea-fight, thus elevating it to quasi-legendary status.

The contrast between the corner figures of these two new pediments, both Trojans, is instructive (Figs. 28 and 29). Arrows have wounded both of them, mortally, in the chest. One (Fig. 28) is a jagged assortment of limbs; his muscles convulse and his archaic smile becomes a rictus below his closing eyes. Yet the patterning is so emphatic, the body so upright – like a puppet on

57

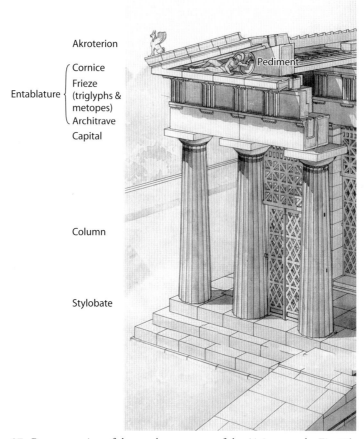

Akroterion

Cornice
Frieze
(triglyphs &
metopes)
Architrave

Entablature

Capital

Pediment

Column

Stylobate

27. Reconstruction of the southeast corner of the Aigina temple, Fig. 26, ca. 479–70.

a string – and the agony so insistently externalized that we feel little sympathy for him. He strains to be human but does not quite make it.

The other, however (Fig. 29), is so natural-looking that the sculptor must have used a living model. He seems about to pass out and roll off the pediment. Even his veins are true, and correspond exactly to the descriptions of the (later) Greek medical handbooks. (Fifth-century sculptors apparently paid much attention to medical advances such as these.) But he is still a brilliant exercise in geometry. Notice how his legs repeat (with slight variation) the angular pattern of his arms. But now the design serves the subject, not the other way around.

As this warrior's life ebbs away, his left hand drops from his shield, his head sinks on his chest, his lips purse, and his eyelids droop. The sculptor has rethought – indeed refelt – what it means to be wounded and to die, consulting the best and most demanding tutor of all: life. Getting inside the warrior's skin, he invites us to do so as well. We feel what the Greeks who fought at Salamis, Thermopylai, and Plataia must have felt when they saw their comrades fall "in the murderous storm of Zeus," in the showers of Persian

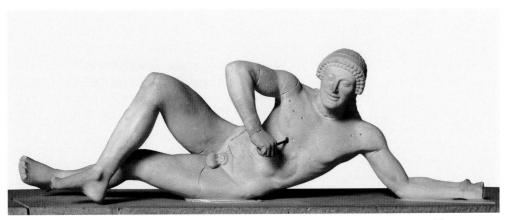

28. Dying warrior from the west pediment of the Aigina temple, Fig. 26, ca. 479–70. Marble, length 1.59 m (5′2″). Munich, Glyptothek. The warrior, mortally wounded in the second sack of Troy by the Greeks under Agamemnon, is trying to pull an arrow, added in bronze but now lost, from his chest.

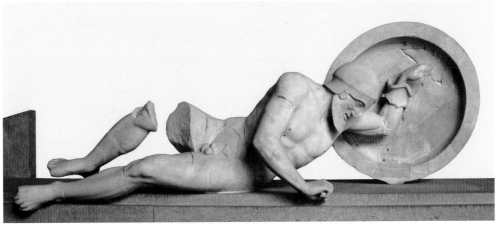

29. Dying warrior from the east pediment of the Aigina temple, Fig. 26, ca. 479–70. Marble, length 1.85 m (6′1″). Munich, Glyptothek. The warrior, mortally wounded in the first sack of Troy by Herakles and Telamon, is trying to pull an arrow, added in bronze but now lost, from his chest.

arrows so thick that they darkened the sun; or what ancient Greek audiences must have felt when tragic heroes were ferried out on stage to die in agony: *sympatheia* or "suffering with."

But this warrior, remember, is a Trojan. Uniquely in the ancient world, classical Greek artists could bestow such sympathy equally upon friend and foe. As one Athenian orator later put it, albeit in a context of Greek fighting against Greek: "There is no difference between victor and vanquished, except that one will die a little sooner." With this dying Trojan, classical humanism and the classical style have at last arrived.

DECODING THE CLASSICAL REVOLUTION

So what does it all mean? Is the classical revolution – the so-called Severe Style of the Artemision Zeus and Aigina warrior (Figs. 5, 21, 22, and 29) – merely a formal development, as some maintain? Did it develop naturally and almost inevitably out of late archaic experiments with more lifelike anatomy and visually striking poses (see Figs. 8, 10, and 17)? Or was it invented to restore monumentality, simplicity, and dignity to an art thought to be compromised by late archaic excess (see, e.g., Figs. 6, 17, and 20)? Or does its revaluation of man in some way relate to the advent of democracy? Or does it relate to the Persian Wars? Or were other, different forces at work? Let us begin with the facts.

First, the Severe Style is confined to the visual arts. Fifth-century Greek literature experienced no such revolution. There is nothing austere or simple about the poetry of Pindar and Aischylos, for example. Indeed, sometimes their works are so complex that, although they wrote for oral performance, one wonders how many listeners understood them.

Second, the Severe Style is Panhellenic, remarkably uniform across the Greek world from Athens to Sicily (see Fig. 30).

And third, although the Severe Style certainly owes much to late archaic experiments with naturalistic anatomy and composition (Figs. 8, 10, 17, and 28), it appears suddenly and in revealing circumstances. In the years after Marathon (490) and Salamis (480), four significant archaeological deposits of sculpture and pottery can be securely dated, all of them in Attica: (1) the Marathon tumulus itself, which contained the 192 Athenian dead and the pots buried with them, (2) the debris from the Persian sack of 480–79 discarded in disused wells and pits in the Athenian Agora, (3) the Themistoklean city wall of 478, which contains the carved tombstones and other marbles smashed by the Persians in 480 and 479, and (4) the fill dumped behind the north wall of the Akropolis, rebuilt in the 470s, which contained the korai vandalized by them (see Fig. 6). No hint of the new style appears in their contents. Yet the Tyrannicides (Fig. 5) prove that it had indeed emerged by 477.[8]

The most obvious characteristics of Severe Style figures, cutting right across age, gender, and status, are simplicity, strength, vigor, rationality, and intelligence. Much of this is conveyed via proportion and contrapposto; by dynamic postures and robust modeling; and by sober facial expressions, either focused on some target or averted from the viewer.

8 The famous Delphi Charioteer, part of a monument celebrating Polyzalos of Gela's victory in the Pythian games probably of 478, is the first well-dated Greek original in this style. For illustrations see Rolley, *Greek Bronzes*, fig. 15 (color); Boardman, *Greek Sculpture: The Classical Period*, fig. 34; Boardman, *Greek Art*, cover and fig. 131 (both color); Pedley, *Greek Art and Archaeology*, fig. 7.25; and for the date, see H. Maehler, "Bakchylides and the Polyzalos Inscription," in the formidably entitled *Zeitschrift für Papyrologie und Epigraphik* 139 (2002): 19–21.

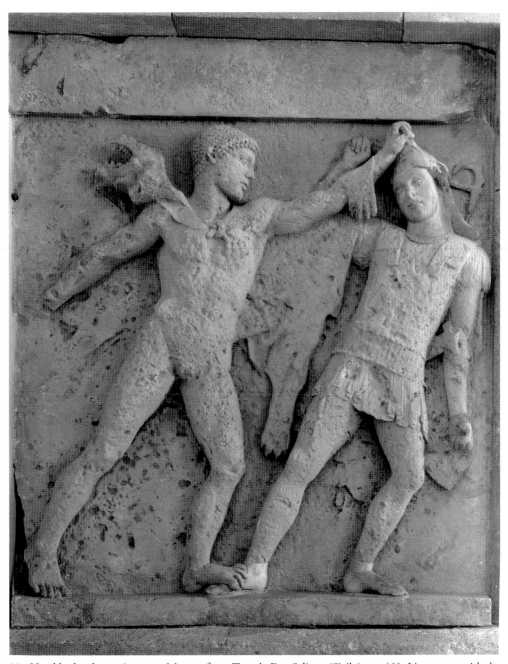

30. Herakles battles an Amazon. Metope from Temple E at Selinus (Sicily), ca. 460. Limestone, with the Amazon's head and some limbs inset in marble; ht. 1.62 m (5′4″). Palermo, Museo Nazionale. Herakles imitates the Athenian tyrannicide Aristogeiton, Fig. 5.

Simple proportions structure the human body in a clear-cut, logical way; contrapposto rationalizes the flux of human movement; forceful postures, modeling, and gazes radiate health, vigor, and determination; and an averted head and sober expression suggest, quite simply, that the subject has stopped to think. So in their own way these bodily cues create, once again, a "reality effect." Indeed, they are essential to holding our attention, for otherwise the impassive faces now in vogue tend to look blank and zombie-like. For in contrast to archaic figures (e.g., Figs. 6, 13, and 28), which seldom invite us to interact with them, Severe Style ones regularly request or even demand our attention. They intimidatingly invade our space (Fig. 5), implacably hunt down our enemies (Fig. 21), engagingly solicit our sympathy (Fig. 29), or boldly ask us to psychologize them (Figs. 17 and 20).

Leaving the archaic style far behind, these innovations changed the face of western art forever. And because images help to shape the ways in which people see, after the 470s the world looked different and would never look the same again.

As we have seen, the stage was set for some of this before the Persian and Carthaginian invasions of 480. Austerity and restraint, even anti-elitism, were in the air. But given the Severe Style's chronology and Panhellenic popularity, it can hardly be coincidence that in 480–79 Thermopylai, Salamis, and Plataia had established Greek physical superiority over the invading barbarians as a fact (Fig. 25), and that restraint, rationality, pondered thought, and self-control were precisely the qualities that, allegedly, Greeks possessed to an extraordinary degree and the barbarian hordes largely or completely lacked. For example, in Aischylos's *Persians*, Queen Atossa admits that

> . . . I have left the golden-furnished chamber that
> I shared with King Darius, to tell you my own dread,
> That our vast wealth may in its rash course overturn
> That fair peace that Darius built up with Heaven's help.
> Two thoughts born of this fear fill my uneasy mind,
> Yet shrink from words: first, that a world of wealth is trash
> If men are wanting; next, that men who have no wealth
> Never find Fortune smiling as their strength deserves.
> We have wealth aplenty, but fear surrounds my eyes.

And soon,

> ATOSSA: Xerxes the rash learned folly in fools' company.
> They said that you, his father, with the sword had won
> Gold to enrich your children; while he, like a coward,
> Gaining no increase, played the warrior at home.
> He planned this march on Hellas, this vast armament,
> Swayed by the ceaseless slanders of such evil men.
> GHOST OF DARIUS: Hence this disaster, unforgettable, complete,
> Measureless, such as never yet made desolate
> Our Persian land . . .

Xerxes and his Persians, in other words, fatally lacked prudence and the wisdom that begets a measured self-control, and Zeus punished them accordingly. Darius's ghost foretells the inevitable outcome:

> On the Plataian plain the Dorian spear shall pour
> Blood in unmeasured sacrifice; dead heaped on dead
> Shall bear dumb witness to three generations hence
> That man is mortal, and must learn to curb his pride.
> For pride will blossom; soon its ripening kernel is
> Infatuation, and its bitter harvest, tears.
> Behold their folly and its recompense, and keep
> Athens and Hellas in remembrance. Let no man
> Scorning the fortune that he has, in greed for more,
> Pour out his wealth in utter waste. Zeus, enthroned on high,
> Sternly chastises arrogant and boastful men.
> As for my son, since Heaven has warned him to be wise,
> Instruct him with sound reason, and admonish him
> To cease affronting God with proud and rash attempts.

So like 9/11 and the fall of the World Trade Center, the Persian invasions were a "tipping point": An earthshaking event after which everything looks utterly different. Their product, the Severe Style, was a self-controlled or prudent style. Shunning both archaic elitism and oriental excess, it promoted the virtues of simplicity, strength, vigor, rationality, and intelligence. Pioneered by men such as Kritios, Nesiotes, and Pythagoras of Rhegion (suggestively, ancient writers credit Kritios with a substantial following or "school"), it represents the decisive triumph of the cooperative, rational "middling" way discussed earlier in this chapter.

Born of the greatest test that the Greeks ever faced, the Severe Style's remarkable uniformity across the Greek world eloquently attests to the survival of the ideal of Greek cultural unity long after the antibarbarian alliances that created it had broken up. Elated by their miraculous deliverance, basking in their newfound freedom, convinced of their military, physical, and cultural superiority, confirmed in their belief in the hybris–nemesis cycle, and sternly repudiating both their elitist archaic past and the defeated and humbled "barbarian" world outside, after the Persians and Carthaginians left in 479 the Greeks simply reinvented themselves – or at least reinvented their own image. The story of this brave new world will occupy the rest of this book.

CHAPTER 2

THE FIRST GENERATION

THE REFUGEES RETURN

The Persians left Athens in July 479, and a few weeks later lost the great battle of Plataia to the massed phalanxes of the Greek alliance, led by the Spartan regent, Pausanias. In his elegy over the fallen, partly preserved on a torn papyrus, the great lyric poet Simonides praises the Greek warriors' matchless courage, declares that their glory will be imperishable, compares them to the heroes of the Trojan War, and likens their victory to the sack of Troy. All this struck a chord that soon began to resonate strongly in both literature and art (see, e.g., Figs. 28, 29). Returning to Sparta, Pausanias celebrated a magnificent triumph and used his spoils from the battle to erect a splendid white marble portico with columns bearing statues of the defeated Persian commanders and their men.

The Athenian homecoming could not have been more different. It must have been a sobering sight: Boats as far as the eye could see, bringing the evacuees home. Then hour after hour, day after day, tens of thousands of them, laden with whatever they had saved from their homes and trudging the five long miles from the beach to the city, which from afar perhaps looked much as they had left it. And then the shock: tombs desecrated; walls fallen; houses vandalized; temples burnt; offerings stolen; statues shattered on the ground (see, e.g., Fig. 6).

It was now late 479. The Persian remnants had retreated to Asia and a Greek counteroffensive was under way, led by Pausanias and his king, Leotychidas, but Greek politics had already returned to normal. The Spartans, alarmed at the Athenians' newfound sea power and dynamism in the anti-Persian struggle, decided to stop them from refortifying their city.

Themistokles, Athens's leading politician and the architect of the Greek victory at Salamis, immediately mobilized the entire population, men, women, and children alike. Dismantling the wrecked houses and tombs, they rebuilt the walls and even fortified Athens's port of Piraeus before Sparta could intervene.

Piraeus too had been thoroughly destroyed by the Persians, so a leading city planner, Hippodamos of Miletos, was engaged to rebuild it from scratch. The business generated by the new, modern port soon boosted Athens' prosperity immensely, as Aristophanes noted half a century later in a comic jumble of metaphors:

> Finding Athens like a cup
> Of wine half-drunk, Themistokles filled her
> Right to the brim, and baked Piraeus too
> As her lunchtime dessert, adding new fish
> To her menu next to her favorite ones.

Athens itself, on the other hand, was not replanned, but retained its ancient maze of streets and cheerfully irregular dwellings. (This was true of most mainland Greek cities, where centralized planning remained the exception rather than the rule.) Property rights and cultic considerations – Athens was full of little shrines – trumped modernity and the planners.

Although grid plans were not new – some eighth-century Greek sites show traces of them, and the western colonies had adopted them in the seventh and sixth – Hippodamos's design for Piraeus, tentatively recovered from the scattered remains turned up by construction work in the busy modern port, was revolutionary, rational, and most revealing (Fig. 31). Using the Doric 32-cm foot (12.6 inches), he laid down a grid of 15-foot-wide lanes, 25-foot-wide streets, and 45-foot-wide avenues – a ratio of 3:5:9. Each city block measured 124 × 145 feet (a ratio of 6:7) and contained eight parcels of 62 × 36.25 feet (a ratio of 12:7), making a grand total of around 4,000 houses. As in many planned developments today, these houses followed roughly the same design (Fig. 32). Often fronted by shops and provided with few or no exterior windows, they featured a small central courtyard surrounded by a half-dozen rooms on the ground floor and others above. This introverted design served the Greek family well, securing its privacy from the prying eyes of neighbors and the intrusions of the state.

So Hippodamos's plan added a new dimension to that peculiarly Greek notion, explored in the previous chapter, of the unity of the natural, social, psychological, and manmade worlds and the subordination of all of these to an ideal (and preferably mathematical) metaphysic. Despite asserting the priority of state over individual, it was basically democratic, following the principle of isonomia ("equality of rights" and "equality under the law"), and respected the integrity and privacy of the nuclear family. Perhaps all this was inevitable given the city's large, feisty population of sailors and artisans, but in any case, Piraeus soon became a democratic stronghold. In 411

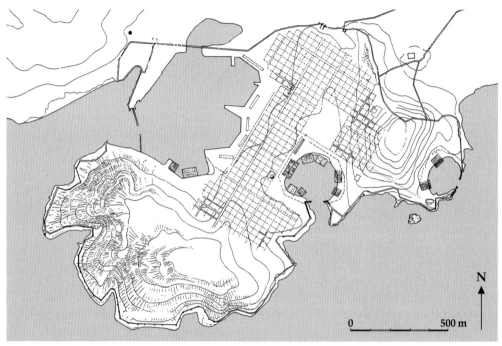

31. The port of Piraeus as replanned in the 470s.

and again in 403, it provided the base for democratic counterattacks against elitist, pro-Spartan governments that had temporarily seized control of the state.

But Hippodamos's own private convictions were quite different. Aristotle tells us quite a lot about him and the textbook he wrote, which was apparently the first on the subject of town planning (see Box 1. *Hippodamos's Ideal City*). An eccentric, he wore his hair long (like the kouroi, Fig. 13) and flaunted expensive jewelry over his cheap clothing. He divided his ideal city – the first known utopia in history – into three classes: artisans, farmers, and warriors kept at the expense of the other two. This arrangement suspiciously resembles Sparta's, and we shall meet another version of it in Plato's *Republic* (see Chapter 6, Box 1). All in all he sounds like an unrepentant elitist, but one quite prepared to cater to the new "middling" trend in Greek life if the price was right.

To return to politics. Increasingly corrupt and dictatorial, the two Spartan commanders soon became mired in scandal. Unable to hold the allies together, they were ordered home to face trial. The Athenians, petitioned by the Ionian cities of Asia Minor (still threatened by Persia), at once took over the alliance and briskly reorganized it. Assessing every member for a contribution of either ships or cash, in 478 they established a treasury in Apollo's temple on the sacred island of Delos, where the allies met and decided policy under their guidance. Secession, now tantamount to treason,

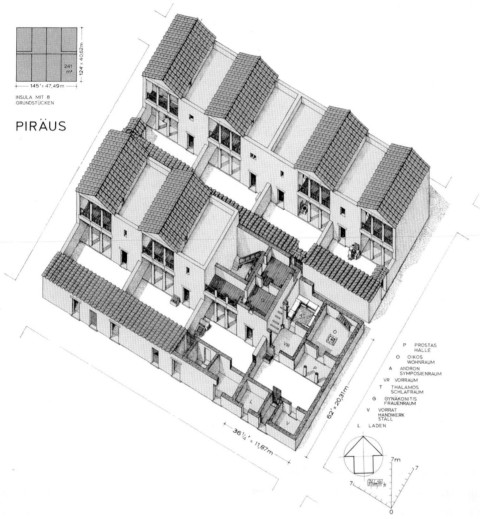

32. Conjectural reconstruction of a typical block of houses in the Piraeus, ca. 470–400. The house plans were somewhat more variable than shown, and by the end of the fifth century, a herm (see Fig. 38) stood outside the front doors of many of the houses.

was severely punished. Reenergized, the allies began to strike deep into Persian territory.[1]

1 As David Schaps acutely has commented, "It is striking . . . to note that modern alliances seeking a permanent structure seem to have been less conscious of the importance of finance: both the Articles of Confederation under which the United States was first governed and the more recent charter of the United Nations created central organizations critically enfeebled by their lack of a secure financial base" (*The Invention of Coinage and the Monetization of Ancient Greece*, 140, n. 9).

BOX 1. *HIPPODAMOS'S IDEAL CITY*

Aristotle, *Politics* 2.5.1–2, 1267b22: Hippodamos son of Euryphon of Miletos was the first nonpolitician who tried to speak on the best kind of constitution. (He invented the division of cities into blocks and subdivided Piraeus, wanting to be a scholar of natural science generally, and also became somewhat eccentric in his behavior owing to a desire for distinction, so that some people thought he lived too much like a dandy, longhaired and festooned with jewelry, and with lots of cheap but warm clothes not only in winter but in summertime too.) He envisaged a city of ten thousand, divided into three classes, one of artisans, one of farmers, and the third of warriors who bore arms and defended the state in war. He divided the land into three parts, one sacred, one public, and one private; the sacred land provided the customary offerings for the gods, the common land fed the warrior class, and the private land was owned by the farmers. He thought there were three divisions of the law also . . . [*details of his constitution then follow, and are severely critiqued*].

 7.10.4–5, 1330b22–8: [In cities], the arrangement of the houses is thought to be more agreeable and more generally convenient if they are laid out in straight streets, after the modern fashion – the one introduced by Hippodamos. But it is more suitable for security in war if the opposite plan is followed, as cities used to be in olden times. For that arrangement is difficult for the enemy to enter and navigate when attacking. . . .

 The allied petition to Athens followed a familiar pattern that recurs in several Attic tragedies and also helps to explain the popularity of certain mythological themes in the art and literature of the following years. Now installed as freedom's champions and keen to exploit their position, the Athenians tried to leverage it in every way they could. Myth was an obvious recourse. Suppliant plays such as Aischylos's and Euripides's *Suppliant Women* and the latter's *Children of Herakles* show the Athenians' heroic ancestors, especially King Theseus, eager to protect the needy even at the risk of their own lives.

 Funeral speeches over the Athenian war dead soon turned these good deeds into a solemn catalog of legendary enemies repelled, refugees harbored, wrongs righted, and crimes punished. Four key assertions about Athens and Athenian identity emerge, as follows: The city is Greece's (1) universal refuge and (2) benefactor, and its citizens are (3) "earth-born" and (4) true-blue Ionian (in contrast to the Dorian Spartans). Endlessly recycled in prose and verse, these assertions – which range from the questionable to the utterly fictitious – are often called "charter myths." Old stories such as the mission of Triptolemos (Fig. 33) and the ancient battles with the Centaurs (the Centauromachy)

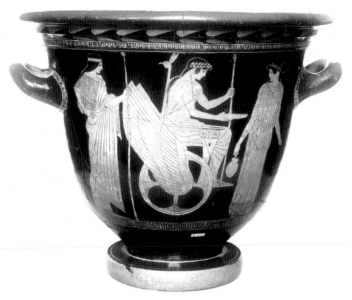

33. Demeter, Triptolemos in his magic chariot, and Kore. Athenian red-figure mixing bowl (bell krater) from Gela (Sicily) attributed to the Villa Giulia Painter, ca. 460. Ht. 33.3 cm (1'1"). London, British Museum.

and Amazons (the Amazonomachy) soon fell into step. For in the first case the goddess Demeter had sent her protégé, Triptolemos, from Eleusis (long under Athenian control) to teach Greece the technē of agriculture and in particular the cultivation of grain; in the second, the Athenian king Theseus had saved his friend Peirithoos's bride and family from rape and murder at his wedding in Thessaly; and in the third (allegedly), Theseus had saved all Greece from the Amazon invaders. We shall examine these latter two claims shortly.

Together, these developments determined the pattern of Greek politics for the next generation. At center stage were the anti-Persian offensive, Athenian expansion on all fronts, the city's growing rivalry with Sparta, and its gradual conversion of the Delian League into an Athenian empire and the Aegean into an Athenian lake. For as Athens's grip on the League tightened, it soon began uncomfortably to resemble the Persian hegemony that it had so recently supplanted, and as the Persian threat receded, it turned increasingly into a blatant protection racket. Like the proverbial phoenix, the fundamental contradiction that afflicts all tributary empires (see Chapter 1) had emerged once again.

Shrewdly foreseeing some of these developments, the Athenians soon made a pair of brilliant moves in anticipation. They linked their new port of Piraeus to the city of Athens proper by the famous Long Walls (Map 3), turning the whole Piraeus–Athens conurbation into a huge fortress secure from Spartan assault, and in 454 they deftly used a Persian invasion scare to move the League treasury from Delos to the Akropolis. Predictably, even

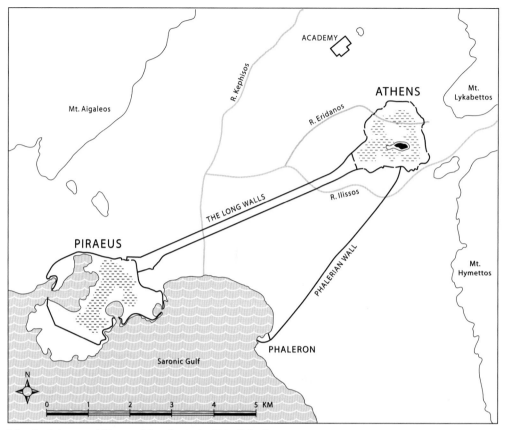

Map 3. Athens and Piraeus. Map drawn by Erin Babnik.

before the Persian war ended in 450, tensions with Sparta and its allies had increased greatly, exploding into bitter, full-scale conflicts that ended only with Athens's decisive defeat in 404.

MARATHON MAN–SALAMIS MAN

Against this background of desolation at home and adventure – indeed almost incessant warfare – abroad, the Athenians' decision in 477 to replace not the temples destroyed by the Persians but a civic icon, the Tyrannicides (Figs. 5, 34), is striking indeed. An oath taken by all the allies before the battle of Plataia supplies a motive – if it is authentic (many historians are skeptical):

> I swear never to rebuild the shrines burned and sacked by the Persians, but to leave them in ruins forever as a memorial to the impiety of the barbarian.

Naked, bronzed, iron-man fit, and storming forward with swords in hand, the Tyrannicides represent the "new Athenians" of the 470s: the victors

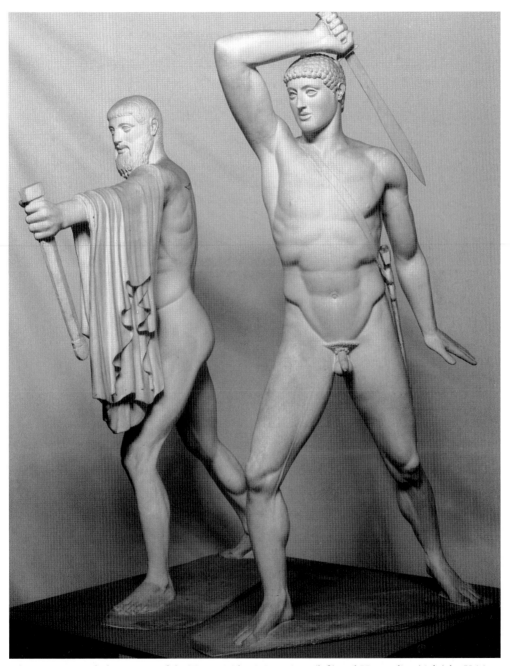

34. Reconstructed plaster casts of the Tyrannicides Aristogeiton (left) and Harmodios (right) by Kritios and Nesiotes of Athens; bronze original, 477/6. Plaster, using the marble copies of Fig. 5; height 1.85 m (6′). Museo dei Gessi, Rome. The original group stood in the Athenian Agora near the *orchēstra* and was erected to replace a predecessor stolen by the Persians in 480; it commemorated the assassination of the tyrant Hipparchos in 514.

of Marathon, Salamis, and Plataia, bold and invincible in the defense of freedom and defeat of *hybris.*[2] Made by the virtuoso bronzeworkers Kritios and Nesiotes, and slightly overlifesize, the dynamic duo survives only in incomplete Roman marble copies, which is why Fig. 34 illustrates completed plaster casts of them.

The Tyrannicides' story is complex. In 514, the tyrant Hippias and his younger brother Hipparchos were rulers of Athens. Outraged at a personal slight, two aristocrats, Aristogeiton and his young lover Harmodios, ambushed Hipparchos at the Panathenaic festival and paid for their deed with their lives. As the embittered Hippias's rule tightened in response, the two dead assassins quickly became heroes, and soon after he was expelled, in 510, and the hoplite republic installed, the Athenians commissioned statues of them in bronze from the sculptor Antenor. They stood in the Agora by the *orchēstra,* where the Assembly met, deliberated, and made its decisions, and where the dramatic competitions were held before these were moved to the Theater of Dionysos on the south slope of the Akropolis.

So Antenor's bronzes were Greece's first purely civic and secular icons, for hitherto, Greek sculpture had been exclusively religious or funerary. Images of the city's present (for the murder was still fresh in everyone's minds, and Hippias's return was still very much a possibility), paradoxically they presaged one of the great breakthroughs of the classical revolution, namely, historiography.

For Greek history writing – secular and in prose, not verse – began as the discovery of the *present,* not of the past. Hekataios of Miletos, who in 499 shrewdly advised the Ionians not to revolt from Persia, inaugurated it with his *Journey round the World* and *Genealogies* of then-prominent families, boldly denouncing the world of myth and legend with the words, "I write what seems to me to be true; for the Greeks have many stories that, in my view, are absurd." Soon, Herodotos (the "Father of History"; ca. 484–20) tackled the Persian Wars, the second and greatest of which had occurred during his own lifetime (in art, see – though in a much more modest vein! – battles such as that of Fig. 25); and at the century's end, Thucydides (ca. 460–390) wrote up the Peloponnesian War, in which he himself had fought as a general.

The Persians seized Antenor's Tyrannicides (and much else) in 480. Yet by then, popular belief had begun create a legend out of the two men and their deed, crediting them with actually *overthrowing* the tyranny and (as contemporary drinking songs alleged) "making the Athenians *isonomoi*" or equal under the law. Herodotos and Thucydides both tried to correct the record, but to no avail, incidentally showing how easily myth can trump history and fiction can quash fact. Indeed, even the normally reliable Thucydides bears

2 Surprisingly, political freedom was a new concept in Greece. For only with the threat of Persian "slavery" had *political* freedom superseded "justice" or "equality of rights" (isonomia) in the political arena. On this issue see Kurt Raaflaub, *The Discovery of Freedom in Ancient Greece* (Chicago 2004).

witness to this sad but undeniable truth, for in a rare but revealing slip he calls Aristogeiton, a true-blue aristocrat if ever there was one, "a middling citizen"!

Thucydides' mistake hints at why, in 477, the Athenians chose these two men above all to stand at the center of their ruined city and to preside over its reconstruction. They had become democratic icons. One imagines their bronzed bodies shining and drawn swords glinting in the bright Athenian sun, their lips and nipples coated with burnished copper, their eyes inlaid with polished ivory and gleaming glass or rock crystal, and the inscribed and painted epigram on their base (by the great Simonides) making all this explicit: "A great light shone for the Athenians when Aristogeiton and Harmodios killed Hipparchos [... *one and a half lines missing*... and] established the fatherland." A brilliant, irresistible pair.

Resolutely striding forth to destroy freedom's enemies, they warn us, as we stoop to read the inscription on the front of their marble base, to keep the faith: An intimidating sight. "Compact, sinewy, hard, and precisely partitioned by lines," as the critic Lucian later put it, these statues simultaneously celebrated this new, militaristic, almost puritanical Athenian civic ideal; consigned the kouros (Fig. 13) and its world to history; and formally inaugurated what art historians call the Severe Style in Greek art – the first phase of the Classical. But they do more.

For not only were the two assassins lovers, but their statues proclaim that they acted as one flesh. As befits a mature Athenian *erastēs* (lover), Aristogeiton is bearded; Harmodios, his *erōmenos* (beloved), is still young and beardless – an updated Kroisos (Fig. 13). So as Plato saw a century later, the group implicitly puts the homoerotic bond at the core of Athenian political freedom, and urges us to do the same.

> If we go on to consider decorum in love affairs among men, we shall find that whereas in other cities principles are laid down in black and white and thus are easily comprehensible, ours are more complicated. In Elis, Boeotia, Sparta, and other places where speech comes hard, the code states quite simply that it's good to gratify a lover, and no-one young or old would say otherwise... In many parts of Ionia, on the other hand, and elsewhere under Persian rule, the state of affairs is quite the reverse. The Persians condemn such love because of their empire's absolutism; it doesn't suit the interest of the state that a generous spirit and strong friendships and attachments should spring up among its subjects – effects that this love has a special tendency to produce. The truth of all this was actually experienced by our tyrants at Athens: it was the love of Aristogeiton and Harmodios that destroyed their power.

So as with funerary display (see Chapter 1), the democratic city now targets a formerly elite custom – here, homoeroticism – and makes it its own. And in the private sphere and its imagery a new decorum emerges as the democracy begins to understand what this custom – essentially, institutionalized pederasty – meant for the integrity of its citizen body. For in a macho society such as this, a citizen's masculinity cannot be compromised. So male prostitution

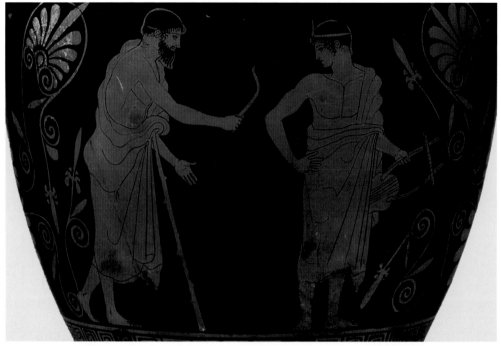

35. Man and youth in the *gymnasion*. Athenian red-figure wine cup (*skyphos*) from Chiusi (Italy) attributed to the Lewis Painter (Polygnotos II), ca. 460. Ht. 19.1 cm (7.5″). Berkeley, Hearst Museum of Anthropology. The word *kalos* ("beautiful") is written above the head of each figure. The painter apparently adopted the name of his famous contemporary, the muralist Polygnotos of Thasos.

is soon banned; the erastes–erōmenos relationship is camouflaged as a mentor–pupil one (presumably the Tyrannicides were read in this way); and the explicitly homoerotic scenes of the archaic period give way to reticent, even coy ones, such as those on the skyphos – a symposion vessel – in Figs. 35 and 36.

These two scenes beg to be read together. In the first one (Fig. 35), a man holds out a strigil (used for scraping off dirt and sweat at the *gymnasion*) to a youth who has been diligently practicing his lyre. The implied injunction, reinforced by the phallic-looking strigil, the framing lotus spikes, and the inclusion of the word *kalos*, "beautiful," beside each figure, is "come on, drop that and get naked!" Yet the youth's reserve – a sure sign of good breeding – is signaled by his ambiguous, Sappho-like posture (compare Fig. 17), his standoffish hand-on-hip gesture, and the downward-pointing lotus spike at bottom right.

But by the second scene (Fig. 36) he has succumbed. Now indeed naked, he stands before the *gymnasion*'s turning-post and meekly holds out his cloak to the older man, who again proffers the strigil; once again, the painter labels both figures as "beautiful." For as Theognis had confessed a century earlier, "It's nice to exercise naked while in love, then to go home and siesta with a beautiful boy." So whereas on one level these pictures simply show two

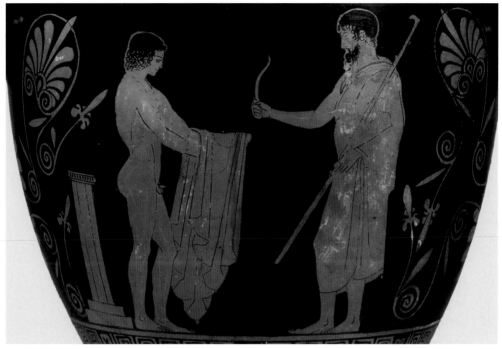

36. Reverse of the skyphos, Fig. 35. Youth and man in the *gymnasion*. The word *kalos* ("beautiful") is written above the head of each figure; the column at left is probably the turning post of a racetrack.

complementary sides of a good Athenian education (music and athletics), they also ask us to read them in a more suggestive way. Athenian vase painters loved such double-entendres.

These figures are purely generic and nameless, but the Tyrannicides were portraits. Because the two assassins were long dead (like Alkaios and Sappho, Fig. 17; see Chapter 1), however, it is best to think of Kritios's bronzes of them not as specific likenesses, but as types rather than individuals. Liberated from their elite origins and purged of any obviously individual features, they have become the city's ideal representatives. We must now confront this thorny problem of individuality directly.

INDIVIDUAL AND CITY

A scene from the Monty Python movie *Life of Brian* (1979) may help to put the issues in perspective:

> BRIAN: You're all individuals!
> CROWD: Yes, we're all individuals!
> BRIAN: You're all different!
> CROWD: Yes, we're all different!
> DENNIS: I'm not!

Anthropologists, sociologists, and philosophers, when faced with the problem of individuality, often prefer to talk about *personhood*: The notion that humans differ from other animals and from machines in the kind of relations to the self, to others, and to the world that they have or are capable of having. Each individual is unique, but personhood itself is socially constructed. It depends upon the relationships one builds and the society one lives in.

In traditional societies, the pressures for conformity and against personal autonomy are great. Often they are intensified (as in Greece) by the habit of pigeonholing people into types, each of which supposedly manifests a set of more-or-less homogeneous character traits. This tendency is particularly clear in classical Greek literature, especially in Athenian tragedy, where study after study has shown how inconsistent (from our point of view) the characterization often is. For as Aristotle noted in his *Poetics*, tragic action does not exist to express character; instead, character exists for the sake of tragic action. This tendency to typecast people, to consider them in terms of social context rather than personality, continued throughout antiquity. Biography remained a relatively weak literary genre until the Roman period, and even Plutarch's *Lives*, written in the second century A.D., start from similar premises.

In a transitional, increasingly democratic, and egalitarian society such as fifth-century Athens, however, where the Persian Wars and the Empire offered hitherto undreamt-of opportunities for bold men to shine, the tension between conformity and autonomy may reach the breaking point. We have already seen In Chapter 1 how the Athenians suppressed "undemocratic" extravagance at funerals and the like; in 488 they introduced ostracism, a device that enabled them to vote the overly ambitious into exile for ten years. Many Athenian politicians, suspected of aiming at tyranny, or simply regarded as too powerful for everyone's comfort, fell victim to it.

Eulogizing Athens in 431, the city's leading politician, Perikles, tried to have things both ways. Using the collective pronoun "we" throughout, he stresses that all good Athenians are but variations upon a single character type. They all share the same values and aspirations, and instinctively think and act alike in defense of their city. But he emphasizes also that each one personally ponders his actions and takes personal responsibility for them, and he strongly condemns dropouts, "for we do not say that a man who takes no interest in the city's affairs is a man who minds his own business; we say that he has no business here at all." The historian Thucydides agreed. Not only does he report Perikles' speech with obvious approval, but also throughout his great history he consistently emphasizes communal decision making over individual initiative.

So a study of "true" individualism in this strongly egalitarian society might begin with people who "break the mold" – who transcend the city and its tightly knit "men's club" (see Chapter 1), treat it critically, or operate outside it. Though these three categories are not necessarily mutually exclusive, one thinks, respectively, of (1) Themistokles, Perikles, and Alkibiades; (2) Sokrates and Plato; and (3) Philip II and Alexander the Great (see Figs. 37, 56, 132, 133, 147, 155–159, 169–172).

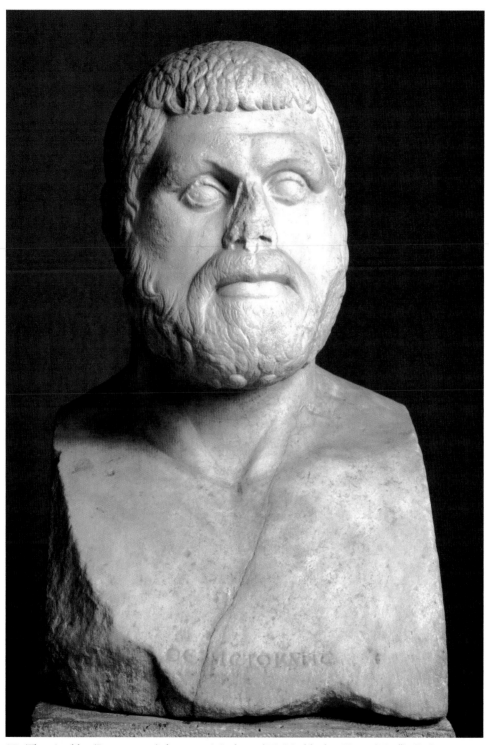

37. Themistokles (Roman copy); bronze original, ca. 475. Marble; ht. 50 cm (19.7″). Ostia.

A portrait of Themistokles, known only in a single Roman copy in Ostia (Fig. 37), may clarify these issues further. His biographer Plutarch tells us that "no man was more ambitious than he" (*Themistokles* 5.2), and with its close-cropped hair and beard, cauliflower ears, blunt features, and stern expression, this portrait strongly resembles contemporary images of the superhero Herakles (see Figs. 46, 47, 49). After orchestrating the Greek victory at Salamis in 479 and rebuilding the walls of Athens in 478, Themistokles, now a national hero but an increasingly controversial and polarizing figure, had become involved in a power struggle with Kimon, the pro-Spartan son of the victor of Marathon. Their rivalry climaxed in 472. An ostracism was held; Themistokles lost, left town, and (after numerous adventures) managed to worm his way into the Persian king's favor, ending up, ironically, as one of his governors in Asia Minor.

The ancient sources note several portraits of Themistokles in Athens, one of which sounds very like the Ostia herm. In the 470s he had built a shrine to Artemis Wisest in Counsel next to his house in the suburb of Melite, "hinting," according to Plutarch, "that he had given the best advice to the Athenians and the Greeks." In this temple, Plutarch saw a portrait of him, which showed "that he was a man not only of heroic spirit but also of heroic appearance."[3] Themistokles surely dedicated it himself; the others, in such public venues as the Akropolis, the Agora, and the Theater of Dionysos, must have been commissioned by his sons after his death, or by later generations nostalgically keen to glorify the heroes of the Persian Wars.

For egalitarian fifth-century Athens never erected portraits of its own citizens after giving this honor to the Tyrannicides. Indeed, when in 475 Kimon and two other generals had asked for such an award for annihilating a Persian force at Eion in northern Greece, the dēmos responded by allowing them only to erect three herms (Fig. 38) – generic, phallic, and to our eyes somewhat comic representatives of thrusting Athenian manhood – in the Agora. The inscriptions on these herms duly memorialized the victory but not the victors. Nor, in this climate of personal restraint, did living individuals put up their own portraits in public, even as offerings to the gods; indeed, even Themistokles' private gift of his portrait to Artemis was condemned as boastful and hybristic. If it indeed typed him as a new Herakles – Greece's legendary benefactor, staunch ally of the weak and powerless, and implacable foe of malefactors and monsters – was it a factor in his ostracism?

3 Plutarch calls this portrait an *eikonion,* or "little image." This is usually taken to mean that it was a statuette, but the term could equally indicate a truncated or abbreviated image, lacking a proper body. For in this period, the portrait conventions of later times had not yet been established. Probably it was not a herm like the Ostia marble (for portrait herms are not attested till much later), but a bust, a protome (head and neck only), or just a head (as, for example, the portrait described in the *Greek Anthology* 11.75).

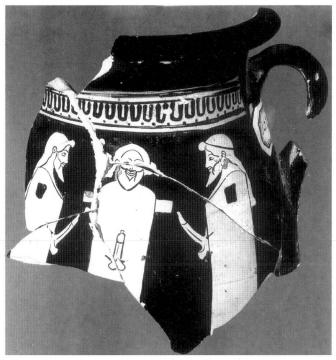

38. Three herms. Fragment of an Athenian red-figure wine or oil jar (*pelike*) attributed to the Pan Painter, ca. 470. Preserved ht. 20 cm (8″). Paris, Louvre. The three herms may echo the triad dedicated in the Athenian Agora by Kimon and the other two generals who defeated the Persians at Eion in Northern Greece in 475.

CONFIDENCE AND DOUBT

One of Kimon's earliest tasks, in 477, had been to repatriate the bones of the Athenian national hero Theseus from the northern Aegean island of Skyros. Duly discovered in a Mycenaean tomb and conveyed to Athens, they were solemnly interred in the Theseion, a custom-built hero shrine in the Agora. The great early classic painter Mikon was engaged to embellish this shrine with frescoes of Theseus's exploits, including his fights with Amazons and Centaurs and his visit to Poseidon's palace on the seabed. Although both building and paintings are lost, Pausanias helpfully describes them and contemporary Athenian vases hint at the appearance of the battles (Fig. 39).

These vases typically feature complex compositions and eye-catching foreshortenings, and in one key respect break decisively with earlier red-figure tradition. Rocky ground lines both liberate the figures from the picture's base line and begin to suggest a kind of stacked or bird's-eye perspective. Anticipated in Near Eastern, Egyptian, and Greek Bronze Age art, and the next step after foreshortening in the conversion of Greek art from a *con*ceptual approach to an optically based or *per*ceptual one, to the creation of a more intense *reality*

effect (see Chapter 1), this device is the one of the four basic components of western pictorial perspective.

Its other three components, also Greek inventions, are *diminution* (whereby figures and objects shrink in size as they recede from the eye); the *orthogonal* (whereby lines above eye level drop and lines below eye level rise as they recede from the eye); and *atmospheric perspective* (whereby colors shift toward the cold or blue end of the spectrum and become increasingly less saturated as they recede from the eye). Rediscovered during the Italian Renaissance, these have had an incalculable impact upon the Western world-view, enabling (for example) both the stunning utopia illustrated in Fig. 1 and the witty parody pictured in Fig. 2.

Diminution and orthogonals both turn up on Attic vases by 400 B.C. (see Figs. 108, 109), but atmospheric perspective only appears three centuries later. Yet because almost all Greek painting between ca. 300 and ca. 100 B.C. is lost, this delay may be fortuitous. In mural and panel painting, these devices liberate the image from the confines of the painted surface, or *picture plane*, and take the observer's own subjective experience of the world as the measure of pictorial verisimilitude.[4] In vase painting, though, they seriously undermine the Greek potter-painter's basic intuition that his picture was not an independent "window on the world," but a way to embellish a pot: A tridimensionally curved surface that continually changes aspect as one circles it, rotates it, or picks it up in one's hands. Such pictures should complement the vessel they embellish, and not violate its integrity as an impermeable, functional container.

In these vase-paintings, Theseus and his companions are icons of heroic strength and fortitude, cast in the mold of the Tyrannicides (Fig. 34). Whether they echo the Theseion's frescoes or not, they certainly document the triumph of the Tyrannicides' "new Athenian" in the city's collective psyche by the 460s. For here and in hundreds of other pictures with unrelated subjects (e.g., Fig. 25), the men closely echo the Tyrannicides' "iron-man" physiques and stern expressions, and often quote their poses too. At a stroke, it seems, Kritios and Nesiotes had created a new macho ideology for the Athenian state.

Fit, hardy, enterprising, aggressive, resolute, and buoyed by the emotional bond he shared with his fellow-citizens in the democracy, the new Athenian was simply invincible. Whether fighting Persians in Asia Minor, Cyprus, Phoenicia, or Egypt, or fellow Greeks in Greece itself, he tolerated no rival. Of course, cold reality was often different. Although the Athenians scored many striking successes, they also suffered some spectacular reverses.

4 It is a mistake, however, to see them as conscious steps in an *investigation* of pictorial space as such. Classical Greek art is resolutely anthropocentric. It investigates people and their interrelations and regards space as merely the void between bodies. Its forays into landscape and perspective were intended to lend greater verisimilitude – a better reality effect – to human actions and interactions. If a concept of pictorial space emerged from all this (and some Roman painting seems to suggest that it did), it was a later byproduct, an unintended consequence, that postdated the classical period.

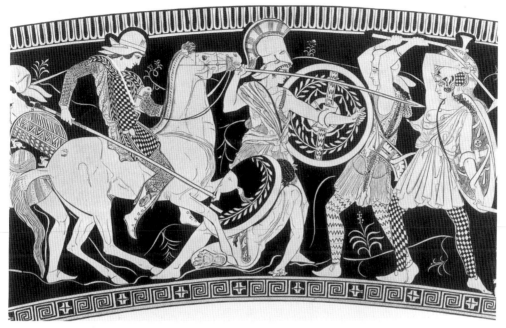

39. Amazonomachy. Redrawing of an Athenian red-figure mixing bowl (volute krater) from Numana (Italy) attributed to the Painter of the Woolly Satyrs, ca. 460. Ht. of main frieze, 22 cm (9″). New York, Metropolitan Museum of Art. The theme and perhaps the composition echoes Mikon's painting for the Theseion in the Athenian Agora.

In 464, hostile natives wiped out their showcase colony in Thrace; in 457 the Spartans thrashed them in battle at Tanagra; in 454 the Persians annihilated their expeditionary force to Egypt; and in 447 their decade-long attempt to rule neighboring Boeotia collapsed. Yet they always bounced back, and not one of the many revolts that plagued their alliance-turned-empire was ultimately successful.

So it is not surprising that alongside this new, bubbling self-confidence we also find voices urging caution. As we saw in the previous chapter, Pindar's poetry is full of such sentiments, albeit cast in the most general terms, but the most explicit warnings came from the greatest dramatist of the day, Aischylos. Alongside its triumphalism, his *Persians* of 472 raised the possibility that his fellow Athenians might well succumb to the same hybris–nemesis cycle that had ensnared the Persians. For even then it was becoming obvious that in many respects they had simply stepped into the Great King's shoes; that resentment against them was beginning to heat up; and that one day they would surely stumble:

> Be mindful of Athens and Greece; let none,
> Scorning his present bliss, in greed for more,
> Pour out and waste the blessings that he has.
> For Zeus, enthroned on high, will punish him,
> The stern chastiser of proud and boastful men.

Although a Persian addresses these words to Persians, the warning is clear. Athenian hyperactivity needs tempering, for Zeus (Fig. 21) is always watching.

No such doubts seem to have affected Mikon's work for the Theseion, probably because his frescoes were state commissions, not personal meditations on success and failure like Aischylos's. Like the painting in Fig. 39, they were stridently patriotic and nationalistic. Visually arresting, they showed Athenian heroes victorious over barbarism, retribution (nemesis) requiting hybris, and justice triumphant both at home and abroad. For whereas Theseus's fight with the Centaurs (see Fig. 45) had taken place in Thessaly, as mentioned earlier the Persian Wars had inspired a new legend that the Amazons had actually invaded Greece and overrun Attica, seizing everything except the Akropolis. Aischylos described their attack on it, slyly omitting (like Mikon's frescoes) any mention of its unsavory cause, Theseus's rape of the Amazon queen Antiope:

> This is the Crag of Ares where the Amazons
> Once pitched their tents when they came marching down
> On Theseus, full tilt in their fury, erecting
> A new city to overarch his town, its towers thrust
> Against his towers – they sacrificed to Ares,
> And named this rock from that day onward Ares' Crag.

This new twist to the Amazon legends neatly killed several birds with one stone. Showing that heroic myth was still a living force and central to Greek self-definition, it proclaimed the Athenian "men's club" as the right and proper form of society; it established the Athenians as Panhellenic benefactors for crushing its perverted and hybristic opposite, a barbarian matriarchy; and it put down the hated Persians as latter-day versions of these invading viragos. The latent anxiety betrayed by this shrill misogyny is fascinating and revealing.

The equation "Amazons = Persians" soon became a cliché, reinforced visually by the simple but effective device of dressing the former like the latter, in cap, jacket, and trousers, and arming them with bows and arrows. For as mentioned in Chapter 1, the contrast between armored (or naked) Greek and trousered Persian, and between manly spear and cowardly bow, had already become a cornerstone of Greek anti-barbarian propaganda (see Fig. 25). Aischylos's *Persians* is riddled with such notions. As for Theseus's aquatic adventure, when Poseidon's wife Amphitrite gave him a ring thrown overboard by the Cretan King Minos, this implicitly and none too subtly legitimized Athens's current naval supremacy. For Minos, ruler of Knossos and builder of the labyrinth, was famous for creating the first such naval empire in history. Yet this fresco's nautical emphasis was unique. In the Athenian (and Greek) consciousness it was the hoplite, not the sailor, who customarily personified the warrior ideal.

Those who want a specifically democratic slant to these pictures might perhaps find it here. For in the 470s and 460s the rowers in the fleet, drawn from the lowest and poorest ranks of Athenian society, were gaining more and more power in the Assembly. Outnumbering the hoplites and increasingly

self-assertive, they had a vested interest in naval adventures because they were paid to row and shared in the plunder (if any), and so tended to be more bellicose and imperialistic.

In 462, Ephialtes and Perikles carried a controversial reform of the Areiopagos (the Athenian high council and supreme court, which met on the Crag of Ares), all but emasculating it (only its power to try homicide and sacrilege cases remained), and also introduced state pay for juries. Since these juries were hundreds strong in order to discourage bribery, at a stroke this measure democratized the justice system, funded these rowers when the fleet was in port, and created a thirst for more handouts of the same kind. Kimon, away in the Peloponnese helping the Spartans to suppress a revolt, hurried home to protest but was promptly ostracized. Though Ephialtes soon fell to an assassin's dagger, the radical democracy, now dominated by what its opponents called the "naval mob," had triumphed across the board.

These momentous events prompted a strong reaction from Aischylos, in his *Oresteia* trilogy of 458. Simultaneously, the core issues at stake – character, leadership, power, and justice – were being chiseled into marble on the greatest building of the day, the new Temple of Zeus at Olympia. Trilogy and temple beg to be examined in tandem, not least because they chronicle the tragedies and triumphs of the same ancient family, the House of Pelops.

THE JUSTICE OF ZEUS

Aischylos, writing in the glorious days after Marathon and Salamis, and before the horrors of the Peloponnesian War, impresses almost every modern reader as the proudest advocate of Athens and its new democracy. In the *Persians*, he presents Athens, with its navy, spearmen, olive trees, and silver currency, as the brave and resourceful defender of Greece against the gold-rich barbarian hordes of archers and cavalry; in the *Suppliant Maidens*, Pelasgos and his quasi-democratic city of Argos resemble a kind of proto-Athens as they undertake the protection of the defenseless maidens against exotic, despotic invaders; while the *Seven Against Thebes*, by contrast, can be seen as portraying the archetypal un-Athenian (or pre-democratic) city, a city where the ruling family has run amok for generations.[5]

Aischylos's masterpiece, the *Oresteia*, written in the wake of Perikles's and Ephialtes's reforms, had its debut in 458, winning first prize. The only tragic trilogy to survive among hundreds, its plot is a simple tale of atrocity and revenge, but its themes are legion (see Box 2. *Aischylos's* Oresteia) – inescapable imperatives, impossible choices, irreconcilable claims, the dead-end logic of the vendetta, hybris and nemesis, family and city, and so on. Four of these in particular stand out: leadership, power, justice, and a blatant idealization of

5 Mark Griffith, "Brilliant Dynasts: Power and Politics in the Oresteia," *Classical Antiquity* 14 (1995): 62–129, at pp. 63–4.

BOX 2. *AISCHYLOS'S* ORESTEIA

The *Oresteia*, first staged in 458, is the only tragic trilogy that survives. A "slice from Homer's banquet," it takes place immediately after the fall of Troy. Its theme is a vendetta among the children of Pelops, the first ruler of the Peloponnese and ancestor of the Argive and Spartan monarchies. Long before the opening of the first play, *Agamemnon*, Pelops had been cursed by the charioteer Myrtilos, just before his death [see Box 3: Pelops and Oinomaos]. His son Atreus, King of Argos, quarreled with his brother Thyestes, who then seduced Atreus' wife in return; enraged, Atreus promptly cooked Thyestes' children and served them to him to eat. Discovering the truth too late, Thyestes cursed Atreus and his children – a curse that one of Thyestes' later sons, Aigisthos, would eventually fulfill.

But by then Thyestes was long dead; Atreus's son Agamemnon had become king of Argos and his brother Menelaos had become king of Sparta and had married Helen, the most beautiful woman in Greece. Visiting Sparta, the Trojan prince Paris seduced her and eloped with her to Troy; Agamemnon then agreed to gather an expedition to regain her and to punish the Trojans. When the Greeks assembled at Aulis, however, they learned that the winds would favor them only if Agamemnon sacrificed his daughter Iphigeneia to Artemis. Once he did so the winds changed and the expedition duly sailed for Troy. Left alone and enraged at their daughter's murder, Agamemnon's wife Klytaimnestra (Helen's sister) took up with Aigisthos and began to plot her husband's death . . .

Agamemnon opens with the arrival in Argos, ten years later, of the news of Troy's fall. Soon after, the victorious Agamemnon himself appears,

Athens. For the aristocratic protagonists of the first two plays – Agamemnon, Klytaimnestra, Aigisthos – are all models of *failed* leadership and the egregious abuse of power. The warmonger Agamemnon blithely sacrifices thousands of lives for a private quarrel and arrogantly tramples his own household's riches (its fine tapestries) underfoot; the mannish Klytaimnestra, blinded by hate, usurps legitimate authority and the prerogatives of men; and the creep Aigisthos plays the tyrant as her lover, consort, and fellow assassin.

Attic tragic convention prohibited Agamemnon's murder from being enacted onstage. But a great *symposion*-krater in Boston (Fig. 40), painted a decade or so before Aischylos wrote his trilogy, perhaps after a lost epic or lyric version of the story (several are attested, but do not survive), shows vividly how the poet's audience would have imagined it before sitting down to watch his plays. As the doomed king battles his filmy prison, Aigisthos lunges forward with sword in hand in a grotesque parody of the tyrannicide

accompanied by his new concubine, the Trojan princess Kassandra. Klytaimnestra persuades the king to enter the palace over a carpet of fine tapestries. She then traps him in a net, stabs the couple to death, displays the corpses to the unhappy chorus (the people of Argos) like dead fish, and tries to justify her deed. Aigisthos arrives and reveals that he masterminded the plot, and the two usurpers claim the kingdom for themselves.

The second play, the *Choephoroi* or *Libation-Bearers*, begins with the return from exile of Agamemnon's son Orestes and his friend Pylades. After meeting and recognizing Elektra at Agamemnon's tomb, they resolve to avenge the dead king. Disguised as a messenger, Orestes convinces Klytaimnestra of his own death; summoned to the palace to celebrate, Aigisthos is ambushed by Orestes, who then kills Klytaimnestra also. Displaying the murdered usurpers in a net just as they had formerly displayed Agamemnon and Kassandra, Orestes then justifies his revenge, but is interrupted by a horrible vision. The Furies, those ancient and implacable spirits of retribution, are coming to get him . . .

The final play, the *Eumenides* or *Furies*, begins with Orestes besieged by the Furies in Apollo's shrine at Delphi. Refusing to accept Apollo's claim that he has exonerated and purified the young avenger, the Furies surround him, but Apollo helps him to escape to Athens, where he takes refuge in Athena's temple. The Furies follow and try to drive him mad, but Athena arrives to save him and hears the rival cases for his innocence or guilt. She resolves to found the first-ever homicide court (the Areiopagos) to decide where true justice lies. At the trial's conclusion, she votes for acquittal, and because the other jurors' votes are even, Orestes goes free. Enraged, the Furies threaten to destroy Athens, but Athena gradually calms them and persuades them to accept an honored position in the city as "August Goddesses." All parties then join a final torchlight procession of celebration.

Aristogeiton (Fig. 34), while the implacable Klytaimnestra, similarly poised, follows him with an axe; the distraught Kassandra and Agamemnon's two young daughters Elektra and Chrysothemis frame the action. The outcome appears on the other side (Fig. 41). Orestes and Elektra, armed with the same weapons, storm forward implacably to kill Aigisthos in almost exactly the same way. They invite us to compare and contrast the two acts of vengeance, the true tyrannicides with the false ones.

These pictures not only foreground the violence that could not be shown onstage, but also highlight Aischylos's own originality and willingness to toy with his audience's expectations. In Fig. 40, as in earlier images of Agamemnon's murder, Aigisthos himself stabs him with Klytaimnestra in tow, but in *Agamemnon* he stays clear of the palace and cravenly gets the queen to do his dirty work for him. This was surely the tragedian's own idea. Switching gender roles in this way allowed him to blacken the two assassins further, and

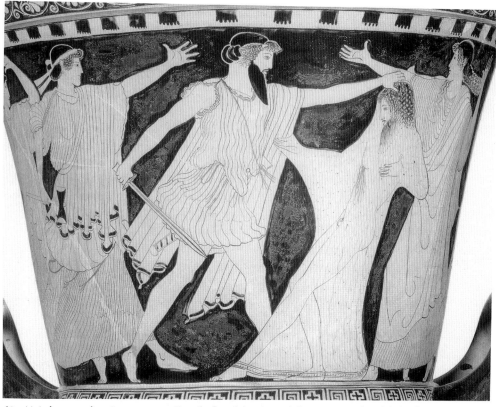

40. Aigisthos murders Agamemnon. Detail of an Athenian red-figure mixing bowl (calyx krater) attributed to the Dokimasia Painter, ca. 470. Ht. 51 cm (1′8″). Photograph © Museum of Fine Arts, Boston; for detailed credit see *Sources of Illustrations*. Klytaimnestra (left), and Elektra and Chrysothemis flank the protagonists.

to complicate the future case against Orestes for killing them in turn. In *The Libation-Bearers* Orestes does the deed on his own, presumably so that in the final play, *The Furies*, he alone is the one that the Furies go after.

Aischylos also counters these larger-than-life characters with the views of lesser folk, from the chorus of Argive elders in *Agamemnon* to the Athenian jurors in *The Furies*, and with an Athens where civilization and true justice reign supreme. Yet he is no radical democrat. In his world, elites and the family/household remain essential to society's fabric, and the dēmos's voice is usually inarticulate "murmurs," "groans," "curses," and "shouts" of approval or disapproval. It never initiates, only reacts. And even though *The Furies* ends with the triumph of law over vendetta, to characterize this ending as a liberal humanist hymn to social justice or a conservative critique of Ephialtes's and Perikles's reforms is quite a stretch. For although Aischylos pointedly invokes the Areiopagos in its remaining role as a homicide court, its proceedings end with a hung jury, and only Athena's casting vote secures Orestes's acquittal. (This was a neat conclusion, because the fifth-century Areiopagos resolved deadlocks in precisely this way. This clever exercise in *etiology* – identifying the

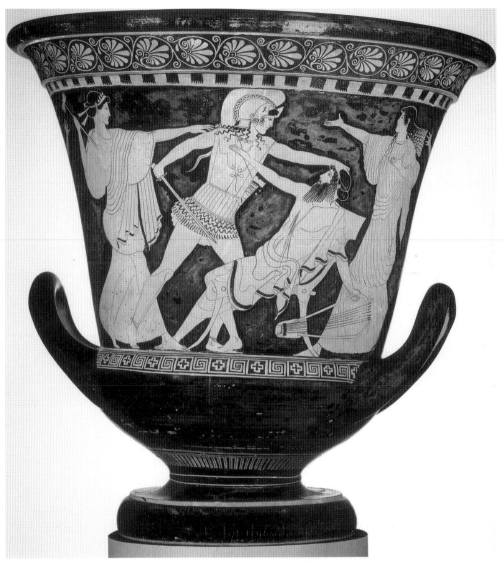

41. Reverse of the calyx krater, Fig. 40. Photograph © Museum of Fine Arts, Boston; for detailed credit see *Sources of Illustrations*. Orestes and Elektra kill Aigisthos.

origins of current events, customs, and rituals – no doubt helped considerably in securing Aischylos his prize.)

So to Aischylos the universe and its microcosm the community (whether polis or oikos, city or palace) are battlefields where all is ambiguous and contested. Classical Attic tragedy seeks to reconcile tradition and the past (represented by the heroic world of kings, courts, and palaces) with innovation and the present (the classical democratic city). Through myth's refracting lens, it examines not only the current status quo but also our innermost thoughts and feelings about life itself. In giving voice to such subtleties, it moves well beyond the "dumb" art of mythological painting (Fig. 40), though the latter's

visual directness and dramatic power reign supreme in its own milieu, the symposion. There, reclining around the brimming krater and quaffing its contents, one could use these images to focus and debate the issues raised by the plays.

Now at every such sympotic gathering, the first krater of wine was dedicated to Zeus and the Olympian gods; the second to the heroes; and the third to Zeus *sōtēr* or savior. And in the *Oresteia*, too, Zeus is omnipresent – even though in accordance with tragic custom he never actually appears onstage. The participants invoke him repeatedly in many different but overlapping roles: as *xenios* (god of hospitality and guest–host relations); as *basileus* (god of kings and legitimate rule); as *agoraios* (god of the assembly-place and of political debate); as *herkeios* (god of the family hearth and marriage); as *patēr* (god of fathers and patriarchal authority); as *teleios* (god of completion, who brings things to perfection); and as *tritos sōtēr* (god of third-time-charm; god the savior). Channeled in these ways, his omniscient will guides the action and shapes its outcome from afar: compare, for example, Fig. 21. With this in mind, let us now relocate to Olympia.

A CONSERVATIVE RESPONSE

The fifth-century Peloponnese was a conservative place. Landowners dominated its broad, fertile plains, herdsmen roamed its hills and mountains, and (as we have seen in Chapter 1) two-fifths of it, comprising the rich valleys of Lakonia and Messenia, was ruled by the most reactionary of all Greek peoples, the formidable Spartans.

In the years after Plataia, the Peloponnesians usually took their cue from Sparta but were by no means deaf to siren songs from Athens. Sparta's own birthrate had begun to fall, and the helots and Messenians were becoming increasingly restive. In this situation, the Spartans could barely retain control over their own subjects, let alone exploit their enormous prestige as the backbone of Greek resistance on land to Persia. In 479–8, as we have seen, this prestige suffered a triple blow. The Athenians rebuilt their city walls under the Spartans' very noses; their king and regent, the two leaders of the anti-Persian alliance, self-destructed; and Athens took control of the allies.

The two great powers henceforth began to drift apart, though the pro-Spartan Kimon kept the façade of cooperation intact for the moment. Indeed, when in 465 a great earthquake killed many young Spartiates and the helots and Messenians promptly revolted, Kimon even showed up to help with an Athenian army. Three years later, however, the Spartans abruptly ordered him and his men out. They gave no open reason for this U-turn, but everyone knew that "they feared that the Athenians' adventurous and revolutionary spirit . . . might infect their own allies." As mentioned earlier, back at Athens the humiliated Kimon was promptly ostracized and war soon followed, culminating in a Spartan invasion of Attica and their great victory at Tanagra in 457.

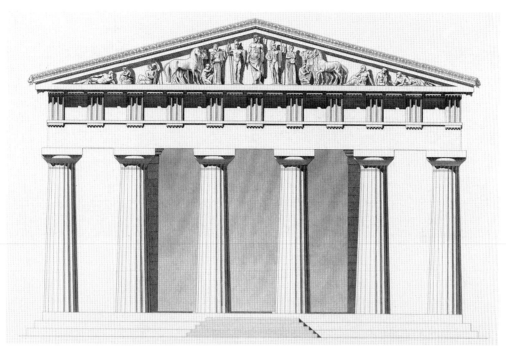

42. Reconstruction of the east front of the Temple of Zeus at Olympia designed by Libon of Elis, ca. 470–57. Limestone, originally stuccoed; ht. 20 m (65'7"). In the pediment, Zeus (at center) oversees the preparations for the chariot race between Pelops (left) and Oinomaos (right) for the hand of Hippodameia (standing next to Pelops). The reconstruction omits the akroteria and the chariots; the kneeling girl second from left should be attending Queen Sterope, on the right of the central group, and the youth kneeling in front of the right-hand chariot team probably is the charioteer of the left-hand one, so he should be placed behind it.

These events form the backdrop to the greatest Peloponnesian monument of the fifth century, the Temple of Zeus at Olympia (Figs. 42–50), and help to explain much about its sculptures.

In 471 the Eleans, who controlled Zeus's sanctuary at Olympia and were loyal Spartan allies, founded a new federal capital 20 miles (30 km) north of the sanctuary. They also decided that Zeus needed a new temple and used plunder from the rebel town of Pisa to finance it. They placed it at the center of a great semicircle of preexisting monuments, both cultic and athletic, ensuring that it evoked a host of positive associations for the attentive visitor.

To the south of the temple stood the council-house and the altar of Zeus Horkios ("Oath-taker"), where the Olympic contestants swore their oath to play fair. To the southeast was the great hippodrome, where the most prestigious Olympic contests, the chariot and horse races, were held; Pelops's race with the cruel king Oinomaos of Pisa had inaugurated the former and Herakles's race with Kyknos the latter. To the northeast was the stadium, where the most ancient contests, the foot races, took place, supposedly inspired by a race between Herakles and his brothers. Immediately to the north were Zeus's altar and Pelops's tomb. Both of them were huge mounds, the one

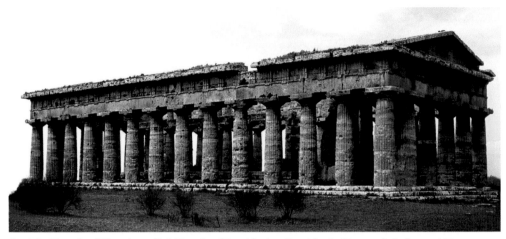

43. The Temple of Hera (so-called Temple of Poseidon) at Poseidonia (Paestum), Italy, ca. 450. Limestone, originally stuccoed; height, 17.5 m (57′5″).

an accumulation of the burned thighs of sacrificed victims, and the other an earthen tumulus surrounded by a wall. On their far side was the archaic temple of Zeus, soon to be rededicated to Hera; and finally, beyond this was the sanctuary's northern boundary, the hill of Kronos. Here Zeus had wrestled his father Kronos for control over the site, thus initiating the Olympics' combat sports. As we shall see, much of this was referenced on the temple itself.

Fortunately, the indefatigable Pausanias visited Olympia around A.D.170 and describes the new temple thoroughly – though he does, it seems, make some mistakes (see Box 3. *Pelops and Oinomaos*). Begun around 470, its fabric was finished by 457, when the Spartans dedicated a golden shield above its eastern gable to celebrate their triumph over Athens at Tanagra. Its architect, Libon of Elis, produced a massive Doric building that was a model of early classical austerity (Fig. 45). Employing the long Peloponnesian foot of 32.6 cm (12.75 inches), he based his design on simple integral ratios: column height, 32 ft.; interaxial spacing (the distance between the column axes), 16 ft.; width of Doric capitals, 8 ft.; distance between triglyph centers, 8 ft.; distance between mutules and lion's head gargoyles, 4 ft.; tiles, 2 ft. square. This proportional system produced a more massive and denser façade, for it increased both the diameter of the columns in relation to their spacing, and the entablature's height in relation to that of the column. But it did more. More comprehensive than the system used at Aigina (see Chapter 1; Fig. 26), it exploited the power of the *algorithm*, of a simple mathematical formula repeatedly applied. Nature builds structure algorithmically – one cell becomes two, two become four, four become eight, and so on – and Libon let his design develop in a similar way.

Unfortunately, Christian zealotry has reduced Libon's temple to rubble (though one single column now stands again, reerected for the 2004 Olympics). Fortunately, however, the contemporary temple of Hera (so-called "Poseidon") at the Greek colony of Poseidonia or Paestum in Italy (Fig. 43)

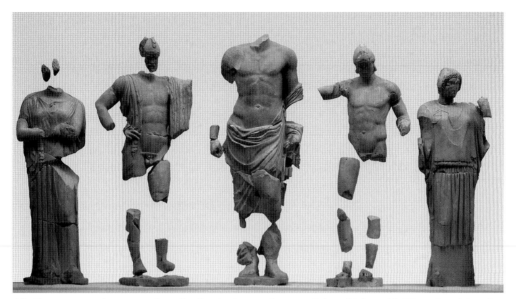

44. Zeus oversees the preparations for the chariot race between Pelops (right, with Hippodameia) and Oinomaos (left, with his wife Sterope). From the east pediment of the Temple of Zeus, Fig. 41, as reconstructed in the Olympia Museum, ca. 460. Marble; original ht. of Zeus, ca. 3.15 m (10′4″). This reconstruction of the central group reverses that of Fig. 42. See box 3.

gives a good idea of its overall appearance. Although slightly smaller, it employs the same ratio of interaxial to column height. As J. J. Pollitt has observed, "There were, of course, small variations and disparities in these measurements in different parts of the temple, but the overall impression of a quite simple *logical equivalence* presented by the structure as a whole must have had a strong psychological effect (probably consciously perceived by architects, subconsciously by others) on all who saw it. Like the Apollo of the west pediment [at Olympia, Fig. 45] it connoted simplicity, balance, and measure superimposed on raw matter."[6] In other words, it was an imposing monument to *kosmos* (order) and technē alike.

Furthermore, Libon was able to finesse the problem of the so-called "corner conflict" – the conflicting rules that (1) triglyphs must be centered above the axes of the columns and the spaces between them; and (2) the frieze must end with a triglyph, not a half-metope (see Chapter 1). He compressed the colonnade and stretched the frieze as usual, but carefully shifted the corner columns exactly to the point where the rectangle of the façade (width of colonnade: column height + architrave + frieze) conformed to a 2:1 ratio. But he was unable to extend this system to the flanks, whose 13 massive columns produce an awkward façade-to-flank ratio of 1:2.316 – almost but not quite one to two and a third.

Libon's system used what mathematicians call a geometric progression (1, 2, 4, 8, 16, 32, . . .), one of three such algorithms or "means" known

6 Pollitt, *Art and Experience in Classical Greece* (Cambridge 1972): 42.

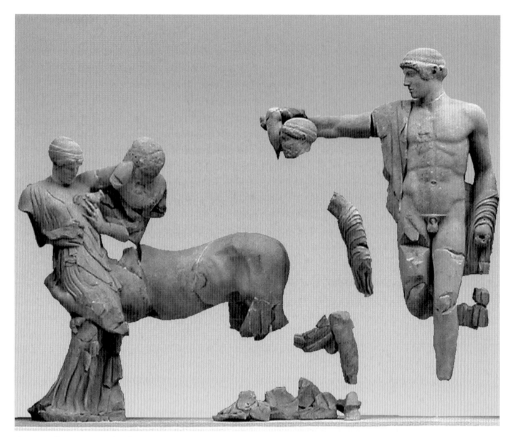

45. Apollo oversees the fight between Perithoos (left), Theseus (right), and the Centaurs at Peirithoos's wedding to Deidameia (at far left). From the west pediment of the Temple of Zeus, Fig. 42, as reconstructed in the Olympia Museum, ca. 460. Marble; ht. of Apollo, ca. 3.1 m (10′2″).

to fifth-century Greeks.[7] These progressions were particularly important in classical Greek music, where (as we saw in Chapter 1) the developing science of harmonics was itself based on the precise calculation of the intervals of the musical scale (Fig. 23: the octave, 1:2; the fifth above, 2:3; the fourth above that, 3:4; etc.).

The enthusiastic employment of such ratios by early classical artists not only demonstrates their close links to the exciting new discoveries of Greek science, music included. It also shows that they continued to refine the use of proportion or *symmetria* (see Chapter 1) as a means to unify and impose order (kosmos) on their work and so to align it with other manifestations of the rational. All described by the word "kosmos," these included women's adornment, temple decoration (sculpture included), and of course the universe

7 The Greeks called these progressions "means" because the formula in question relates each term after the first to its neighbor on either side ($[a + c]/2 = b$, etc.); thus, 2 is the arithmetic mean between 1 and 3, and the geometric mean between 1 and 4.

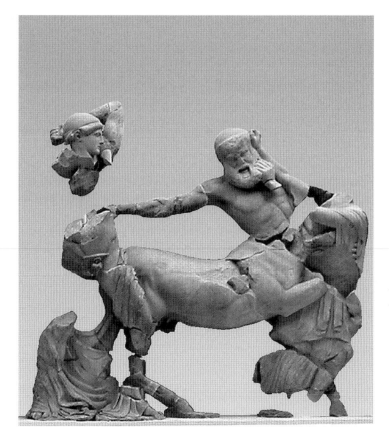

45 (*continued*)

itself. This is why there is plenty of evidence in classical Greek architecture for the use of simple, rational ratios such as 1:2, 1:3, or 1:4, but almost none for irrationals such as $1{:}\sqrt{2}$, $1{:}\pi$, or 1:1.618 ... (the so-called Golden Section).[8]

8 The famous – or infamous – "Golden Section" is the section of a line in extreme and mean ratio and is constructed by the intersection of the diagonals of the pentagon. If one of these diagonals, a line of length A, is divided in this way by another into two unequal parts, b and c, A is to b as b is to c and vice versa ($A{:}b{::}b{:}c$).

Although geometrically and aesthetically satisfying, mathematically the ratio is an irrational (1:1.6180339887 ...). Its integral approximation, the so-called Fibonacci series (1, 1, 2, 3, 5, 8, 13, 21, 34, 55, 89, ...), was, however, used in the theater at Epidauros (see Fig. 167) around 330, but for a special reason: See Chapter 7. Within this series, the ratio 5:8 (1:1.6) approximates the Golden Section most closely. Forgetting this and the fact that Greek builders and modern temple surveyors were rarely so precise, partisans of the Golden Section often have conjured it up where probably just the simple 5:8 ratio was intended.

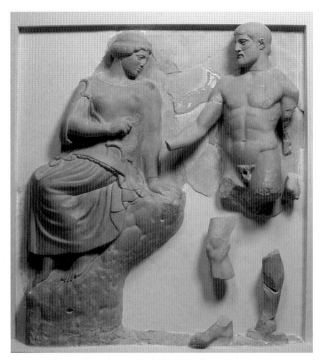

46. Herakles offers the Stymphalian Birds to Athena. Metope 3 from the Temple of Zeus, Fig. 42, ca. 460. Marble; ht. 1.6 m (5′3″). Olympia Museum; completed by casts of fragments in Paris.

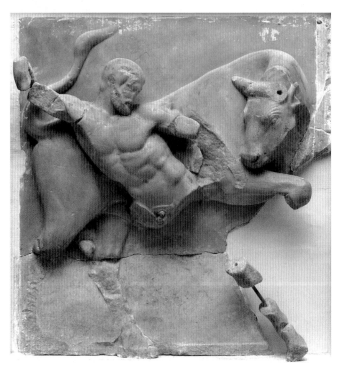

47. Herakles battles the Cretan Bull. Metope 4 from the Temple of Zeus, Fig. 42, ca. 460. Marble; ht. 1.6 m (5′3″). Olympia Museum, completed by casts of fragments in Paris.

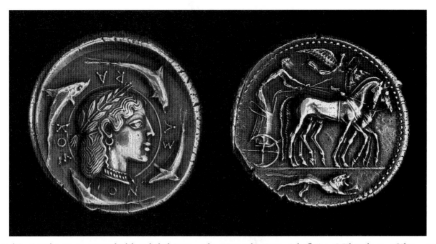

48. Arethusa surrounded by dolphins, and racing chariot with flying Nike above. Silver dekadrachm (ten-drachma piece) of Syracuse, ca. 480–70. Diam. 3.5 cm (1.4″). London, British Museum. Arethusa was the nymph of the spring that watered Ortygia, the island-citadel of Syracuse, and the chariot probably alludes to an Olympic victory by the Syracusan tyrant Gelon (ruled 485–78) or Hieron (478–66).

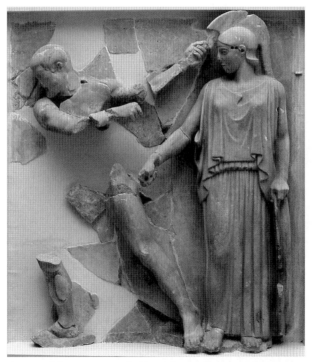

49. Herakles, superintended by Athena, cleans out the Augean Stables. Metope 12 from the Temple of Zeus, Fig. 42, ca. 460. Marble; ht. 1.6 m (5′3″). Olympia Museum.

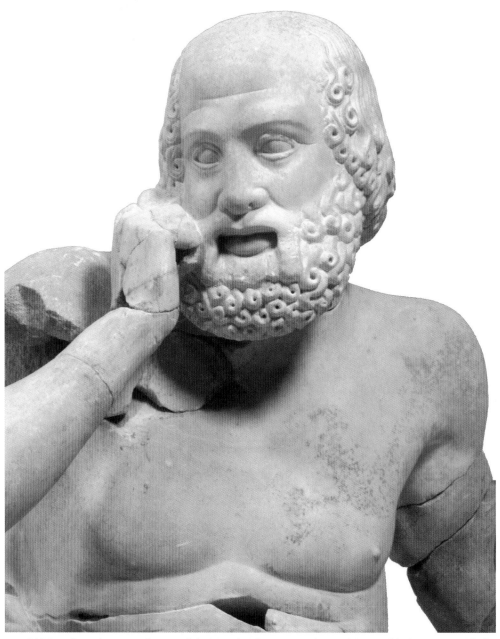

50. Old Seer from the east pediment of the Temple of Zeus, Fig. 42, ca. 460. Marble; ht. 1.38 m (4′6″). Olympia Museum.

BOX 3. *PELOPS AND OINOMAOS*

Arriving in the Peloponnese from Asia, Pelops decided to seek the hand of the Elean princess Hippodameia in marriage – in part because thirteen others had tried but had fallen victim to her father Oinomaos's spear. For each suitor had to undergo an ordeal: a chariot-race to the Isthmos of Corinth. The suitor started first, taking Hippodameia with him. Oinomaos then sacrificed to Zeus, gave chase, and when he caught up (his horses were gifts from the war-god, Ares), stabbed his hapless quarry in the back. There are two versions of Pelops's attempt. Either he received a gift of immortal – some say winged – horses from Poseidon (who loved him), outran the king, and then killed him; or – more sensationally – he bribed Oinomaos's charioteer Myrtilos to replace the lynch-pins of the royal chariot with wax, which promptly melted when the vehicle gathered speed. The king died in the crash, and when Myrtilos claimed his reward (a night with Hippodameia) Pelops promptly killed him.

Because Pausanias's description of the east pediment (5.10.6–7) is ambiguous ("on the right of Zeus is Oinomaos . . . and to the left from Zeus is Pelops . . . ": Does he mean the god's left and right or ours?), and because most of the sculptures were not found exactly where they had fallen, the pediment's reconstruction remains controversial. The one illustrated here (Fig. 42), first proposed in the nineteenth century, differs somewhat from the current installation at Olympia (Fig. 44). Taking Pausanias's remarks literally, it puts Oinomaos on our right (Zeus's ill-omened left side), along with the shocked and fearful seer (Fig. 50), and Pelops and Hippodameia on our left (Zeus's well-omened right side). It also agrees with Pausanias's comment that the corner figures, the river god Alpheios and his offspring/tributary the Kladeos, were located on the sides of Pelops and Oinomaos, respectively. For the man on Pelops's side (our left) is bearded and the one on Oinomaos's (our right) is clean-shaven, just as their father-son relationship demands.

In Fig. 44, Pelops's chariot has both charioteer and groom, but Oinomaos's, not yet ready to depart, has neither. Myrtilos being absent, the likelihood is that the sculptures follow the sanitized version of the myth. This same version was also seen by Pausanias (5.17.7) on the spectacular "Chest of Kypselos" dedicated by the Corinthian tyrants at Olympia around 600, and was celebrated in Pindar's first *Olympian Ode* of 476, just before these marbles were commissioned, designed, and carved.

For if one equates measure and commensurability with beauty and excellence, it is only logical to consider irrationals – incommensurable by definition – as abominations.

To return to the Temple of Zeus. Its fabric was of local shelly limestone, stuccoed to conceal its coarse texture, but its sculptures – its own particular kosmos – were made of the finest Parian marble. They comprised two enormous pedimental groups, almost ninety feet (26.4 m) wide and eleven feet (3.3 m) high at the center (Figs. 42, 44, 45), and six five-foot (1.6-m) metopes over each inner porch (Figs. 46, 47, 49). So the metopal figures were almost life-size and the pedimental ones almost twice that. The artist's name remains unknown, so for convenience he is usually called simply the Olympia Master. The cult statue itself, a gigantic gold and ivory Zeus by Pheidias (later deemed one of the Seven Wonders of the World), was not begun for another generation, and must have required a separate fundraising campaign.

The sculptures must have been designed in the early 460s. On one level, their overall theme is quite straightforward: Zeus and his children. On the east pediment (Figs. 42, 44) the sky-god himself (figure H) presides over the preparations for a chariot-race between Pelops (G) and the cruel king of Pisa, Oinomaos (J), for the hand of the king's daughter, Hippodameia (K; see Box 2. *Aischylos's* Oresteia). On the west (Fig. 45), Zeus's son Apollo presides over the defeat of the Centaurs at the wedding of Peirithoos and Deidameia, when they got drunk and tried to rape the bride. And on the metopes (Figs. 46, 47, 49), Zeus's daughter Athena presides over the twelve Labors imposed on his son Herakles for killing his own children in a fit of madness. Familiar with these tales from childhood and keen to see Pheidias's great Zeus inside the temple (one of the Seven Wonders of the World), some visitors probably would have quit looking right there – just as Pausanias did.

Others, however, especially those interested (like Aischylos) in etiology and genealogy, might have scrutinized the scenes more closely. For by anchoring the present in the world of myth and legend, they embedded it firmly in tradition and thereby powerfully strengthened the visitor's sense of belonging.

These visitors would certainly have known that Pelops was both the archetypal Greek king and a real, talismanic presence at Olympia. Beloved of Zeus *and* Poseidon, after his victory over Oinomaos he had sired *both* the great royal houses of the Peloponnese, those of Argos and Sparta, through his two sons, our old acquaintances Atreus and Thyestes. (His fiancée, Hippodameia [Fig. 44, far right], even has short-cropped hair just like contemporary Spartan brides.) This is why (Pausanias tells us) the Eleans revered Pelops above all other heroes, just as they revered Zeus above all other gods. He was the archetypal Peloponnesian king.

Moreover, Pelops was both Olympia's founding hero (his huge burial mound, the Pelopion, lay just north of the temple and overlooked the start of the Olympic racecourse) and – through his victory over Oinomaos – the inspiration for the Olympic four-horse chariot race. By the 470s, this had become the most spectacular and prestigious of all the Olympic competitions, inspiring some of Pindar's best poetry, and was frequently celebrated on the

coins of the Sicilian tyrants, who won it often (Fig. 48). Herakles, of course, had founded the Olympics proper, and even Hippodameia had a part to play in the festival. In gratitude to Hera for her marriage, she had founded the Heraia, the women's Olympics, now documented for us almost exclusively by the indispensable Pausanias.

What of the east pediment's two seated old men (Fig. 50)? Were they perhaps the ancestors of Olympia's two great clans of seers, the Iamids and the Klytiads, who enjoyed enormous prestige in both Elis and Sparta? Indeed, the greatest of these seers, Teisamenos, was still alive. He had helped the Spartans win at Plataia; had been awarded Spartan citizenship – a unique honor – for this; and then had proceeded to steer his Spartan patrons though the crises of the next two decades, culminating in their great victory at Tanagra. And why was Theseus, an Athenian hero, so prominent on the west pediment? Was this perhaps a reference to Athenian–Spartan co-operation? Finally, on the metopes, why did Herakles fight with a club instead of his traditional bow? Was it because this had been the weapon of the Persian barbarians (see Fig. 25)? In short, anyone with some local knowledge could connect, and do so with pride.

Those inclined to look deeper would have realized that Pelops, Peirithoos, Theseus, and Herakles were enforcing nothing less than the Justice of Zeus himself. The tyrannical Oinomaos, the drunken Centaurs, and the beasts and monsters of the Labors – all of them had violated the natural order of things: Oinomaos by his cruel, fixed-up competition for his daughter's hand, and the others by their blind, insensate violence. These monsters of arrogance and violence – of hybris – were now confronting retribution (nemesis) in the form of divinely guided heroes of surpassing prowess and excellence.

Three of these heroes – Pelops, Peirithoos, and Theseus – are fully mature men, but Herakles's Labors (Figs. 46, 47, 49) show how hard the climb to excellence really is, even for those predestined to achieve it. Exhausted after his first Labor (the Nemean Lion), he gradually gains in strength, dexterity, and understanding – in heroic technē – as the series proceeds, aided by Athena in panels one, three, ten, and twelve (Figs. 46, 49). Indeed, even the goddess herself matures. At first a mere girl (Fig. 46), by the end of the series (Fig. 49) she is very much the favorite daughter of the supreme god of the sky, erect and commanding, faultlessly dressed, and fully equipped with her trademark helmet, shield, and spear.

What of composition and style? A typically modern obsession, probably they rated far lower in Greek eyes. For one thing, viewers would have expected a rendering that was up to date, and so by the time that the great ensemble was unveiled they would have taken much of it in their stride. Second, many of the subtleties that so delight us in the sculptures' present museum setting would simply have been invisible from below and forty or fifty feet away. They were meant for Zeus. And third, far from having a word for everything as is popularly supposed, the Greeks did not develop a sophisticated stylistic vocabulary until quite late, so they would have found it hard to articulate any feelings on the issue that they did have.

Even so, attentive visitors surely would have approved of the austere, "severe" style of the rendering, with its clear-cut poses, bold modeling, simple clothing, and intense facial expressions. Contrast, for example, Figs. 6 and 17, which by then probably looked somewhat extravagant and excessive. They would also have noticed the emphatic contrast between the still but tension-filled composition of the east pediment and the turmoil of the western one (Figs. 44, 45), and between the more static metopes and the more violent ones (Figs. 46, 47, 49). And at some level, they might have caught the differences in behavior among the various classes represented: the commanding postures of the kings and heroes, the magnificent carriage of their women, the simple courage of their battling retainers, and the meek submissiveness of their servants.

So what message did all this send?

MENO'S QUESTION

In the year 402, half a century after the completion of these sculptures, a young Thessalian aristocrat called Meno supposedly asked Sokrates the following question:

> Can you tell me, Sokrates – is excellence [aretē] something that can be taught? Or does it come by practice? Or is it neither teaching nor practice that gives it to a man, but natural aptitude or something else?

Meno's question was opportune. For much of the century, the sophists – itinerant professors who lectured for a fee – had asserted that excellence *could* be taught. Conservatives such as Pindar scornfully disagreed:

> What nature gives is best in every way, but many
> Have tried to win renown
> By taking lessons in excellence.

Yet native talent could, of course, be improved by training:

> One born to excellence
> May be whetted and stirred
> To win huge glory
> If a god is his helper.

This is exactly the situation at Olympia. On the metopes, with Athena by his side (Figs. 46, 47, 49), Herakles's native talent duly expands to fill the space allotted to it, and the pediments show the results of such training. Throughout, excellence clearly has a *class* meaning. Each class has its own path to tread, its own predetermined destiny to fulfill: *That* is the Justice of Zeus. It is universal, because the gods are omnipresent to enforce it; it is

intersocial, because each responsible participant knows his or her place and is completely at home in it; and it is absolute, as clear-cut and inexorable as Libon's algorithmic proportions.

So the Olympia Master was the first Greek sculptor to create what we would call a *world* – a rounded, wholly credible kosmos of gods, humans, and beasts. Elitist and conservative, his sculptures neatly complement and complete the well-ordered fabric – the kosmos – of Libon's building. Their message – a far cry from egalitarian Athens and the political subtleties of the *Oresteia* – would have appealed to many, especially the reactionary Spartans, always afraid of Athenian adventurism and political radicalism. With the loss of almost all fifth-century Peloponnesian literature, the Olympia Master opens a window onto that region that is precious indeed. Yet this by no means meant that he disdained everything Athenian, as we shall see.

ART AND DRAMA

The stilled yet tense composition of Olympia's eastern pediment (Figs. 42, 44) has often been likened to a stage play, with good reason. Its theme – a people enslaved by a tyrant, and then liberated by a hero coming from afar – is popular in Attic drama (witness, for example, Aischylos's *Libation-Bearers*). All the protagonists face us, the audience, like actors on a stage. Oinomaos barks out his terms like a true tragic villain, while Pelops listens intently and the women look on (Fig. 44); the old seer (Fig. 50) reacts like a chorus-leader, hand to mouth and with brow creased in shock. And Zeus, unseen except by us, presides over everything, turning his head to favor Pelops, who stands tellingly on his well-omened right side. (Like many cultures, including our own, the Greeks had a strong bias toward the right, which also manifested itself in the world of divinely sent signs or omens. For instance, a flock of birds appearing on one's right was a good omen, but on the left, it meant the opposite.)

Presenting the suspenseful moment of decision before an action – in Greek, the *krisis* (compare our *crisis*) – not only was a popular dramatic device but also had a respectable history in Greek art. For its appeal is precisely that we know more than the actors do, and can match our knowledge against theirs. We are in the know, but they are not. (In this respect, then, the old seer, Fig. 50, represents us. He is the viewer in the frame.) Pioneered by the sixth-century vase-painter Exekias, the *krisis* shows up on Euthymides' amphora (Fig. 10), where Herakles dons his armor before going out to fight – for the last time?

In Figs. 10 and 17, the frontal postures, like those of actors "cheating out" (see Chapter 1), help to bring this sense of crisis home to us. This technique reaches full maturity in the 460s and 450s, on this pediment (Figs. 42, 44), some of the metopes, and numerous Attic vases, of which the most spectacular is the famous Niobid krater in Paris (Figs. 51, 52). On one side of it, Apollo and Artemis punish the Niobids for their mother's hybris, and

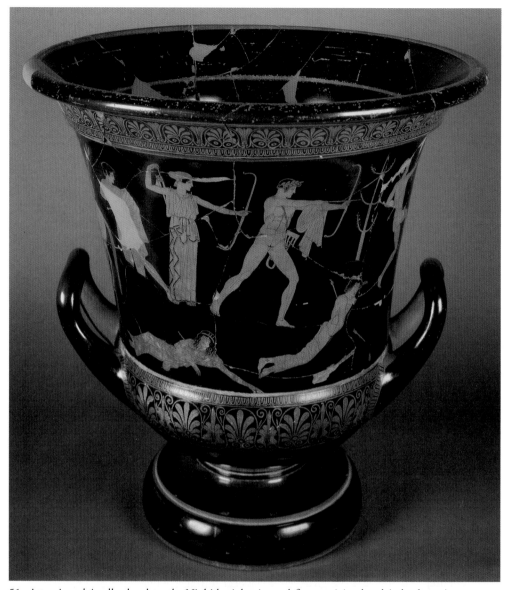

51. Artemis and Apollo slaughter the Niobids. Athenian red-figure mixing bowl (calyx krater) from Orvieto (Italy) attributed to the Niobid Painter (name vase), ca. 450. Ht. 54 cm (1′9″). Paris, Louvre.

on the other, Athena and nine heroes gather around the figure of Herakles in a scene best interpreted as either the prelude to the Battle of Marathon or its sequel.[9]

9 Examination of the vase in 1995 revealed that the painter first sketched Herakles standing on a three-stepped base, but in the end decided to substitute a flat-topped rock. This representation of Herakles as a living statue strengthens the connection with Marathon, for the Athenian army mustered in his sanctuary before the battle.

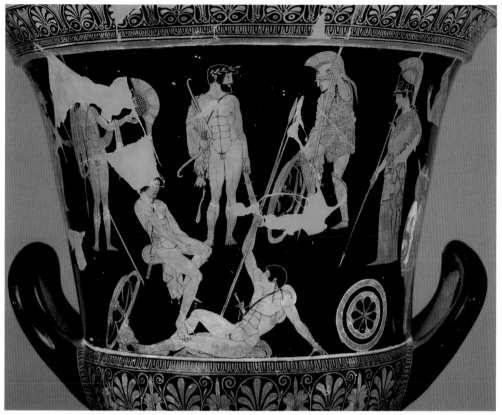

52. Heroes gather around Herakles, observed by Athena. Detail of the reverse of the calyx krater, Fig. 51. The painter first showed Herakles as a statue on a three-stepped base, but then replaced this base with a flat-topped rock. Because the Athenian army mustered in Herakles' sanctuary before the Battle of Marathon, this detail suggests that the scene illustrates the prelude to the battle.

In these pictures, the bird's eye perspective is far more radical than in the Amazonomachy of Fig. 39. Fortunately, we know who perfected it and blended it with the dramatic devices (acting postures and the articulation of character and feelings via facial expression, pose, and gesture) that have dominated this chapter and the last: the great early classical muralist Polygnotos of Thasos. Here is an excerpt from Pausanias's long description of his great panoramas of the *Underworld* and *Troy Taken* at Delphi:

> In the lower part of the [Underworld] . . . Hektor is seated, clasping his left knee with both hands in an attitude of mourning [compare Fig. 52]. After him comes Memnon, seated on a rock, and then Sarpedon. Sarpedon buries his face in his hands, while Memnon places one hand on Sarpedon's shoulder . . . Above them is Paris, still beardless. He is clapping his hands like some rustic. You will say that Paris appears to be summoning Penthesileia by doing this. Penthesileia looks at Paris; she seems by the toss of her head to show her disdain and contempt for him . . . Above her are women who carry water in broken clay vessels.

At Athens, Polygnotos collaborated with Mikon and Pheidias's brother Panainos on the Painted Stoa in the Agora, a portico donated to the city by Kimon's brother Peisianax as a shady place for citizens to relax and talk. (Did Polygnotos's notorious affair with Kimon's sister Elpinike help him to get the commission?) Begun around 460, its paintings included an Amazonomachy and Sack of Troy bracketed by two contemporary subjects: a confrontation between the Athenians and Spartans at Oinoe and the Battle of Marathon.

Now Simonides had already used the Sack of Troy to eulogize the Greek dead at Plataia in 479, followed by the author of the Eion epigrams of 475, and mobilizing the Amazonomachy in such circumstances was a familiar tactic also (cf. Fig. 52). Vase-painters, too, had been picturing Greeks fighting Persians for a generation (see Fig. 25). But monumental, publicly displayed pictorial commemoration of such contemporary events was quite new, inaugurating the great Western tradition of history painting and its successor, the documentary photograph.

Pausanias's description of one section of the Marathon painting so closely recalls Fig. 52 as to raise the suspicion that the vase painter borrowed from the muralist:

> Here too is a depiction of the hero Marathon, after whom the plain is named; Theseus is represented rising out of the earth, and Athena and Herakles are here also. For Herakles was first declared a god by the Marathonians, as they themselves say. Of the combatants the most conspicuous are Kallimachos...

So whereas the *Oresteia* gives us six hours of high drama, vividly enacted and spectacularly staged (Aischylos was famous for his dazzling masks, costumes, and props), and psychological closure at the end, early classical narrative art offers somewhat different rewards. The temple of Zeus's eastern pediment (Figs. 42, 44), the "Prelude to Marathon" (Fig. 52), and the huge Polygnotan murals present(ed) either the moment before or after great dramatic events. This is when character (ēthos) is tested and best revealed, and feeling (pathos) is most intense.

The temple of Zeus's western pediment, the Niobid picture, and the two Oresteia pictures on the Boston krater (Figs. 40, 41, 45, 51), on the other hand, all carry scenes that could never be shown on stage, only narrated secondhand by messengers: The violent and bloody retribution visited on tyrants and criminals – all men of hybris – by the enforcers of justice, both human and divine. Framing the plays (which were rarely performed again until systematic revivals began in the fourth century), these works fixed their themes in the Greek imagination for as long as they lasted. The pots, often exported to Sicily and Italy, ended up in graves, but the murals survived till the fourth century A.D. and the Olympia marbles till the fifth, when Christian zealots finally pulled down the great temple, banned the Olympic games, and closed Zeus's sanctuary forever.

As for Aischylos, he died in Sicily in 456, only two years after his *Oresteia* premiered and won first prize. But his self-composed epitaph said nothing

about his plays at all. Instead, it singled out his proudest moment, that bloody but glorious summer's day at Marathon:

> Here Aischylos, Euphorion's son, of Athens, lies
>> Beneath this stone in Gela's wheat-lands, dead.
> The Marathonian grove his courage will declare,
>> Also the dread-locked Mede: he knows it well.

CHAPTER 3

THE CLASSICAL MOMENT

IMPERIAL ATHENS

By 450, the Delian League had become an Athenian empire, and the city was profiting handsomely from the transformation. Indeed, the glories of classical Athens – from the radical democracy to the Periklean building program – would have been unthinkable without it. For the city was now the largest, richest, and strongest in Greece [see Box 1. *How Many Athenians?*]. *The Stevedores*, a comedy by Hermippos, gloatingly listed the benefits:

> Silphium and hides from Kyrene, from Hellespont everything salted,
> From Thessaly sides of good beef, and wheat meal as fine as can be.
> And this from the land of Sitalkes – a pox for the Spartan foe!
> And these from Perdikkas's country – lies by the shipload or so!
> From Syracuse pigs and fine cheese, and Kerkyra her navy aboard:
> Because she won't make up her mind, destroy her, Poseidon my Lord!
> So far so good; next Egypt sends paper and sailcloth; Crete
> Best cypress wood for the shrines of the gods; Syria incense sweet;
> Libya ivory sells us, Euboia choice apples and pears;
> Dried fruits that flavor our dreams – these are the Rhodian wares;
> Phrygia sends us good slaves, Arkadia fighters for pay –
> Pagasai bondsmen branded, to keep them from running away.
> Paphlagonians succulent almonds, and chestnuts to flavor our feast;
> Phoenicians send rugs from the west, and dates and fine flour from
> the east.

Contrast the simple Spartan mug illustrated in Fig. 16, the Spartiates' daily diet of black gruel, and the clunking iron spits that still served as Sparta's only currency!

BOX 1. *HOW MANY ATHENIANS?*

Calculating the Athenian population is not easy, because Greek cities kept no accurate statistics. Fortunately, two fifth-century sources offer some help. Herodotos 9.28 tells us that 8,000 Athenian hoplites fought at Plataia in 479 and Thucydides 2.13 says that Athens could field no fewer than 29,000 hoplites in 431. The latter, however, included many resident aliens, who were often prosperous and also liable for the draft. Other (equally rough) criteria include the rule-of-thumb density of 150 persons per hectare (100 × 100 meters) accepted for ancient cities by many archaeologists and the number of councilors provided by the Athens conurbation (the city proper, its suburbs, Piraeus, Phaleron, and environs: see Map 3) as a proportion of the entire Council of Five Hundred.

Given these uncertainties, it is hardly surprising that estimates of the number of Athenian adult/citizen males in 431 vary considerably, from around 45,000 to around 60,000. Whichever figure one chooses (and I incline to the high one), by modern standards the *total* population of Attica was small: No more than 300–400,000, including women, children, resident aliens, and slaves. Because the Athens–Piraeus conurbation contributed 26 percent of the councilors, and the city proper contributed one-fifth of this group, up to 100,000 people could have lived in the former, and up to 20,000 of these within the city walls. (The habitable area inside the city walls was about 140 hectares, at 150 persons per hectare producing roughly the same total: i.e., 21,000.) The rest were scattered around Attica in smaller towns such as Acharnai, Eleusis, Rhamnous, Marathon, Thorikos (Fig. 18), and Sounion, or in the countryside itself. So the city proper probably contained somewhat fewer people than New York or Boston in 1776, and all of Attica about the same number as Las Vegas, St. Paul, Newark, or Oakland in the United States in 2000, Leicester or Cardiff in the United Kingdom, Canberra in Australia, or Christchurch in New Zealand.

In 454, the Athenians had moved the League treasury – a massive, accumulated surplus of 8,000 talents or over *two hundred tons* of silver – to the Akropolis, and in 450 they made peace with the Persians, cementing their hegemony over the Aegean and Ionia. The imperial tribute now reached 400 talents – ten tons of silver – annually, over and above the ore from their own mines at Laurion and (later) on the island of Thasos. Every summer it was solemnly paraded in the Theater of Dionysos at the beginning of the dramatic competitions, vividly reminding the massed spectators – both Athenian and foreign – of the city's power and wealth, its sources, and its benefits to the Athenians. And because they increasingly voted to spend this money on paying themselves to serve in the military, on juries, and as legislators, and

BOX 2. *THE PERIKLEAN BUILDING PROGRAM*

1. **Philochoros, *Attic History* fragment 121:** [In the year 438/37] the golden image of Athena was installed in the great temple, its gold weighing 44 talents; Perikles superintended it and Pheidias made it. And Pheidias the artist, accused of embezzling its ivory veneer, was found guilty; fleeing to Elis, he contracted to make the image of Olympian Zeus, and when he had completed it, he was killed by the Eleans.

2. **Plutarch, *Life of Perikles* 12–13:** But that which brought the most attractive adornment to Athens, and the greatest amazement to the rest of mankind – that which alone now bears witness that Greece's vaunted ancient power and splendor is no fiction – was his building program; and it was this that Perikles' opponents most maligned and slandered in the Assembly. They protested that the dēmos had been dishonored and brought into disrepute because it had removed the common fund of the Greeks from Delos into its own keeping. Moreover, the best of all excuses for doing so, namely, that the dēmos had moved this fund in fear of the barbarians and was now guarding it in a fortress – of this excuse too Perikles had robbed it. Indeed, surely Greece was now sorely insulted and openly tyrannized when it saw that the dēmos was gilding and prettifying the city with its compulsory exactions for the war, like some shameless hussy adorning herself with precious stones and thousand-talent statues and temples.

Perikles, however, used to instruct the dēmos that that it owed no account to the allies of their money if it prosecuted the war for them and kept the barbarians out. For the allies were not providing a single horse, ship, or hoplite, but just money alone; and this belongs not to the giver but to the recipient, provided that he renders the services thus paid for. And if the city was sufficiently equipped with everything required to prosecute the war, it could quite properly divert any surplus to projects that would bring both everlasting glory upon their completion, and real profit whilst under construction. For construction generates all sorts of work and all manner of demands which mobilize every skill and engage every hand, more or less turning the whole city into an employee, so that it both adorns itself and supports itself in the process.

Moreover, just as Perikles kept the manly and vigorous well supplied from the public coffers through his military adventures, so too did he also want the unsoldierly crowd of laborers and craftsmen to share in the wealth, but not to profit from being lazy and idle. So he boldly proposed to the dēmos projects for great constructions and plans that would engage many skills and take much time, so that no less than the sailors and sentinels and soldiers, these men too might have a reason to benefit and prosper from the public purse.

The materials to be used were stone, bronze, ivory, gold, ebony, and cypress-wood; the trades that would work them up and elaborate them were those of carpenter, molder, smith, stone-cutter, gold-and-ivory worker, painter, inlayer, and embosser, and of course the carriers and suppliers of these materials, such as traders, sailors, and helmsmen by sea, and wagon-makers, draymen, and drivers by land – yes, and ropemakers, weavers, leatherworkers, road-builders, and miners too. Each particular craft, like a general with his own army, had its own force of unskilled manual laborers, obeying it like an instrument obeys the player or a body obeys the mind, so that for virtually every age and capacity (so to speak), these requirements distributed and disseminated the surplus thus accrued.

And so the works arose, as towering in their grandeur as they were inimitable in their form and gracefulness, as the craftsmen competed to surpass each other in the beauty of their workmanship. But the most wonderful thing about them was their speed. Each one of them, people thought, would require many generations to complete, but all of them were finished in the zenith of one man's administration.[1] And yet they say that when Agatharchos the painter once was boasting about the speed and facility with which he painted his figures, Zeuxis replied, "Mine take, and last, a long time." And it is true that facility and speed in working do not make a work particularly profound or beautiful, whereas time invested in laborious creation pays great dividends in preserving the end result. For this reason Perikles's works are even more marvelous: they were created in a short time for all time. In its beauty, each one of them was then and at once antique, but in its vigor, each is even today fresh and newly made. A bloom of perpetual newness rests upon them, making them seem to be untouched by time, as if an unfaltering and ageless spirit dwelt in them.

Pheidias managed everything and was the overseer of all, though each project employed great architects and artists besides. Kallikrates and Iktinos built the Hekatompedon Parthenon; Koroibos began the construction of the Telesterion at Eleusis, erecting the columns and yoking them with architraves; but when he died, Metagenes of Xypete added the frieze and the upper colonnade; and Xenokles of Cholargos put the lantern over the shrine. Kallikrates was the contractor for the Long Wall, for which Sokrates says that he himself heard Perikles propose the motion. Kratinos pokes fun at this work's slow progress, thus:

> For a long time now, they say,
> Perikles has pushed this thing in words, but in fact has never budged it.

They say that the Odeion, with its many internal seats and columns, and a roof descending from a single peak, was an image and imitation of the Great

1 An exaggeration: some were unfinished at Perikles's death, and others not even begun until well after it.

King's tent,[2] and Perikles oversaw this too. Thus Kratinos, in his *Thracian Women*, pokes fun at him again:

> Here comes our squill-headed Zeus
> With the Odeion perched like a cap on his head,
> Now that the ostracism's been and gone.

Then Perikles, honor-struck as ever, first got a decree passed that made a musical contest part of the Panathenaic festival, got himself elected festival manager, and prescribed how the contestants played the flute, sang their songs, and strummed the kithara. These contests, both then and thereafter, were held in the Odeion.

The Propylaia of the Akropolis were completed in five years, with Mnesikles as the architect. An amazing thing happened while they were under construction, which indicated that the goddess was not standing idly aside, but was involved in both the work's inception and its completion. One of the most active and eager of the craftsmen slipped and fell from a great height, and lay there in agony, despaired of by the doctors. Perikles was most depressed at this, but the goddess appeared to him in a dream and prescribed a treatment, by which he quickly and easily healed the man. For this he set up the bronze statue of Athena Hygieia near the goddess's altar, which, they say, was already in place.

But it was Pheidias who produced the great golden image of the goddess, and he is duly credited as such on the stele. He controlled almost everything, and (as we have said) oversaw all the artists owing to his friendship with Perikles. This brought envy upon the one and slander upon the other, to the effect that Pheidias would make dates for Perikles with freeborn women who came to see the art.

on funding Perikles's building program (all else apart, a massive job-creation scheme: see Box 2. *The Periklean Building Program*), it created a need for continued imperial expansion that soon would spiral out of control. One of the great ironies of classical Greece is that cultured and cultivated Athens, not militaristic Sparta, was the aggressor most of the time. The Spartans preferred to stay at home.

Despite or perhaps because of the peace with Persia, war with the Peloponnesians continued, and soon began to go badly. In 446 the two sides, exhausted, signed a Thirty Years' Peace. It lasted for a mere fifteen, punctuated by a Samian revolt that Perikles crushed in 439 – expending a shocking 1,200 talents of imperial tribute to do so, most of it spent on paying the

2 I.e., Xerxes's tent, captured after the Battle of Plataia in 479; the ostracism that Kratinos
 mentions is that of Thucydides son of Melesias (i.e., not the great historian) in 443, the
 leading foe of the Periklean building program and its "thousand-talent temples."

fleet. In the late 430s, however, tensions rose again over the northern city of Potidaia, which though a Corinthian colony was a grudging, tribute-paying Athenian "ally."

One thing led to another. In 432, the Potidaians revolted, the Corinthians sent help, and the two sides clashed. The Peloponnesian League met in emergency session, and the Spartans, cautious as ever but increasingly alarmed at Athens' growing power and the consequent erosion of their own position, were persuaded to declare war. While the Spartans ravaged Attica but were foiled by the Long Walls (see Map 3) from taking the city, the Athenian fleet ravaged the Peloponnesian coast. (Did anyone at the time compare the conflict to one between an elephant and a whale?)

In late 431, at the end of the first year's fighting, Perikles delivered the customary public eulogy over the fallen. Thucydides uses it to present a full-dress synopsis of Athenian ideology, an encomium of the city's power and aspirations, and a highly idealized panegyric upon its democracy.

In it, "Athens is depicted as the one society where justice applies equally to all and where social restrictions do not prevent a man from becoming as great in public life as his natural capacity permits; submission to law and authority and acceptance of the dangers of war are maintained voluntarily, without force and without complaint; power and discipline are balanced by a free intellectual life and a buoyant spirit; the functioning of the society is open for all to see; neither secretiveness nor suspicion exist. Such a society, Perikles felt, was a paradigm for all societies, the 'school of Hellas'. If it controlled others, it did so by virtue of innate merit, and its subjects could therefore have no cause for complaint." Moreover, each Athenian citizen "is free and master of himself, courageous in war but easy in his private life, a democrat with the manners of a gentleman, a manly warrior with a taste for the finer things in life. [His] perfection is reflected in and proved by the perfection of Athens, which has left memorials of its power throughout the world, and whose daring spirit will be the wonder of future ages . . . The entire esthetic of the speech presupposes the leisure and breeding of the 'few' but generalizes those qualities to the [many]: they lead relaxed and easy lives, they love beauty and wisdom, their very excellence and freedom are bequests handed down from their noble ancestors."[3]

We shall revisit this speech often, for its sentiments resonate strongly with the artworks of the period and provide the surest key to them. Along with Sophokles's great "Ode to Man" in his tragedy *Antigone* (produced around 442), it catches a moment when, for the first time in Western history, a society exorcized the demons of doubt, however temporarily. Suggestively, Sophokles excludes the gods until the very end, as man alone proudly bestrides the earth:

> *First semichorus:*
> Wonders are many on earth, and the greatest of these
> Is man, who rides the ocean and makes his way
> Through the deeps, through wind-swept valleys of perilous seas
> That surge and sway.

3 Pollitt, *Art and Experience in Classical Greece* 68; Wohl, *Love Among the Ruins* 34, 36.

111

He is master of ageless earth, to his own will bending
The immortal mother of gods by the sweat of his brow
As year succeeds to year, with toil unending
 Of mule and plow.

Second semichorus:
 He is lord of all things living; birds of the air
Beasts of the field, all creatures of sea and land
He takes, cunningly to capture and ensnare
 With sleight of hand.
Hunting the savage beast from the upland rocks,
Taming the mountain monarch in his lair,
Teaching the wild horse and the roaming ox
 His yoke to bear.

First semichorus:
 The use of language, the wind-swift motion of brain
He learnt; found out the laws of living together
In cities, building him shelter against the rain
 And wintry weather.
There is nothing beyond his power. His subtlety
Survives all chance and conquers every threat.
For every ill he has found its remedy,
 Save only death.

Second semichorus:
 Wondrous are the arts of man, the craft that draws
Him to good or evil ways. Great honor is given
And power to him who upholds his country's laws
 And the justice of heaven.
But he that, too rashly daring, walks in sin
In solitary pride to his life's end,
At door of mine shall never enter in
 To call me friend.

So to quote the Nobel laureate Seamus Heaney, the Periklean Age was one of those rare moments "when hope and history rhyme." People felt that they could impose reason on the world and shape it according to their own desires, banishing tyranny, irrationality, and chaos over the horizon. For (as Perikles reminds the Athenians) they had created a truly model city, and, although their grandfathers and fathers, respectively, had freed it from tyranny and created the Empire, "we ourselves here today, most of us in the prime of life, have both augmented its power and provided it with the resources to be self-sufficient in both peace and war." Athens was Greece's "it" city and the Athenians were Greece's "now" generation. Their horizons were limitless.

But immediately after Perikles quits the podium, Thucydides returns to the war, and, in a classic demonstration of the tragic cliché that pride comes before a fall, bluntly informs us that a few months later, "the Peloponnesians again invaded Attica . . . and set about devastating it, . . . but they had not spent many days there when plague broke out among the Athenians." In 450, however, these disasters were far in the future.

ITINERANT INTELLECTUALS

By 450, as mentioned above, Athens had become the "it" city of the Mediterranean, and thus of the Western world – a role that in time would pass to Alexandria (see Fig. 161), and thence to Rome, Byzantium, Florence, Venice, Paris, and New York. It had become a magnet not only for foreign merchants and artisans, but also for foreign intellectuals. (Its lone native thinker was Sokrates, born in 469, but he began teaching only just before the Peloponnesian War.) First to arrive were Parmenides of Elea (ca. 510–440), Anaxagoras of Klazomenai (ca. 500–428), and Protagoras of Abdera (ca. 490–20). Though Parmenides and Anaxagoras were natural philosophers in a tradition that reached back into the sixth century, Protagoras was quite different, as we shall see. Even so, the interests of all of them coincide in important respects with ours.

Parmenides visited Athens only once, in the 440s. His ideas are hard to summarize, but basically he thought that ordinary beliefs are fallacious (his "Way of Seeming") and that the only true subject of language and of thought is "without birth or death, whole, single natured, steadfast, and complete" (his "Way of Being" or "Way of Truth"). He stands for a persistent current of Greek thought (famously exemplified a century later by Plato) that favored an adamantine, unchanging reality behind the chaotic flux of appearance. In their own ways, Libon's Temple of Zeus (Fig. 42) and – as we shall see – Polykleitos's Doryphoros (see Figs. 71 and 72) both follow this categorically ideal path.

By contrast, Anaxagoras and Protagoras argued for plurality and change. Both of them lived for long periods in Athens and both were friends of Perikles. A natural philosopher like Parmenides, Anaxagoras wrote only one major book, on the cosmos (all of it!), which by the time of Sokrates' trial in 399 could be bought in the Agora for a mere drachma – the sad fate of most scholarship! Sidelining the Olympians, he taught that Mind created and controlled everything, causing a rotation that "separated off" the different kinds of matter from a primordial soup. His contention that "phenomena are a sight of the unseen" invited one to look for hidden structures and meanings in the world. Prosecuted for impiety in 436, he spent his last years in exile. (Athenian tolerance had its limits, especially on the religious front – as Sokrates himself was soon to find out.) We shall meet Anaxagoras again apropos the Parthenon sculptures, and writing on the subject of perspective (see Fig. 108).

Protagoras, on the other hand, was a new-style Greek intellectual: one of those itinerant self-made teachers nicknamed the Sophists or "Wise guys." Products of the new spirit of unfettered inquiry that had begun to pervade Greece, they took nothing for granted, were skeptical about religion, questioned traditional wisdom, and charged lecture fees that were often exorbitant. (In *Meno* 91D, Plato remarks that Protagoras was richer even than Pheidias and ten other sculptors put together!) They were relativists, united only by their conviction that human perception was the sole guide to reality and human experience the sole basis for constructing society. So much for the

age-old Greek quest for certainty, for a transcendent order (*kosmos*) that governed everything!

Disturbing and destabilizing, the Sophists tended to become more and more radical as the century wore on and new arrivals on the scene jostled for attention. Many of them, including Protagoras, wrote manuals – called *technai* – publicizing their methods. They had their greatest effect upon the young – the generation that came of age in the Peloponnesian War. Needless to say, they were banned from Sparta.

Protagoras himself argued that "man is the measure of all things," that is, that all appearances and beliefs are true for the person who experiences or holds them. (So much for Parmenides!) He also proposed a theory of social evolution based on the discovery and gradual refinement of human skills (technai); this shrewd idea may lie behind Sophokles' great "Hymn to Man" quoted above. The high priest of anthropocentrism and social relativism, he created a revolution in Greek thought. Could it be (as the German philosopher Friedrich Nietzsche later put it) that "there are no facts, only interpretations"? That all universals are only illusions and human law only a convention (*nomos*), not derived from nature (*physis*)? And that one's subjective perceptions and feelings are the only basis for judgment and furnish the only standard of behavior?

Even though in the end Protagoras tended to favor a somewhat bland conventionalism, all this was still deeply distressing. Sokrates (see Fig. 132), of course, fought mightily against it, as did Plato (see Fig. 133), who even wrote a dialogue about an encounter between Sokrates and Protagoras that ends more-or-less in a draw. Yet even so, it was Sokrates that Aristophanes famously – and unfairly – parodied as the prototypical sophist in his *Clouds* of 423.

But nothing comes from nothing. As the previous chapters have shown, Greek painters had followed this path for some time, taking the observer's own subjective experience as the measure of pictorial verisimilitude (see, e.g., the foreshortenings of Figs. 8 and 17 and the bird's-eye perspective of Figs. 39, 51, and 52). Unfortunately, whether Protagoras knew about these developments and, if so, what he thought about them remains a mystery, because no writings of his survive. Asked by Perikles to write a constitution for his colony at Thurioi in 443, he too was prosecuted later for impiety, this time because of his agnosticism.

These three approaches to the phenomenal world, then, all were rooted in earlier Greek attitudes to it, and in popular form were widely shared. As such, they help to illuminate and clarify the main concerns of classical Greek artists. These tended to be categorical idealists like Parmenides or, starting from the sensible world like Protagoras, either idealized it on an ad hoc basis; tried to render it in nuts-and-bolts fashion, particular by particular (realism); and/or probed it for hidden meanings (Anaxagoras's "phenomena as a sight of the unseen"). Of course, all these approaches were merely different forms of representational Truth, which was turning out to be just as slippery a concept in art as in philosophy.

Reaction in the street to such ruminations was predictable (Fig. 53). Like the emaciated, barefooted egghead illustrated here (one of these itinerant

53. Caricature perhaps of a philosopher. Detail of an Athenian red-figure oil flask (*askos*) from Italy, ca. 440. Ht. 7 cm (2.75″). Formerly Paris, Louvre; stolen apparently in the 1990s.

thinkers?), Sokrates too could stand still for hours, contemplating a philosophical problem. This fellow's staff and cloak mark him as a free man, and his grotesquely swollen skull seems about to burst with all the profound ideas fermenting away inside it. Compare Aristophanes's parody of Sokrates and his ilk in the *Clouds*:

> PHEIDIPPIDES: Who're they?
> STREPSIADES: I don't quite know but they're deep
> Analytical thinkers and of course
> Real gentlemen –
> PHEIDIPPIDES: Bah! Stinkers!
> I know that lot: barefaced, whey-faced,
> Barefoot, big mouths – that lousy Sokrates
> And Chairephon.
> . . .
> CHORUS: We welcome you, old veteran – one of the Old School
> Seeking for wisdom among the words of the new!
> And you, Sokrates, high priest of the subtlest rubbish,
> Tell us your desires. Of all the windbags
> Of the present day, it is to you we listen
> For your wisdom and learning – you who go strutting
> Barefoot along the street, your eyes darting.

The dēmos's own self-image was quite different, as we shall see.

...AND SOVEREIGN DĒMOS

In 462, Athens had become a radical democracy. Perikles's Funeral Speech and the Attic comic poets show that the dēmos now saw itself as a new aristocracy. An elite sprung from Attica's very soil, it thought itself to be uniquely qualified by its intelligence, boldness, and incomparable achievements to rule the city and to lead the world.

This is one reason that, instead of extending their citizenship to their allies and subjects, as (later) the Romans did, the Athenians actually restricted it. In 451, "because of the multitude of citizens," Perikles pushed through a law that "no-one should share in the city who was not born of native Athenians on both sides." His wording speaks volumes. Athens was an exclusive club for the privileged: A *birth elite*, as anthropologists call it. Everyone was welcome to contribute to the city's prosperity, but only the hereditary in-group – the sovereign dēmos – could enjoy its full range of benefits. Yet foreigners (both Greek and non-Greek or 'barbarian') were flocking to it in droves, lured by its mushrooming prosperity. Intermarriage was expanding the in-group to an unacceptable degree, threatening to dilute those innate qualities that had made it great in the first place. If this law had existed in the 480s, it would have left both Themistokles and Kimon, whose mothers were Thracian "barbarians," out in the cold.

This Athenian project of self-ennoblement, clearly visible in Perikles' Funeral Speech, sheds new light on that most brilliant and enigmatic of classical Athenian monuments, the Parthenon and its sculptured Ionic frieze (Figs. 54, 55). It now seems that this key component of imperial Athens's most lavish and impressive temple was – amazingly – an afterthought. Although the dēmos authorized the Parthenon in 449 and building began in 447, major modifications occurred during construction. Their most obvious legacy is the series of stone pegboards (the so-called *regula* and *guttae*) above the eastern and western architraves of the interior porches, directly below the frieze. Fossils from the time when Doric temples were wooden and triglyphs were pegged to the architrave's crowning fascia, they make sense only if a Doric frieze was originally planned to go here, not the continuous Ionic one now extant.

Why make this disruptive and expensive change? The frieze's most conspicuous participants, accounting for over a third of its figures and about half its length, are the famous horsemen (Figs. 54, 55). Yet even though Athena supposedly had invented the bit and bridle, cavalry played a distinctly subordinate role to hoplites both in the Athenian army and in the great Panathenaic procession that quadrennially honored Athena with a new robe. This procession is still the frieze's most likely subject, because its eastern side features just such a ceremony, robe included.

Moreover, although the hoplite battalions marched in the Panathenaia, in the frieze they are nowhere to be found. Their total eclipse by the comparatively insignificant cavalry suggests a particular agenda at work, and a plausible motive for it has been found in Perikles's reform of the Athenian

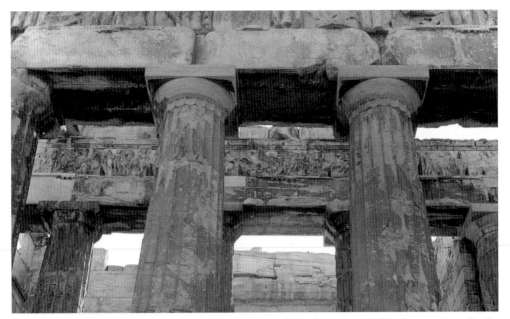

54. Detail of the west façade of the Parthenon, ca. 447–38. The Ionic frieze and its horsemen are (just) visible intermittently between the columns; in the 1990s they were removed and replaced with concrete casts. Note the Doric regula and guttae (pegs) immediately below the horsemen: fossils of a planned *Doric* frieze?

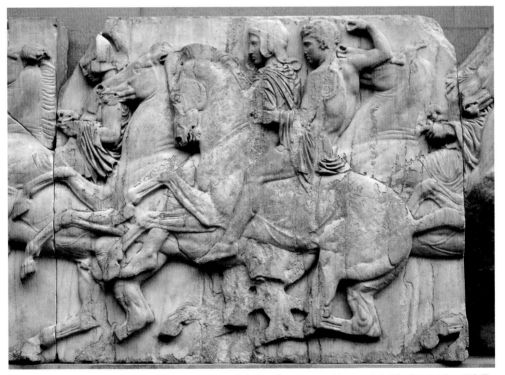

55. The Athenian cavalry in procession. Frieze of the Parthenon, ca. 442–38. Marble, ht. 1.06 m (3′6″). London, British Museum. The occasion is probably the festival of the Greater Panathenaia.

cavalry corps. This reform occurred between 445 and 431, probably after the series of humiliating defeats of 447–6. As (yet another) explanation for such a stunning display of sculptural virtuosity, it may seem at first sight to be thuddingly banal, but (as so often in classical Greece) there is more to it than meets the eye.

For Perikles not only increased the cavalry's enrollment to 1,000 from a mere 300 and added a squadron of 200 mounted archers, but also partially democratized it. Formerly the preserve of the rich (who alone could afford to keep horses) and a bastion of aristocratic snobbery, in theory it was now open to any qualified citizen, for the state now provided a loan for a horse and a food allowance for both it and the applicant if necessary. So whereas on the archaic Akropolis, equestrian statues had been the aristocratic dedications of choice (for nothing so elevates one as riding while others have to walk), the frieze announced, somewhat optimistically, that every Athenian was now an aristocrat, either actually or potentially. Graven in stone around Athena's greatest temple atop her holy rock, it both set the seal on the dēmos's project of self-ennoblement and concretely fulfilled Perikles' promise to them: "So far as it is within my power, you will live forever and be immortal."

PERIKLES *MONARCHOS*?

All Athenian magistracies rotated annually, and many were filled by lot, on the theory that any citizen could perform them. Yet one major group was still elected, for obvious reasons: the generals. Ten of them, chosen annually, ran the army and navy, and as a result this office now became the supreme prize in the ferociously competitive world of Athenian politics. Perikles held it often after 462 and continuously from 443, when his last major opponent was ostracized, until 430, when resentment at his conduct of the Peloponnesian War drove him briefly from office. Reelected in 429, he died soon after of the plague. In a revealing eulogy, Thucydides tells us that

> Because of his position, his intelligence, and his known integrity, he could respect the liberty of the people and at the same time hold them in check. It was he who led them, rather than they who led him, and, since he never sought power for the wrong reasons, he had no need to flatter them. In fact, he was so highly respected that he could scold and contradict them. When he saw that their self-confidence was pushing them too far, he would remind them of the dangers that threatened them; and when they were discouraged for no good reason he would restore their confidence. So in what was nominally a democracy, power was actually in the hands of the first citizen.

Predictably, then, anxieties about leadership and the lurking specter of tyranny grew considerably during Perikles' ascendancy. His critics called him "The Olympian" and compared him (unfavorably) to Zeus. Intrusive measures such as his Citizenship Law also sharpened debate over another old concern

of Athenian politics: the boundary between public and private, city and family, state and kin, polis and oikos. Sophokles' *Antigone* of ca. 440, Perikles's own portrait (Fig. 56), and a series of Attic vase paintings all address these issues in their own particular ways.

We have encountered the *Antigone* already, via Sophokles' great Ode to Man. This glorious poem, quoted above, is embedded in a tragedy that has been more potent politically than any other (see Box 3. *Sophokles's* Antigone). Its legacy ranges from rival ancient endorsements of its protagonists' competing views, through modern versions inspired by Nazism, Vietnam, Northern Ireland, postcommunist Eastern Europe, and feminism, to several classic movies.

Perhaps reflecting on Perikles's rise to power (the Theban ruler, Kreon, is introduced as "general," and to fifth-century Athenians much of what he says about consultation, conspiracy, anarchy, law, and the public good would have been unexceptionable), the play examines the perils of political preeminence in a sophisticated and powerful urban society. It shows what can happen to both city and family when leadership forgets its roots and turns authoritarian – when it becomes, in fact, a tyranny.

When is it right to suppress or limit free speech? When to command and when to listen? When to make a stand and when to be flexible? When to invade someone's privacy and when to back off? When to prefer human law to natural – even divine – law? "The right stuff," it reminds us, is a two-edged sword that may help or harm the community that helped to forge it. Like Kreon, Perikles too was accused of tyrannical aspirations and behavior. Fortunately, he kept to the straight and narrow, but for his successors the tragedian's warnings would prove prophetic.

Perikles's portrait (Fig. 56) participates in the same discourse and negotiates the same tricky terrain. The image that survives today in a handful of Roman marble copies (two of them inscribed with his name) is probably the one erected on the Akropolis soon after his death by his only son to survive the plague, also named Perikles. Made by Kresilas, it shows him in his role as general, wearing the venerable but now obsolete Corinthian-type helmet on his head. Kresilas's original bronze must have been full-length, slightly over life size, probably naked but for a cloak, and equipped with spear and shield.

Compared with the Themistokles (Fig. 37), Perikles looks bland and barely individual – hardly the ambitious politician and dashing soldier of Athenian history. Suggestively, a similar head type recurs on the Parthenon frieze and on late fifth-century Athenian gravestones. Its carefully styled, U-shaped beard, well-coiffed hair, understated modeling, regular yet emphatic features, slightly open mouth, averted gaze, sober expression, and gentle movement radiate good breeding and self-control. An icon of prudence, the very type of the perfect citizen-soldier, it tactfully negotiates the dilemma of leadership in a radically egalitarian society: a necessary evil, indispensable to the city's welfare but a magnet for suspicion and distrust, for accusations of tyranny. And the ever-politic Perikles almost certainly did not dedicate it himself.

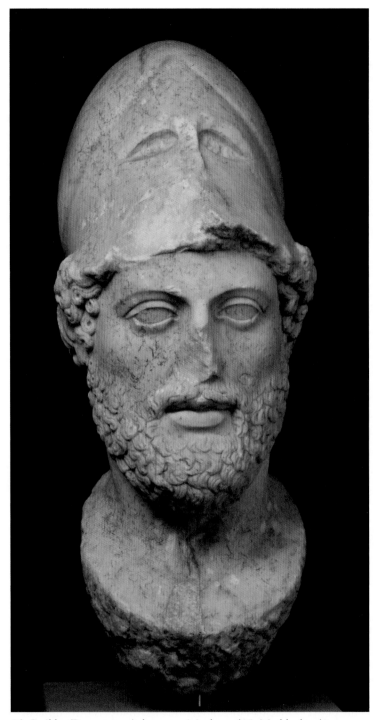

56. Perikles (Roman copy); bronze original, ca. 425. Marble; ht. 48 cm (1'7"). Berlin, Staatliche Museen. Excerpted from a full-length bronze statue, which probably stood on a statue-base found on the Akropolis that was dedicated by his sons and signed by the sculptor Kresilas.

BOX 3. *SOPHOKLES'S* ANTIGONE

The ill-fated marriage between Oedipus and his mother Jocasta had produced two brothers, Eteokles and Polyneikes, and two sisters, Antigone and Ismene. When Eteokles became ruler of Thebes, Polyneikes promptly raised an army in Argos to overthrow him. After the two brothers killed each other in the battle, Kreon took over the city. He decreed that the patriotic Eteokles should have a noble funeral, but that the traitor Polyneikes should lie unburied for dogs and birds to eat. Anyone defying this decree would be stoned to death.

The play begins with an explosive exchange between the sisters. Antigone resolves to bury her brother regardless of Kreon's decree, Ismene advises obedience to it, and the two part in anger. Kreon then enters and acquaints the chorus (the Theban elders) with his decree, emphasizing that although the just ruler must be a good listener, the city's needs come first and obedience to them is mandatory. A sentry then announces that someone has sprinkled dust on the body, technically giving it burial. Kreon, enraged, suspects a plot by his political opponents. The famous Ode to Man then follows (see the beginning of this chapter), climaxing in a contrast between the perfect citizen, at the apex of human development, and the anticitizen, the city's bane. Why does one man choose one fork in the road, another the other?

The sentry returns with Antigone, caught red-handed anointing Eteokles' corpse. Matters then degenerate into an irresolvable and increasingly bitter conflict between law and custom, politics and kinship, and city and family. By the play's end, Antigone is dead, Kreon's wife Eurydike and his son Haimon (who is secretly in love with Antigone) have committed suicide, and the increasingly tyrannical and rigid Kreon is a broken man, all because he has stuck to his principles and refused to listen to anyone, including the old seer Teiresias. Only the chorus remains on stage, lamenting the fate of city and family, and concluding that

> Of happiness the crown
> And chiefest part
> Is wisdom, and to hold
> The gods in awe. This is the law
> That seeing the stricken heart
> Of pride brought down,
> We learn when we are old.

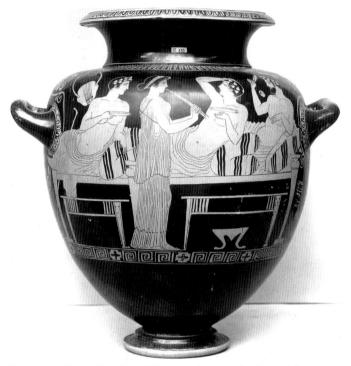

57. Symposion, with a flutegirl in attendance. Athenian red-figure stamnos from Vulci (Italy) attributed to the Peleus Painter, ca. 440–30. Ht. 39 cm (1′3″). London, British Museum.

His Roman-period biographer Plutarch explains further:

From [his study of philosophy] Perikles derived not only a dignity of spirit and nobility of utterance which was entirely free from the vulgar and unscrupulous buffooneries of mob-oratory, but also a composure of countenance that never dissolved into laughter, a serenity in his movements and in the graceful arrangement of his dress which nothing could disturb while he was speaking, a firm and evenly modulated voice, and other characteristics of the same kind which deeply impressed his audience.

In addition, Perikles stopped attending exclusive dinners and symposia (a populist move); kept his friendships with Anaxagoras, Protagoras, and other controversial figures quiet; limited his public appearances; and even refused to acknowledge or respond to abuse – a stance hitherto unthinkable for a member of the elite. Although no one believes today that philosophical rumination inspired this almost puritanical self-stylization, Thucydides and the jibes of the comic poets certify it as historical. Like the portrait in Fig. 56, it was political through and through. It cast Perikles as *the* model citizen: mature, noble, handsome, dignified, incorruptible, wise, prudent, eloquent, patriotic, public-spirited, egalitarian, and bold in the formulation of policy and courageous in its execution. (Notice how much more succinctly, efficiently, subtly,

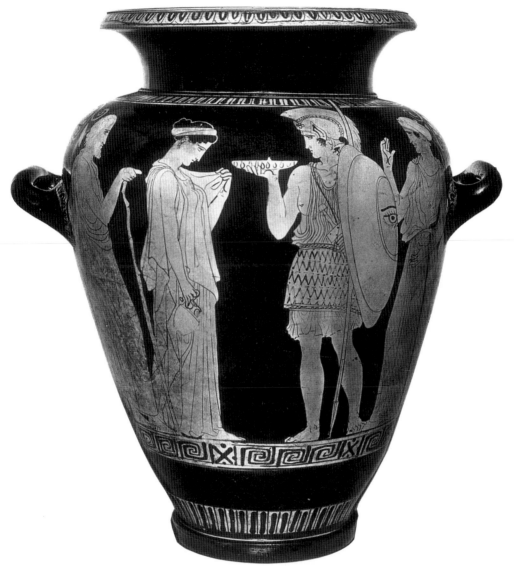

58. Warrior leaving home. Detail of an Athenian red-figure wine jar (stamnos) from Vulci (Italy) attributed to the Kleophon Painter, ca. 430. Ht. 43.5 cm (1′5″). Munich, Antikensammlung.

and persuasively art expresses all this.) He and his portrait personally exemplify the perfect Athenian of his Funeral Speech.

To judge from Plutarch's biographies of Kimon and other pre-Periklean politicians, and from the numerous early classical vases that show gods and heroes behaving in precisely this way, this ideal was basically aristocratic. Yet the many vases that show ordinary Athenians also behaving thus, even at parties (Fig. 57) or in moments of great stress (Fig. 58), indicate that by the midcentury it had become an Athenian social norm, integral to the dēmos's gradual climb to self-ennoblement – though how many people paid

it more than lip service is of course unknowable. The rambunctious scenes and characters of Attic comedy suggest that everyday reality was often quite different.

POLIS AND OIKOS

The scene in Fig. 58, an Athenian soldier departing for war, strongly recalls heroic departure scenes such as Euthymides's (Fig. 10). Implicitly heroizing the young man and his family, it vividly illustrates the classical city's wrenching intrusion into its citizens' private lives. These intrusions became depressingly frequent as the century wore on and Athenians were mobilized year after year to campaign not merely in Greece but in places as remote as Cyprus, Palestine, Egypt, and Sicily. A casualty list of 458 furnishes stark testimony to the appalling human cost of empire:

> Of the Erechtheid tribe,
> These are the men who died in the war, in Cyprus, in Egypt, in Phoenicia, at
> Halieis, in Aigina, and at Megara, in the same year . . .

No fewer than 177 names follow, and no fewer than nine more lists, one for each remaining tribe, must have been set up alongside this one.

As we have seen, this tension between polis and oikos, city and family, state and kin, public and private, reaches back into the archaic period. Resolved in drastic fashion at Sparta, it became particularly acute in fifth-century Athens, where the collective now dominated all aspects of life and increasingly asserted control over matters hitherto considered private – such as memorializing the dead (see Chapter 1, Fig. 13). It also largely drives the plot of *Antigone*. As Attic dramatists often do, Sophokles explores an extreme case. With all the males of her family now dead, Antigone – a woman excluded from politics by her gender and from society by her incestuous birth – asserts her right and duty to bury her brother regardless of his treason, and duly pays the price.

Figure 58 – the call to arms and the family's response to it – could almost serve as Sophokles' prologue but for its obviously Athenian setting. The old father, on the left, is probably a veteran of the Persian Wars; the beautiful, demure, dutiful wife unveils herself to her husband one last time as she holds the libation jug; and the young, strapping, handsome hoplite piously holds the ritual libation bowl. Everyone seems calm and stoical, almost eerily so. The woman on the right, however, gestures wildly, channeling and externalizing the pent-up emotions of the others. Is she the soldier's mother, his sister, or even his slave? Her headgear might suggest the last (compare the slave-girl at the left of Fig. 80), but the painter leaves her exact status open. Her function, though, is clear. She is a one-woman tragic chorus.

In a rare congruence of artistic and sociopolitical ideals – a rare unanimity of discourse – this clay pot's simple elegance and moving theme find exact

echoes in Perikles's Funeral Speech. In his glitteringly idealized description of Athens, he notes that "we love beauty with frugality . . . and in our own homes we find a beauty and a good taste which delight us every day and which drive away our cares." Yet the Athenians are no stay-at-home aesthetes: "We are capable at the same time of taking risks and of estimating them beforehand. Others are brave out of ignorance; and when they stop to think, they begin to fear. But the man who can most truly be accounted brave is he who best knows the meaning of what is sweet in life and what is terrible, and then goes out undeterred to meet what is to come."

THE PERIKLEAN BUILDING PROGRAM

Yet despite Athens's impressive power and far-flung imperial reach, in 450 its citadel and religious hub, the Akropolis, was still largely a mass of ruins. True, its north wall had been rebuilt to display the vandalized remains of the Old Temple of Athena and the Older Parthenon (unfinished in 480), and a new south wall (a massive enterprise funded by Kimon from Persian spoils) was also well advanced. On the summit, this loot also had financed a great bronze Athena by Pheidias (the so-called Athena Promachos), carefully positioned to face the island of Salamis, the site of the great victory of 480; a small new home for the city-goddess, Athena Polias, had been built beside the destroyed Old Temple (technically respecting the Plataian Oath, if this is authentic – see Chapter 2); and some minor shrines had been patched up and dedications made. Moreover, in 454 the Athenians moved the League treasury there from Delos. But they had rebuilt none of the major temples and other buildings, which were still as ruinous as in 479.

In 449, Perikles persuaded the dēmos to rectify this situation. The details of his proposal are obscure, and he cannot have initiated or superintended every project (many of them postdated his death in 429), but the results are not in dispute. Between 449 and Athens's surrender to Sparta in 404, dozens of major buildings were voted, funded, and built, not just on the Akropolis but also in the city and the Attic countryside. Beginning with the Parthenon (Figs. 59–70) and its counterpart at Eleusis, Demeter's great cult hall or *Telesterion*, they included temples, altars, porticoes, auditoria, theaters, gateways, storehouses, arsenals, forts, and even roads and bridges. Plutarch gives a stirring description of it all in his biography of Perikles (see Box 2. *The Periklean Building Program*); the buildings themselves and their inscribed authorization decrees and financial accounts furnish the rest. The Athenians had begun to divert one-sixtieth of the imperial tribute to Athena in 454, and Perikles now used this money to help fund the building program. The opposition accused him of "decking the city out like a harlot," but collapsed when he succeeded in getting its leader ostracized in 443.

Greek states had embarked upon building programs before, but Perikles's was unprecedented both in scope and thrust. Uniquely, too, it was the brainchild of a democracy, not a monarchy, tyranny, or aristocracy. Most of

PLAN OF THE CLASSICAL AKROPOLIS

1. West ascent	12. Trojan Horse
2. Terrace to the West of the Propylaia	13. Terrace of the Artemis Brauroneia precinct
3. Pinokotheke	14. Buildings of the Artemis Brauronia precinct
4. Unfinished North wing	15. Stoa(?) of the Arrephoreion
5. 'North-west Building'	16. House of the Arrephoroi
6. Temple and altar of Athena Nike	17. Terrace of the Arrephoreion
7. South-west wing	18. Athena Promachos
8. Propylaia	19. Quadriga
9. Propylaia East porch	20. Propylon of the South-east precinct
10. Athena Hygeia	
11. Athena Hygeia altar	
21. Chalkotheke	31. Zeus Poleius precinct
22. Terrace of the Chalkotheke	32. Shrine of Zeus
23. Votive Bull of the Areopagos	33. Temple of Zeus and altar
24. Terrace of the Old Temple of Athena	34. Terrace of the Parthenon
25. Old Temple of Athena	35. Propylon of the South-east precinct
26. Stoa of the Pandrosos shrine	36. North-east precinct (Shrine of Pandion?)
27. Erechtheion	37. Terrace of the South-east precinct (of Pandion?)
28. Altar of Athena	38. Expansion of the Kimonian Wall
29. Naiskos and altar of Athena Ergane	
30. Parthenon	

59. Plan of the classical Akropolis, ca. 400.

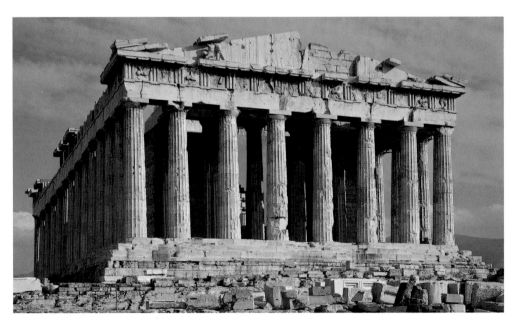

60. The Parthenon on the Athenian Akropolis, by Iktinos, Kallikrates, and Karpion, 447–32. Marble; preserved ht. 19 m (62′4″). The photograph is taken from the west. From this vantage point the following sculptures would have been wholly or partially visible: its floral and figural akroteria; the contest between Athena and Poseidon for the land of Attica, in its west pediment; the Amazonomachy, in its west metopes; the Sack of Troy, in its north metopes; and the procession (probably the Greater Panathenaic festival), in its Ionic frieze.

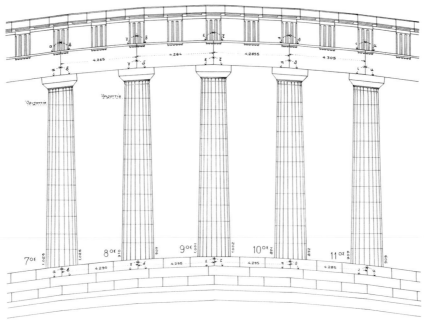

61. The Parthenon, as shown in Fig. 60. Exaggerated drawing of the façade showing curvatures and column inclinations.

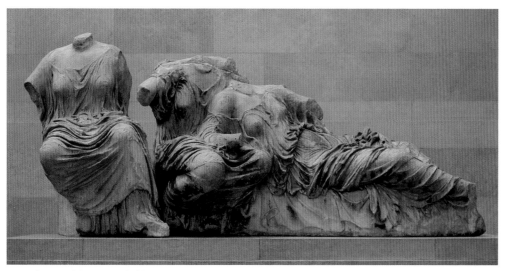

62. Three goddesses, probably Hestia, Dione or Themis, and Aphrodite, from the east pediment of the Parthenon, 438–32. Marble; ht. of Hestia, 1.73 m (5′8″). London, British Museum.

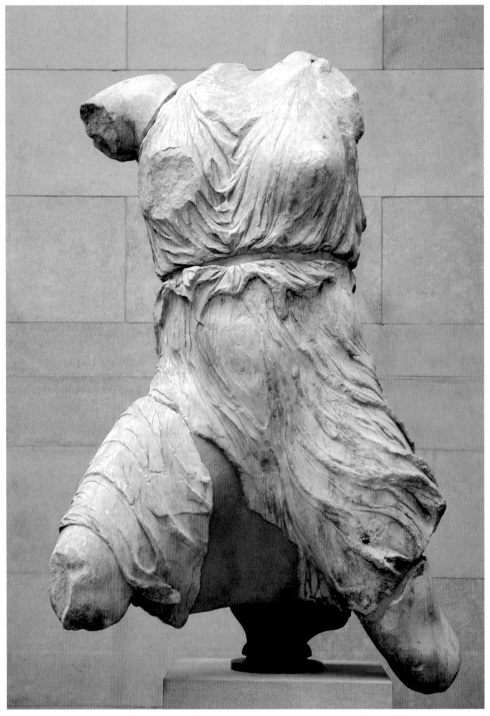

63. Iris, from the west pediment of the Parthenon, 438–32. Marble; ht. 1.35 m (4′5″). London, British Museum. Two gilded bronze wings once were attached to her back.

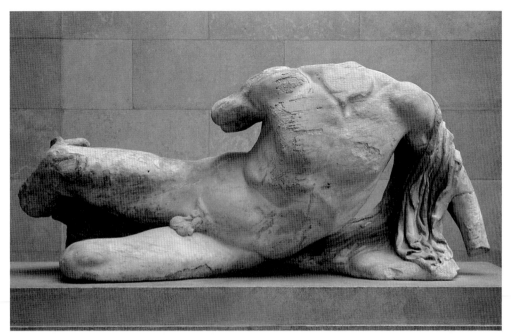

64. The River Ilissos (?), from the west pediment of the Parthenon, 438–32. London, British Museum. Marble; ht. 1.56 m (5′1″).

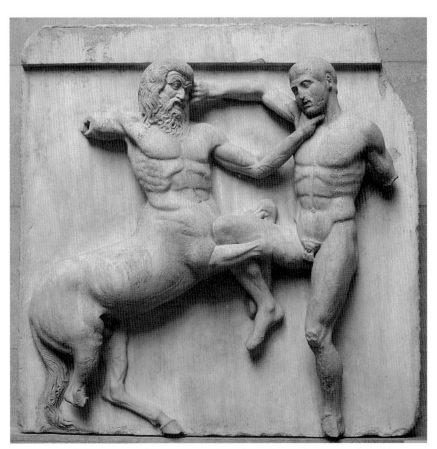

65. Centaur fighting a Lapith, metope south 31 from the Parthenon, ca. 447–442. Marble; height 1.33 m (4′5″). London, British Museum.

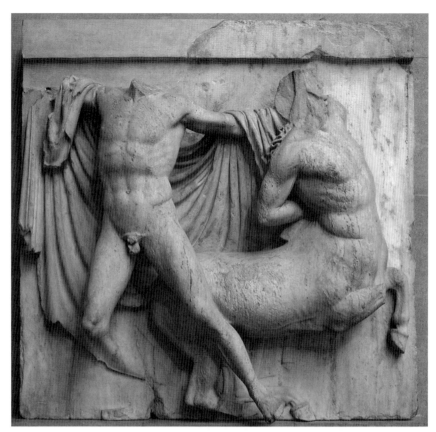

66. Centaur fighting a Lapith (Theseus?), metope south 27 from the Parthenon, ca. 447–2. Marble; ht. 1.37 m (4′5″). London, British Museum.

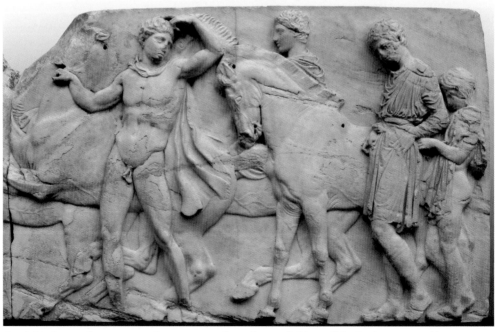

67. Athenian cavalrymen preparing to mount, from the north frieze of the Parthenon, ca. 442–38. Marble; ht. 1.06 m (3′6″). London, British Museum.

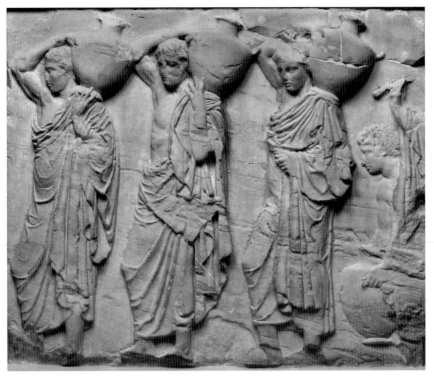

68. Youths carrying jars (hydriai), from the north frieze of the Parthenon, ca. 442–38. Marble, ht. 1.06 m (3′6″). Athens, Akropolis Museum.

the major buildings replaced ones destroyed by the Persians, and many were thank-offerings to the gods, especially Athena, for the victories over this barbarian foe. Since these victories and Athens's subsequent rise to preeminence had massively validated the hybris–nemesis cycle, this program both repaid the Olympians in kind and blatantly petitioned them for more. Like the mythical Ikaros, the Athenians were flying closer and closer to the sun, and they knew it. Only the gods could avert disaster.

Moreover, the whole enterprise was an awesome demonstration of Athenian power and technē, of the imperial city's control of unprecedented resources of men, money, materials, and skill. It thereby implicitly put the niggardly, philistine Spartans firmly in their place. As Thucydides shrewdly remarked, "If Sparta were to become deserted and only the temples and foundations of buildings remained, future generations would find it very difficult to believe that the place really had been as powerful as it was said to be . . . Yet if the same thing were to happen to Athens, one would think from its visible remains that the city had been twice as powerful as in fact it is."

On the Akropolis, Persian sacrilege and its outcome were memorialized in four key ways. The vandalized ruins became a yardstick for the structures that replaced them; they were incorporated physically into the latter; these replacements were declared to be dedications from Persian spoils, regardless of

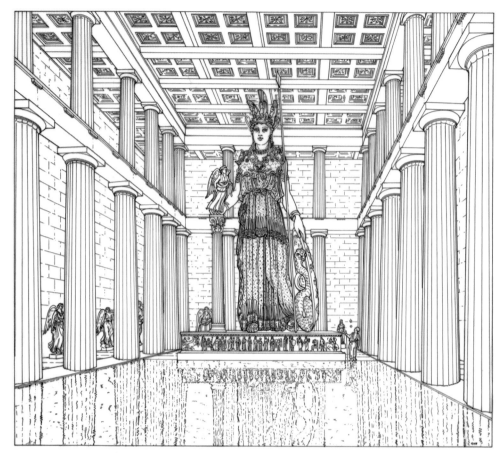

69. Reconstruction of the Athena Parthenos in the cella of the Parthenon, by Pheidias of Athens, 447–38. Gold plate, ivory, and other precious materials over a wooden core; original ht. ca. 11.5 m (37'7"); of the room, 13 m (42'7'). Athena's base showed the Birth of Pandora, her sandals the Centauromachy, and her shield the Amazonomachy (on the exterior) and Gigantomachy (on the interior). The water basin and column are late fifth-century additions, in order to humidify the statue and to support the weight of the Nike in her right hand.

their actual contribution to the budget; and the victories of the Persian Wars were evoked, directly and indirectly, throughout the sanctuary's sculptural program.

The ruins of the Old Temple of Athena, the former home of Athens's holiest icon, the goddess's ancient olivewood statue, provided the fulcrum of the entire scheme (Fig. 59). We have already noted the incorporation of parts of its Doric order into the citadel's new north wall. Whether its rear chamber was actually restored to serve as a state treasury or not (the evidence is ambiguous), the width of its platform or stylobate on its short eastern and western sides, 21.3 m or 72 Attic feet, was used as a starting point or *module* for some of the new buildings' own dimensions and even their siting. Its massive

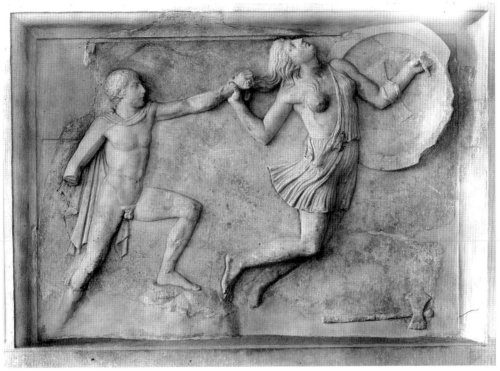

70. Athenian chasing an Amazon (Roman copy), after the shield of Athena Parthenos, Fig. 69. Marble; ht. 90 cm (2′11″). Piraeus Museum.

foundations, several courses tall, crowned the imposing archaic terrace that faced one as one emerged from the Propylaia.

This 72-foot module determined the widths of the Parthenon's main room, the Propylaia's east and west porches, the Erechtheion's entire western side, and the length of its cella. Moreover, the Erechtheion and Parthenon are two modules apart at their nearest point; the Parthenon's western terrace lies one module to the east of the Propylaia's projected central axis; and the shrine of Kekrops (an extension of the Erechtheion's western side) is four modules distant from the Propylaia's east porch.[4] According to the same theory that governed sculptural proportions (see Fig. 22), visitors would intuitively recognize these correspondences and subconsciously grasp the relationships among these splendid new buildings and their ultimate dependence upon the destroyed Old Temple.

4 The Athena Promachos does not fit this scheme, presumably because it pre-dates it, and the relation between the Parthenon and Propylaia was calculated differently. If one projects the western edge of the Parthenon's stylobate northward, the Propylaia's eastern stylobate is one Parthenon length removed from it, measured on the perpendicular. Because the Parthenon's north side was the first thing to appear on one's right when one exited the Propylaia, it was the obvious yardstick to use in order to relate the two buildings.

BOX 4. *THE PARTHENON AND ITS TRANSFORMATIONS*

Soon after it was completed, the Parthenon required modification. By ca. 400 a water basin had been installed before the Athena Parthenos in order to humidify her, her snake had been switched from her right side to her left, and a column had been inserted in its place in order to stop her arm from bending under the weight of the golden Nike (see Fig. 69).

In 296, the Athenian tyrant Lachares, strapped for cash to pay his mercenaries, stripped the statue of its gold. At this point, darkness descends. We do not know whether the gold was ever replaced (if not, what did Pausanias see?); when the catastrophic fire occurred that gutted the building's interior, destroyed its roof, and (presumably) burnt the statue too; who replaced them and when (did Pausanias see a copy?); and last, after the Christians removed this replacement around A.D. 460, whether they destroyed it or took it (like Pheidias's Zeus at Olympia) to Constantinople. Nor do we know exactly when the temple became the cathedral of Our Lady of Athens; when its entrance was switched from east to west and its interior was remodeled accordingly; and when its west, north, and east metopes were defaced by Christian iconoclasts: in the sixth century A.D or even the seventh? More changes followed in the twelfth and thirteenth centuries, including a lavish overhaul of the interior and yet another new roof.

In 1458 the Turks conquered Athens and lost no time in converting the Parthenon into a mosque and the Akropolis into a fortress. Yet Jacques

THE PARTHENON: THE ARCHITECTURE SPEAKS...

The program's crown jewel and inaugural venture was the Parthenon (Figs. 54, 55, 59–70, 78). Iktinos was its architect and Pheidias its master sculptor.[5] Inscriptions show that it too was funded from various sources, including both Persian spoils and allied tribute, but – in a tacit nod to the latter's political sensitivity – Athenian writers name only the spoils. Together with its cult statue, it cost around 1,200 talents: three whole years of imperial tribute.

5 Some sources add two other architects, Kallikrates and Karpion, to make a committee of three, which is consistent with Athenian democratic practice; but their work must have been subordinate to Iktinos's. Pheidias's role as director of the sculptural program is fiercely controversial, but a plan (especially one so complex) requires a planner. The stylistic variation within the metopes (carved, ca. 447–2) and pediments (carved, ca. 438–2) would then be explained in the first case by the team's lack of experience in working together and in the second by Pheidias's exile in 438 on a charge of embezzling ivory meant for the golden image.

Carrey's famous drawings of its fabric and sculptures, executed in 1674, show that the building still remained essentially intact. In 1687, however, the Turks hid their gunpowder there (along with their women and children) during a Venetian attack. An intense bombardment soon led to the inevitable. A vast explosion ripped the heart out of the building, killing all inside. After the Venetians departed, a new, much smaller mosque soon arose within its ruins, which soon became a target for plunderers. In 1801 the British Ambassador to the Sultan of Turkey, Lord Elgin, obtained his permission to cast, draw, and remove "any pieces of stone with inscriptions or figures" from the Akropolis; in 1816 the British Museum purchased these "Elgin Marbles" from him (Figs. 55, 62–67) and much else besides.

After the Greek War of Independence (1821–9) and a plan (fortunately stillborn) to convert the Akropolis, Parthenon and all, into a sumptuous palace for the new Greek monarchy, the temple was declared a national monument on August 28, 1834. In the following years, it was stripped of virtually all its later appendages and underwent extensive restoration, including the re-erection of its entire north colonnade. In 1980 an earthquake nearly brought down its northeast corner, by which time a UNESCO-funded study had already revealed severe deterioration of its fabric due to Athens's ferocious smog and to its earlier restorers' crude techniques. At the time of writing, an intensive conservation campaign is still ongoing, as are Greek efforts to secure the return of the Elgin Marbles and other sculptural fragments now in Italy, France, and Denmark.

It sat on the rock's very summit, directly on top of a predecessor, the so-called Older Parthenon, begun as a thank-offering after Marathon but destroyed in 480 while still under construction. This temple's platform protruded significantly on the Parthenon's east and south sides and was even visible on the west, and its steps and column drums that were not reused in the Akropolis's north wall were recycled for the Parthenon's own colonnades. So from the latter's very foundations to the great winged Victories that (if recent research is correct) crowned the corners of its pediments, it proclaimed its violent, sacrilegious origins with pride. Its subsequent history has been no less turbulent (see Box 4. *The Parthenon and Its Transformations*).

Clearly intended to outdo Libon's temple at Olympia (Fig. 42; see Chapter 2), the Parthenon was not only slightly larger but, uniquely in mainland Greece, boasted an eight-column façade. Like its figured Ionic-style frieze and the four Ionic columns of its rear chamber, this was an Ionic feature that invoked one of Athens' four key charter myths: its Ionian heritage. The city's architects had used the Ionic order for a century, but in the electric atmosphere of the 440s, when Spartan–Athenian rivalry was increasingly acquiring racial overtones as a Dorian–Ionian divide, it took on new significance.

Implicitly but firmly rehabilitating Ionia from its long association with softness, luxury, and effeminacy, and repudiating Sparta's persistent

propaganda to that effect, Iktinos was asserting that (as in Perikles's Funeral Speech) Athens was truly an "education to Greece": the trend-setter and arbiter of taste, the glittering new capital of a culturally united people. Indeed, perhaps his fusion of the disparate traditions of Ionia, the Peloponnese, and their colonies (see Fig. 43) even insinuated that in some profound sense Athens *was* Greece.

Iktinos's temple was far more lavish and sophisticated than Libon's. Now built entirely of shining white marble – a staggering 30,000 tons of it – from top to bottom, it boasted proportions that were much more complex and even more tightly integrated. The major ones, for example the temple's width-to-length ratio, column diameter to standard intercolumniation, and the latter to column height, conform to the ratio 4:9 or $2^2:3^2$. This 4:9 ratio, in turn, is itself derived from the formula that generated the number of flank columns from the number of those on the façades.[6] It yielded columns that were both slimmer and one-eighth higher than Libon's in relation to the standard intercolumniation and a façade that was more compact than its eight columns would otherwise have permitted.

Iktinos also added architectural refinements hitherto undreamt of, and sculpture on an unprecedented scale. The latter included six colossal akroteria, two pediments, ninety-two metopes, the 524-foot continuous Ionic frieze, and the dazzling gold and ivory statue of Athena, almost 40 feet high, that stood at its heart and was itself a technical feat of the highest order.

Plutarch (see Box 2. *The Periklean Building Program*) gives some idea of the labor involved in this massive undertaking, but little of the skill. Many finished blocks weigh over 5 tons, and some (the capitals and architraves, for instance) weigh almost 10 tons. Tens of thousands of them, from the 506 drums of the outer colonnade to the 8,957 marble roof-tiles, had to be quarried, hauled the 10 miles to the Akropolis, cut, dressed, and finished to tolerances so fine that they exceed any in use today. For example, the platform's joints are so tight (less than one ten-thousandth of an inch) that a 60-power microscope cannot penetrate them, and the joining surfaces of the column-drums, totaling over a thousand, deviate from the flat by less than a thousandth of an inch.

Iktinos's addition of minute deviations from the horizontal and vertical (his famous "refinements," Fig. 61) complicated this work immeasurably. Doric architects had used many of these small adjustments before (for example, at Aigina, Olympia, and Paestum: Figs. 26, 42, 43), but never as subtly and comprehensively. The Parthenon's platform slopes upward about an inch toward the west and is also slightly domed (curving upward just over 2 inches on the façades and 4 inches on the flanks); the columns lean slightly inward and are tapered and also slightly curved; and the steps, entablatures, and cella walls lean inward too.[7] But the cornices, the antefixes, and the abaci of the

6 I.e., $2n + 1$, where *n* is the number of façade columns, producing a colonnade of 8×17 columns.

7 These gradients are almost infinitesimal. Horizontally, they equal 1 in 450 on the stylobate's front, 1 in 750 on its sides, and 1 in 600 on the entablatures; vertically, the inward lean is 1 in 250 on the steps, 1 in 150 on the columns, and 1 in 80 on the entablatures

anta capitals all lean *outward,* presumably in compensation. So almost every marble block – thousands in all – had to be individually drafted, cut, and dressed on the bias; no right angles were possible and no two blocks could be identical. The builders accomplished all this without the aid of accurate rulers, protractors, or other precision instruments.

Several explanations have been proposed for these finicky adjustments. Was Iktinos trying to correct some unpleasant optical illusions (as the Roman architectural theorist Vitruvius believed), such as the supposed tendency for a horizontal line to sag when seen against the sky and for a vertical one to look concave? Or, because his temple was meant to be seen from below (Fig. 60), was he trying to reinforce the tendency for lines to look *convex* when seen from this angle, and thus to make it seem bigger and more imposing? Or (perhaps most plausibly) was he merely attempting to give it spring and life, in the same way that one's muscles flex when lifting a heavy weight? The jury is still out, but whatever the eventual verdict, the common motive that underlies all of them is a desire to satisfy the viewer's subjective perceptions of what looks right.

Similarly, whereas Doric architects had always moved the corner columns inward and the two end triglyphs outward in order to cope with the so-called Doric "corner conflict" (the two conflicting rules that (1) triglyphs must be centered above column axes and intercolumniations and (2) Doric friezes must end with a triglyph, not a half-metope), Iktinos went one better. He moved *both* the corner columns *and* the penultimate ones inward. This freed him from elongating the corner metopes and made the contraction seem less abrupt and the building even more compact. But as a result, half of each façade and a quarter of each flank now broke the rules.

So like the early classical painters, Iktinos took a crucial step in converting his art from a *conceptual* to a *perceptual* approach, from objective truth (mathematically and geometrically exact horizontals, verticals, and proportions) to subjective appearance, to what looks good to the eye in practice. Protagoras would have approved. Yet by introducing yet more irrationality into the design, did not these deviations from strict mathematical and geometrical regularity – from categorical idealism or absolute Truth – fatally compromise the temple's otherwise flawless beauty? For to repeat Plato's axiom once more, "measure and commensurability are everywhere identified with beauty and excellence."

Perhaps this is why Iktinos took care to deflate potential critics by arranging that the Parthenon's contracted façades formed a rectangle whose height-to-width ratio (i.e., column height + architrave + frieze + cornice in proportion to colonnade width) was again 4:9, and that the contracted flanks formed one of 16:81 or $4^2:9^2$. Brilliantly integrating plan, elevation, colonnade, façades, and flanks, and brilliantly reconciling subjective and objective "truth," this solution neatly solved two problems at a stroke.

and cella walls, and the outward lean is 1 in 100 on the horizontal cornice, 1 in 20 on the antefixes, and an astonishing 1 in 140 (one sixteenth of an inch) on the abaci of the anta capitals. The converging axes of the columns, if projected into space, would meet in the form of two ridged roofs about one mile and three miles above the building.

...AND THE SCULPTURE ANSWERS

Just as the Parthenon's architecture certified that the Athenians led the world in inventiveness and expertise, that is, in technē (and that building the Pyramids, for example, was a piece of cake by comparison?), its sculpture also proclaimed, to paraphrase Sophokles once more, that "wondrous are their arts; there is nothing beyond their power." And just as its architecture exploited and synthesized a tendentious array of powerful antitheses (Doric/Ionic; straight/curved; truth/appearance; objective/subjective), so too did its sculpture (divine/human; nemesis/hybris; West/East; Greek/barbarian; Athenians/other Greeks; civilization/savagery; democracy/tyranny; city/family; and so on). In this it again far outdid Libon's temple at Olympia (Figs. 42, 44–50), whose themes seem somewhat parochial by comparison.

In other words, using the binary oppositions that were basic to Greek thought and language (represented by the ubiquitous oppositional particles *men/de* or "on the one hand"/"on the other"), this sculpture both created its own kosmos – a truly vast one – and engaged, directly or indirectly, the burning social and political issues of its time. Although Pheidias probably was involved in the marbles only as their planner, his team mobilized whole arsenals of naturalistic effects to persuade us of their insistent reality; of geometrical patterns to endow them with timeless, universal significance; and of colorful embellishments in paint and metal to heighten their effect.

Finally, Pheidias himself secured a veritable 800-talent treasure-trove of glittering, precious materials for his great colossus of Athena, in order to convey the goddess's awesome power, beauty, and grandeur. Like Iktinos, he and his associates brilliantly reconciled subjective and objective "truth," the relative and the absolute, and the natural and the expressive, in a style whose equilibrium often seems poised on a pinhead.

As at Olympia, one could relate to these sculptures on several levels, but here their hierarchical distribution, Athena's insistent presence, and their often-Athenian setting and protagonists integrated them far more tightly. The largest and most conspicuous of them, in the pediments, showed two scenes from protohistory, Athena's birth and her contest with Poseidon for the land of Attica (Figs. 62–64). The metopes below shifted to prehistory, with Athena, Herakles, and the other Olympians battling the Giants; the Sack of Troy; the Centauromachy (Figs. 65, 66; an echo of Olympia, Fig. 45); and the Amazon assault on Athens. And finally, the Ionic frieze with its recurring ritual of the Panathenaia brought one completely up to date (Figs. 54, 55, 67, 68, 78).

Yet this sequence was not merely temporal and descriptive. As we shall see, it implies the same breadth of vision and spirit of inquiry that inspired contemporary historians such as Herodotos and Thucydides to take on world-shaking events and to investigate their origins, causes, and effects: to *explain* them rather than merely to chronicle them.

Pheidias then repeated several of these themes on his colossal golden image of Athena (Fig. 69), enabling the awed visitor to follow the chain of

causation to its source and channeling the goddess's cosmic power back to him in response. After this experience, few Athenians would have departed without the famous lines of their great sixth-century lawgiver Solon ringing in their ears:

> Our city, by the immortal gods' intent,
> And Zeus's word shall never come to harm.
> For our bold champion, of proud descent,
> Pallas of Athens shields us with her arm.

Or as Aischylos more recently had put it in the *Eumenides*:

> All hail, all hail!
> High destiny shall be yours
> By right. All hail, Athenians,
> Seated near the throne of Zeus,
> Beloved by the Maiden he loves,
> Civilized as years go by,
> Sheltered under Athena's wings,
> Grand in her father's sight.

So now we arrive at yet another reason for the addition of the Ionic frieze (Figs. 54, 55, 67, 68). Its brilliant array of riders, marshals, charioteers, attendants, acolytes, and so on, witnessed, uniquely, by all twelve Olympians, boldly proclaims what the temple's dazzling display of technē only hints at. It asserts that the Athenians stood at the summit of creation, that they were truly the best, most beautiful, most pious, most fortunate, and most divinely favored people on earth. Even the ease with which they handle their horses and chariots radiates control, of both self and others. To expand our earlier citation from the Funeral Speech: "In sum, our city is an education to Greece, and every single one of our citizens, in all the manifold aspects of life, can show himself the rightful lord and owner of his own person, and can do this, moreover, with exceptional grace and exceptional versatility." Athenian masculinity, it declares, is sublimely effortless.

The Olympian family's appearance in this frieze as witnesses introduced a second, complementary theme, balancing this collective hymn to Athena, the city, and the dēmos: an insistence on the importance of the family/household or oikos. On the east pediment and metopes, the Olympians also witness Athena's birth and defend their mountain home against the perverted clan of the Giants; and on the west pediment, the two mythical Athenian royal houses, the Kekropids and Erechtheids, witness Athena's victory over Poseidon. By contrast, on the south metopes the Centaurs violate the family and its most basic ritual, marriage; on the northern ones the Trojans duly pay the penalty for condoning a similar crime, namely, Paris's abduction of Menelaos's wife, Helen; and on the western ones the Amazons, daughters gone bad, meet their match in the Athenians of old. For society to thrive, one concludes, family and city must coexist in justice and harmony.

A CLOSER LOOK

Scrutinizing the pediments, an alert visitor would have noticed that many figures were strikingly expressive. For example, two of the seated goddesses in Fig. 62 are heavily swathed and quite matronly, but the third (surely Aphrodite) is blatantly sexy, with her languid posture and off-the-shoulder drapery whose transparent fabric and looping folds – once gaily painted – emphasize her swelling breasts and stomach. The sprinting young woman of Fig. 63 with her windswept, fluttering drapery is certainly the divine messenger Iris (sockets for huge marble wings are cut into her back), and the young man of Fig. 64 with his fluid muscles and cascading cloak may be the River Ilissos, watching the drama unfold.

So whereas the Olympia Master had relied upon posture and gesture to indicate the character or ēthos of his subjects, these sculptors now pressed anatomy and drapery into doing so as well. Choosing expressive effect over stylistic consistency (so much for one of classicism's supposedly key components!), they both engaged the spectator more closely and laid the groundwork for later masterpieces such as Praxiteles' Knidia (see Fig. 140). Once more, Protagoras would have approved, for tapping into the spectator's feelings – into his own subjectivity – was crucial to getting the cosmic implications of the scenes across.

Meanwhile, more thoughtful viewers might have been struck by the fact that Athena's birth on the east pediment, the key factor in completing the Olympian family and enabling it to fulfill its cosmic potential, was framed by the rising sun and setting moon – by the great revolving wheel of the cosmos itself. Was this a covert reference to Anaxagoras's theory that Rotation "separated off" the elements from the primordial chaos? One's suspicions would have increased after entering the temple and seeing the Athena Parthenos herself. For embellishing her base was yet another creation scene, that of Pandora (the first woman), similarly framed by Sun and Moon. Of course, Anaxagoras, a notorious atheist, could not be quoted directly, but his belief that "phenomena are a sight of the unseen" clearly invited artists to allegorize and audiences to look for hidden meanings. And Anaxagoras and Pheidias both were friends and confidants of Perikles, the statue's official supervisor (see Box 2. *The Periklean Building Program*).

To return, though, to our average Athenian. Eyeing the metopes and schooled by a generation of anti-Persian rhetoric, he would soon realize that their common denominators were the familiar antitheses between east and west, barbarism and civilization, and hybris and nemesis. These directly referenced the Persian Wars and the Parthenon's declared function as a victory monument. For as we have seen, the analogy Amazonomachy–Sack of Troy–Persian Wars was by now a poetic cliché, already translated into fresco in the Painted Stoa down in the Agora.

The historian Herodotos, a great fan of Athens, thoroughly reworked this analogy at the beginning of his great history of the Persian Wars, which he

recited to great applause in Athens and published perhaps around 430. He saw the invasions as merely the latest round in an ongoing East–West vendetta that began with the Phoenicians' rape of Io from Argos and continued through Paris's seduction of Helen and the Trojan War to the present. The orators selected (like Perikles) to eulogize Athens's war dead soon incorporated all this into their speeches, routinely prefacing them with high-octane, blatantly chauvinistic accounts of Athenian courage, altruism, and self-sacrifice from the Amazon invasion through the Persian one. Surrounding the Parthenon like a kind of civic memory bank, then, these sculptured panels fitted snugly into the Athenians' emotional landscape and resonated deeply in the Athenian psyche.

Closer attention would have paid richer dividends still. For example, although Fig. 65 may strike us as somewhat awkward, it would have struck a strong chord with contemporaries, who could connect with it on a personal and visceral level. For Centaur and Lapith are engaged in a *pankration*, the brutal combination of boxing and wrestling that was the ultimate trial of strength in the games, from which only biting and gouging were barred – except at Sparta! In this case, the Centaur scissor-grips his opponent's leg and tries to throttle him, while the Lapith lands a well-placed right hook squarely on his ear.

Figure 66, however, propels us into another world. Horizontals and verticals predominate, and the cloak's great looping folds seem to suspend the hero (perhaps Theseus himself) in space and time, as if the scene were emblematic of victory – and thus of heroic excellence – instead of a dramatization of it. The hero's magnificent physique and enviable economy of movement imply total control of both body and mind. Only the turn of his head to follow his great bronze spear as it sliced diagonally across the panel into the writhing Centaur's spine would have galvanized the scene into any semblance of real battle. To this culture, mastery of the bestial in one's own nature was the supreme ethical achievement, and confrontation the supreme test of one's self-control. As Aischylos had declared, "it is advantageous to practice prudence under stress." But such excellence is hard won. It comes only through Pindar's "hard climb" to excellence, exemplified by the still-struggling heroes around (Fig. 65). And if this magnificent figure is really Theseus, once again it is an Athenian hero who has reached the top.

Next, squinting up at the Ionic frieze (Figs. 54, 55, 67, 68), our Athenian spectator would not only have felt his patriotism swell even further, but perhaps (since most of the males in the frieze were youthful and some even were naked: Fig. 67) his erotic desires as well. For as the Tyrannicides and the vases demonstrate (Figs. 5, 33–35), classical Athens took homoeroticism for granted, camouflaging and codifying it in an erastēs–erōmenos relationship between the older "lover" or erastēs (the bearded citizen male in his twenties or early thirties) and the younger "beloved" or erōmenos (the unbearded youth in his early and mid-teens).

In the frieze's case, Athenian political discourse of the 430s and 420s may offer some support for this reading. In his Funeral Speech, Perikles exhorts

his audience to "gaze, day after day, upon the power of Athens and become its lovers" (erastai again), and in the 420s Aristophanes put the personified Dēmos on stage and had two self-proclaimed "dēmos-lovers," one of them a sausage-seller (!), compete for his affections, with predictably hilarious results. Evidently the idea was now familiar enough to milk for laughs. Plato, too, even describes two prominent Athenian politicians as "lovers of the dēmos" in dialogues set in 432 and 427. So although no Athenian midcentury political writings survive to push this conceit back to the 440s, was the frieze meant to provoke this very reaction?

Finally entering the temple, our spectator would have found himself confronted by the awesome majesty of the Parthenos (Fig. 69), almost 40 feet high and glittering in the half light. Among the many dazzling items to catch his attention might well have been the Birth of Pandora on her base and the Amazonomachy on her shield (Fig. 70). The figures were in gold relief, with details in silver, ivory, and enamel. As to the significance of the Pandora scene:

> ... [in Hesiod's *Catalogue of Women*] Pandora is the primeval woman, wife of Prometheus and mother of Deukalion. Deukalion married Pyrrha, also a daughter of Pandora by Epimetheus ... and their son is Hellen, the ancestor of all the Greeks. Thus Pandora is the progenitor of the Greek race. She is moreover the child of [the smith-god] Hephaistos, who fashioned her out of clay, and of Athena, who breathed life into her. And Pheidias has chosen to show the moment when Pandora is adorned by Athena, aided by her companions, the Graces. The political implications are obvious: Athens is showering Greece with the gifts of civilization; Athens not only adorns Greece, she educates it as well. And each Athenian citizen is trained in all the arts of peace and war. Pheidias's frieze anticipates the sentiment publicly expressed in his Funeral Oration of 431: "In sum, our city is an education to Greece, and every single one of our citizens, in all the manifold aspects of life, can show himself the rightful lord and owner of his own person, and can do this, moreover, with exceptional grace and exceptional versatility."[8]

Athena's mighty shield, on the other hand, spotlighted the Athenians themselves, playing their familiar role as victors over the invading Amazons (compare Fig. 39). Excerpts from it survive (Fig. 70), and show that Pheidias recast the "iron-man" type of the Tyrannicides (Figs. 5, 34) into a more agile, supple, and appealing form. Athenian grace and versatility are here displayed in a desperate battle for their city and indeed for Greece as a whole, whose selfless protectors they have now become. So this composition exactly complemented the Ionic frieze (Figs. 54, 55, 67, 68), substituting war for peace and the past for the present, and showing that in the interim the "earth-born" Athenians had not changed at all.

8 Olga Palagia, "Meaning and Narrative Techniques in Statue Bases of the Pheidian Circle," in N. Keith Rutter and Brian A. Sparkes, *Word and Image in Ancient Greece* (Edinburgh 2000): 53–78, at p. 61.

But Who Had the Patience?

Does the Parthenon protest too much? Although it squarely targets an Athenian audience – there is no sign in the Ionic frieze of the hoplite armor that the allies presented at the Panathenaia, for instance, or of the resident alien girls who carried jars full of water for the sacrifice (contrast Fig. 68) – its message seems massively overdetermined even so. The sheer volume of sculpture, taxing even in its present museum settings, was surely more so when new, complete, in place on the building, and ablaze with every color of the rainbow.

Moreover, the temple's siting and form meant that the tidy sequences described above were in fact sundered among its four sides, presented in two separate planes (one behind the other), and in the case of the Ionic frieze (Fig. 54) only visible intermittently through the outer colonnade. Tradition also dictated that Athena's birth, the earliest episode chronologically, was not even placed in the western pediment to greet the visitor emerging from the Propylaia (Fig. 60), but in the eastern one, above the temple's main entrance. So one had to zigzag back and forth in order to read the compositions in any rational order at all. Who had the patience? No wonder Pausanias simply noted the subjects of the pediments (the eastern one first) and then quickly strode inside to check out the golden image. What a difference from his reaction to the Olympia sculptures (Figs. 42–50; see Chapter 2, Box 3)!

But it is unfair and indeed unhistorical to end on this note. The marbles were not intended primarily as entertainment for Athenians but as gifts to Athena. They gloriously completed her temple's kosmos and prefaced her gold and ivory colossus within (Fig. 69). As to the latter, the pithiest and most perceptive assessment comes not from a Greek but from a Roman. Writing around A.D. 80, the orator Quintilian states his view quite simply:

> Pheidias is credited with being more skillful in making images of gods than of men, and in ivory work he is thought to be far beyond any rival and would be so even if he had made nothing besides his Athena in Athens and his Olympian Zeus in Elis, the beauty of which is said to have added something to the traditional religion; to such an extent is the majesty of the work equal to the majesty of the god.

So if Libon had won Round One of the Peloponnesian-Athenian contest with his temple of Zeus, then Iktinos and Pheidias had won Round Two. But as Quintilian himself suggests, Round Three went to the Peloponnese with Pheidias's even more enormous Zeus. Commissioned after his exile from Athens in 438 and installed in Libon's temple around 425, it soon became one of the Seven Wonders of the World. Yet in the end, survival is all. Libon's temple lies in ruins and the Zeus is utterly lost, leaving no scrap or even trustworthy copy behind. But the Parthenon still stands. Though battered, bruised, bereft of its "Elgin Marbles," and threatened by the most insidious enemy of all, air pollution (see Box 4. *The Parthenon and its Transformations*), it is magnificent even in its ruin and now has become (irony of ironies!) the Panhellenic symbol of Perikles' dreams.

The True Measure of Man

We now move from Athens to Argos, and from the glories of the Periklean building program to a single, naked, slightly over-life-size bronze statue. Unlike the Akropolis and the Parthenon, the Argive sculptor Polykleitos's Doryphoros or Spearbearer can be taken in at a glance – except that (like Pheidias's Athena Parthenos and Olympian Zeus) it too no longer exists! We know it only from Roman copies (Fig. 71) and from texts; its reconstruction is problematic; and its original location, patron, and exact subject are all obscure. For "Doryphoros" is clearly a nickname or moniker: Classical statues always had precise subjects. Yet its importance is inestimable.

Compared with the Parthenon, the Doryphoros seems obsessively focused. The summit of categorical idealism in the visual arts, of that Parmenidean strand in Greek thought that sought eternal, unchanging Truth beneath the confusing flux of appearance, it served as a model for generations of artists, many of whom (Pliny tells us) followed it "like a law." It is suggestive that Polykleitos, who also wrote a handbook on his statue called the *Canon* (Greek, *Kanōn*) or "Rule," chose to encode this "law" in the figure of a warrior: The "Greek men's club" personified and Greek art's central genre. (Indeed, there are hints in the sources that it represented Achilles, the greatest of all heroic warriors.)

Polykleitos's handbook is lost but for a few quotations, but this does not lessen its stature or importance to Western art. True, sixth-century temple-builders had produced construction manuals; Iktinos and Karpion wrote one on the Parthenon; and, in Chapter 2, we encountered Hippodamos's treatise on town planning (which was probably more of a political polemic). Yet Polykleitos was apparently the first to lay down a set of aesthetic principles "like a law." The apostle of academicism in the visual arts, he has a lot to answer for.

Nor was he alone. Professionalism was in the air. The earliest Hippokratic medical treatises – also handbooks of technē, based upon observation and deduction – date to this period, as do the now-lost musical manuals of Glaukos of Rhegion and Damon of Athens (one of Perikles's teachers), Protagoras's rhetorical textbook, and Sophokles's handbook on the tragic chorus. Sokrates even teased a late fifth-century Athenian bookworm at length for obsessively collecting them.

To return to the copies, whose very abundance proclaims Polykleitos's success. Recent examination of corrosion lines on the Naples copy's left forearm (Fig. 71) shows that possibly it carried a bronze shield in addition to its spear; moreover, the configuration of the fingers of the right hand suggests that they too held something, perhaps a scabbard or sword-hilt (Fig. 72). These startling new observations both align the Doryphoros with earlier warrior figures and might explain why its echoes in later sculpture often carry some of these items (see Fig. 118).

It is instructive to compare the Doryphoros with the Artemision Zeus (Figs. 21, 22). On first analysis, its chiasmus/contrapposto – in Greek,

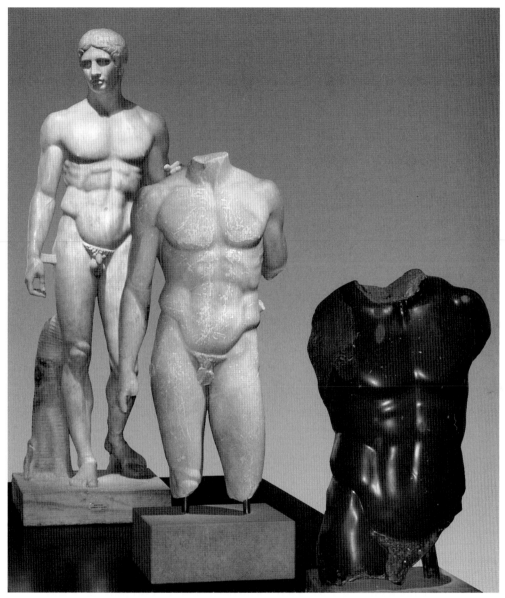

71. Plaster casts of three Roman copies of the Doryphoros by Polykleitos of Argos; bronze original, ca. 440. Ht. of left-hand copy, 2.12 m (6′11″). The copies are in Naples (left), Berlin (center), and Florence (right); the first two are of marble, the third of black basalt.

its rhythmos – looks quite similar, but actually is far more emphatic and comprehensive. The entire figure is an exercise in antithesis: a binary code in bronze. The "engaged" right leg again balances the "working" left arm and the relaxed left leg balances the relaxed right arm, but now both limbs on the statue's left side are flexed and both those on its right are straight. And though its physique also recalls the Zeus's, not only is it more solid (ancient writers

145

describe it as "foursquare"; "the mean in this particular case"; "neither too tall nor too short, nor too fat or too thin, but exactly well-proportioned"),[9] but also every muscle clearly reflects this crucial opposition between tense and relaxed. Finally, its mathematics was far more sophisticated, as the Kanon made clear. Starting with the somewhat cryptic statement that "Success comes about – just barely – through many numbers," Polykleitos developed a comprehensive proportional system that related every part of the human body exactly to every other part and to the whole.

Although Polykleitos's handbook is lost and the copies are too inexact to measure with confidence, his message is clear. His statue was literally the textbook case of symmetria: a completely measured man. His comprehensive new system surely was based on a single mathematical formula or algorithm such as those we encountered in Chapter 2.

Polykleitos's own remark that "the work is hardest when the clay is on the [finger]-nail" not only indicates the difficulty of attaining such accuracy (recalling the "just barely" of his manifesto), but also hints at how he did so. Although the "clay" must allude to the process of creating his clay casting-mold or investment, of pressing it into the archetype's every nook and cranny, his choice of the fingernail – the smallest measurable part of the body – as his example is instructive.

Polykleitos must have worked either from part to whole or (perhaps more likely) from whole to part. In the first case he would have begun with the fingernail, the smallest unit of all, using a geometric progression (1, 2, 4, 8, 16, 32, etc.) or the simpler arithmetic one (1, 2, 3, 4, etc.) to proportion the remainder of his figure up to the body's full height. (Both these formulae had great resonance outside the narrow world of mathematics, as we have seen.) In the second case, he would have worked from the opposite direction, using a fractional system that divided the figure's height by 2, 3, 4, 5, etc., or 2, 4, 8, 16, etc., until he reached the fingernail.[10] For only in this way could he relate every part exactly to every other part and to the whole. Yet even then by his own admission he "just barely" made the grade, despite all his efforts succeeding only by the skin of his teeth.

The Doryphoros's controlled poise, anatomical precision, and comprehensive proportional harmony soon established it as an icon of male beauty, of the perfectly measured man. This ideal is fourfold, and recalls the sixth-century philosopher Thales' famous statement that he was glad that he was

9 As a result, Polykleitos later became a favorite of that great exponent of the Mean in all things, namely, Aristotle. In *Nikomachean Ethics* 6.7, where Aristotle expounds this idea, he singles out Pheidias as the best stone-carver and Polykleitos as the best at making statues of humans – i.e., as opposed to gods, Pheidias's specialty.

10 The old suggestion that Polykleitos was a Pythagorean has now been refuted, though in an essay so far published only in French: Carl Huffman, "Polyclète et les Présocratiques," in André Laks and Claire Louget (eds.), *Qu'est-que la philosophie preesocratique?* (Lille 2002): 303–30. He may still, of course, have *borrowed* the mathematics of his system from the Pythagoreans.

72. Two alternative reconstructions of the Doryphoros, Fig. 71. The shield, scabbard, and sword are conjectural, but their presence is indicated by the position of the fingers of the right hand and encrustation marks on the left arm of the Naples copy, Fig. 71, left.

a human being not an animal; a man not a woman; and a Greek not a barbarian.

1. The Doryphoros is a model human being, Nature personified;
2. He represents the best human type, a Greek male;
3. He is a model Greek male, the perfect citizen warrior; and
4. He is an artistic standard or law as well.

A true microcosm (a kosmos in a capsule), he thus represents what any fifth-century intellectual would kill for: a perfect synthesis of nature (physis) and culture (nomos).

So the Doryphoros is both exemplary and didactic, in that his measured poise alerts us to the prudence and self-knowledge that we need in order to be ideal citizens; his "middling" physique and perfect proportions exhort us to work out till we drop; and his lowered glance urges modesty before the gods (Fig. 21). Finally, the sheer difficulty of achieving all this – and of Polykleitos's own struggle to distill it into a single nude – reminds us how hard this "steep climb to excellence" really is.

For every Greek knew the slogans blazoned across the façade of Apollo's temple at Delphi: "Know yourself" and "Nothing to excess." And every Greek understood that achieving this self-knowledge was the first step to understanding others, and that self-control automatically translated into control over others – in other words, into power. As well as insinuating all this through its posture and gesture, the Doryphoros referenced it quite literally, through the most formidable weapon known to fifth-century Greeks: the mighty, eight-foot thrusting spear of the hoplite. The epitome of martial discipline, he was a one-man phalanx (Fig. 15), the ancestor of such towering figures as the Primaporta Augustus and Michelangelo's *David* and—yes!—even of today's superheroes and Action Men.

Yet unlike these individuals, the Doryphoros was "middling" man personified – or rather, he indicated what, given the right circumstances, regimen, and willpower, such an individual might become: the freest, most powerful man in the world. Sidestepping the sunny egalitarianism of the Parthenon frieze, Polykleitos's bronze was a distinctly Peloponnesian response to Periklean and Pheidian classicism. It climaxed a long Peloponnesian tradition, as the last chapter has shown, and the absolutism and universality of its claims gave Protagoras's "man the measure of all things" an entirely new twist.

CHAPTER 4

INTERLUDE: CITY, HOUSEHOLD, AND INDIVIDUAL IN CLASSICAL GREECE

ANOTHER PERSPECTIVE

Development – political, social, economic, and artistic – is a historian's meat and drink. But in ancient times, when life was slower, most people barely noticed changes in artistic style, and writers rarely thought them worth discussing. As Aristotle remarked, what interests most people is the *subject matter* of an image: What is it, and how well is it done? So let us stop the clock for a while and examine our material from this point of view.

Fifth-century Greek society, as we have seen, was a tripolar affair, with city (polis), household (oikos), and individual locked in a shifting and often uneasy embrace. How did each of them register on the Greek representational landscape? How did the Greeks view and represent *themselves*? Why? And how effectively? As always, Athens furnishes most of our evidence, though it was by no means a typical Greek city. Not only was it bigger, more powerful, and more dynamic than any other, but also its democracy was the most radical, its citizens the most articulate, its artists the most prolific, and its art – for our purposes – the most informative.

Yet Athens's fifth-century preeminence is both a blessing and a curse. A blessing, because its artistic legacy – ranging from the Parthenon to thousands of painted vases – is incomparably rich. A curse, because the city's political, commercial, and artistic supremacy all but extinguished the vibrant local artistic traditions of archaic Greece. So what follows necessarily focuses upon Athens, but glances elsewhere when appropriate and possible.

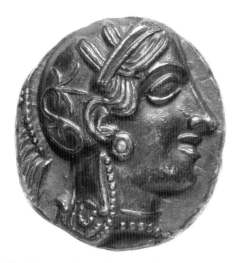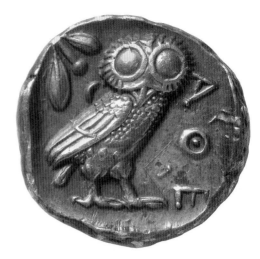

73. Athena and an owl on an Athenian tetradrachm (four-drachma piece), ca. 450. Silver; diam. 2.5 cm (1″). Berlin, private collection.

REPRESENTING THE CITY

At some level, every publicly commissioned sculpture, painting, photograph, movie, or other image is a representation of the community in question, in that it encodes some belief that its members hold about it. Yet because societies are dynamic and infinitely complex, no single image or group of images can represent *everything* that they stand for, believe, or feel. Mom, the flag, and apple pie; the American eagle; Uncle Sam; Lady Liberty; and even the Thanksgiving turkey and the hamburger all represent that entity called the United States (or "America") only partially. Likewise, for the United Kingdom, the Union Jack, Britannia, Beefeaters, John Bull, and fish-and-chips; for France, the tricolor, Marianne/La Liberté, the Eiffel Tower, haute couture, haute cuisine, and quiche; and so on. To put it another way, both reality and ideology are always radically *underdetermined* by images. This is why, in those societies that have acquired the representational habit, images of the body politic are always evolving. (In France, Marianne/La Liberté, for example, has undergone many facelifts over the years, and in 2002 a pro-immigrant group chose yet another one in order to showcase the country's ethnic diversity.)

In classical Greece, four classes of images could function in this way: gods, heroes, personifications, and (on state seals and coins) local emblems of all types. For as society grew more complex, the city's guardian deity acquired new epithets, functions, and attributes, and other cults (divine and heroic) were introduced as needed. Personifications, too, could be invented at will. State seals and coins could feature not only any of the above or their distinguishing attributes (Fig. 73), but also choice local products (Fig. 7), and even punning or canting devices – such as the rose (*rhodon*) for Rhodes and the apple (*mēlon*) for Melos – in such bewildering profusion that I cannot discuss them further here.

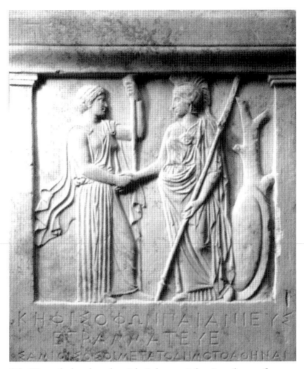

74. Hera shakes hands with Athena. Athenian decree from the Athenian Akropolis, 403. Marble; ht. of relief panel, 50 cm (1′8″). Athens, Akropolis Museum. The inscription below the relief honors Samos and its citizens for their loyalty after the Athenian defeat at Aigospotamoi in 405.

Gods

In Athens, by the fifth century the rude olivewood stake that from time immemorial had represented Athena Polias, the city goddess, had been given a proper face, hands, and feet; wore sumptuous vestments, jewelry, and an aegis complete with Gorgoneion; and held out a golden offering dish in one hand and a golden owl in the other. Yet by then Athena Ergane, Athena Nike, and Athena Hygieia had joined her on the Akropolis, signaling her growing importance as a patron of industry, victory, and health, respectively.

In 438, when the city's power was at its height, these various Athenas were supplemented but not supplanted by the very icon of imperial Athens, Pheidias's colossal – and colossally over-determined – Athena Parthenos (Fig. 69). The goddess's helmeted head and owl already had come to personify the city on its state seals and coinage, circulating its name, fame, and divine sponsorship all around the Mediterranean (Fig. 73), and prompting widespread imitation from Africa to the Black Sea: a truly international currency. From the 420s Athena represents the city in reliefs appended to decrees honoring foreign dignitaries and to treaties with other cities (Fig. 74), which are themselves personified by their divine guardians (in this case, the goddess Hera). Sometimes these Athenas echo the Parthenos, but more often they reference

other statues of the goddess displayed around the city or break new ground entirely.

Yet Athena was not the city's only divine representative. For example, Zeus Polieus was honored on the Akropolis too (see Fig. 59 for the location of his sanctuary), and down in the city the cult of Aphrodite Pandēmos reflected both the unification of Attica by Theseus (of whom more shortly) and the central importance of marriage for the maintenance of the state. Aphrodite in the Gardens, worshiped by the River Ilissos, on the north slope of the Akropolis, and in a border shrine at Daphne near Eleusis, was particularly concerned with fertility (both human and agricultural). The Meidias Painter was fond of her in this guise (see Figs. 119, 120). Finally, Aphrodite Ourania ("heavenly"), the goddess's oldest and most sacred aspect, embraced all these "earthly" functions and more. Uniting heaven and earth in universal love, she oversaw the social union between the Attic parishes or *demes*, between husbands and wives, and even between *hetairai* or "courtesans" and their customers (more about them below). The Aphrodite of the Parthenon's east pediment (Fig. 62) perhaps referenced much of this, encouraging the viewer to weigh her contribution to the city against Athena's in the center of the pediment, and the grain-goddess Demeter's in its opposite wing.

Heroes

Every Greek city had its founding hero, often buried in the center of town or in a conspicuous tomb outside its gates. Indeed, many had more than one, adding important kings, lawgivers, and champions to the roster as circumstances dictated. The Spartans, for example, honored Menelaos and Helen both in town and at the Menelaion, the ruined Bronze Age palace across the valley to the east, over which they erected a monumental hero-shrine. Yet this did not prevent them also from worshiping Helen's brothers, the Dioskouroi; their great lawgiver Lykourgos; Cheilōn, an "overseer" who was also one of the Seven Sages; and Orestes, whose bones were repatriated from Tegea in response to an oracle from Delphi. Indeed, one scholar has even identified Polykleitos's enigmatic Doryphoros (Figs. 71, 72) as Orestes. All of them in some sense personified Sparta, particularly its men, just as the incomparably beautiful Helen personified its women.

Athens was no exception to these trends. Its "earthborn" kings Erichthonios/Erechtheus and Kekrops had important cults in the city, and in 509 Kleisthenes had designated them and eight other Attic heroes to personify the ten tribes of his new hoplite republic. These so-called Eponymous Heroes soon received their own statues in the Agora, whose plinth served as an official billboard, turning them into the public voice of the democracy. The Athenians must have erected this monument by 421, when Aristophanes gave vent to what seems to have been a common wartime complaint. A citizen from rural Attica visits Athens, and to his shock, "standing by the statue of Pandion sees his own name" among the lists of draftees for the war. He's brought no gear or supplies, and he has to report for duty tomorrow!

Yet it was the hero-king Theseus whom the Athenians revered above all and who, in the fifth century, came to personify true Athenian grit.[1] Slayer of the Minotaur, scourge of the Amazons and Centaurs, and equipped with his own set of labors (undertaken on his way to Athens to claim the kingship), he comes fully into focus only after the fall of the tyranny in 510 and the Persian invasions of 490–79.

A sudden fad around 510–480 for pictures of his labors on Attic red-figure cups is sometimes credited to the appearance of a new epic poem about him, the *Theseis*. In the 480s the Athenians immortalized these same deeds in marble on the metopes of their treasury at Delphi (Fig. 75), alongside those of Herakles and directly above Athens's own victory monument to the battle of Marathon, which stood against the treasury's south side. Finally, as we have seen in Chapter 2, in 476 Kimon repatriated his bones from Skyros with great fanfare, housing them in a custom-built shrine, the Theseion, which Mikon duly embellished with frescoes of the hero's fights with Amazons and Centaurs and his visit to Poseidon's palace on the seabed. Contemporary vases hint at their appearance (see Fig. 39). These exploits turn him into a symbol of Athens's naval hegemony and military might, and thus of its democracy.

These pictures deliberately model Theseus's pose and physique on the new style, macho Athenian represented by the Tyrannicides (see Figs. 5, 34) – also heroes and role models, honored by bronzes in the Agora and a cult at their tomb in the Kerameikos. This happy synthesis of myth and history – or as contemporaries would have seen it, of old Athens and new, of monarchy and democracy – continues for the rest of the century (Fig. 76), though Theseus's physique gradually softens in accord with current artistic and homoerotic fashion. The Theseus of Fig. 76 also suggests a more supple and flexible individual than the "iron man" type of the Tyrannicides. All this parallels the hero's development in the world of Athenian drama, where he becomes the unchallenged symbol of Athenian democracy and the fulcrum of two of its four charter myths (see Chapter 2), though at the cost of some tension with his monarchical position.

Euripides' *Suppliants* of ca. 420 (contemporary with Fig. 76) explores the intersection of these two charter myths. It presents Athens as Greece's universal refuge and benefactor, and Theseus (paradoxically) as both king and democratic crusader. He sums up the contradiction himself:

> I need the whole city's agreement too;
> It will agree if that is what I want;
> But if I have a reason, then I know
> The dēmos will be in a better mood.
> For I have made the land one single realm,
> Freeing the city and endowing all
> Alike with access to an equal vote.

1 The fact that Erichthonios/Erechtheus and Kekrops were always represented as part snake – a device to signal their earth-born origin – surely told against them here. Not only did this drastically curtail their freedom of action, but it is hard to identify with a serpent.

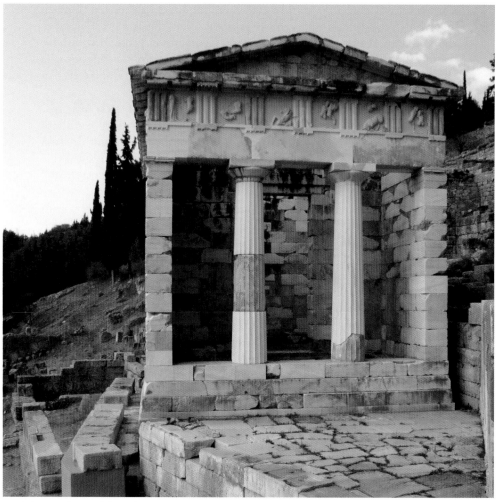

75. The east front of the Athenian treasury at Delphi, ca. 490–80. Marble; ht. of building, 7.59 m (24′11″). The treasury probably celebrated the Athenian victory over the Persians at Marathon in 490; a trophy and (later) bronze statues of Athenian heroes stood on the base against its south wall (to the left). Riding Amazons served as akroteria, and the pediment and east metopes show(ed) an Amazonomachy. The white marble sections are modern restorations; the metopal scenes are concrete casts of originals now in the Delphi Museum and are located randomly on the building.

In this play, where democratic Athens is starkly contrasted with tyrannical Thebes, its antitype and frequent enemy, the young king gradually learns the classic Athenian virtues of flexibility, prudence, tolerance, pity, and justice, until he becomes the very personification of the ideal city. And when the suppliant Adrastos addresses him as "glorious victor," a salutation proper to Herakles, the audience would have recalled that he had accompanied Herakles against the Amazons and also stood beside him on both the city's treasury at Delphi (Fig. 75) and the Hephaisteion in the Agora, begun in the 450s but not completed until these very years. To the Athenians he was *allos houtos Hēraklēs*, "a second Herakles."

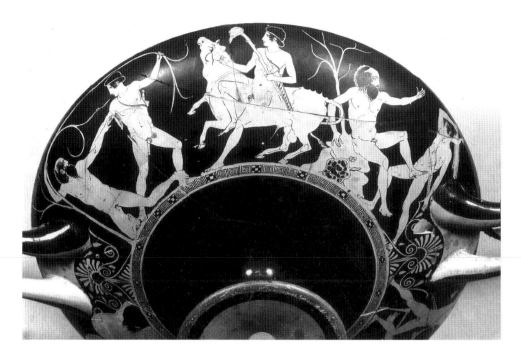

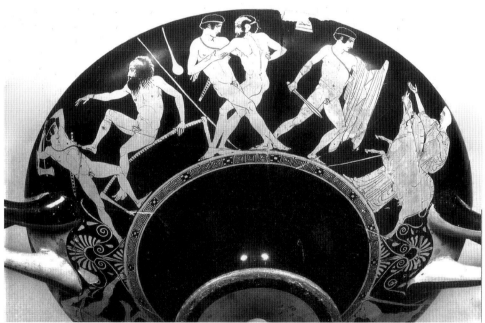

76. The deeds of Theseus. Details of an Athenian red-figure cup from Vulci (Italy) attributed to the Codrus Painter, ca. 420. Ht. of picture ca. 9 cm (3.5″). London, British Museum. Above (a): Sinis, the Marathonian Bull, Skiron. Below (b): Prokrustes, Kerkyon, the Krommyon Sow. Theseus encountered all but the Bull on his journey to Athens from Troezen; in two of the scenes he imitates Harmodios and Aristogeiton, Figs. 5 and 34.

155

Personifications

Dēmos was honored with a cult on the hill of the Nymphs (near where the Assembly met) around 450 and first appears as a distinct character in Aristophanes's *Knights* of 424. By then, the Assembly's mercurial moods were notorious, and Parrhasios soon parodied it in paint. His Dēmos, we are told, was "changeable, irascible, unjust, and unstable, but also placable, clement, and full of pity; boastful and [lacuna], illustrious and humble, ferocious and fearful – all at the same time."

Fourth-century Athenian document reliefs name Dēmos twice (Fig. 77), and from these he has been identified in over a dozen others, beginning with one carved in 409. On these, the official "voice" of the state, he is always represented as a dignified, bearded patriarch in a himation, explicitly belying Parrhasios's characterization. (Did he paint it for his own entertainment or for the oligarchic opposition?) Dēmos often leans on a staff, and when seated he holds a scepter to signify his sovereignty. He and Athena (personifying the city itself) solemnly shake hands in case of an internal agreement between different organs of the government, or he joins her when she greets and crowns citizen honorees and benefactors. In scenes involving international relations, however, it is she who personifies the state, not he (Fig. 74).

Dēmokratia, on the other hand, is a relative latecomer on the scene. The first hard evidence of an image of her does not occur till 403, and like Parrhasios's Dēmos it is not flattering. On the tomb of the pro-Spartan Kritias, a leader of the "Thirty Tyrants" of 404 (see Chapter 5), who was killed the following year in the civil war that toppled them, his friends erected a bronze group showing Oligarchy setting her on fire! She reappears several times in fourth century official Athenian art, including the relief in Fig. 77, where she crowns the mature, dignified Dēmos.

THE OIKOS

As we have seen, the oikos or household was the basic unit of life in every Greek city. It was also the basic unit of the state – even in communally inclined Sparta, which honored kinship, marriage, and the family despite its commitment to barrack-style living for its men. At Athens, in the scrutiny undergone by every prospective officeholder, the following questions were asked:

> Who is your father and to what parish (*deme*) does he belong? Who is your grandfather? Who is your mother and who is her father and what is his parish? Do you have a Family Apollo and a Household Zeus, and where are their shrines? Do you have family tombs and where are they? Do you treat your parents well? Do you pay taxes, and have you done your military service?

The household/family also is everywhere in fifth-century art, though some imagination often is required to detect it.

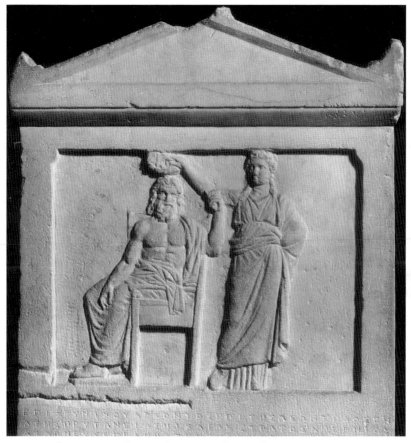

77. Dēmokratia crowns the seated Dēmos. Athenian decree against tyranny, 336. Marble; ht. of relief panel, 41 cm (1′4″). Athens: Agora Museum.

On the temple of Zeus at Olympia, we find it represented in both pediments. The eastern one (Figs. 42, 44) shows a household gone rotten: The House of Oinomaos, fatally corrupted by his hybris – his cruel and unnatural refusal to let his daughter marry. His queen, Sterope, looks on helplessly while a seer foresees the inevitable (Fig. 50). Pelops's house soon will supplant Oinomaos's; his name will identify the land – the Peloponnese; and his descendants by Hippodameia – the houses of Atreus and Thyestes – will rule it. The west pediment, by contrast, shows a "good" household – the House of Peirithoos – under assault from without (Fig. 45). As its members bravely fight off the drunken, hybristic Centaurs, the gods and its human allies come to their aid. Apollo directs the counterattack and Theseus leads it. According to this deeply conservative vision, the household/family *is* society and one household alone – the royal house – personifies and rules it.

Contrast the Parthenon, where the Olympian family's appearance in the frieze as witnesses to the dēmos's collective piety (Fig. 78) introduces the household/family in counterpoint to the city, here represented by its citizens en masse. Taking up this theme, on the east pediment the Olympians – the

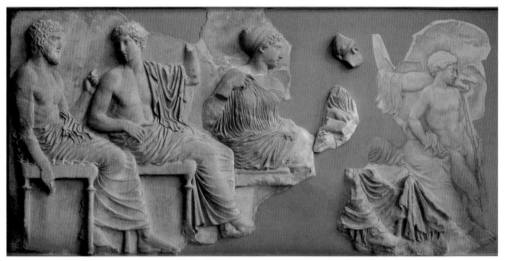

78. Poseidon, Apollo, Artemis, Aphrodite, and Eros, from the east frieze of the Parthenon, ca. 442–38. Marble; ht. 1.06 m (3′6″). Athens, Akropolis Museum.

House of Zeus – witness Athena's birth (Fig. 62), and on the west, the two Athenian royal houses, the Kekropids and Erechtheids, witness her victory over Poseidon (Figs. 63, 64). By contrast, the metopes show the family under threat, as at Olympia. On the east the Giants try to overthrow the House of Zeus; on the south the Centaurs again violate the household/family and its central ritual, marriage – invisibly presided over by Aphrodite Pandēmos (Figs. 65, 66); on the north the Trojans pay the penalty for condoning a similar crime, namely, Paris's elopement with the already-married Helen; and on the west the Amazons, a tribe of daughters who reject family, marriage, other filial obligations, and indeed urban life as such, meet their match in the Athenian citizenry of old. In sum, these sculptures proclaim that household/family and city must coexist in justice and harmony for society to thrive.

These themes, echoed as we have seen in contemporary Athenian tragedy, resonated at a private and popular level also. We have already met the Kleophon Painter's brilliant characterization of the brutal intrusion of city imperatives into the life of the household (Fig. 58). In the next chapter we shall encounter the toll taken by war and plague upon its members (see Figs. 100, 118, 121) and the survivors' yearning for better, happier days (see Figs. 119, 120).

Finally, the household in death. Just as the nekropolis outside the city gates mirrored the polis inside them, Attic fifth-century funerary oil-flasks or *lēkythoi* often show the dead as if still alive, amongst their families – though scenes of leave-taking, echoing that of Fig. 58, are common.

In the late fifth century the Attic cemeteries begin to sprout symbolic "portraits" of the household in the form of walled family burial plots embellished with assemblages of inscribed gravestones. These places were important not only to the family itself – custom prescribed commemorative visits at prescribed intervals – but also to the city. Its scrutiny procedures show that one's

79. The burial plot of the Koroibos family in the Kerameikos cemetery, Athens, ca. 410–370. Hegeso's gravestone is on the left. For the plot's location, see Fig. 96.

family tombs alone could prove one's ancestry and thus one's qualifications for citizenship and its benefits, the right to hold office included.

Among the most appealing of these memorials is that of the Koroibos family in the Kerameikos (Fig. 79), now reconstructed on site using concrete casts. The three gravestones accumulated between about 410 and 370, though dates and relationships remain uncertain. First, perhaps, came the beautiful relief of Hegeso, daughter of Proxenos and apparently Koroibos's wife (Fig. 80); next the gravestone carved with the water-jar or *loutrophoros*, commemorating Koroibos's unmarried brother, Kleidemos; and finally the tall palmette memorial, with an inscription recording Koroibos's own death. The names of Koroibos's son and grandson later joined his on the palmette memorial when they, too, passed away.

In keeping with Athenian democratic protocols of austerity and personal restraint, few offerings were found in the tomb below: only three small oil flasks and one alabaster vessel. Similarly, the palmette memorial, embellished only with two rosettes and a luxuriant palmette floral, celebrated not the actual physical appearance of the men of the household but (indirectly) their collective potency. Thanks to them, it suggests, this household flourished.

On the left, backed up against these men, Hegeso (Fig. 80) represented the women of the household: demure, stunningly beautiful, and clad in

semitransparent drapery, as if Koroibos were crying, "Look! I had the best and most gorgeous wife in Athens!" Her nameless slave girl, meekly offering Hegeso her jewel-box, stood for its servants.

On the right, the loutrophoros, a vessel used at both weddings and funerals to carry water for the ritual washing of brides, grooms, and the dead, compensated Kleidemos for the wife and children he never had. His inscription is the most informative, leaving little doubt of his fate. After invoking prudence and "excellence good in battle," it ends by calling him "once a glory to his father and now a sorrow to his mother." So probably he was killed while still young and lay not in the family plot but alongside his compatriots in the public cemetery just to the north.

Like Hegeso's tombstone (Fig. 80), fifth-century Attic ones generally feature only single figures or pairs – usually people who died a premature death in battle, in childbirth, or before they could marry. But in the fourth century they evolve into fully-fledged, self-contained portraits of the household (see Fig. 128). Many include representatives of its entire complement of free and slave; place them within stylized versions of its front door or inner courtyard (Fig. 32); and memorialize both the wrenching loss of one or more of its members and its continuity beyond mere time and space. Wish fulfillment, perhaps? For owing to the high mortality rate (in childbirth, in battle, and of disease) and the high rate of serial marriages, few Athenian households lasted intact for more than three generations (witness Koroibos's), and almost none for more than five.

Greek views about death and the afterlife were as various and confused as our own. Whereas Homer (always the supreme authority) chillingly depicted Hades as a ghastly, desolate, murky realm, and the dead as merely bloodless, stupid, gibbering ghosts bereft of memory, emotion, and thought, others still clung to the hope that after death one would rejoin one's family there. In *Agamemnon*, for example, Klytaimnestra, after killing her husband for sacrificing their daughter Iphigeneia so that the fleet could sail for Troy, remarks sarcastically that Iphigeneia will be the first to greet him in Hades, "with gagged and silent tongue." And in *Antigone*, the heroine enters her living tomb with the following words:

> So to my grave,
> My bridal bower, my everlasting prison,
> I go, to join those many of my family
> Who dwell in the mansions of Persephone,
> Last and unhappiest, before my time.
> Yet I believe my father will be there
> To welcome me, my mother greet me gladly,
> And you, my brother, gladly see me come.
> Each one of you my hands have laid to rest,
> Pouring the due libations on your graves.
> It was by this service to your dear body, Polyneikes,
> I earned the punishment that I now suffer,
> Though all good people know it was for your honor.

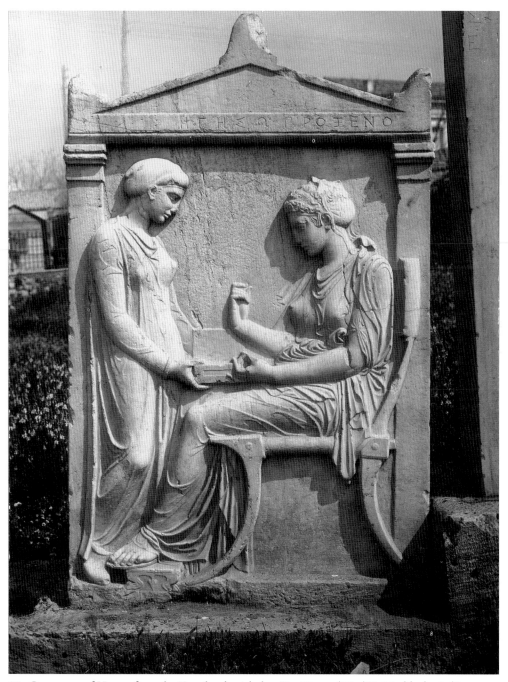

80. Gravestone of Hegeso from the Koroibos burial plot, Fig. 79, ca. 410–400. Marble; ht. 1.48 m (4′9″). Athens, National Museum.

Although in Fig. 128 the locale is left unspecified, and many gravestones clearly unite both living and dead, did the artist intend some reference to this ancient belief?

MEN

Although men are everywhere in classical Greek art, artists were actually quite selective in representing their everyday lives, and certainly do not offer us a simple panorama of them. The reasons for this include the following:

1. The clientele. Most Greeks shared an elitist perspective regardless of their own station in life. They had scant interest in representations of lower class or even democratic activities – for example, manual labor of any kind (a slavish thing), rowing in the fleet, voting in elections, or serving on juries. Worshiping the gods, hunting, exercising, feasting, or fighting with "manly" spear and shield was a different matter (see, e.g., Figs. 25, 35, 36, 57, 58).
2. Genres and functions. Greek sculpture was broadly religious, and in the classical period its themes and formats were few (see, e.g., Figs. 44–47, 74, 80, etc.). Painted pottery was less restricted, but it too still privileged myth and was produced for particular contexts with their own protocols and agendas: the symposion, the home, and the tomb (see, e.g., Figs. 35, 36, 40, 41, 51, 52, 57, 58, 76).
3. Greek anthropocentrism. The Greek focus upon the human body and the classical Greek "cult" of beauty meant that artists tended to play down or eliminate individualizing features (compare, e.g., Fig. 37 with Fig. 56); to reduce men's clothing to token wisps of drapery or dispense with it altogether (see, e.g., Figs. 5, 25, 30, 34, 44–47, 51, 52, 64, 67, 76); and to ignore settings or denote them in minimalist fashion by a column, a door, a chair, a tombstone, or the like (see, e.g., Figs. 8, 10, 36, 40, 41, 57, 80).
4. Classical decorum. The general acceptance of the ideal of self-regulation, of prudence and restraint in one's daily doings, and – in Athens – of the dēmos as a new elite soon caused the raunchier themes of archaic Greek art to go out of fashion. By ca. 450, gods seldom abduct mortal women; satyrs seldom molest maenads; explicit sex scenes all but vanish; symposia become decorous (see Fig. 57); men seldom dance naked at parties (contrast Fig. 8); and so on.

Warfare, athletics, the symposion, and cult – these are the main areas of men's lives that classical Greek artists addressed. But even here the transition from the archaic often brought major changes. Their common thread is an emphasis on the individual's personal qualities as manifested in these particular situations, and their deployment in the everyday life of the city. In sum, then, they are broadly educational and mutually reinforcing. They are broadly *didactic*.

Warfare

Archaic artists had delighted in the cut and thrust of battle, and particularly in duels where warriors faced each other eye to eye, shield to shield, and spear to spear. But in classical red-figure such duels rarely appear outside the heroic world (see Figs. 39, 76) and the battles with the Persians (Fig. 25), where the artist could showcase the triumph of Greek values over oriental barbarism. The contrast between the trim, naked Greek and clothed Persian in Fig. 25 neatly engages other cultural antitheses too: manly spear versus cowardly bow (a long-distance weapon); austerity versus display; masculinity versus effeminacy; strength versus weakness; and so on. As we shall see in Chapter 5, the same stereotypes reappear even more emphatically on the Nike Temple frieze (see Fig. 103).

Why are scenes of Greek fighting Greek so rare on fifth-century Attic pots, and the prelude to battle (see Fig. 58) or its results so much more popular? For as we have seen, this period saw a huge increase in intercity warfare, and the feeling that this was increasingly fratricidal seems not to have taken root until the fourth century. Indeed, sculptured memorials featuring such scenes are quite common, particularly during the Peloponnesian War (Fig. 81), and epitaphs sometimes glory in the number of men that the warrior dispatched to Hades before joining them himself.

Several reasons come to mind. First, most of these pots were intended for symposion or household use. What was appropriate for a warrior's tombstone would be less welcome in those contexts, now increasingly dominated by the sunny figures of Aphrodite, Dionysos (see Figs. 109 and 110), and their retinues. Second, fifth-century Greek art increasingly tends to prefer the moment before the event or the moment after it, since that is when character is most clearly revealed – in Figs. 58 and 121, the warrior's fortitude and self-sacrifice in leaving the comforts of home to fight for his city, and his sad fate when he does so. And third, the triumph of what one might call the tragic sensibility increasingly predisposed consumers (at least in Athens) toward such loaded scenarios.

A straightforward battle of Greek on Greek would engage little of this. Indeed, as Lysias remarked of one such contest, "There is no difference between victor and vanquished, except that one will die a little sooner."

Athletics

Greek athletics was little more than war pursued by other means (the word *agōn*, "contest," covered both). Again, classical vase-painters tend to avoid actual scenes of running, boxing, wrestling, chariot racing, and the like, preferring to show the athlete practicing, warming up, or victorious (see Fig. 36). Only the special prize jars or *amphorai* for the olive oil given to victors at the Panathenaic festival, still anachronistically decorated in black-figure, continue to illustrate the contests themselves as a matter of course, because the pot's whole purpose was to advertise them and to glorify the victor (Fig. 82).

In contrast, the four "crown" festivals at Olympia, Delphi, Isthmia, and Nemea offered only token rewards – a simple cloth ribbon or fillet followed

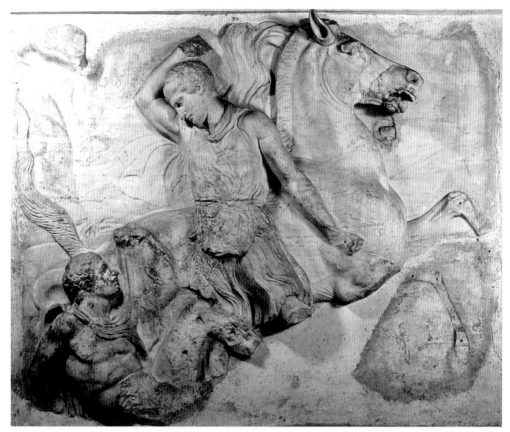

81. Gravestone of a warrior or warriors, ca. 420. Marble; ht. 1.8 m (5′11″). Rome, Villa Albani. The relief's unusually large size suggests that it may have embellished an Athenian state tomb for the war dead.

later and more formally by a plaited crown of olive, laurel, parsley, or celery. By 500, however, the organizers did allow victors to erect statues of themselves as a part of their prize, and the victors' hometowns often followed suit, with the city center or agora being the favorite venue. The statues – always of bronze, but represented today almost exclusively by Roman marble copies – were costly, and ranged from individual athletes preparing to compete, in action, or accepting their prizes (Figs. 83 and 84), to full-scale chariot groups complete with driver (see Fig. 48), victorious sponsor, and grooms. To be on the safe side, the victors often dedicated them to the gods anyway, and athletes at rest often deferentially bow their heads (Fig. 84).

The huge popularity of these victor statues from around 500 coincides with the invention and heyday of the publicly performed victory ode and with the heroization of a few lucky victors in cult. Because these supermen often belonged to the moneyed elite, these honors did not merely certify their attainment of superhuman status through their victories. (Indeed, the inscribed bases sometimes stress that the statues were exactly life-size, and the

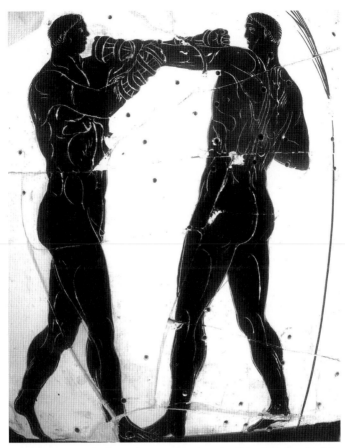

82. Boxers. Detail of an Athenian Panathenaic oil jar (amphora) of the Nikomachos series, from Cerveteri (Italy), 336. Ht. of vase, 83.2 cm (2′9″). London, British Museum.

surviving copies – such as Fig. 84 – concur.) Instead, the statues erected back home embodied a negotiation between city and victor over his acquisition and possession of special charismatic powers.

As Pindar makes clear in his ode for Psaumis of Kamarina in Sicily, who won the Olympic chariot-race in 452, the key word here is *kudos*:

Son of Kronos, master of windy Aitna,
Where powerful Typhos is trapped,
The hundred-headed,
Welcome an Olympian conqueror,
And, for the Graces' sake, this procession,
A light most lasting on deeds of great strength.
For Psaumis comes
On his chariot, crowned with the olive of Pisa.
He is eager to set up *kudos*
For Kamarina.

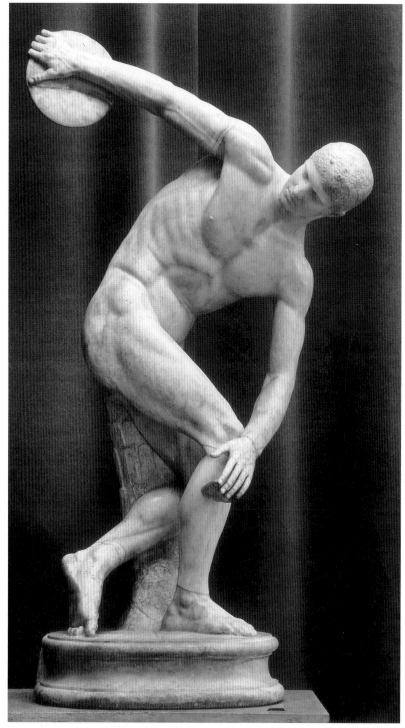

83. Diskobolos by Myron (Roman copy); bronze original, ca. 450. Marble; ht.
1.55 m (5′1″). Rome, Museo Nazionale Romano.

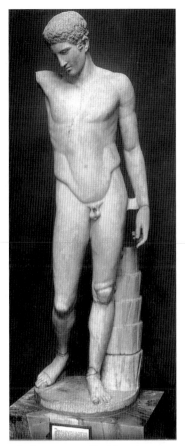

84. "Westmacott" athlete (Roman copy); bronze
original, ca. 430. Marble; ht. 1.49 m (4′10″). London,
British Museum. Probably a copy of the boy-boxer
Kyniskos at Olympia by Polykleitos, crowning himself
after winning his victory (see the reconstruction).
The tree stump and strut were added by the Roman
copyist.

This kudos is what we might call the victor's *mana*: the electrifying charisma
and unique, talismanic power of a man blessed by the immortal gods. The
sequel to this ode, celebrating Psaumis's triumphal entry into Kamarina, tells
us that he dedicated his kudos to his city. His victory and his receipt of his
victory fillet and crown certify this kudos (hence the two statue types illustrated
in Figs. 83 and 84, which concretize and perpetuate it for him). He then lays
it at his city's feet, thereby reintegrating himself into the fabric of society. So
everyone gains. The victor rejoins the city's "men's club" and the city gains
handsomely from his triumph. Indeed, so powerful was this heaven-sent kudos
that in battle the Spartans even stationed their "crown" victors next to the king
himself, and other cities chose them to lead the charge.

The Symposion

Two thoroughly masculine subjects whose popularity continues undiminished into the classical period are the symposion and the revel that preceded and followed it (Figs. 8, 57, 85, 130). Almost exclusively found on the two most popular sympotic shapes, the *krater* and the *stamnos*, they often encircle the vessel completely. Used to cut the wine with water (usually in a 2:3 or even a 1:3 ratio),[2] these big punch bowls would sit on a table in the center of the room, with the guests reclining on couches around it. They would thus see a mirror image of themselves in the picture.

Slaves would then dip jugs or *oinochoai* (Fig. 25) into the bowl and serve the wine to the guests, who used smaller bowls or cups (*skyphoi* or *kylikes*: Figs. 35, 36, 76) to drink it, according to preference. The early fifth-century poet Xenophanes of Kolophon describes the protocol:

> For now the floor is swept, and every hand and cup
> Is clean. A slave puts plaited crowns upon
> Our heads; another brings a dish of fragrant oil.
> The krater stands brim-full of party cheer,
> And other wine is ready, promising that it
> Will not run out; it's sweet and fragrant too.
> And in the midst the frankincense gives forth its scent,
> And water stands there too, cool, fresh, and pure.
> The yellow loaves lie close to hand, the table groans,
> Piled high with cheese and luscious honey-pots.
> An altar sits at center, all festooned with flowers,
> And song and feasting echo through the house.
> But merry men should first of all give praise to God
> With pious stories and pure-sounding words;
> Should pour libations, pray for power to do the right –
> For that's the foremost duty of us all.
> It's fine to drink as much as you can hold, and still
> Get home without a slave – unless you're old!
> I praise the man who even in his cups can show
> A decent memory and zeal for good.
> He marshals not those hoary tales of old, the fights
> Of Titans, Giants, Centaurs, and the like,
> Or quarrels of the past in which there's nothing worth.
> But always to respect the gods: That's best!

As we saw in Chapter 2, the first krater of wine was dedicated to Zeus and the Olympians; the second to the heroes; and the third to Zeus Soter (Savior), whose assistance one would surely need by that point. And Xenophanes's distaste for Titans, Giants, and other violent "fictions of men of old" was not widely shared until the fourth century, to judge from the popularity of such scenes on fifth-century crockery (see Figs. 39, 41, 51, 76).

2 Greek wines included the skins, stems, and pits, and so were extremely tannic. Moreover, watering them down increased the drinkers' endurance proportionally.

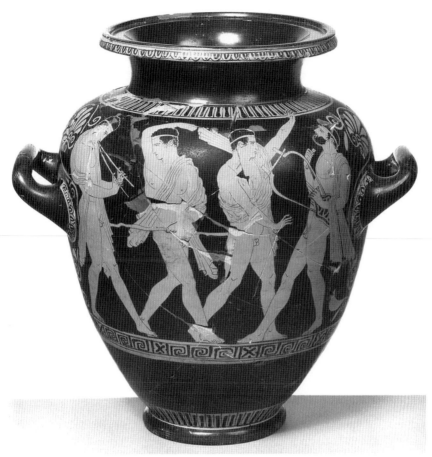

85. Revel. Athenian red-figure wine jar (stamnos) from Orvieto (Italy) attributed to the Kleophon Painter, ca. 430. Ht. 38.5 cm (1′3″). Copenhagen, Ny Carlsberg Glyptotek.

By ca. 450, this originally elite practice had been democratized – officially so in Athens, where in the Agora a new South Stoa provided banquet rooms that probably could be rented by those lacking such facilities at home. And whereas many earlier symposion pictures are quite rambunctious (see Fig. 8), now greater decorum reigns (see Fig. 57). The guests drink and converse quietly, and only the occasional head thrown back and hand clapped to brow signal that someone has downed too much. A flute-girl – now decorously draped – and the occasional acrobat or armed dancer provide the entertainment.

Relatively few pictures recall the heady days of the archaic. Some early classical ones still show symposiasts sharing couches with naked girls, and a handful of others pursue the story further. Among them, an exquisitely painted oinochoe in Berlin shows a young girl climbing on a boy's lap for sex while tenderly meeting his gaze (Fig. 86), and a bell krater in London shows a young boy enthusiastically trying the same gambit with a man while a couple inside a nearby house eagerly look on. A stamnos in Paris shows two men about to engage in highly athletic sex with a girl to the accompaniment of the lyre, and

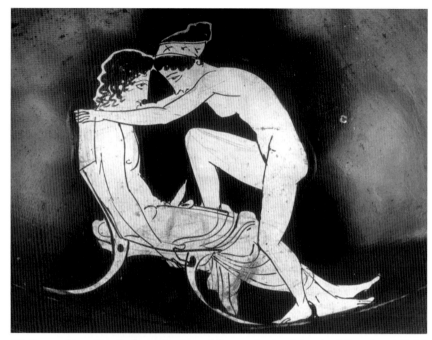

86. Lovemaking. Detail of an Athenian red-figure wine jug (oinochoe) from Locri (Italy) attributed to the Shuvalov Painter, ca. 430. Ht. of picture 6 cm (2.3″). Berlin, Staatliche Museen, Antikensammlung.

on its reverse two more men accost a naked flute-girl. Yet their sober, very classical expressions spoil the fun, unintentionally turning the event into a bit of a chore and perhaps helping to explain why most painters now preferred to avoid this sort of scene.

By no means would all symposia have been dominated by heavy Socratic discussions like those recorded by Plato and Xenophon, however, and these last few pots bring us somewhat closer to the bawdy, rough-and-tumble city of Aristophanes. Indeed, even Xenophon's *Symposion* ends with a bit of soft porn: A playlet about the love of Dionysos and Ariadne – a popular scene on late fifth-century vases (see Fig. 110, top left). After it, "seeing the two embracing and obviously leaving for bed, the bachelors among the guests swore they would marry forthwith, and those who were married mounted up and rode off to their wives to enjoy them!"

Cult

Both sculpture and pots abound with examples of individual and collective piety, reminding us that the Athenians considered themselves the most pious people on the planet. The Parthenon frieze (see Figs. 54, 55, 67, 68, 78) inspired a whole industry of votive reliefs in Athens and, eventually, other cities. They soon become quite formulaic (Fig. 87). Within an architectural or rocky frame alluding to the shrine in question, one or more individuals,

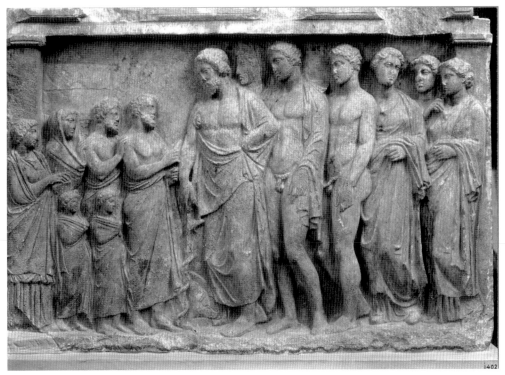

87. An Athenian family brings a sacrificial pig to Asklepios. Athenian votive relief from Loukou (Attica), ca. 375–350. Marble; ht. 53 cm (1′7″). Athens, National Museum. Asklepios's family stands behind him.

sometimes leading a sacrificial animal, approach the divinity or divinities, who are always larger in scale. Fig. 87, for example, is set within the Athenian sanctuary to the healing god Asklepios, established in 420 after the great plague. On the left, a family with a sacrificial pig and a slave-girl carrying a huge offering basket draped with a cloth approach Asklepios, who leans on his snake-entwined staff, looking down benevolently at them. Behind the god stands his own family: his wife Hygieia (Health); his two sons, the doctors Podaleirios and Machaon; and his three daughters, Iaso, Akeso, and Panakeia.

Cult scenes – processions, sacrifices, and other rituals – are popular on vases too. The most famous of these, clearly echoing the Parthenon frieze, is the Kleophon Painter's sacrificial procession to Apollo (Figs. 88, 89).[3] Not

3 Another krater in the manner of the same painter, also showing a sacrifice, is one of the very few overtly "political" vases to survive. The great connoisseur Sir John Beazley called it the "oligarchs' sacrifice," because among the participants the painter names Mantitheos and Kallias (prosecuted in 415 for mutilating the herms), Aresias (one of the Thirty Tyrants of 404), and Hippokles (one of the ten oligarchs who in 403 briefly succeeded the Thirty): *American Journal of Archaeology* 33 (1929): 366–7; *Attic Red-Figure Vase-Painters* (Oxford 1963): 1139 no. 9; cf. Susan B. Matheson, *Polygnotos and Vase Painting in Classical Athens* (Madison 1995): pl. 131.

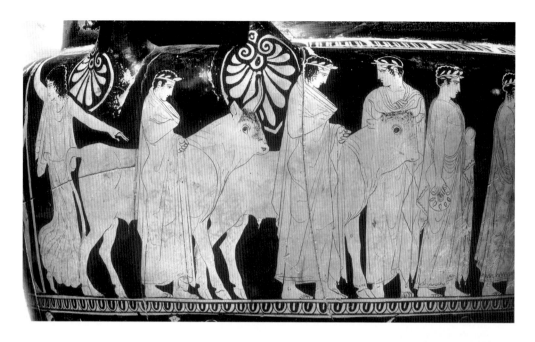

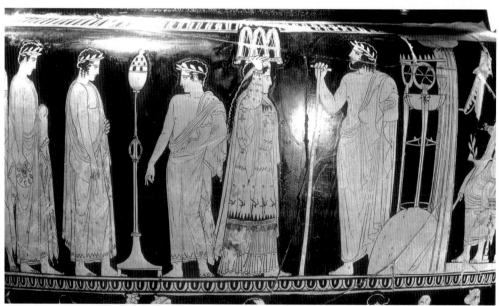

88. Sacrificial procession to Apollo. Details of an Athenian red-figure mixing bowl (volute krater) from Spina (Italy) attributed to the Kleophon Painter, ca. 430. Ht. of picture, 18 cm (7.1″). Ferrara, Museo Archeologico di Spina. The gesticulating girl at far left – a maenad – belongs to the Dionysiac scene on the other side of the vase.

only are the ages, deportment, and style of the figures similar, but as on the frieze most of them solemnly bow their heads in reverence. Apollo himself sits enthroned in his temple, identified by his quiver, laurel, Delphic navel-stone or *omphalos*, and tripods. The sacrificial bulls go quietly to their fate (a good

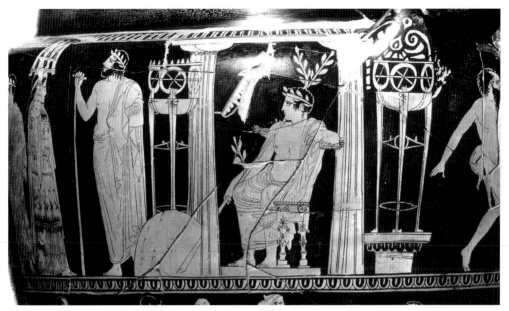

89. Apollo in his temple, from the krater, Fig. 88. The satyr at far right belongs to the Dionysiac scene on the other side of the vase.

omen), staring obliviously out of the picture. This device neatly involves us, the symposiasts reclining around the brimming krater, in the ritual. Xenophanes would have approved.

The painter alludes to the ritual's climax only by the offering dish in the hand of the youth directly in front of the leading bull, which will be used to catch its blood and to pour it on the altar (not shown), and the elaborate basket on the head of the richly dressed young priestess at the head of the procession. This holds the barley that the participants will sprinkle on the bull's head, and, beneath it, the sacrificial knife. In this way the painter disguises the violence of the occasion behind an orderly façade – the very order maintained and reaffirmed by the sacrifice itself, which decisively subordinates animal to man and man to god in a cosmically ordained hierarchy: the so-called Great Chain of Being.

On the krater's other side, Dionysos leads Hephaistos back to Olympos, accompanied by satyrs and maenads, who also cavort around the frieze below. This juxtaposition speaks volumes. It directly signals the pot's function and reminds us that Apolline moderation and seriousness represent only one side of the coin, the other being the ecstatic world of Dionysos; that balance is necessary in all things human and divine; and that these two worlds meet precisely at Delphi, the navel of the earth, where Dionysos ruled during Apollo's annual winter visit to the Hyperboreans.

An important group of vases, some of which may have been specially ordered, commemorate victories at festivals. Here a decline in the popularity of scenes showing victorious athletes is countered by a sharp increase in those commemorating dramatic and musical victories. In Fig. 90, for example, a

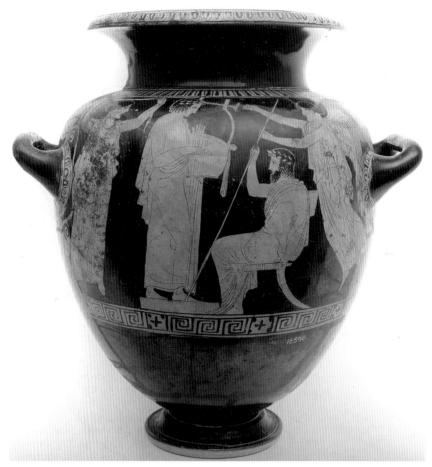

90. Kithara-player, judge, and winged Nikai. Athenian red-figure wine jar (stamnos) from Vulci (Italy) attributed to the Peleus Painter, ca. 430. Ht. 39.3 cm (15.5″). Vatican, Museo Gregoriano Etrusco.

kithara-player solemnly stands on a dais in front of a judge while two Nikai fly in to adorn him with victory fillets. Nothing better emphasizes the gulf between the classical and the archaic than a glance back at the ecstatic kitharode of Fig. 20.

WOMEN

The subject of women in Greek art, and particularly on Athenian ceramics, is colossal, complex, and contentious. Tens of thousands of images survive – but (as mentioned in the Introduction) almost certainly men made all of them and bought and used most of them. Many show women in what seem to be quite straightforward circumstances (e.g., Figs. 10 and 80), but others are more problematic and/or seem to conflict with the evidence of the texts. Some

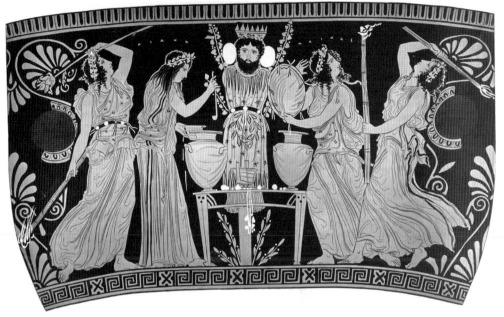

91. Maenads worship an image of Dionysos. Redrawing of an Athenian red-figure wine jar (stamnos) from Nocera de'Pagani (Italy) attributed to the Dinos Painter, ca. 430–20. Ht. of picture, 26 cm (10.2″). Naples, Museo Archeologico. The image, a bearded mask on a T-shaped post draped with real clothing, is that of Dionysos Lenaios, so the picture probably alludes to the Athenian festival of the Lenaia, held in early spring.

of these problems may be due to the complications mentioned earlier (genre, function, anthropocentrism, decorum, and so on), others not. The advent of feminism and the intensive scrutiny of both images and texts from this standpoint have demolished many earlier ideas about them, but have erected little that is substantial in their place.

Several ways of tackling this mass of material come to mind.

We can try to use the mythological and cultic scenes to reveal men's attitudes to women. Thus, unmarried girls (*parthenoi*) are Amazons at heart and so require male "conquest" (see Figs. 39, 101) in order to become socialized; women in general are oversexed and promiscuous, ruled by the irrational side of their natures as represented by Helen, Aphrodite (see Fig. 109), and Dionysos (Fig. 91); and so on.

As for the everyday scenes, we can try to use them to reconstruct female realities, examining what they tell us about women and their roles in society – as girls, brides, wives, mothers, hetairai, prostitutes, slaves, tradeswomen, priestesses, and so on. Or we can view them as parts of a representational subsystem, a complex set of gendered images that creates its own reality within the highly ideological visual landscape of the Greek city. Or (finally) we can investigate them from the customer's point of view, attempting to discover which were made for men, for women, and for both sexes, and treat them accordingly.

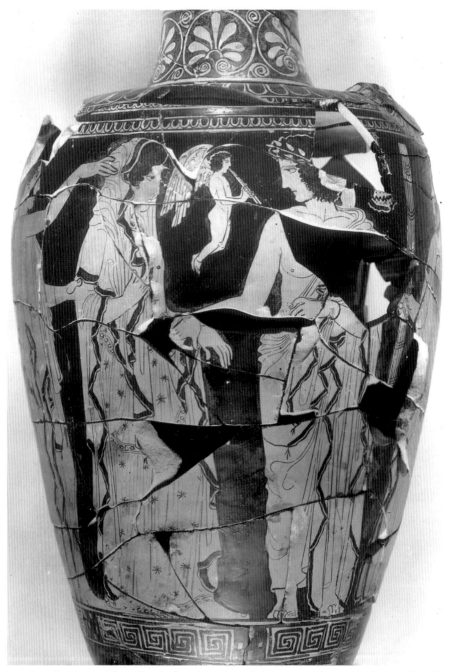

92. An Athenian wedding. Detail of an Athenian red-figure nuptial water jar (loutrophoros) from Pikrodafni (Attica) attributed to the Washing Painter, ca. 420. Height of picture, ca. 18 cm (7″). Athens, National Museum. The bridegroom takes his bride's wrist as an Eros plays the pipes between them, while a woman adjusts the bride's veil and another lights the way with torches.

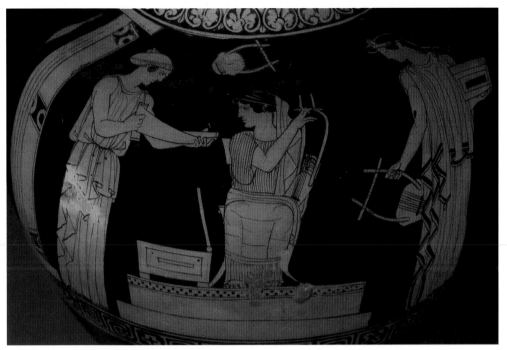

93. Indoor concert. Detail of an Athenian red-figure water jar (hydria) attributed to the Niobid Painter, ca. 460. Ht. 28.8 cm (11.3″). Solow Art and Architecture Foundation, New York.

These approaches are not mutually exclusive, but to give each its due would require a book in itself. So what follows is merely a glimpse of the possibilities, using a few selected objects as test cases.

Classical Greek artists indeed document many aspects of Greek women's lives from cradle to grave (for a selection, see Figs. 58, 80, 86–88, 100, 121). Yet they omit pregnancy, childbirth, work (many women helped to farm the land and sold goods in the agora), and the moment of death – those times when women confound male fantasies the most. We can also hazard (though strictly speaking we cannot prove) that conjugal sex is taboo.

Yet as soon as we begin to examine these images more closely, problems emerge. An unschooled viewer of Figs. 92–95, for instance, might conclude that for women, classical Athens was very like the modern West – indeed, was even more liberal. Athenian women married handsome young bridegrooms for love (Fig. 92); held concerts and poetry-readings in their houses (Fig. 93); let their daughters meet and entertain young men quite freely (Fig. 94); and stripped naked to exercise just as the men did (Fig. 95). But the texts prove that little or none of this is true.

Concerning Fig. 92, a scene repeated on hundreds of such vases, most Athenian girls married at around fourteen to fifteen and most Athenian men at around thirty. Yet the bride is fully mature and the groom ought to be bearded. Moreover, most such marriages were not love-matches but arranged in order to forge an advantageous bond between two households. As to Fig. 93,

177

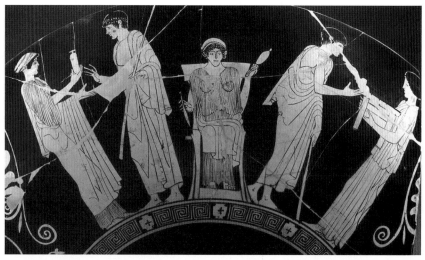

94. Brothel scene (?). Detail of an Athenian red-figure cup attributed to the Euaion Painter, ca. 470. Ht. of picture ca. 10 cm (3.9″). Berlin, Staatliche Museen, Antikensammlung. The seated woman at center is spinning wool.

the education of most women seems to have been quite rudimentary, even in Athens, and cultural events such as this must have been few and far between, if held at all.

But if these scenes are problematic, then Fig. 94 is totally perplexing, for it conflicts with everything that the ancient writers tell us about Athenian sexual segregation.[4] Girls and women were by no means free to meet men either indoors or outdoors. Instead, they were strictly chaperoned, particularly after Perikles' Citizenship Law of 451, which made legitimacy, and thus female chastity, crucially important to every Athenian family. Finally, Fig. 95 is unthinkable in classical Athens, where athletics and the *gymnasion* (literally, the "naked place") were exclusively male preserves. Compare the following exchange between Sokrates and Glaukon in Plato's *Republic* (see Chapter 6, Box 1):

> "I dare say," I rejoined, "that the novelty of our proposals would make many of them seem ridiculous if they were put into practice."
>
> "No doubt about that," he said.
>
> "Which of them," I said, "do you reckon to be the most absurd? Won't it be to see the women exercising naked with the men in the gymnasion? Not just the young ones: There'll be older ones too, just as

4 Not, however, actual physical *seclusion*. The seclusion of women sometimes alluded to by the Attic orators in their law-court speeches is a mirage conjured up to impress juries with the unbending rectitude of their clients. Moreover, archaeologists have consistently failed to locate such a secluded women's space or *gynaikeion* in the houses they have excavated (e.g., Fig. 32). Athenian men did not sequester their wives and daughters, but merely ensured that as far as possible they led segregated and chaperoned lives.

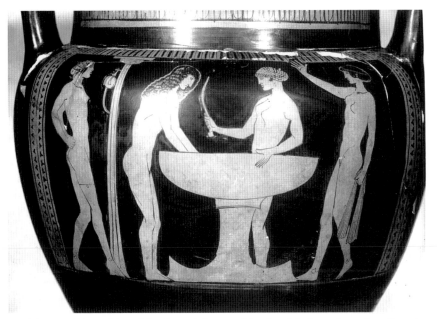

95. Teenage girls washing. Athenian red-figure mixing bowl (column krater) attributed to the Painter of Tarquinia 707, ca. 450. Ht. of picture 19 cm (7.5″). Vienna, Kunsthistorisches Museum. The column with hanging oil-flask or *aryballos* and strigil and the strigil held out by the girl at center right locate the scene in a *gymnasion*.

> there are old men who go on exercising when they're wrinkled and ugly to look at."
>
> "By Zeus, yes," he said; "by today's standards that'll be really hilarious!"

So what are we to make of these pictures?

The pot in Fig. 92 is a wedding vase, one of two closely related types used for the ritual washing of bride and groom and then perhaps exchanged as wedding presents. Whereas the painter has "matured" the bride, he has drastically "youthened" the groom (to borrow one of Sir John Beazley's useful coinages). The one has become a gorgeous young woman, Aphrodite's look-alike, and (like the Parthenon riders: see Figs. 54–55) the other represents "youth's gilded springtime." The Eros who serenades them on the flutes personifies this romantic spin on the event. This double dose of wish fulfillment shows each participant just as the other hoped that he or she would be when the bridal veil was lifted.

The pot in Fig. 93 is a water-jar, so its intended audience would have included women, whose responsibility it was to fetch water for the household; but it was also a symposion vessel, used to water down the wine. The open door shows that the scene takes place inside a house. Yet the lyre-player is sitting on a large, two-stepped platform that is quite out of place in a domestic setting. Moreover, on Attic vases women usually play the harp or the flutes, not the lyre. The young woman on the left might be a slave (she wears a headscarf like

Hegeso's slave girl, Fig. 80), though her action is ambiguous. Is she reading from the scroll that she has just taken from the open chest, or unrolling it for the lyre-player to sing from?

These puzzles are solved when one realizes that the scene combines elements from two quite different genres. The isolated musician playing on a platform is imported from the world of men's competitions and festivals (Fig. 90), and a get-together of women with scrolls and musical instruments comes from a gathering of the Muses. So this picture bestrides both worlds, the everyday and the mythical – an increasingly popular tactic in fifth-century vase painting. It thereby signally flatters its female subjects by assimilating them both to the Greek "men's club" and to the immortal goddesses of high culture. The scene may be total fantasy. But if real women truly did inspire it, were they elite Athenians or members of the demimonde (courtesans or *hetairai*)?

So a pessimist might argue that this picture tells us nothing concrete about women's lives in classical Athens beyond what we knew already: that some learned to read, and some to play and sing. An optimist, on the other hand, might retort that the artist was at least able to envisage the possibility of women's gatherings of this kind, and must have had something to go on in order to do so.

What of Fig. 94, a cup intended for the symposion and an audience of men? Vases showing young men approaching women spinning or propositioning others in their presence are not uncommon, and have prompted varying reactions. Early scholars thought that the men were trying to lure the girls away from home with fancy gifts. But others, realizing that no respectable household would have permitted such visits, and noticing that the men sometimes hold moneybags, argued that the setting must be a brothel. But if so, is the spinster (in the case of Fig. 94) its madam? Is she a prostitute earning her keep by doing some wool-work on the side? Or is her spinning equipment an exotic fetish, like today's Little Red Riding Hood or French Maid costumes? Were fifth-century Athenian men turned on by whores playing housewife?

To answer these questions, one's first instinct should be to check out the other pictures on the vase, but unfortunately these are of little direct help. The reverse shows a youth and a bearded man each chatting up a young woman while a woman with jug and offering dish looks on (trysting at a festival?), and the interior a very young couple conversing by a stool.

Fortunately, in Fig. 94's case archaeology comes to the rescue. In the 1970s the excavators of the Athenian Kerameikos found a large house in the angle between the city wall and the Sacred Gate, the now-notorious Building Z (Fig. 96). Built around 440, it was destroyed and rebuilt several times over the next few centuries. Its entrance was the first on the right inside the gate, and it was much bigger than a normal Athenian house (see Fig. 32). It included at least twenty rooms, most of them quite small, grouped around a courtyard (later, two courtyards) containing a well and cisterns. The finds included many symposion vessels; numerous terracotta figurines and amulets of Aphrodite and other goddesses; a silver plaque showing Aphrodite Ourania crowned by Eros and riding a goat across the night sky; and vast quantities of loom weights, which turned up in nearly every room.

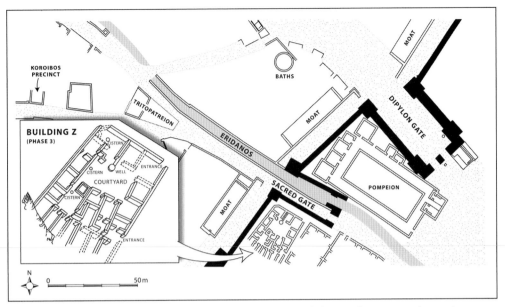

96. Building Z in the Kerameikos, Athens, ca. 330. Built around 450 as a large private house, it was destroyed and rebuilt several times; the picture shows phase 3, when probably it served as a brothel.

With all this in mind, the excavators concluded that Building Z probably served as a brothel, at least in the later fourth century. It is situated exactly in the right place for the weary traveler, and indeed, a fourth-century comedian refers to a brothel in this very area that employed over thirty women. To judge from the ethnic jewelry found in the house, its inhabitants came from Thrace, Anatolia, and Syria – all major suppliers of slaves to Athens, and especially of women notorious for their sexual prowess. In Building Z, as in Fig. 94, they evidently plied a dual trade, making textiles for sale when not working in bed. Indeed, the normal Greek word for brothel was simply "workshop," and because weaving and sex were women's work *par excellence*, Greek poets often slyly juxtaposed the two.

So is Fig. 94 a "realistic" picture of the interior of one such brothel? Maybe, maybe not. Everyone here and elsewhere on the cup is properly attired (though the spinster's dress is revealingly transparent); everyone behaves with perfect decorum; and no money changes hands. Yet the Athenian comic poets, our main sources for such things, show that real life was often quite different.

> The things the young get up to in our town!
> For we've got some bodacious lasses here
> Inside the brothels – y'all should check 'em out –
> Girls lounging naked in the sun, their tits
> Quite bare, outflanking you to left and right.
> From these you choose whichever one you want:
> Girls thin or fat, rotund or tall or squat,
> Girls young or old, mature or overripe.

And:

> They stand there naked; all's up front; go look!
> Down on your luck and got a hard-on too?
> The door's wide open; one obol's the fee.
> Just pop in! No one's shy – no crap like that –
> And no one runs and hides. You get the girl
> You want straight off, and any way you want.
> Then out you go. Fuck her! She's nowt to you.

The Greeks had a word for this kind of woman: *pornē*, or common whore. In principle, at least, she occupied the opposite end of the scale from the elite hetaira or courtesan (literally, "female companion"). Characterized as beautiful, independent, educated, witty, expensively dressed, and charmed only by gifts, not money, the courtesan emerges in the context of the late archaic symposion as the aristocratic answer to the "democratic" whore, open to all for a penny a go. Against vulgar cash (at that time a relatively new invention) and the sordid commerce of the agora, the courtesan pits aristocratic gift-exchange and the refined camaraderie of the symposion. But because both of these categories are male constructs, diametrically opposite ways of describing the same phenomenon, in reality the boundary between them was fuzzy indeed. One man's courtesan was often another man's whore: Witness the comic jibes at Perikles's favorite courtesan and mistress, Aspasia.

So probably the scene in Fig. 94 masks the crude realities of prostitution by drawing a veil of decorum and aristocratic gift-exchange over them. Moreover, in the cup's three pictures a total of no fewer than five such couples are involved, all engaged in the same kind of refined transaction. Does the painter protest too much?

Finally we turn to Fig. 95, one of several fifth-century scenes of young women cleaning up after exercising (washing at a basin and scraping themselves with bronze scrapers or *strigils*). They appear exclusively on men's symposion vases.

It has been pointed out that although they echo pictures of male athletes cleaning up, they systematically exclude the characteristic features of the gymnasion – the hermaic pillar and turning post (see Fig. 36) – and often substitute the more ambiguous column, which equally could signify the interior courtyard of a house. Furthermore, despite the young women's supposedly dirty and sweaty state, not one of them has a hair out of place, and the one on the left of Fig. 95 even wears a thigh-band, an accessory more at home in the bedroom. Finally, on one stamnos, a youth pops up from behind the basin to fondle the breast of one of the girls, who raises her hand in annoyance to slap him away.

These pictures were once thought to be straightforward representations of Athenian girls exercising, and the practice of reserving public facilities for women on specific days, attested later in Asia Minor, was invoked to explain them. Yet Sokrates's remarks, quoted above, make it clear that nothing of the sort took place in classical Athens. So other scholars promptly turned to Sparta, where girls certainly did exercise naked. Organized like the boys into "herds,"

they were not taught the usual women's work of weaving, cooking, and so on, for in Sparta all such chores were done by slaves. Instead, they practiced dancing, singing, and sports, including running, wrestling, discus, javelin, and ball games.

Everyone agreed that the main purpose of this curriculum was eugenic, because, as Xenophon bluntly remarked, "if both parents are strong, they produce the most vigorous offspring." The physical fitness of these Spartan girls was legendary, as was their beauty. Poets from Homer to Theokritos and a series of sixth-century Lakonian bronze mirrors using naked girls as supports enable us to visualize this Spartan ideal: lithe, fast, slim, and tall, with fine ankles, strong thighs, firm breasts, and long, auburn hair. In our period, the irrepressible Aristophanes parodies it in his *Lysistrata*:

> LYSISTRATA: Welcome, Lampito my dear. What's up in Sparta?
> Darling, you look simply gorgeous. Such color, such resilience!
> Why, I bet you could throttle a bull.
> LAMPITO: So could you, my dear, if you were in training.
> I practice rump-jumps every day, you know.
> LYSISTRATA (prodding her): And such marvelous tits too.
> LAMPITO (indignantly): Oi! Don't treat me like some sacrificial beast!

But is Fig. 95 a straightforward picture of Spartan girls at exercise? At least one scholar disagrees, arguing that the distinctly erotic flavor of these scenes and the omission of the contests themselves show how impossible it was for Athenians, lacking any tradition of women's athletics, to conceptualize them outside the sign of Eros. For whereas men's exercises prepared them for war (and the vessel's reverse shows three boys training), these are characterized as preparation for bed. The painters never show the women's actual gymnastics because they were irrelevant to this function and indeed would have actively undercut it.

Yet might Sparta still lurk behind these pictures? In Fig. 95, not only do the strigil and oil flask hanging casually on the column indeed seem to mark the setting as a gymnasion, but also Spartan girls were famous in Greece for their unorthodox education and the forwardness it supposedly instilled. Indeed, another, late archaic batch of symposion vases showing "liberated" naked women, this time partying together at their own symposion, gives some of the participants recognizably Spartan names. Now, Athenian aristocrats admired Sparta. Kimon even named one of his sons Lakedaimonios, "Spartan," and the oligarchs of 411 and 404 all flaunted their pro-Spartan sympathies, as did Xenophon. One of the Thirty Tyrants, Kritias (we encountered his rabidly antidemocratic memorial earlier in this chapter), even praised Sparta's constitution in both prose and verse, exercising naked for both sexes included.

So were these vases painted for this reactionary cabal, whose closed-door parties were notorious? Or – because oligarchs surely were not the only Athenians who enjoyed suggestive pictures of this sort – for others? Or were they just a sexist joke, as Aristophanes's *Lysistrata* and Sokrates's comments in the *Republic*, both quoted above, might suggest?

It is pleasant to turn from these puzzles to an object that definitely was made for a woman, the bronze hand-mirror in Fig. 97. These were exclusive to women, who often received them as presents at puberty or marriage; some ended up as dedications in sanctuaries, whereas others went with their owners to their graves. This kind of "caryatid" mirror (so-called because it uses a girl as a support, as on the Erechtheion; see Fig. 111) was popular from the sixth through the mid-fifth century. Many different workshops produced them; this one perhaps was made in Argos.

The young woman stands proudly erect on an elaborate, lion-footed base, holding out a bird in her right hand: a dove for Aphrodite? Her garment, the severe *peplos* worn by (among others) Sterope, Hippodameia, and Athena at Olympia (see Figs. 44, 46, 49), modestly covers her body but discreetly accentuates her arms, breasts, and neck. Her expression is serious, her hairdo as simple as her clothing: bound by a circlet, parted at center, and drawn back in a bun. Two naked Erotes flank her, looking and gesticulating toward her as if proudly presenting her to the viewer.

Above her, a support in the form of a palmette flanked by two half palmettes (symbols of life and fertility) secures the mirror disc. Two hounds pursuing hares, two rosettes, and a Siren complete the ensemble. The hunt is a favorite metaphor for the sport of love; the rosettes symbolize beauty in full bloom; and the Siren reminds us of the song that captivated Odysseus and lured less wary travelers to their deaths. In this highly eroticized environment, it reminds us that a woman's magnetism resides not only in her looks but in her voice and indeed her scent as well.

So the lucky owner of this exquisite object could both enjoy it for its own beauty and, as she held it, identify physically with the peplos-clad girl grasped in her hand – a paragon of female prudence and reserve. Moreover, as she gazed into its once-polished mirror disk, she would see her own face surrounded by erotic symbols – hovering Erotes, luxuriant palmettes, eager hounds, perfumed blossoms, and serenading Siren. But the latter might also remind her that her charms could be used both for good or – quite devastatingly – for ill. As the chorus remarks in *Antigone*,

> Where is the equal of Love?
> Where is the battle he cannot win,
> The power he cannot outmatch?
>
> In the farthest corners of earth, in the midst of the sea,
> He is there; he is here
> In the bloom of a fair face
> Lying in wait;
> And the grip of his madness
> Spares not god or man.
> . . .
> For the light of desire that burns in the eyes of a bride
> Is a fire that consumes.
> At the side of the great gods
> Aphrodite immortal
> Works her will upon all.

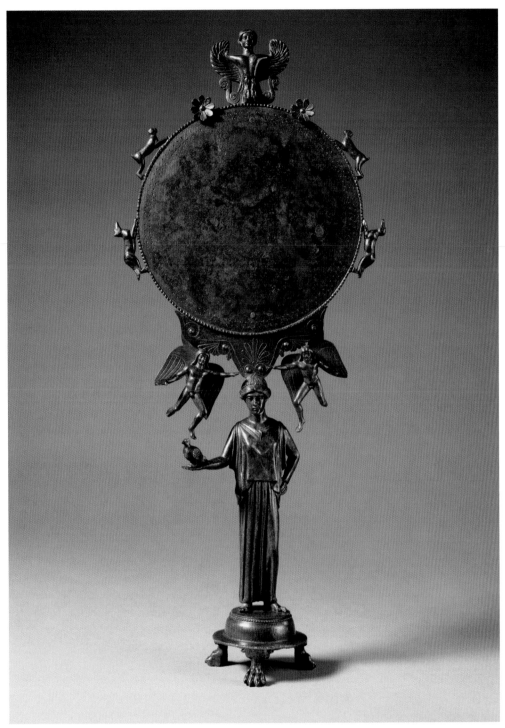

97. Young woman supporting a mirror, ca. 450. Bronze; ht. 40.4 cm (1'4"). New York, Metropolitan Museum of Art; for detailed credit see Sources of Illustrations.

CHILDREN

The Greeks sharply distinguished childhood from adolescence, when boys and girls mature sexually and begin to attract social and erotic attention. Sixth- and fifth-century artists fixate upon teenagers (see Figs. 5, 6, 34–36, 92, 94, 97, 100, 119, 120), and only around 500 do younger children begin to appear. Soon, artists begin to recognize different developmental stages in childhood, noting their characteristic details of appearance and behavior (Figs. 98–100). At Athens, Perikles's Citizenship Law of 451, with its focus on citizen legitimacy, perhaps quickened this growing interest in young Athenians-to-be.

Some, at least, of these objects were made *for* children, and engage us with often startling directness. For example, the terracotta in Fig. 98, one of many made in Boeotia around 500–450, shows a woman teaching her daughter how to cook. She sits in front of a three-handled pot, which rests on a trivet set over a charcoal fire. Raising her left hand to shield her face from the heat, and turning her head toward her daughter, she sprinkles salt or herbs into the pot. The girl eagerly holds her mother's wrist and peers inside to check out the result. Although some have connected these images with death and the afterlife, likening them to Egyptian *ushabtis*, the simplest explanation is that they are children's toys. Of course, this does not prevent them from being vaguely instructional, like toy cooking sets today, nor from being buried with their owners if they died young – for in the ancient world, half of all children failed to reach puberty.

In classical Athens, it was fashionable to give boys and girls special juglets or *choes* such as that in Fig. 99 for the spring festival of Dionysos, called the Anthesteria or flower-festival. On its first day, the jars of new wine were opened and tested; the second, known as the Choes or "Jugfest," was devoted to a drinking contest, with the prize going to whoever drained his or her juglet first; and the third, dedicated to Hermes, to appeasing the spirits of the dead, when the girls ritually swung on swings. So as one scholar has remarked, "The Anthesteria was in large measure a festival that celebrated new growth and transformation: the juice of the vine into a potent drink, the bud to the blossom, and Athenian infants into the newest members of the community." Some of these small pots, of which over a thousand survive, furnish our best evidence for little children's lives (Fig. 99), whereas others spiral off into fantasy.

Some of these juglets have been found in children's graves, as souvenirs of happier days or as compensation for the child's premature demise before he or she could enjoy them. All Greeks agreed that the death of a child before its parents was the worst tragedy that could befall a family. Poem after poem, in both Attic drama and the specialized genre of the funerary epigram (Fig. 100), tells us of children cruelly extinguished before fulfilling their potential and of parents cruelly shorn of love, joy, and hope. Indeed, about a third of all classical Greek gravestones depict children, and on many of these they are alone and therefore definitely the deceased.

In the 420s, a certain Mnesgora and Nikochares were memorialized thus by their grieving parents after "demon fate" snatched them both brutally away

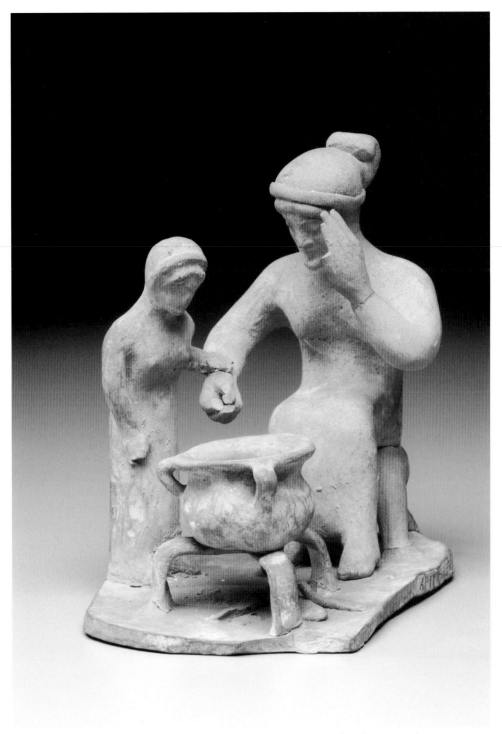

98. Woman teaching a girl how to cook, from Tanagra (Boiotia), ca. 480. Terracotta; ht. 10.7 cm (4.2″). Photograph © Museum of Fine Arts, Boston; for detailed credit see Sources of Illustrations.

99. Child in a potty-chair. Athenian red-figure miniature wine-jug (*chous*), ca. 430–400. Ht. 4.5 cm (1.8″). London, British Museum.

(Fig. 100). Mnesagora is a *parthenos*, a virgin ripe for marriage and so probably around fourteen to fifteen years of age. Faultlessly attired and with her long hair modestly but attractively gathered in a ponytail, she hands a pet bird to her chubby sibling, who must be about 3 or 4. His playful gesture and happily open mouth are full of childish innocence, for he is still ignorant of mortality and the human condition, but her lowered head and solemn expression tell us that she knows better and subtly evoke the memorial's function. The bird in her hand is a favorite pet, but also may make an oblique reference to death. As Theseus says of his dead wife Phaidra in Euripides' *Hippolytos*,

> You are like some bird vanished from my hands,
> Launching yourself with a sheer leap to Hades.

Indeed, on a few contemporary white-ground lekythoi the souls of the dead even are depicted as birds.

SLAVES

Slaves are ubiquitous in Greek art, though it needs some experience to recognize them. Essentially, because there were no paid servants in antiquity, anyone who is doing slavish things – conspicuously serving others or working for

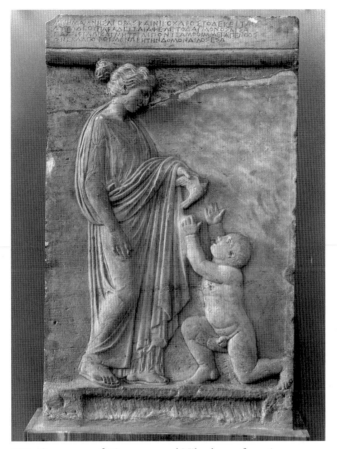

100. Gravestone of Mnesagora and Nikochares, from Anagyrous (Vari) in Attica, ca. 430–20. Marble; ht. 1.19 m (3′11″). Athens, National Museum. The epigram above tells us that "demon fate" brutally snatched them both away to Hades.

them – is likely to be a slave. These include the crouching servants at Olympia (Fig. 42), the flute girls entertaining symposiasts (Fig. 57), the boy tying the rider's belt on the Parthenon's north frieze (Fig. 67), Hegeso's maidservant (Fig. 80), and the girl also holding a box at the far left of the Asklepios relief (Fig. 87). Slaves are often represented as smaller than their freeborn owners (like antebellum Southerners in the United States, the Greeks called their slaves "boy" or "girl"), and their hair is often cropped short and badly combed. In addition, Hegeso's maid wears the long, sleeved shift that Greek writers tell us was a slave girl's garment.

All this, however, leaves a large class of women whose exact status remains in doubt, such as the gesticulating girl to the right of Fig. 58, the one holding the scroll to the left of Fig. 93, and – we may now add – those attending the youths in Fig. 94. For although all are well dressed, one late fifth-century pamphleteer alleges that Athenian slaves could be as smartly turned out as their owners and just as free in their manners as well. This may be mischievous

exaggeration, but must have contained a grain of truth to be credible. Pointers to slavery include the simple headscarves that the girls wear (compare Hegeso's maid, Fig. 80); the lack of self-control of the girl in Fig. 58; and the servile action of the one in Fig. 93. Yet their exact status must remain open. Either the painters were not interested in emphasizing it or thought they had given their customers enough information pro or con. We cannot tell.

But we must revisit Hegeso's maid (Fig. 80). Her filmy clothing, blatantly emphasizing her breasts, belly, and thighs, introduces another dimension to the issue of slavery – the sexual. Here, rather surprisingly given her servile status, she competes with her mistress for our attention, and perhaps even eclipses her. But recalling that the principal audience for this memorial was Hegeso's bereaved husband, Koroibos; that in Greek art the spectator is typically gendered male; that to the Greeks, vision was long-distance touch; and that (again as in the antebellum South) slaves' bodies were always at their masters' disposal – recalling all this, we can begin to guess what was in the sculptor's mind.

Despite assigning a different value to each woman through her dress, pose, action, and (in Hegeso's case) her elegant chair, footstool, and inscription, he insinuates that by virtue of their sex, both are – or were – Koroibos's possessions, to be used at his pleasure. Yet whereas the slave-girl is only a thing, a living tool wholly at her owner's disposal, Hegeso's matronly pose, downcast eyes, elaborately confined hair, and decorous clothing proclaim her superior status, her perfect womanly prudence and reserve. She is the ideal Athenian wife. As a character in Xenophon's contemporary dialogue *On Household Management* revealingly remarked of his own new bride:

> Exercise [at household tasks] gives her a better appetite, improves her health, and colors up her cheeks. And when she's standing next to her maid, more freshly scrubbed and more becomingly dressed, it's a ravishing sight, especially since she grants her favors willingly, while those of the girl are compulsory.

Further commentary seems redundant.

CHAPTER 5

THE GREAT CONVULSION

THE ARCHIDAMIAN WAR

In 431, Athens and Sparta came to blows again. Convulsing most of the Greek world, the war dragged on for twenty-seven years, as Fortune favored first one side and then the other. Evacuating the countryside before the Spartan King Archidamos and his Peloponnesian army, the Athenians retreated behind their impregnable Long Walls (see Map 3). Thucydides describes the scene:

> The inhabitants of Attica were bitter at having to uproot their entire households, especially since they had reestablished themselves only recently after the Persian invasion. It was sadly and reluctantly that they now abandoned their homes and ancient, time-honored shrines . . . When they arrived at Athens a few had houses of their own to go to and a few more were able to find shelter with friends and relatives; but most of them had to settle down in those parts of the city that had not been built over and in the sanctuaries and hero-shrines – excepting the Akropolis, the sanctuary of Eleusinian Demeter, and any other precinct that could be securely closed . . . And many took up residence in the towers along the walls and, in fact, wherever they could find space to live in. For the city was too small to hold them all, so later they also subdivided the land between the Long Walls and most of the Piraeus and lived there.

These tens of thousands of refugees jammed together in squalor proved to be a perfect incubator for the great plague – probably typhoid – of 430–26. It killed about a quarter of the adult population, including Perikles, but (ironically) spared the Peloponnese entirely.

In Athens, the plague caused appalling suffering, widespread despair, and wholesale disruption of life and ritual. Thucydides grimly describes the

symptoms and chillingly evaluates their effect, and Sophokles's *King Oedipus*, produced probably at this very time, vividly catches the city's mood. A plague has struck Thebes:

> A tide of death from which there is no escaping;
> Death in the fruitful flowering of her soil;
> Death in the pastures; death in the womb of woman;
> And pestilence, a fiery demon gripping the city,
> Stripping the house of Kadmos, to fatten hell
> With profusion of lamentation.

No sacrifices or prayers can quiet this demon; the wise, far-sighted Oedipus is Thebes's last hope. Apollo's oracle at Delphi has warned of a hidden pollution in the city, and commands that it be driven out. But Oedipus, blinded by his own intelligence, cannot see that Apollo is pointing at him. Unknowingly, he had killed his father and married his mother, and for the rest of the play he slowly and painfully discovers the awful truth, clue by clue and revelation by revelation. The moral is clear. All men make mistakes; sometimes they make them for the best of reasons, but must pay even so. Intelligence helps only so far, the gods are inscrutable, and happiness is ephemeral:

> For mortal man must always mind his end.
> Call no man happy till the day he takes
> His happiness down to the grave in peace.

Perikles' glittering edifice had begun to crack. Indeed, when in 420 the Athenians solemnly imported the healing god Asklepios's sacred snake from Epidauros, its host until suitable quarters were built and a cult inaugurated was none other than Sophokles himself – inspired, he said, by a vision. For hosting this medical reptile the poet received heroic honors and the posthumous cult title of Dexion or "The Receiver."

The plague may have been what prompted the Athenians to begin erecting carved gravestones again, as compensation to the victims – especially the young – for their untimely fate. Otherwise, why do these memorials suddenly reappear, after a seventy-year hiatus, at this very moment? Why do some cram several names onto a two-person composition? And why do a few even hint darkly as to the cause of death? Thus the relief of Mnesagora and her little brother Nikochares (Fig. 100) proclaims that their grieving parents erected it after "demon fate" snatched them both cruelly away. Coincidence – or not?

But when the demon was done, the Athenians recovered remarkably fast. Now led by Perikles's successor Kleon, a factory owner and a far less temperate man, they crushed their rebellious allies; more than doubled the imperial tribute; and in 425 even succeeded in marooning a Spartan force on the Peloponnesian island of Sphakteria. Among the captives were 120 Spartiates, whose surrender was a huge blow to Spartan prestige – for Spartans *never* surrendered. Yet when Sparta sued for peace, Kleon, thirsting for more, persuaded the dēmos to refuse. But Sparta's best general, Brasidas, counterattacked

vigorously in the north, and after both he and Kleon fell fighting there in 422, the two sides, exhausted, soon declared a draw.

Early in 421, with peace in the offing, Aristophanes staged his comedy of that name. Parodying a now-lost tragedy by Euripides, his hero Trygaios rides a huge dung beetle up to Olympos to find out why Zeus is destroying the Greeks by war. Hermes meets Trygaios, tells him that the gods are fed up with Greek squabbles, and bluntly blames them for prolonging the war. He then explains that War has imprisoned Peace in a cave, has found a huge mortar to grind down the Greeks, and has sent his slave Tumult in search of pestles to do the job. But Tumult has learned that Athens and Sparta have each lost their pestles – Kleon and Brasidas. So there might be a chance of setting Peace free.

Miraculously, Trygaios eventually gets the squabbling Greeks to co-operate and to pull Peace to freedom on the end of a giant rope. The play ends with farmers trading their weapons for plowshares and pruning hooks amid promises of peace and plenty. Although personifications in Greek literature and art are as old as Homer, and Nike in particular had a long history (see Figs. 69, 77, 90), this is the first time that Peace had appeared onstage in the flesh.

So, incredibly, the Athenians had won the war on points. Not only had they weathered invasion, plague, and revolt, but they had emerged with their empire larger, more strictly policed, and more profitable than ever. The Spartans, on the other hand, had lost a lot of prestige and even some key allies. For the Corinthians, Megarians, and Boiotians, enraged at their shabby treatment in the peace treaty, refused to sign it and left the Spartan alliance.

Yet in Athens, all was not as it seemed. Confidence was eroding; doubt returning; and a cultural crisis looming. The war and the Sophists had done their work well. Contemporary drama, too, reveals that the Athenian cultural consensus and the sunny optimism of the Periklean years were eroding fast. Aristophanes' *Acharnians* (425), *Knights* (424), and *Wasps* (422) savage the youth of the day, the Athenian jury system, Kleon, and the fickleness of the dēmos; his *Clouds* (423; revised in 416) takes on Sokrates and the Sophists; his *Birds* (414) skewers Alkibiades and the Sicilian expedition (see below); his *Lysistrata* (411) has the women of Greece go on a sex-strike till their husbands promise to end the war; and his *Frogs* (405) demolishes Euripidean tragedy in favor of good old Aischylos. Although the comic poet's civic duty was to criticize, satirize, and poke fun, Aristophanes' critique is serious and his verdict is clear. The city, once so brilliant and promising, is going to the dogs.

As for tragedy, in Euripides's *Hippolytos* of 428 the young hero's extremism – his flat rejection of marriage and Aphrodite's gifts – leads him to utter destruction. Aphrodite's envy relentlessly undermines and destroys him and his family, and his own guardian goddess, Artemis, is powerless to stop her. For (she tells us) the gods do not interfere with each other's agendas, however vengeful or unjust. In his *Trojan Women* (415), the victorious Greeks apportion the helpless captives and, after a cynical and bitter debate, throw Hektor's only son, the young Astyanax, off the city wall to stop him from avenging his father. Meanwhile Athena, outraged at the Greeks' desecration of her Trojan shrines, coldly plots their destruction on the way home. His *Orestes* (408)

and *Iphigeneia at Aulis* (406) attack the dēmos and democratic institutions for their corruption and failure to deliver, and even question the Greek–barbarian divide. And in his *Bacchai* (406), the god of the irrational, Dionysos, rules all and destroys all who reject him. Whereas Hippolytos had spurned tradition and social consensus, Pentheus now vigorously upholds it, but for his extremism in so doing and his blindness to the awesome new divinity just arrived in the city, he gets destroyed anyway.

The war had unleashed other demons too. These included unscrupulous politicking at home, naked displays of power abroad, unprecedented brutality on the battlefield and off it, unprovoked aggression against neutrals, rising allied discontent, plots and counterplots, and last but not least, class conflict and bloody revolution. And to many, the Athenian empire at last stood revealed as a terrorist organization. "Your empire is a tyranny," Perikles announced in his final speech to the dēmos. "People think that taking it was criminal. Letting it go would be suicidal."

HEROIC DEMOCRACY IN ACTION

In the conference at Sparta that led to the declaration of war, the Corinthians famously compared the two protagonists:

> The Athenians are given to innovation, and quick to form plans and to put their decisions into execution, whereas you are disposed merely to keep what you have . . . They are bold beyond their strength, venturesome beyond their better judgment, and sanguine in the face of danger. But you [Spartans] habitually do less than your strength warrants, distrust your judgment, however sound, and when in danger despair of deliverance. Indeed, they are prompt in decision, while you are dilatory . . . If they win a victory, they follow it up at once; if beaten, they fall back as little as possible. As for their bodies, they regard them as expendable for their city's sake, as if they were the bodies of quite other men; but their minds as if they were wholly their own, to accomplish anything on its behalf . . . If they fail in some undertaking, they at once recoup the loss by aiming their hopes in some other direction. For with them alone hope and attainment are identical as soon as they conceive a plan, since with them action follows immediately upon decision.

In their reply, the Athenian delegates revel in all this, lacing their prose with superlatives as they rehearse the hoary tale of Athenian audacity at Salamis. Soon these qualities were to win them Sphakteria and much else.

A similar hyperactivity also pervades several key Athenian and allied artworks of the 420s. On a splendid squat lekythos by Aison (Fig. 101), for example, the Athenians of old battle the Amazons in the very same way. Echoing Pheidias's great shield of Athena Parthenos (Fig. 70), Aison paints all of them stark naked, with hyperextended, muscular limbs, indrawn stomachs, distended chests, intense gazes, and shields often held carelessly to one side, leaving their bodies (as the Corinthians had said) "expendable for their city's

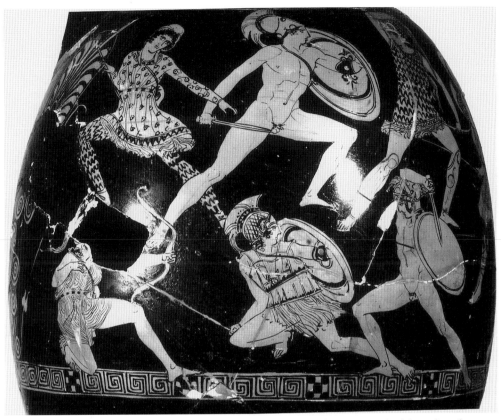

101. Amazonomachy. Athenian red-figure squat oil flask (*lekythos*) from Cumae (Italy) attributed to Aison, ca. 430. Ht. 18.5 cm (7.3″). Naples, Museo Archeologico. The two Athenians, vastly outnumbered, imitate Harmodios and Aristogeiton, Figs. 5 and 34.

sake, as if they were the bodies of quite other men." And just like Perikles in his reply to the Spartan ultimatum, the temple of Athena Nike (Figs. 102–5) projects all this directly onto the victors of Marathon.

Perched high on the southwestern bastion of the Akropolis, where a cult of Athena Nike had flourished since the archaic period, the temple guarded the main entrance to the citadel. Patriotically, it was built in the Ionic order, which also enabled it to carry an exterior frieze on each side. These friezes showed battles against Persians on the south and against fellow Greeks on the west and north; an assembly of the gods, receiving news of the victories, occupied the east. The massive tribute increase of 425 and the booty from Sphakteria and elsewhere provided the funding. The sculptures, carved after Sphakteria, were finished probably by winter 424/3, when the dēmos passed a decree appointing the cult's priestess. As usual, they make no attempt to reproduce the actual tactics of massed phalanx warfare. Instead – to focus on the south frieze, Fig. 103 – naked Athenians heroically duel their Persian opponents. Lean, hard, and trim, they move nimbly with cloaks flying behind them, whereas their clothed, corpulent enemies are in turmoil. Afraid to exercise naked like the Greeks, the Persians prove to be no match for them physically.

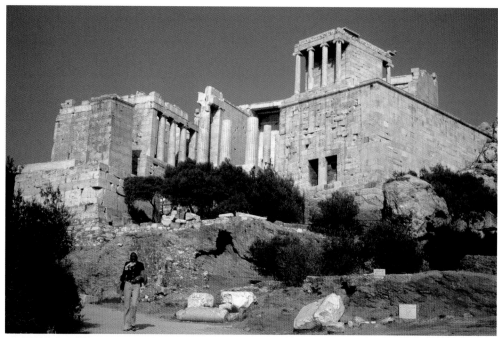

102. The Propylaia and Temple of Athena Nike on the Athenian Akropolis, by Mnesikles and Kallikrates, respectively, ca. 438–2 and 426–4. Marble; preserved ht. of the temple, 7.2 m (23′7″). Nike akroteria crowned the temple's roof; its pediments contained a Gigantomachy and an Amazonomachy; and its friezes showed an assembly of the gods on the east, the Battle of Marathon on the south, and battles between Athenians and other Greeks on the other two sides. The sculptures now displayed on the building are concrete casts; the sculptured parapet atop its bastion, Figs. 104, 105, has been removed entirely.

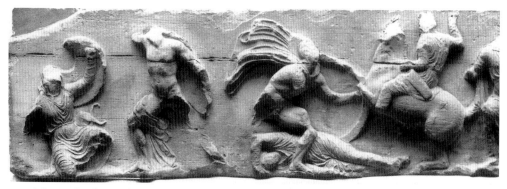

103. The Battle of Marathon. Slab from the south frieze of the Temple of Athena Nike, Fig. 102, ca. 425. Marble; ht. 45 cm (1′6″). London, British Museum. The naked Greek at left may be the Athenian captain general, Kallimachos of Aphidna.

The victors of Marathon had long been worshiped as heroes, but this sculptor casts them precisely in the devil-may-care mold of the 420s. Consider the man second from left. He is probably Kallimachos, the Athenian captain general, who was killed at the moment of victory. Heedless of danger,

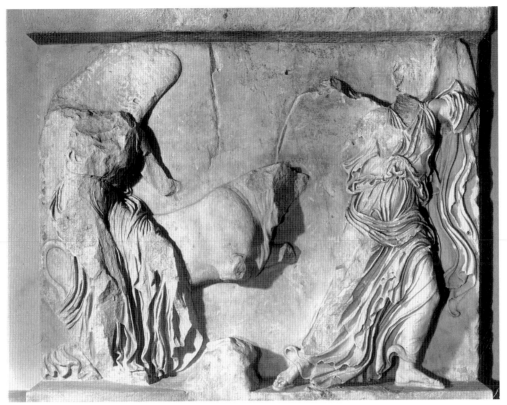

104. Two Nikai lead a bull to sacrifice. Slab from the parapet of the Temple of Athena Nike, Fig. 102, ca. 425–20. Marble; ht. 1.01 m (3′4″). Athens, Akropolis Museum.

he behaves exactly like Harmodios (Figs. 5, 34), echoing Miltiades' famous exhortation to him before the battle:

> Kallimachos, it is for you today to choose whether you will enslave Athens or free her, and thereby leave such a memorial for posterity as was left not even by Harmodios and Aristogeiton. Now is Athens in greater peril than ever since she first became a city; and if her people bow their necks to the Persians, their fate is certain . . . but if, on the other hand, we fight and prevail, Athens may well grow to be the very first city in Greece.

In classical Athenian art, Theseus too often borrows Harmodios's pose, as do many other Athenians (compare Fig. 101). Appropriating such emblematic images helps to take the person or event in question "out of time," to mythicize and eternalize them. Here, abetted by the Athenians' collective nudity and heroic-style tactics, these borrowings mythicize and eternalize the battle of Marathon, while erasing status distinctions among its Athenian participants. All this not only speaks to Marathon's unique place in the Athenian psyche, but also meets the Athenians' preference for excluding the explicitly contemporary in temple sculpture and for commemorating groups rather than individuals.

197

It promotes a kind of "democratic heroism," or to put it another way, "heroic democracy."

VICTORY AT HAND?

A fragmentary Athenian decree passed at the same time as the one that funded Athena Nike's priestess allocates money both for some final work on the temple's ceiling and for a parapet, which must be the famous Nike parapet now displayed in the Akropolis museum. So the whole complex (Fig. 102) was surely completed by the peace of 421.

The parapet was three feet high and its structure was simple. Each of its three sides showed winged Victories (Nikai) setting up trophies and bringing sacrificial bulls and other offerings to Athena (Figs. 104, 105). On the north and south sides the goddess sat at the far western end, whereas on the west she sat in the middle. So the parapet was a miniature version of the Parthenon frieze, sliced into three segments and substituting personifications for mortals. It both referenced the tribute of arms and cattle demanded from the allies in the great tribute reassessment of 425 and conflated two traditional victory rituals: The erection of battlefield trophies hung with the arms and armor of the vanquished, and the thanksgiving sacrifice to the gods. The armor, both Greek and Persian, recalls the battle friezes above.

The winged Nikai are dazzling. Vividly caught in snapshot fashion (Fig. 105) and clad in shimmering, cascading drapery, they carry out their appointed tasks with transcendent grace. As if water-soaked, their clothing is filmy and transparent, revealing the shapely contours of the bodies below. But like a wet T-shirt contest, this is no innocent display. A culture that instinctively gendered the spectator as male, shielded its women from strangers' prying eyes, and regarded vision as long-distance touch would see these gorgeous, scantily clad young females as ravishingly sexy and inviting. Victory teasingly presents itself in the flesh – and what flesh! As the great French novelist Gustave Flaubert drooled shortly after this Nike's discovery (Fig. 105):

> What breasts, my God, what a breast! It's as round as an apple, full, abundant, well spaced from the other, a weight in the hand. There is the richness of maternity and enough of love's sweetness to die for! Rain and sun have turned the white marble into a golden yellow; it's a tawny color that almost makes it seem flesh. So calm, so noble! One would say that it's about to swell, the lungs beneath it about to breathe.[1]

In short, victory herself hovers tantalizingly within our grasp.

Either at this time or just after the peace of 421, Athens's allies in the battle at Sphakteria hired the sculptor Paionios of Mende to erect a similar

[1] *Oeuvres Complètes de Gustave Flaubert. Correspondance*, II (Paris 1926): 298 (letter to Louis Bouilhet, February 10, 1851), tr. Steven Lattimore.

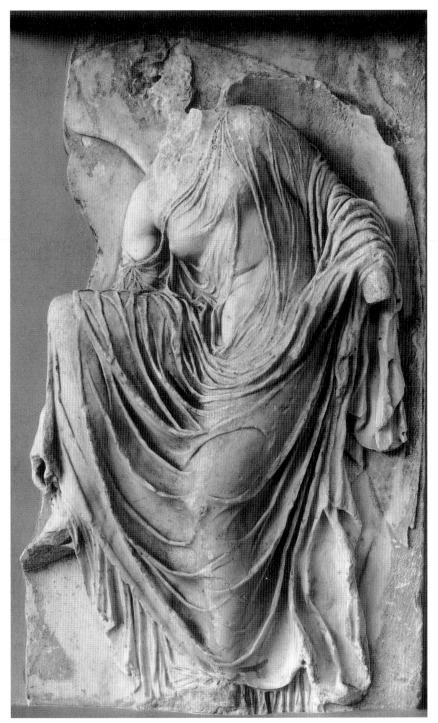

105. A Nike unties her sandal. Slab from the parapet of the Temple of Athena Nike, Fig. 102, ca. 425–20. Marble; ht. 1.01 m (3′4″). Athens, Akropolis Museum.

but freestanding Nike at Olympia (Fig. 106). Poised above Zeus's eagle atop a 30-foot high pillar, and a stunning tour-de-force of sculptural technique that clearly references the bold new tactics that gained the victory, she now quite brazenly bares a breast.

THE RHETORIC OF VICTORY

The aim of all this brilliance is rhetorical: It charms, it beguiles, it arouses, it persuades. In Greece, mastery of rhetoric – of the techniques of persuasion – had become crucial, especially in Athens now that Perikles' monopoly on power was over and the leadership was up for grabs. The master-persuaders were the Sophists and their uncrowned king was Gorgias, a citizen of Leontinoi in Sicily (ca. 485–380).

Gorgias first visited Athens as an ambassador in 427, just before the Nike temple complex was begun, and caused an instant sensation. A master of such rhetorical tricks as antithesis, assonance, chiasmus, clausal balance, onomatopoeia, and the like, he took the city by storm. Though no translation can adequately convey his ear-popping technique, a paragraph on the power of sight in his *In Praise of Helen* gives a faint idea of it:

> Moreover, when painters from many colors and shapes form one shape and composition to perfection, they delight sight; for the creation of statues and the fashioning of images afford a delightful sight for the eyes. Thus some things naturally torture sight, others enrapture it. Many things instill in many men love and longing for many things and bodies. If, then, Helen's eye, for Paris' body taking delight, impassioned her soul with Love's eager intensity, what wonder? For if Love is a god with the godlike power of gods, how can a lowlier being counter and parry it? But if it is a human sickness and a blindness of soul, it should not be reproached as a crime, but considered as a misfortune. But she went, as she went, by Fortune's chicanery, not by judgment's diplomacy, and by Love's compulsions, not by craft's machinations.

Not surprisingly, Gorgias thought that all art operated – like the irresistible Helen herself – by "deception." There is no true reality (*physis*), only human culture, convention (*nomos*), and judgment. It's all in the mind.

Beguiled by these verbal pyrotechnics, Euripides and other poets soon began to use them as well, and Aristophanes soon parodied them on the comic stage. In his *Clouds*, he turns Sokrates (quite unfairly) into a classic Sophist: a grasping, pretentious windbag. Strepsiades, a rustic all but bankrupted by his horse-mad son Pheidippides and spendthrift wife, goes to Sokrates's "think-tank" along with Pheidippides in order to learn how to outwit his creditors by "making the weaker argument appear the stronger."

After much fun at the expense of the Sophists, their rhetoric, and their pseudo-scientific "experiments," comedy becomes farce as the reeducated Strepsiades utterly fails to convince his creditors; gets beaten up by Pheidippides, who justifies his assault using the new rhetoric (one sign among many of a

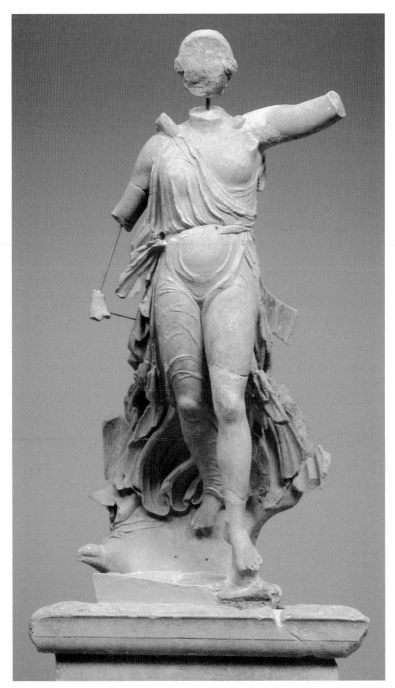

106. Nike alighting on an eagle, dedicated by the Messenians and Naupaktians at Olympia, by Paionios of Mende, ca. 425–20. Marble; ht. 1.95 m (6′5″). Olympia Museum. The Nike, erected on a 9-m/30-foot-high pillar to the left of the façade of the Temple of Zeus, Fig. 42, celebrated the Messenian and Naupaktian contribution to the Athenian victory over the Spartans at Sphakteria in 425, though (as Pausanias tells us) its dedicators were too timid to say this explicitly in their dedicatory inscription. The eagle's wings were added in gilded bronze.

simmering generational conflict); and, enraged, burns down the "think-tank" in frustration. And in one place, the poet contrasts the kind of young men produced by this newfangled education with the victors of Marathon (cf. Figs. 5, 25, 34, 103):

> If you follow my advice
> And keep it always in mind,
> You'll always have a rippling chest, radiant skin,
> Broad shoulders, a wee tongue,
> A grand rump, and a dinky dick.
> But if you do the "in" thing,
> You'll start by having
> A puny chest, pasty skin,
> Narrow shoulders, a grand tongue,
> A wee rump, and a lengthy – e/dic(k)/t.
> And he'll persuade you
> To consider all that's foul, fair,
> And fair, foul,
> And furthermore he'll infect you
> With Antimachos's faggotry.

Contemporary vases occasionally show this wimpy, mincing physical type (Fig. 107), reminding us that wartime Athens was no monolith.

To return to the Nike parapet and Paionios (Figs. 104–6), one could easily press this comparison between rhetoric and sculpture further. Antithesis, assonance, rhyme, chiasmus, lexical extravagance, rhythmic freedom, verbal flourishes, and so on all find visual echoes in these figures. But their strongest bond is their common purpose: They all seek to persuade. And to do so, they shamelessly exploit what Parmenides had dismissed as part of the "Way of Seeing"; what Protagoras had deemed the only true reality; and what Gorgias had bluntly termed "deception": a relativistic art that creates "reality effects", not true realities, and plays blatantly on the subjective perceptions and feelings of "man the measure of all things."

THE "WAY OF SEEING"

Where sculpture went, painting went too. Three momentous pictorial innovations datable to these very years show that the painters' exploration of appearances had by no means slackened. Unfortunately, because their murals and panel-paintings are all lost, we have to recover them from texts and painted ceramics.

First, we learn that as well as introducing a third actor into his tragedies Sophokles also enlivened them with painted scenery. Agatharchos of Samos, a pioneer of the genre, soon produced a textbook on it, upon which Anaxagoras and the atomist philosopher Demokritos promptly wrote a commentary.

Although Vitruvius's discussion of these developments is perhaps the most obscure passage in the whole of ancient critical writing on art, the

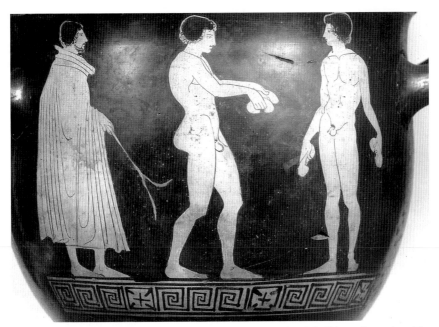

107. Trainer and two youths. Athenian red-figure mixing bowl (bell krater), ca. 420. Ht. 32.7 cm (12.8″). London, British Museum.

vase-paintings fortunately come to the rescue. Some Attic vases of the 420s and a fragmentary South Italian krater perhaps illustrating a performance of Euripides's *Medea* of 431 (Fig. 108) show how Agatharchos solved the problem.[2] Evidently, he discovered the *orthogonal*– the fact that lines above eye level seem to drop as they recede from the eye and lines below eye level seem to rise. For tragic scenery usually involved houses and palaces, not landscape, and the scene-painter's task was to turn these structures into a credible framework for human action. They had to look three-dimensional, to project vividly from the flat painted surface.

Other vases clearly show that some unknown late fifth-century painter had discovered yet another perspectival trick: diminution. The standing figures in Fig. 109 diminish by about 15 percent from foreground to middle ground and another 15 percent or so from middle ground to background: a ratio of about 7:6:5. The painter would have scaled them by eye, of course, and later Greek geometers even challenged the inverse size/distance law that governs the phenomenon (i.e., they denied that objects really do seem to shrink in inverse proportion to their distance from the eye). But Fig. 109 shows beyond dispute that painters indeed took this momentous step in an empirical, ad hoc fashion in the late fifth century.

2 Sophokles first entered the tragic competitions in 468, so he could have introduced scene painting at any time after this date; Vitruvius, on the other hand, tells us that Agatharchos made his stage set for a tragedy by Aischylos, who died in 456. Yet Aischylos's plays were revived periodically after his death, and Plutarch, *Alkibiades* 16, connects Agatharchos with the politician Alkibiades, who reached maturity only in 420.

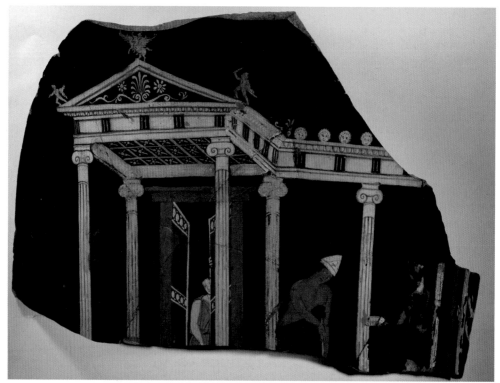

108. Theater scene. Fragment of a Gnathian (South Italian) red-figure mixing bowl (bell krater) from Taranto (Italy), ca. 350. Ht. 23 cm (9.4″). Würzburg, Martin von Wagner Museum. The scene may illustrate Euripides' *Medea* or *Stheneboia*.

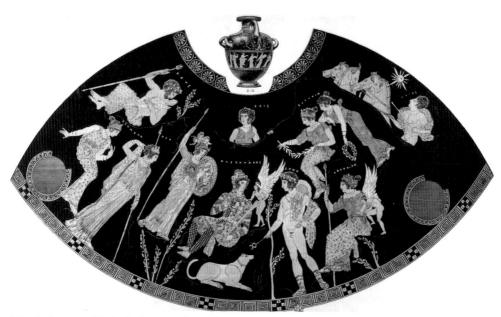

109. Judgment of Paris. Redrawing of an Athenian red-figure water jar (hydria) from Ruvo (Italy) attributed to the Painter of the Karlsruhe Paris (name vase), ca. 410. Ht. of picture, 23 cm (9″). Karlsruhe, Badisches Landesmuseum. Paris, seated at center and dressed in barbarian (Phrygian) costume, decides whether Hera (left), Athena (left of center), or Aphrodite (right, with Eros) is the fairest, while Hermes and Strife (above) look on. The figures shrink in size from the foreground (below) to the background (above).

204

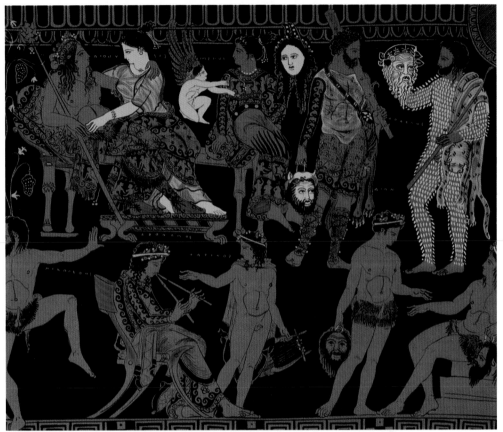

110. Dionysos, Ariadne, satyr players, and actors. Redrawing of part of an Athenian red-figure mixing bowl (bell krater) from Ruvo (Italy) attributed to the Pronomos Painter (name vase), ca. 400. Ht. of picture, 24.5 cm (9.75″). Naples, Museo Archeologico. The cast includes a Herakles and (below) the Theban piper, Pronomos.

Finally, the sources also tell us – in their usual exaggerated way – that Apollodoros of Athens, who "flourished" in the ninety-third Olympiad (408 B.C.), "first established the method of representing appearances, first conferred glory upon the paintbrush as of right," and "first invented the fading out and building up of shadow." His pupil, the great Zeuxis (who "flourished" in 396) then perfected the technique. Now fifth-century vase-painters had occasionally experimented with hatched shading and also with bands of grey to nuance shield rims, rocks, and other objects. But from around 410 real color gradation (now often called by its Italian name, *chiaroscuro*) sometimes begins to supplement these devices (Fig. 110), and eventually (when mural painting reappears in the archaeological record two generations or so later: see Fig. 160) to supplant them.

Although in all three cases theory followed practice, these wartime innovations cannot be divorced from the radical relativism and "deceptions" of the

Sophists. For they all structure reality around the human observer: Protagoras's "measure of all things." This is one of those cases, not uncommon in history, where a "feedback loop" emerges among several different but related trends, intensifying their effect and eventual outcome. By around 400, Greek painting's conversion from a "conceptual" to a "perceptual" style – from the "Way of Being" to the "Way of Seeming" – was all but complete. Begun with the invention of foreshortening a century earlier (Figs. 8, 17), it created the foundations of Western painting (compare Figs. 1, 2). It also sparked bitter controversy.

SOKRATES OBJECTS

These developments deeply disturbed Sokrates, among others, and sparked a debate that raged into the fourth century. Against most of the Sophists, he and his star pupil Plato were convinced that true Being – universals, unchanging archetypes, or Forms of qualities such as Virtue and Justice, and probably even of material objects such as beds and chairs – definitely existed (see Chapter 6, Box 1). They also believed that abstract geometry and mathematics underpinned the flux of the visible world, which was essentially a flawed, unpredictable, and deceptive version of this "true" reality. So they had little time for mere representations of this world, poetry and art included:

> "By Zeus," I said, "this process of representation deals with something at third remove from reality, doesn't it?"
>
> "Yes."
>
> "Then over what part of a human being does it have the power that it has?"
>
> "What do you mean by 'part'?"
>
> "Something like this. An object's apparent size differs if it's viewed from nearby or far away."
>
> "Yes."
>
> "And something will look bent if you put it in the water but straight if you take it out, and differences in coloration can make the same surface appear concave and convex to the eye; so this is clearly all a matter of confusion in our minds. It's this natural weakness of ours that shadow-painting plays upon, just like magic, and conjuring too, and every trick of that sort."
>
> "True."
>
> "But weren't measuring, counting, and weighing invented to help us out here, to ensure that we wouldn't be guided by apparent difference of size, quantity, and weight, but by rational calculations of measurement, number, and heaviness?"
>
> "Of course."

So in addition to condemning art in general as thrice removed from reality (i.e., the Forms → Objects → Representations), and condemning artists as ignorant about the things they are representing, Sokrates – via his pupil, biographer,

and interpreter, Plato[3] – particularly dislikes the new technique of shadow painting/chiaroscuro. He gives two reasons. As an illusion, it distorts true reality by making it conform to mere appearance; and it gives the illusionistic painter (an ignoramus, magician, and peddler of lies) power over the spectator's mind that only the philosopher – the Master of Truth – should have. The illusionistic painter is just a Sophist with a paintbrush. Elsewhere, and for the same reason, Plato criticizes sculptors who adjust the "objective" proportions of their statues in order to make them look better. Oddly, he makes no such attacks against scene painting and its experiments with perspective. Disliking the theater, perhaps he never went to a play.

Nor was Plato alone. The painter Parrhasios of Ephesos entered into a very public dispute with Zeuxis on this very point. Their rivalry surfaces in a number of anecdotes and was analyzed by two early Hellenistic critics, Xenokrates of Athens and Antigonos of Karystos. Pliny paraphrases their discussion:

> Parrhasios ... first gave symmetria to painting, and was the first to give liveliness to the face, elegance to the hair, and beauty to the mouth; and artists acknowledge that he was supreme in painting contour lines – the most subtle aspect of painting. For to paint corporeal forms and the mass of objects is no doubt a great achievement, but it is one in which many have become famous; but to make the contour lines of bodies and to include just the right amount when establishing the limits of the painted figure, is an artistic success rarely achieved. For the outline should round itself off and establish such limits that it suggests other things behind it and thus reveals even what it conceals. This is the glory that Xenokrates and Antigonos, who wrote about painting, conceded to him.

Quintilian is more succinct: "After [Polygnotos], Zeuxis and Parrhasios – who overlapped in time (for both worked during the Peloponnesian War, since a conversation of Sokrates with Parrhasios is to be found in Xenophon) – contributed much to the art of painting. Of the two, the first discovered the calculation of lights and shades, while the second reputedly concentrated on subtlety of line."

Parrhasios's discussion with Sokrates survives, and shows that he was by no means completely hostile to chiaroscuro. (Xenophon shows that Parrhasios mastered character [ēthos] and emotion [pathos] too – though in his anxiety to promote the philosopher over a mere painter, he represents Parrhasios as too stupid to realize that he has done so!) As in Renaissance Italy, when the line/color dispute was revived, the two sides probably were arguing about which of the two should predominate in figure painting, not about whether one should entirely drive out the other.[4] Because Parrhasios painted on wood,

3 Sokrates himself wrote nothing, leaving Plato to interpret, embellish, and massively extend his teachings.

4 In the Renaissance, though, the dispute developed nationalistic overtones: *disegno* (line) versus *colore* soon turned into a contest of Florence versus Venice.

nothing by him survives, but vase-paintings such as those in Figs. 101, 109, 119, and 120 might echo his style.

Like Hippodamos (see Chapter 2, Box 1), Parrhasios also wrote a manifesto and was a show-off. Strutting about in gold-buckled sandals, a purple cloak, and a golden crown, and carrying a gold-embossed staff, he called himself "the prince of painting" and – even more revealingly – a *habrodiaitos* or hedonist. This was truly startling, for the old-time Lydian kings, archaic Ionian aristocrats, and like-minded poets such as Anakreon had prided themselves on being hedonists too; and Parrhasios hailed from Ephesos, a notorious center for such antics. Moreover, as we saw in the previous chapter, he even painted a picture of the Athenian *dēmos* as "changeable, irascible, unjust, and unstable, but also placable, clement, and full of pity; boastful and [*lacuna*], illustrious and humble, ferocious and fearful, all at the same time." No democrat he!

So Parrhasios was signaling that he was a social conservative, even a reactionary, scorning the "middling" ethic popular in classical Greece; that his painting followed the same path; and that his matchless technē and the wealth and fame that it brought elevated him above mere common practitioners of the art, "middling" or otherwise. Indeed, he even composed some bombastic poetry along the same lines:

> A hedonist who respects virtue painted this:
> Parrhasios from Ephesos, that famous town.
> Nor do I forget my father Euenor, who begat me,
> His lawful child and foremost artist of the Greeks.

And:

> Though I speak to the incredulous, I say this: Already
> The clear boundaries of this art have been found
> By my hand. An insurmountable boundary has been fixed.
> But there's nothing completely flawless among mortal men.

Evidently, then, Parrhasios was not merely a classic extrovert. He was both a pioneering spokesman for the view – scorned in many quarters – that "high" art was no longer just a menial craft, a kind of "limited slavery" (as Aristotle later put it), but a high-status endeavor in its own right; and a strident advocate of elitist, even antidemocratic ways of thinking and behaving. In sum, he heralded the future.

OLD WINE, NEW BOTTLES

Several wartime tragedies by both Sophokles and Euripides focus on ancient rituals and images. The war and its attendant evils – plague, revolution, chaos, and sudden death – had created an atmosphere in which these antique survivals now acquired special importance.

BOX 1. *EURIPIDES'S* IPHIGENEIA AMONG THE TAURIANS

Artemis has saved Iphigeneia from Agamemnon's sacrificial knife (see Chapter 2, Box 1. Aischylos's *Oresteia*), and unbeknownst to all has substituted a deer in the girl's place. Spirited off to the land of the barbarian Taurians – the Crimea, in South Russia – Iphigeneia is now the priestess of the goddess's cult and keeper of its ancient idol.

Local custom dictates that Iphigeneia must sacrifice to the goddess every Greek male who lands there. Enter Orestes and Pylades, hounded by the Furies that repudiated the Areiopagos's verdict, sent by Apollo to steal the Taurian idol and take it to Athens (where Orestes will finally become free), and now captured by the locals. Their fate seems sealed. But when Iphigeneia offers to spare Pylades if he will take a letter back to Argos, one thing leads to another and a joyful recognition ensues. By a series of ruses, Iphigeneia then succeeds in removing the idol supposedly for purification in the sea. Image in hand, the three fugitives hurry aboard ship, but high seas drive them back to shore and their waiting pursuers. In the nick of time, however, Athena intervenes, explains all, pacifies the enraged Taurians, and commands Orestes and Iphigeneia to found the Athenian cults of Artemis at Halai and Brauron, respectively. Everything ends happily. The past is linked to the present; the Crimea (the source of the city's vital grain supply) is linked to Attica; two popular Athenian cults of Artemis are explained and boosted in the public eye; and Athens is confirmed once more as the fount of civilization, piety, and justice.

In Euripides' melodrama – hardly a tragedy – *Iphigeneia among the Taurians*, for example (see Box 1. *Euripides's* Iphigeneia among the Taurians), the plot turns on an ancient idol of Artemis in far-off Taurica (the Crimea, in South Russia), the goddess's temple at Halai in northwestern Attica, and her cult at Brauron in northeastern Attica. (The Brauronian temple was rebuilt and its sanctuary much extended in the 420s, during the Archidamian War.)

The play mentions the Taurian idol no fewer than twenty-seven times, but never describes it. Often called a *bretas* (a primitive name of uncertain etymology), it is holy and talismanic, and small and light enough for Iphigeneia to carry easily. And at one point, to hoodwink the Taurian King Thoas into believing that it needs cleansing, she describes it as "shrinking back on its pedestal" and "shaking, and closing its eyes" at the sight of the polluted Orestes. In this way, Euripides links past and present, barbarism and civilization, and the Crimea (the main source for the city's vital grain supply) and Attica in a complicated nexus of relationships that once again establishes Athens as the font of civilization, piety, and justice.

So one is not surprised to find the Athenians building a new temple for their very own ancient idol, the olivewood statue of Athena Polias, during these very years. Saved from the Persians in 480, this statue had been housed in a small shrine on the site ever since, while the city's resources were poured into the Parthenon, Propylaia, and Nike temple. One *is* surprised, however, to find that its new home was not merely extraordinarily lavish – even its Ionic capitals were inlaid with gold, rock crystal, and colored glass – but bizarrely idiosyncratic in design (Fig. 111).

Normally called the Erechtheion after a confusing description by Pausanias, the temple is a monument to asymmetry, even – some feel – sheer perversity. Because the rock slopes abruptly away at this point, its northern side descends a full ten feet below its southern one. Its core is a rectangular cella with an eastern porch but no proper western one; the latter's intercolumniations, set a full sixteen feet above ground level, were closed by marble grilles (the windows in Fig. 111 are Roman). Divided into two chambers by a cross-wall with no connecting door, this cella had a basement that on the east incorporated the foundations of Athena's earlier, post-Persian shrine. At its western end, the cella is flanked by two side porches: The famous "Caryatid" porch on the south, and an Ionic colonnaded one on the north, whose floor is much lower than the other owing to the slope mentioned above.

Pausanias, visiting first its western chamber and then Athena's shrine on the east, helps to explain why its design is so irregular:

> [As for the building called the Erechtheion], before its entrance is an altar of Zeus the Highest, upon which in obedience to an oracle they sacrifice also to Erechtheus, the hero Boutes, and Hephaistos. On the walls are paintings of members of the Boutadai clan. There is also inside – the building is double – seawater in a well ... This well is remarkable for the noise of the waves it emits when a south wind blows. On the rock is the mark of a trident. Legend says that these appeared in support of Poseidon's claim to the land ... But the most holy item, considered so by everyone many years before the districts of Attica were united, is the image of Athena on the Akropolis (formerly just called the *polis*). A legend about it says that if fell from heaven; whether this is true or not I shall not discuss. The golden lamp for the goddess was made by Kallimachos.... In the temple of Athena Polias is a wooden Hermes, supposedly dedicated by Kekrops, but now hidden by myrtle boughs. The votive offerings worth noting are, of the old ones, a chair made by Daidalos, Persian spoils, [etc.]. About the olive tree they have nothing to say except that it was the testimony that the goddess produced when she contended for the land. Legend also says that when the Persians fired Athens the olive was burnt down, but on the very same day it was burnt it grew again to a height of three feet. Adjoining the temple of Athena is the temple of Pandrosos. ...

So this new temple was a multipurpose affair. (The great architectural historian Gottfried Gruben once called it "a luxurious reliquary on the scale of a

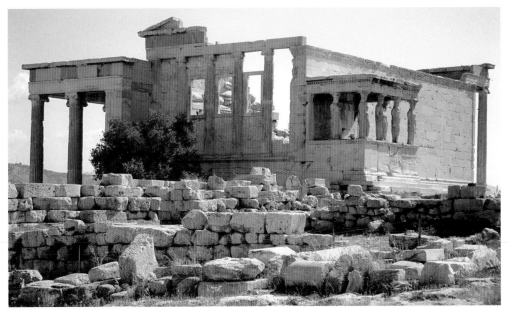

111. The Erechtheion (Temple of Athena Polias) on the Athenian Akropolis, ca. 420–06. Marble; preserved ht. of building, 13.6 m (44′7″). The photograph is taken from the southwest.

temple.")[5] It housed a large number of disparate cults, ancient talismans, and three precious relics of the contest portrayed on the Parthenon's west pediment: Poseidon's well, Athena's olive tree, and the scars left by Zeus's thunderbolt when he parted the two of them. Some of these relics were located in the north and south porches, effectively turning them into canopied display spaces.

But the Erechtheion does not merely accommodate the rich religious diversity of this part of the Akropolis. It ostentatiously *celebrates* it in a glittering display of piety that was surely inspired at least in part by wartime anxiety. It was Athena's jewel-box, its Ionic capitals spun with coils of gold filament and inlaid with rock crystal and colored glass. A lavish, indeed lyrical prayer in marble, it deploys its honeyed devotional rhetoric particularly through its sculptures and architectural moldings (Fig. 112).

The famous, stately "Caryatids" (called *korai* in the building inscription) once held libation dishes in their hands, ready to make an offering. Suggestively, they stand above the tomb of the first Athenian king, the "earth-born" Kekrops (supposedly a son of Mother Earth herself, and thus always represented with a snaky tail), and they face the Parthenon directly. As so often in classical Athens, they represent the city's appropriation of a formerly elite practice: In this case, the brilliant individual korē dedications of the past (see Fig. 6). Above them, a procession frieze of white marble figures mounted on blue Eleusinian limestone backers like ivories on

5 Heinrich Berve and Gottfried Gruben, *Greek Temples, Theaters, and Shrines* (New York 1962): 389.

211

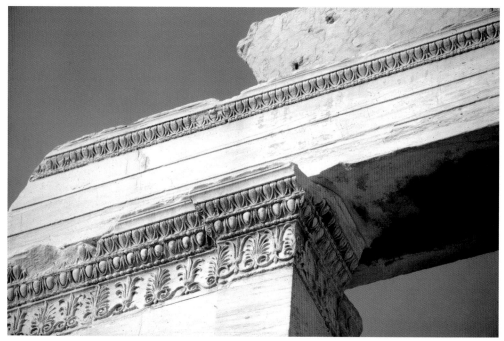

112. Detail of the molded wall crown, architrave, and frieze of the east end of the Erechtheion, Fig. 111. Marble; ht. of section shown, ca. 2 m (6′5″). Note the bead-and-reel and egg-and-dart moldings.

enamel, or a modern-day Wedgwood vase, surrounded the cella like an end-less votive relief (compare Fig. 87); a similar frieze ran around the north porch.

Moreover, some – perhaps all – of the exquisitely carved moldings that encircle the building (Fig. 112) and embellish the capitals on the heads of the "Caryatids" were also implicitly votive in character. Now Greek architects had used these moldings for two centuries, but their true "meaning," if any, has been unclear. Yet eggs and darts often decorate offering dishes such as those that the "Caryatids" and the Athena Polias herself once held – not to mention the silver ones found in classical treasure caches such as the one from Rogozen in Bulgaria (Fig. 113) and presumably also those, now lost, that inscriptions tell us were dedicated to Athena on the Akropolis. Moreover, on a newly discovered archaic temple at Mitropolis in central Greece, eggs and darts even encircle the *Doric* capitals of the exterior colonnade. In essence, then, they turn the entire building into one vast dedication. The so-called bead-and-reel moldings (Fig. 112) reinforce the effect. For they recall the knotted woolen fillets that archaic cult statues often held in their hands and sacrificial beasts wore around their necks as they went to the slaughter.

The "Erechtheion's" interior was gutted during the Middle Ages, so whether it matched the brilliance and originality of the exterior will never be known. Not so for another new shrine to an ancient divinity: the temple of Apollo Epikourios at Bassai in the Peloponnese (Figs. 114–16).

113. Vessels from a treasure found in a tomb at Rogozen in Thrace (Bulgaria), ca. 420–350. Silver and silver-gilt; diameter of the large offering-dish (*phiale*) at top center, 17.9 cm (7″). Vratza History Museum. The treasure comprises 165 silver and silver-gilt vessels and weighs 20 kg (44 lbs). Several of the dishes are decorated with egg-and-dart moldings; one bears a scene of Herakles molesting the Tegean princess Auge.

The Peloponnese had escaped the ravages of the great plague of 430–26, and in gratitude the Arkadians of Phigaleia decided to commission a new temple to Apollo Epikourios, "the Helper," at the god's mountain fastness at Bassai in western Arkadia. Pausanias attributes the building to Iktinos, but if this is correct (and the temple's definitive publication strongly endorses it), he not only produced a building quite different from the Parthenon but also brought few or none of his "dream team" of skilled masons and sculptors to Arkadia with him.

Apollo Epikourios was an ancient Arkadian war-god, the protector of the Arkadian mercenaries (*epikourioi*) mentioned by Hermippos in the lines from his *Stevedores* quoted at the beginning of Chapter Three. Their safe

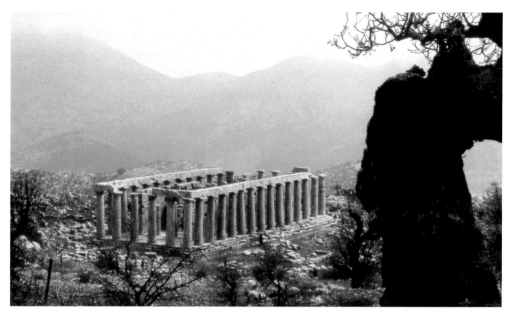

114. Temple of Apollo Epikourios at Bassai, by Iktinos, ca. 427–400. Limestone, originally stuccoed; preserved ht. 8 m (26′3″).

return perhaps was the prime motivation for the new building. But Apollo also was long established as both plague god and healer. Compare Homer's spine-chilling vision of him at the beginning of the *Iliad*:

> He strode down among the pinnacles of Olympos, angered
> In his heart, carrying across his shoulders the bow and the hooded
> Quiver; and the shafts clashed on the shoulders of the god walking
> Angrily. He came as night comes down and knelt then
> Apart and opposite the ships and let go an arrow.
> Terrible was the clash that arose from the bow of silver.
> First he went after the mules and the circling hounds, then let go
> A tearing arrow against the men themselves and struck them.
> The corpse fires burned everywhere and did not stop burning.

But the god who strikes terror from the mountaintops may also heal from there. In the seventh century his restorative hymn, the *paean* (a word that also served as his cult title), had migrated from Crete to Sparta and thence to the rest of the Peloponnese, where he was much honored in this dual capacity. But because his domain was universal and his appeal was Panhellenic, he would soon begin referring individual ailments and particular cures to his gentle and caring son, Asklepios (see Figs. 87 and 138), long enshrined at Epidauros and in 420 piously welcomed to a plague-scarred Athens, as we saw earlier in the chapter.

To rehouse this ancient but now very topical cult, the architect created a truly revolutionary building (Figs. 114 and 115). Unlike most Greek temples, it is oriented north–south, along the god's annual pilgrimage route to the

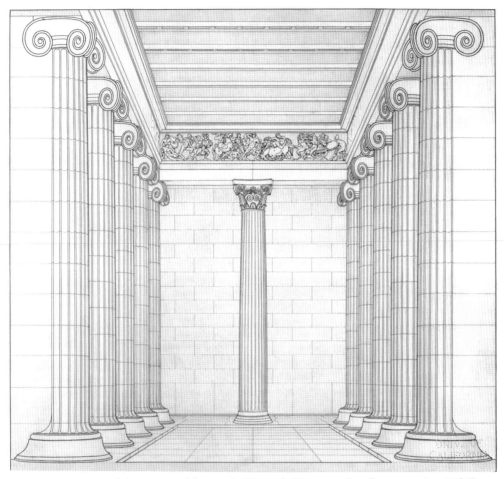

115. Reconstruction of the interior of the temple, Fig. 114. Limestone; ht. of room, 7.13 m (23'5"). Note the single Corinthian column at center rear; for the sculptured frieze, see Fig. 116.

Hyperboreans in the frozen north and facing Zeus's mountain sanctuary of Ithome to the south. Its proportions and exterior detailing are strikingly austere and conservative, recalling Libon's great temple at Olympia (Fig. 42). It carried no pediment sculptures or figured akroteria. Such conspicuous restraint would have raised eyebrows at the time, and requires explanation. Was it intended to make the stern god of measure and limit feel at home?

Inside, however, the atmosphere changes radically. The porches are fifty percent deeper than usual, enabling a better view of the six porch metopes at each end of the cella. Crowned by ornate Ionic moldings, the northern ones, over the entrance, showed Apollo's arrival from the Hyperboreans, and the southern ones showed the rape of Apollo's daughters, the Leukippidai. Only fragments survive, carved in the florid style of the Nike parapet (see Figs. 104 and 105).

Finally, the cult room itself (Figs. 115 and 116). The richest element of all, this was absolutely unprecedented in Greek architecture. A floor-to-ceiling

Ionic colonnade surmounted by a figured frieze and moldings unified the room both horizontally and vertically. The columns are attached to spurs bonded to the side walls, creating a series of half-concealed niches within which votive offerings could be located, surprising the visitor as he walked through the room. Like Artemis's little idol or *bretas* in Euripides' *Iphigeneia among the Taurians*, Apollo's ancient image was so small that its base did not need a proper foundation. Probably it stood at the far end of the cella, against the single column located on the room's central axis. This column, in turn, fronted a small rear chamber that also was accessible from a door in the eastern side. Its function is unknown, though the rising sun shining through the door would have illuminated anything displayed within it.

This central column has a base differently molded than the others. Although only tiny scraps of its capital remain, a nineteenth-century drawing of the entire piece shows that it too was unique: a pioneering *Corinthian* capital. For the austere curved echinus and square abacus of Doric and the horizontally linked volutes of Ionic, it substituted a nest of acanthus leaves and on each side two interior spirals, a palmette, and two exterior volutes, all of which seemed to grow naturally from the column below. Eventually this interloper would conquer the Mediterranean world, but the reason for its sudden appearance at Bassai remains a mystery. Because a legend told by Vitruvius connects its exuberant acanthus foliage with death and the grave, was it invented to mimic Apollo's role, both in general and in the contemporary circumstances of war and plague, as a god of death and life?

The frieze above this colonnade (Fig. 116), now in the British Museum, contains three separate subjects, carved in a tempestuous version of the Athenian "flamboyant" style (see Figs. 104 and 105), and presented without interruption: the Centauromachy, Heraklean Amazonomachy, and Trojan Amazonomachy. A real cacophony results, as the humans' conventional poses and stolid facial expressions clash violently with their chaotically swirling draperies and the Centaurs' wild postures and frenzied grimaces. Apollo and Artemis join this third contest, turning the entire frieze into an explicit warning against hybris, an injunction to "know thyself" (i.e., to know your place), and a stern reminder of Apollo's appointed role as divine enforcer and castigator.

Although fifth-century Greeks often rebuilt their shrines and rehoused their ancient idols, the Bassai temple chalks up a number of "firsts." To begin with, Iktinos (if Pausanias is right) was the first Greek architect to discover the *interior* as a distinct architectural form.[6] For because Greek temples essentially were huge abstract sculptures in a landscape, his predecessors had tended to focus on the exterior. Usually they had treated the interior – however grandly conceived (Fig. 69) – simply as the exterior's negative. Iktinos's new

6 It may be relevant for the attribution of the temple to Iktinos that he had used four tall Ionic columns to support the back room of the Parthenon, and in the 430s had redesigned the interior of the Hall of the Mysteries or Telesterion at Eleusis to include no fewer than 20 such columns, aligned in five rows of four. From this perspective, Bassai may represent the last, decisive step in a lifetime of experiment with interior design.

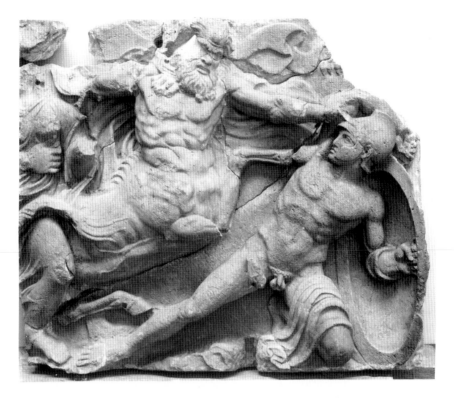

116. Centaur and Lapith. Detail of a slab from the interior frieze of the temple, Figs. 114 and 115. Marble; ht. 64 cm (2′1″). London British Museum.

focus at Bassai upon interior space and its articulation would soon lead to Skopas's experiments at Tegea (Fig. 137), and thence to the stunning interiors of Roman imperial buildings such as the Pantheon and Coliseum; of medieval Gothic cathedrals; and eventually of modern theaters, concert halls, and sports stadiums.

Second, the design was basically *theatrical*, even suspenseful. Its gradual crescendo of special effects, climaxing in the little ancient idol, hallmarked the latter as something unique and altogether different from everyday reality: as *other* by virtue of its age and sanctity. For as Aischylos once had remarked, "the old statues, though simply made, are thought divine; the new, though superbly wrought, have less of the divine in them." The contrast between this ancient image and the up-to-date frieze above (Fig. 116) would amply have confirmed this sentiment, especially as the Centauromachy featured a similar idol, at which terrified Lapith women were shown taking refuge.

Finally, Iktinos's design was overtly *dynamic*. It drew the visitor along an axis that led, as straight as one of Apollo's arrows, from the barren mountains outside (Fig. 114) through the porch and cult room to the ancient image and the exuberant Corinthian column at the heart of the whole complex (Fig. 115). Although the Periklean Akropolis had been planned specifically to showcase its crowning glory, the Parthenon (Fig. 60), Bassai's far more

217

manipulative design presages the authoritarian architecture of the Hellenistic kingdoms and of Rome.[7]

THE WAR RESUMES

The peace of 421, which was supposed to last for fifty years, settled nothing and lasted for precisely three. Disgruntled allies (on both sides) apart, the chief spur to renewed conflict was Alkibiades. An orphan raised by Perikles, brilliant, handsome, unstable, willful, egocentric, flamboyant, and ambitious, he was elected general in 420 and immediately began to undermine the peace. In 418, his newly minted coalition met the Spartans in a great battle at Mantineia in Arkadia, but Spartan discipline won the day and the alliance promptly collapsed. Frustrated, in 416 the Athenians turned on the neutral island of Melos, a Dorian outpost in the Athenian-controlled Cyclades. Hoping for Spartan help, the Melians refused to surrender, and the Athenians decided to punish them as the Persians had punished Miletos in 494. In an appalling display of state terrorism, they killed all the men and sold the women and children into slavery.

The following year, Euripides entered his *Trojan Women* in the tragic contests. Set just after the sack of Troy, the very scene shown on the Parthenon's north metopes (Fig. 60), it would have reminded every Athenian immediately of the Persian sack of the Akropolis and the terrible nemesis visited upon the despoilers. Warning against such hybris, its harrowing plot turned on the Greeks' enslavement of Troy's womenfolk and their decision to throw Hektor's only son, the young Astyanax, from the city walls to prevent him from avenging his father. Despite or perhaps because of its antiwar stance and its protagonists' brilliantly cynical use of the new rhetoric to argue their cases, it failed to win first prize.

By the time that the *Trojan Women* was staged, the Athenians were plotting yet another imperialist adventure, bigger and more risky than ever: the invasion of Sicily. A great expedition of 264 ships and 25,000 men set off in early summer, led by the mercurial Alkibiades and two steadier men, Nikias and Lamachos. But a few days earlier, a bad omen had created uproar. At dead of night, many of the herms (see Fig. 38) that stood outside every

7 Some see these theatrical effects as hinting at a "crisis of faith" during this period, for which presumably they were intended to compensate. Yet not only is there no evidence for such a collapse beyond the skepticism of a few Sophists and, at times, of Euripides, but also this theory misunderstands the nature of Greek polytheism. Unlike Christianity, the Olympian religion did not require or enforce belief. The Greek gods were simply *there*, and if one ignored or slighted them, probably they would retaliate – if not directly, then against one's household, descendants, or city. This is why Anaxagoras and Protagoras (allegedly) were expelled from Athens for impiety, and why Sokrates was executed for, inter alia, the same offense: "refusing to recognize the gods that the city recognizes, and for introducing other new gods into the city" (Diogenes Laertius, *Lives of the Philosophers* 2.40).

Athenian house as patriarchal talismans had been mutilated. Alkibiades and his gang of hell-raisers were fingered and a plot to overthrow the democracy suspected. Fanning the flames was a report that he had also profaned the Eleusinian Mysteries – the sacred fertility rites of Demeter and Kore – by parodying them to outsiders.

In the midst of all this turmoil, Aristophanes continued his political and cultural critique with his *Birds* (414), where the hero's attempt to build a city in the sky – Cloudcuckootown – parodied Alkibiades, the Sicilian expedition, and the inflated ambitions of the intellectuals. A krater in the Getty Museum (Fig. 117) may illustrate its fantastical chorus, though an alternative – the Just and Unjust Argument of the first version of the poet's *Clouds* (423) – also has been proposed.

Aristophanes' unease was justified, for in Sicily everything that could go wrong did so. Allied help evaporated and the expedition bogged down outside Syracuse. Alkibiades was recalled to face trial, but fled instead to Sparta, where he promptly proceeded to advise the Spartans how to win the war and then fled again after getting the wife of the Spartan king Agis pregnant. Setback followed setback, reinforcements failed to turn the tide, and finally, in 413, a retreat ended in rout and massacre. Of the thousands of Athenian and allied captives, few ever saw home again. Some that did were freed because they could recite Euripides from memory to their captors.

Yet, incredibly, Athens's enemies failed to capitalize properly upon this stunning success. On Alkibiades's advice, the Spartans had established a fort at Dekeleia in northwest Attica, tightening their noose around the city; had begun to build and train a navy; and had begun to intrigue with Persia for much-needed funds.[8] In Athens, disgruntled oligarchs even staged a short-lived coup, which thanks to the intervention of the staunchly democratic fleet did not outlast the year 411. Aristophanes's *Lysistrata* deftly caught the beleaguered city's mood: The women of Greece go on a sex-strike till their husbands promise to end the fighting.

Meanwhile, the fortunes of war continued to oscillate, as first one side and then the other gained the advantage, and successive peace initiatives came to nothing. Alkibiades even managed to get the Athenians to recall him, but in 407 a surprise defeat at sea led to his exile again, this time for good. Desperate for cash, with the treasury now empty and the Persians funding their enemies, the Athenians were forced to melt down the golden Nikai dedicated in the Parthenon after each major victory (see Fig. 69).

In 406, seeing the writing on the wall, leading intellectuals such as Euripides, his son Agathon, the lyric poets Timotheos and Choirilos, and (ominously) the great seer Diopeithes began to leave Athens. At year's end, the Spartans again offered peace, but the Athenians again refused. Like Oedipus, they had forgotten the First Rule of Holes: If you're stuck in one, stop digging.

8 A Peloponnesian inscription from this period shows how chronically short of cash the Spartans were: in a list of allied contributions, none exceeds three talents, most consist of small change, and one is a cartload of raisins!

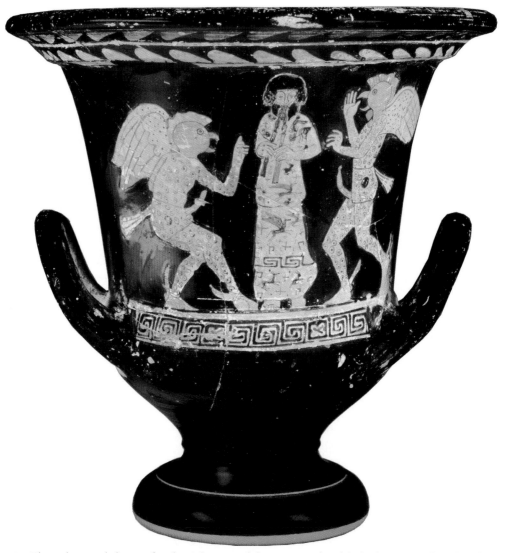

117. Flute-player and chorus of cocks. Athenian red-figure mixing bowl (calyx krater) attributed to the Painter of Munich 2335, ca. 420–10. Ht. 18.7 cm (7.4″). Malibu, J. Paul Getty Museum. The picture may reference or even illustrate Aristophanes' comedy *The Birds*, staged in 414.

At this point a neutral observer might have been forgiven for thinking that the war might go on forever.

THE HOME FRONT

The gravestone of Chairedemos and Lykeas from Salamis (Fig. 118) is a typical product of these years. The casualty lists of 411 and 409 offer a clue to its interpretation. Lykeas, on the right, appears in the 411 list, among more than sixty killed that year from his tribe; a note beside his name (a very rare

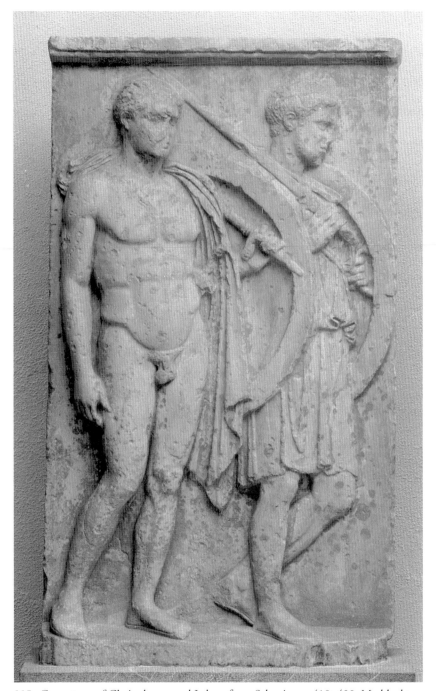

118. Gravestone of Chairedemos and Lykeas from Salamis, ca. 410–400. Marble; ht. 1.81 m (5′11″). Piraeus Museum. Chairedemos (left), a hoplite, appears in the Athenian casualty list of 409; Lykeas (right), a warship captain or *trierarch*, appears in the list of 411.

one) identifies him as a *triērarchos*, the sponsor and commander of a warship. Lampooned by the comic poets for his oligarchic sympathies, he died at the close-fought sea battle of Kynossema in the Hellespont. Chairedemos, on the left, appears in the 409 list, among more than forty that year killed from his tribe. So for all ten Athenian tribes, the butcher's bill in these years may have reached 500 annually: one percent of the adult male citizenry in 431. At first sight, this may seem modest, but in present-day Britain or France it would amount to 100,000 dead annually, and in the United States to *half a million*.

Most modern accounts of this gravestone note the gentle melancholy of the scene, conveyed by the slightly limp postures and downcast glances. They also remark upon the clear echoes of Polykleitos's Doryphoros (Figs. 71, 72) in both figures and then proceed to explain the subtle differences between them as a matter of aesthetics: naked versus clothed, beardless versus bearded (Lykeas's head is damaged, but his chiseled beard is still visible), foreground versus background, and so on. But the casualty lists hint at another explanation. Is Lykeas clothed because he was a sailor, and Chairedemos naked – like the Doryphoros – because he was a hoplite? And as for their joint appearance on the same memorial, were they father and son, older and younger brother, or even lover (erastēs) and beloved (erōmenos)? With typical reserve, the monument leaves these matters open, but in its original setting and to its intended audience – the family or families of the two men – the facts would have been clear.

This audience would also have caught other nuances that can easily elude the modern spectator. In typical Athenian fashion, the composition subtly privileges the soldier over the sailor, and even takes the former "out of time" by stripping him naked (on the gravestones, only athletes, some soldiers, and little boys are unclothed, as in Fig. 100). In this way it parallels the public eulogies delivered annually over the war dead, inscribing them in the roster of those heroes who *have always* sacrificed themselves for the city and *will always* continue to do so. And it reminds us that this is no proper tomb but merely an empty monument or *cenotaph* for heroes buried elsewhere. For like their fallen companions, Chairedemos and Lykeas would have been honored in these annual eulogies and then buried in the public cemetery in the most beautiful part of the Athenian suburbs, outside the Dipylon gate (sadly, it is now one of the ugliest). Finally, in the special circumstances following the oligarchic coup of 411, when Athens's soldiers and sailors found themselves on opposite sides of the political fence, this relief would have certified that despite Lykeas's oligarchic reputation these two, at least, were above such fratricidal behavior.

So much for the men of wartime Athens; what of the women? Here one turns, inevitably, to the "Meidian" vases (Figs. 109, 119, and 120). Over 200 red-figured vases survive that can be attributed to the so-called Meidias painter, his workshop, and his circle: A mere fraction of an enormous output that could have exceeded twenty thousand. Most are women's vessels, and all are painted in a delicate, calligraphic, sensuous style that immediately recalls the Nike parapet and Paionios (Figs. 104–6). Its monumental counterpart was probably the art of Parrhasios. For as we have seen, he was "the first to

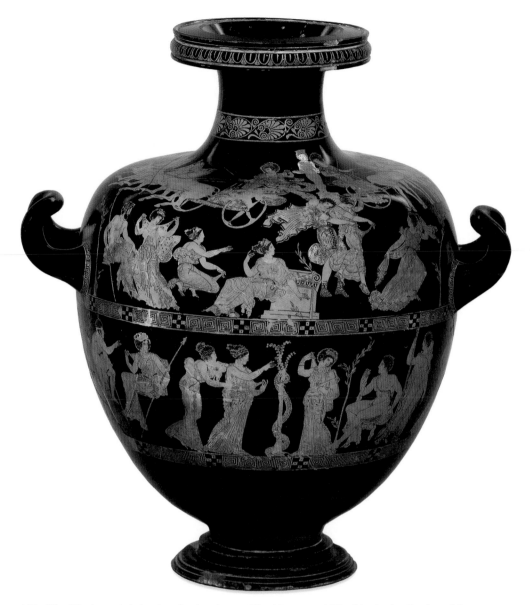

119. The Dioskouroi abducting the daughters of Leukippos, and Herakles in the Garden of the Hesperides. Athenian red-figure water jar (hydria) attributed to the Meidias Painter, ca. 410–400. Ht. 52.1 cm (20.5″). London British Museum.

give liveliness to the face, elegance to the hair, and beauty to the mouth; and artists acknowledge that he was supreme in painting contour lines – the most subtle aspect of painting."

The lush, romantic character of these vases has been brilliantly characterized by Attic vase-painting's greatest connoisseur, Sir John Beazley: "Here also there's beauty: the gleam of gold, loves and ladies with soft limbs, in soft raiment, and all that is shining, easeful, and luxurious: perfume, honey, and

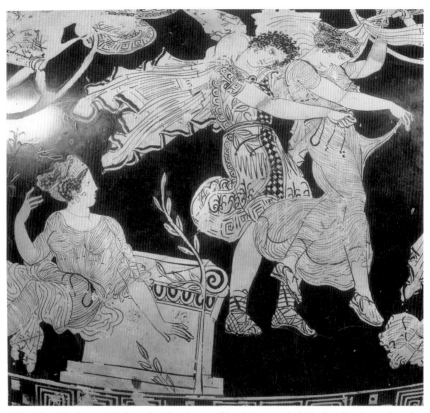

120. The Dioskouroi abduct the daughters of Leukippos, while Aphrodite (seated at the altar) looks on. Detail of the hydria, Fig. 119.

roses, till the heart longs for what is fresh, pungent, and hard."[9] Beazley's heart evidently did so – and a robust, powerful, assertively masculine style, the descendant of Figs. 40, 41, and 101, did flourish alongside the Meidian – but many consumers both inside Athens and out clearly could not get enough of them.

Long ago recognized as broadly escapist, they beg for firmer contextualization. In particular, their mostly female clientele might have seen them in a double light, as both a welcome diversion from the seemingly endless fighting and a consolation (however small) for the long absences overseas of their soldier or sailor husbands. Increasingly, many such women even had to take in work (particularly weaving and wet-nursing) and even to do agricultural labor (planting and picking) in order to survive, in essence reducing themselves to the level of slaves.

But anyone among the tens of thousands cooped up within the city's defenses could warm to these sunny Meidian utopias as year succeeded year and enemy patrols continued to roam the Attic countryside at will, preventing all but the boldest from venturing far from the walls' protective shield (see Map 3).

9 *Attic Red-figured Vases in American Collections* (Cambridge, MA, 1918), p. 185.

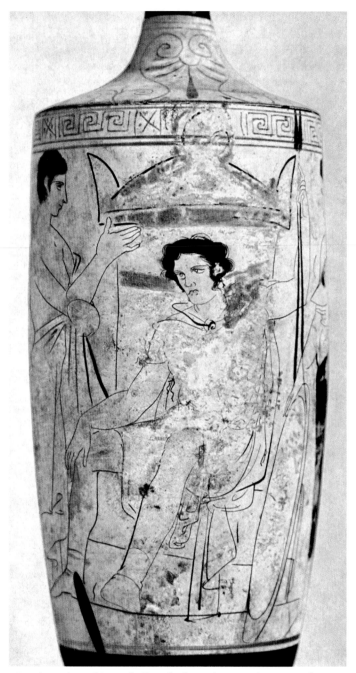

121. A warrior at his tomb. Detail of an Athenian white-ground
funerary oil flask (lekythos) from Athens attributed to Group R (the
following of the Reed Painter), ca. 405. Ht. of picture ca. 22 cm (8.6″).
Athens, National Museum. Much of the color, added after firing, has
disappeared.

So whereas the Nike parapet brilliantly projected the city's yearning for victory and its attendant delights onto women's bodies (Figs. 104 and 105), here it is peace and plenty's turn, reminding us of the infinite malleability (for a male-dominated society) of the female body, its status as a blank slate upon which men can inscribe their innermost desires.

The paintings themselves eloquently speak to these feelings. Often set in paradise gardens, they focus on carefree tales of love and leisure, and especially on Aphrodite, Eros, and their cohorts (Figs. 109, 119, and 120). Mortal women are assimilated to the goddess and her attendants, and even rapes turn into romantic elopements (Figs. 119 and 120). In the world of literature, their counterparts are those "tragedies" of Euripides that against all expectations end happily, such as *Iphigeneia among the Taurians* [see Box 1. *Euripides's* Iphigeneia among the Taurians]. Female personifications abound, further warming the already cheerful mood: Persuasion, Health, Good Order, Good Repute, Wedding-Feast, Happiness, Harmony, Good Luck, Leisure, Play, and even All-Night Partying! Other women, though not strictly personifications, bear names redolent of feminine beauty and allure, such as Golden-Faced or Shining. The painters make little attempt to distinguish these figures from each other, physically or otherwise. Their purpose is to act as an omnipresent, always upbeat, visually stunning chorus. They nuance and contextualize the narrative and offer a glimpse of utopia in the midst of hell.

Harsh, everyday reality is represented by another group of vases, designed for display at the tomb: the white-ground funerary lekythoi of the Reed Painter and his workshop (Fig. 121). Their composition is often quite stereotyped. The deceased sits at his own tomb, tended by the loved ones he has left behind. The style is sketchy and powerful, the mood gloomy, brooding, and oppressive. The youth of Fig. 121 has died in battle, and for what? By then, around 405, the gilded summertime of Athenian imperialism was long past; this is fall, turning to winter.

THE END

In August 405, the brash Athenians at last met their nemesis. Fatally underestimating the Peloponnesian navy and its brilliant strategist, the Spartan admiral Lysander, and ignoring a warning from Alkibiades (living in exile nearby), they let themselves be caught on the beach at Aigospotamoi in the Hellespont. One hundred seventy-one ships and twenty thousand men were captured; only nine ships escaped. Lysander executed all the Athenians among the prisoners, more than three thousand in all, and released the rest. Xenophon describes what happened when the awful news reached Athens:

> It was night when the *Paralos* sailed in and reported the disaster. The wailing spread from the Piraeus up the Long Walls to the city as each man told his neighbor the news. That night no one slept, not only in grief for the dead but also in terror for themselves, for they expected to be treated as they themselves had treated the people of Melos, Histiaia, Skione, Torone, Aigina, and many other places besides.

Lysander then toured the Aegean, liberating the Athenian empire city by city and dispatching every Athenian he found back to Athens, further swelling the numbers crammed within the walls. By November his fleet was blockading Piraeus and Spartan campfires were burning around the stricken city. Food began to run short, but even so, the Assembly rejected yet another peace proposal because it demanded the demolition of the Long Walls (see Map 3). Famine stalked the streets, and at last, in April 404, the Athenians surrendered. The Thebans and Corinthians wanted them to suffer the same cruel fate as they had inflicted upon the Melians, but the Spartans, to their eternal credit, demurred, "for we have no wish to destroy that city which in its time has done such great things for the Greeks."

Lysander's fleet then sailed into Piraeus and his army began to demolish the walls to the sound of flutes. The Athenian empire was formally dissolved and the Athenian navy was cut to twelve ships. (To rub salt into the wound, the rest were burnt and the dockyards destroyed, all on the very anniversary of Salamis.) Athens was forced to become a formal ally of Sparta, and a pro-Spartan oligarchy – soon dubbed the Thirty Tyrants – was installed in the city, its rule enforced by 300 "whip-bearers." The dream was over.

CHAPTER 6

THE FOURTH CENTURY: AN AGE OF THE INDIVIDUAL?

FROM AIGOSPOTAMOI TO ALEXANDER

The end of 404 saw Sparta supreme in the Aegean and (an ominous prece-dent) its victorious admiral, Lysander, honored as a god by the Samian oligarchs he had restored to their island home. As a bonus, the Samians even renamed their annual festival to Hera the "Lysandreia." At Sparta, Lysander dedicated two Nikai on eagles, trumping Paionios's single Nike at Olympia (Fig. 106). This dedication is one of the very few Spartan ones during our period, but (importantly) it was personal, not offered by the state. Finally, at Delphi Lysan-der celebrated by dedicating a gold and ivory model of a warship (a present from his Persian backers) and a splendid victory monument, which he provoca-tively sited immediately before the Athenian one to Marathon (Fig. 122).

Made by Polykleitos's sons and pupils and dominating the entrance to the sanctuary, this monument consisted of at least three dozen life-size bronzes arranged in two rows. Lysander stood triumphantly at its center, crowned by Poseidon and flanked by Zeus, Apollo, Artemis, the Dioskouroi, and his own soothsayer and pilot. Behind them stood his admirals, as silent witnesses to his success. Here and at Delos, where he returned control of Apollo's sanctuary to the Delians, the message was clear. After three generations, Athenian control of the Aegean was over.

Yet although Lysander basked in his newfound glory, in the end the Peloponnesian War did no one any good. As the Viennese critic and essayist Karl Kraus once remarked, in every war,

> At first, there's the hope that one will be better off;
> Next, the expectation that the other guy will be worse off;
> Then, the satisfaction that he isn't any better off;
> And finally, the surprise that everyone's worse off.

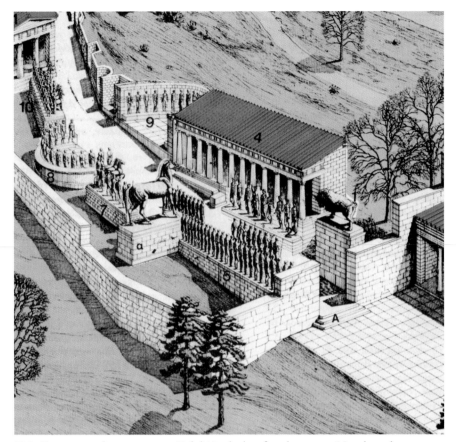

122. Entrance to the sanctuary at Delphi in the late fourth century. Note how the competing multifigure dedications of bronzes line the Sacred Way inside the entrance to the sanctuary. Key: **A** Entrance to the sanctuary; **1** Bull, dedicated by the Korkyreans (ca. 470); **2** Dedication of the Arkadians (369); **4** Portico perhaps dedicated by the Tegeans (360s); **6** Aigospotamoi dedication of Lysander (403); **a** Trojan Horse, dedicated by the Argives (414); **7** Marathon dedication of the Athenians (460s?); **8** Dedication of the Argives (456); **9** Dedication of the Argives (369); **10** Dedication of the Tarentines (ca. 490).

Kraus's quip neatly describes Greece from 404 to Philip II of Macedonia's triumph over Athens and Thebes in 338 and Alexander's accession to the Macedonian throne two years later: Three generations of short-lived hegemonies, fratricidal intercity wars, ephemeral peace treaties, political instability, economic depression, a widening gulf between rich and poor, and last but not least, individual self-aggrandizement. For despite an upsurge in federalism and intercity leagues, this was also an age of big men who often transcended the polis or trampled upon it: of kings, tyrants, generals (often mercenary ones), and even financiers. And for the eastern Aegean, it meant a double change of master: the Spartans until 386 and the Persians (with Spartan connivance) thereafter – until 334 and the coming of Alexander.

Yet, as so often, adversity stimulated creativity. Culturally the fourth century was a golden age, particularly at Athens. For the Athenians had managed

to oust the Thirty Tyrants, to restore the democracy, and to recover their autonomy quite quickly after 404. Though still prone to faction and politically inspired litigation, the revived democracy proved to be remarkably stable, for the Thirty's excesses had discredited the city's oligarchs once and for all; literature flourished; and last but not least, the arts reached new heights, both at Athens and elsewhere. Some of the intellectuals and many of the artists were non-Athenians, but Athens was now their undisputed Mecca. Ironically, the city was now far more the "education to Greece" of Perikles's dreams than when he was alive.

Yet fourth-century Athens was also deeply nostalgic for its lost glories. Not only are the orators and even philosophers full of slighting comparisons between the present and the fifth-century past, but the city even went so far as write this nostalgia into law, canonizing Aischylos, Sophokles (Fig. 164), and Euripides as the three "classic" tragedians. Aristophanes's *Frogs* of 405, featuring a contest between Aischylos and Euripides over which one of them should be released from Hades to rescue the city from its present plight, is the first sign of this canonization, which the dēmos formally recognized in 386. Thenceforth the city entered one of their plays in the annual tragic competitions at the Great Dionysia to set a standard for the work of contemporaries. We shall encounter the trio's equally nostalgic commemorative portraits in Chapter 7. Aristophanes was similarly canonized in 339, and the inscribed records show that these annual revivals of the old classics often beat the newcomers.

Because of this canonization of the four titans, fourth-century drama survives only in pitiful fragments, but this was also the classic age of Attic prose: of the speechwriters and orators Lysias, Demosthenes (Fig. 173), Aischines, Lykourgos, and others; the political commentator, pamphleteer, and educator Isokrates; the historians Thucydides (see Fig. 165: he wrote perhaps as late as 395) and Xenophon; and the philosophers Plato (Fig. 133) and Aristotle. In art, it is also the age of the master architects Theodoros of Phokaia, Polykleitos the Younger of Argos (Figs. 167, 168), and Philon of Eleusis; the architect-sculptors Pytheos of Priene and Skopas of Paros (Figs. 136, 137); the sculptors Lysippos of Sikyon (Figs. 154–156, 166, 170), Kephisodotos (Fig. 131), Silanion (Fig. 133), Praxiteles (Figs. 140, 141), and Leochares, all of Athens; the sculptor–painter Euphranor of the Isthmos; and the painters Nikias of Athens, Pausias of Sikyon, Philoxenos of Eretria (cf. Fig. 158), Apelles of Kos (cf. Fig. 169), and Protogenes of Rhodes. A stellar array.

CONCERNS AND OBSESSIONS

Fourth-century thinkers grappled endlessly with the burning issues of the day, greatly widening the scope of fifth-century inquiry, but achieved even less consensus than before. Four concerns in particular are relevant to us: government, religion, ethics, and the question of "reality."

Government

The ongoing democracy/oligarchy/monarchy debate was only one facet of fourth-century political discussion. In the democracies, the major problem was how to reconcile powerful individuals and an egalitarian state, whereas in the monarchies, it was how to reconcile one-man rule and Greek standards of individual freedom.

Lysias and Demosthenes stoutly defended democracy against all comers; Plato constructed his oligarchic utopia of philosopher-kings and guardians (see Box 1. *Plato's* Republic); and Aristotle (a staunch monarchist) tutored the young Alexander the Great in enlightened kingship. Yet others, sickened by the endless fighting, promoted Panhellenism or at least intercity concord. Isokrates, after favoring first a dual Athenian–Spartan hegemony and then the mirage of a Common Peace, eventually tried to interest a succession of leaders in a Panhellenic crusade against Persia. The last and most receptive of these was Philip II of Macedonia, a northern Aegean kingdom hitherto on the fringes of Greek affairs. Isokrates was not to see his dream fulfilled, however. After Philip decisively beat Athens and Thebes at Chaironeia in 338, the aged pamphleteer, sick, disillusioned, and ninety-eight years old, starved himself to death.

As we shall see, fourth-century art addresses these concerns in numerous ways, ranging from the promotion of egalitarianism, elitism, or autocracy in civic, military, and royal portraiture to tendentious representations of democracy, peace, wealth, and other key political concepts (see Figs. 77, 131–3, 153–9, 164–6, 169–72).

Religion

Although Euripides had treated Athens' divine patroness Athena more and more critically as the Peloponnesian War dragged on, the war did not cause a general crisis of faith, still less any sustained flight from traditional piety. In 399, the Athenians tried, condemned, and executed Sokrates not just for elevating his own inner "voice" above the city's gods, but also for tutoring such destructive figures as Alkibiades and some of the Thirty Tyrants, Kritias included. Yet on a broader front, the fifth-century enlightenment had done its work well. Some sophists had been agnostics or even atheists, and their relativism and skepticism had shattered the authority of the poets on matters religious. Responding to an increasing conviction that the divine should be autonomous and perfect, Plato invented his Demiurge or Divine Creator, and Aristotle his Unmoved Mover (!), but these were intellectual constructs of no consequence outside narrow philosophical circles.

Yet the war did spawn important new cults, as we have seen. The benign healing god Asklepios, introduced to Athens in 420 presumably in reaction to the plague (see Chapter 5), was destined for a great future there, at Epidauros, and elsewhere (see Figs. 87, 138); and Lysander's victories of 405–4 inspired the first ruler and benefactor cult of a still-living man, which would resurface dramatically with Alexander.

BOX 1. *PLATO'S* REPUBLIC

The *Republic*, set in the aged Kephalos's house in Piraeus, begins as an enquiry into the nature of Justice. Sokrates prompts the guests to come up with their own definitions. Justice is "giving everyone his due" (an extreme traditionalism/conventionalism), or "the rule of the strongest" (an extreme naturalism), or some sort of compromise between the two. *Nomos* (human law; convention) apparently conflicts irreconcilably with *physis* (nature). After revealing the weaknesses of each suggestion in turn, Sokrates proposes a different (but hardly revolutionary) approach: City first, individual second.

After sketching the city's evolution to the present day, he proposes a tripartite social structure of Guardians, Auxiliaries, and Producers. They will work together in harmony precisely because they mirror the three parts of the soul: Reason, Spirit, and Desire. We all possess these attributes in different measure, and it is the purpose of a good educational system to develop them: Nurture must fulfill nature. The Guardians will lead the city because of their powers of reason, developed by philosophy; the Auxiliaries will defend it well because of their warlike spirit; and the Producers will produce because they want to.

The Guardians are, in fact, philosopher-kings. Their education consists of Pindar's "hard climb to excellence," up a long developmental ladder that takes them from the physical world of appearances and objects, to the intelligible world of mathematics and geometry, and finally to the universals or Forms. Only at this last stage can they apprehend the Form of the Good. Knowing the Good in all its beauty, order, and harmony and by necessity following it (for no one does wrong willingly – another Sokratic axiom), they will then know and be able to administer Justice. They will dedicate their lives to philosophy and to promoting the public good, keeping their own individuality on the shortest leash possible (as at Sparta, though Plato leaves the comparison unstated).

En route, we learn that women can be Guardians too; that their education will equal the men's, exercising naked included (see Chapter 4 and Fig. 95); and that strict censorship will protect everyone from corrupting influences such as love poetry and illusionistic painting (see Chapter 5 and Figs. 108–10), which not only belong on the lowest rung of the ladder mentioned above, the world of appearance and illusion, but are actively dangerous, for they give poets and painters a power that must only be wielded by philosophers.

In fourth-century art, images of divinities are legion (see Figs. 138–41), and hundreds of votive reliefs also eloquently assert the continuing vitality of the traditional religion (see Fig. 87). For the burning questions were not whether the gods existed, but in what form, and whether human beings could

relate to them. Hence the special popularity of Asklepios, Dionysos, and Aphrodite (Figs. 87, 129, 140, 141, 150, 151), because health, wine, and love appeal to us all. But so does power. What of the exploits of Philip and especially Alexander (see Figs. 169, 170–72)? Were they god*like*, divinely inspired, or even – ye gods! – actually, really, truly divine?

Ethics

Sokrates had invented the study of ethics, but in Greece the question of how one should live was as old as Homer. Among the many fourth-century responses to it, one stands out because of its deep roots and wide currency, not least in Athens: an updated version of the "middling" ideal discussed in Chapter 1. This ideal now generated its own specialized ethical vocabulary. As well as being prudent and intelligent, the good citizen should be moderate, orderly, and self-controlled, while bravely and strenuously exerting himself on behalf of his city.

Meanwhile, Aristotle, a non-Athenian whose horizons were considerably wider than this (not least owing to his close relations with the Macedonian court), promoted the Magnificent Man (rich, noble, splendid, generous, "an artist in expenditure") and the Great-Souled Man ("who claims much and deserves much; . . . an extreme in regard to his claim, but the mean by reason of its rightness"). Whereas the former "likes to furnish his house in a manner suitable to his wealth, since a fine house is a sort of distinction," the latter "likes to own beautiful and useless things rather than profitable ones, since the former show his independence more." So much for Athenian democratic moderation!

Fourth-century art vividly illustrates the strength of these competing ideals. Whereas Figs. 124 and 128 illustrate the "middling" Athenian citizen, Figs. 155 and 156 show the ultimate "great-souled" man, Alexander. Meanwhile, in much of Greece increasingly expensive houses and tombs, and an upsurge in privately dedicated portraits in sanctuaries, confirm the exhibitionist trend noted by Aristotle. Most Athenians still kept a low profile at home, but elsewhere houses became larger and their interiors began to boast pebble mosaics and even frescoes, even though they remained democratically austere on the outside. Precious metalware ousted red-figured pottery from rich men's tables (see Fig. 130, where the host holds a fancy silver or gold drinking horn), and women began to wear gold jewelry again. Lavish grave goods were a central and northern Greek specialty (see Figs. 150, 151), but even in Athens, many tombs now boasted costly figured gravestones in marble (see Figs. 80, 124, 125, 128).

Appearance and Reality

Fifth-century Greek thinkers had been obsessed with the problem of true Being, with the gulf between *nomos* (human law; custom; convention; culture) and *physis* (nature). What, if anything, lay behind or beyond the material world? Mathematics (Pythagoras)? Atoms (Demokritos)? Or another,

"real" reality (Parmenides)? Or was one's personal perspective the only truth (Protagoras) and was Being merely a language game (Gorgias)? Did everything boil down to human judgment?

Fourth-century thought was just as fractured. Plato, a bitter enemy of Sophistic relativism, posited a system of transcendent Forms of everything from beds to justice (see Box 1. *Plato's* Republic) – though he balked at Forms of mud and hair! Earthly beds, earthly justice, and so on, were mere second-hand copies of these Forms, which constituted the only true reality and were the only proper objects of thought, and thus of philosophy. (Artworks, being copies of copies, were even more deceptive and problematic.) Aristotle, reversing the procedure, asked what form was inherent in each piece of matter, thus reestablishing Being's immanence in the physical world. And (to judge from the orators, the pamphleteers, and Xenophon's and Plato's Socratic dialogues) popular thought was totally confused, usually accepting the existence of fundamental principles of some kind but deeply unsure of their status beyond the purely conventional.

Contemporary artists were equally divided. Although Polykleitos's pupils followed his principles "like a law" (as in the great victory dedications at Delphi, Fig. 122), others firmly rejected his hard-line idealism in favor of either realism (a minority: see Fig. 123) or a personal, subjective approach that sought truth in appearance – anathema to traditionalists such as Plato (see Box 1. *Plato's* Republic). Lysippos explicitly pursued the latter course (see Box 1, Chapter 7. Pliny on Lysippos), and he and Apelles, both deft manipulators of proportion (*symmetria*), aimed to create not a categorical "truth" but (like Gorgias) a highly crafted illusion of grace and elegance – making them both much desired as portraitists (see Figs. 154–6). With them, the perceptual approach pioneered almost two centuries before by Euphronios and Euthymides (Fig. 8) finally triumphed across the board. And although some artists specialized in portraiture, the ultimate expression of the here-and-now (see Figs. 132–4, 153–9, etc.), others created images that concretized different levels of reality and concepts behind, above, and beyond the particular and palpable (see Fig. 131).

ATHENS: CITY AND INDIVIDUAL

A mere nine years after the double trauma of the surrender to Sparta and the Thirty Tyrants, the Athenians again found themselves at war with the Spartans – but now leading a coalition of Sparta's former allies and partners, fed up with Spartan arrogance and brutality. The monument that most clearly announces the city's reinvention of itself in this period is Dexileos's cenotaph in the Kerameikos (Figs. 124, 125). Its inscription tells us that it honors Dexileos son of Lysanias of the deme Thorikos, who was killed, aged 20, at the Battle of Corinth in July 394. One of the "five riders" who had distinguished themselves in the battle (which the Spartans won), Dexileos would have been buried with his compatriots in the public cemetery just outside the Dipylon gate of the city.

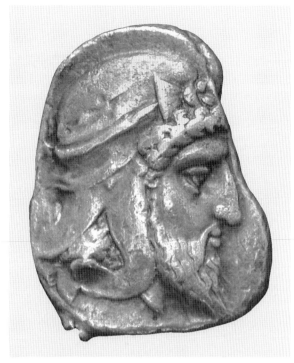

123. Persian noble. Silver tetradrachm (four-drachma piece) of Miletos, ca. 412–11 or later. Diam. 2 cm (0.8″). Oxford, Ashmolean Museum. The subject is perhaps the satrap Tissaphernes, who bankrolled the Spartan fleet at the end of the Peloponnesian War; his hooked nose and crafty smile are realistic touches.

In his empty tomb were placed five small red-figured jugs, four of them with Dionysiac and Anthesteria-related themes (see Chapter 4), and one with a picture, appropriately, of the Tyrannicides (Fig. 126; cf. Figs. 5, 34). Fragments survive of the Athenian state memorial to the battle; they include a version of the scene shown on Fig. 124, with Dexileos's name duly listed among the dead. Moreover, by a unique coincidence, Lysias's eulogy for the fallen has also survived – an oration in direct line of descent from Perikles' famous Funeral Speech of 431, discussed in Chapter 3.

The relief shows Dexileos on his horse, towering over a fallen foe and thrusting down at him with his spear. This was added in bronze, as were Dexileos's helmet, his horse's reins and bridle, and his opponent's sword and sword-belt; the figures and background probably were painted as well. The relief stood on a tall, curving wall that closed off a triangular enclosure dominating the junction of three streets: the so-called Street of the Tombs, leading directly out of the city, and two side roads (Fig. 125). This wall ended in two piers topped by marble sirens, one playing a bronze lyre and the other (probably) the pipes. They added a note of eternal mourning to the ensemble, echoing the lamentations of Dexileos's family and Lysias's civic eulogy.

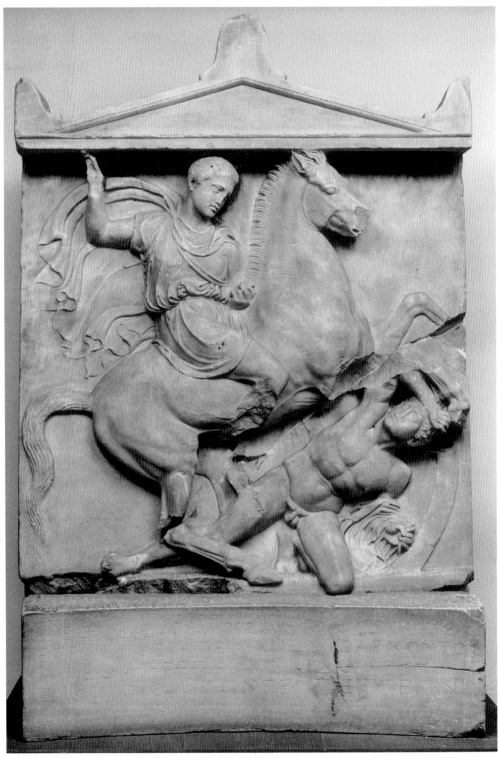

124. Gravestone of Dexileos son of Lysanias from the Kerameikos cemetery, Athens, 394–3. Marble; ht. 1.40 m (4′7″). Athens, Kerameikos Museum. Dexileos's helmet, spear, and horse's reins and his opponent's sword were added in bronze. The inscription states that he died in 394, aged 20; another, on the official Athenian war memorial, says that he died at the battle of Corinth.

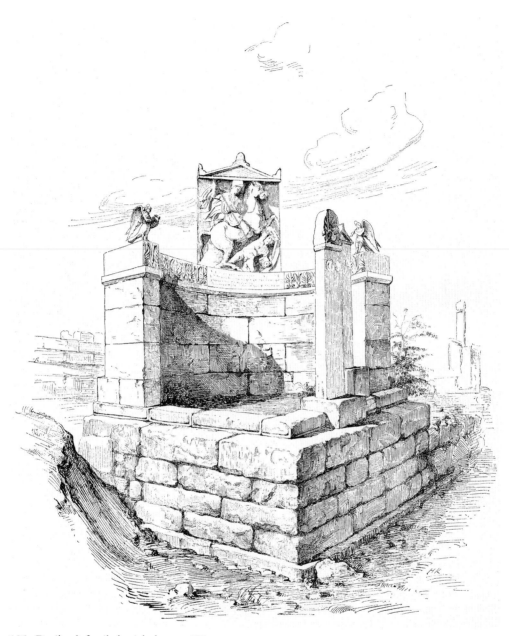

125. Dexileos's family burial plot, ca. 390.

So this cenotaph was deliberately positioned where it would catch the attention of everyone leaving the city. Ostensibly a private memorial, it performed a decidedly civic function. It showcases Dexileos as an exemplary young Athenian, one of those who *have always* sacrificed themselves for the city and *will always* continue to do so. As Lysias noted with high rhetoric, these men followed a great Athenian tradition that included the victors over the Amazons (see Figs. 39, 60, 101) and the Persians (see Figs. 25, 103) and

those who had driven out the Spartan occupiers and their stooges less than a decade earlier:

> These men, both in their life and in their death, are enviable; for first they were trained in the virtues of their ancestors, then in manhood they both preserved that ancient fame intact and displayed great prowess of their own. The benefits they have conferred on their country are many and splendid; they restored the broken fortunes of others, and kept the war away from their own land. They closed their lives with a death that befits true men, for thus they repaid their country for their nurture and are justly mourned by those who reared them ... But why chafe now at a fate so long expected? Death neither disdains the wicked nor admires the virtuous, but is evenhanded with all. Their memory can never grow old, while their honor is every man's envy. Their nature constrains us to mourn them as mortal, but their valor compels us to praise them as immortal.

So it is not surprising that Dexileos's duel pointedly echoes several of the metopes from the Amazonomachy on the Parthenon's west side (see Fig. 60), and Dexileos himself strongly recalls the Parthenon riders (see Figs. 54, 55), though the carving is harder and the relief much higher, as if the sculptor were putting him in quotation marks for our benefit. In the tomb below, the little Tyrannicides jug (Fig. 126) expressed the hope that when he arrived in Hades these archetypal freedom fighters (see Figs. 5, 34) would welcome him as a latter-day Athenian hero in their own mold. For (to quote Lysias again), they and their compatriots had been

> ... the first and only people at that time to drive out the despotic rulers of our state and to establish a democracy, believing the liberty of all to be the strongest bond of agreement. By sharing with each other the hopes born of their perils they acquired freedom of spirit in their civic life, and created law for the purpose of honoring the good and punishing the evil.

Finally, the prominent inscription, with its unique attention to the date of Dexileos's birth (414) and death (394), implicitly absolves him from any involvement with the two oligarchic coups of 411 and 404. As a member of the equestrian class he was naturally suspect here, because despite Perikles' reforms the cavalry was still dominated by the aristocratic and often pro-Spartan elite.

This may not be the only note of anxiety in this otherwise stridently patriotic composition, which on closer inspection looks more like a ballet than a battle. Dexileos, in particular, is completely inorganic. His torso is twisted to flatten it against the relief, and an emphatic, undeviating chasm divides him and his opponent, whose ultrahard, naked body, dramatized by his frontal pose, highlights Dexileos's heroism in besting him. Moreover, the scene's omissions are just as telling as what it includes. The setting is completely indeterminate; Dexileos is utterly emotionless; the only armor in sight is his bronze helmet; and the ugly reality of battle with edged weapons – the ghastly butcher's yard of ancient Greek warfare – is totally effaced, for his spear stopped short of his opponent's body, leaving it whole and unpierced.

126. The Tyrannicides. Athenian red-figure wine jug (oinochoe) from Dexileos's burial plot, ca. 400–395. Preserved ht. 14 cm (5.5″). Boston, Museum of Fine Arts. Compare the statues by Kritios and Nesiotes, Figs. 5, 34.

So this relief is no straightforward dispatch from the front but a superbly realized fictionalization and idealization of war. It sanitizes battle, injury, blood, and death and redescribes them metaphorically as a chance encounter of two young men on the road to glory. Contrived like a frozen ballet, a kind of superclassicism, to glorify a fleeting moment of success in the hour of defeat, does it betray a shiver of anxiety about whether Athens's revival would last, and whether the city could sustain the cost? For war and plague had halved its population;[1] its empire and tribute were gone forever; and its former subjects never completely trusted it again.

Almost immediately after this battle, stunning news arrived from Asia. The Athenian admiral Konon, a survivor of Aigospotamoi now commanding a Persian fleet (for Athens still had no proper navy of its own), had annihilated the Spartan fleet off Knidos. Upon his return, Konon used part of the spoils to rebuild the city's fortifications, including the Long Walls and those of Piraeus (Map 3; Fig. 31). Ecstatic and grateful, and even hailing the victory as reversing the defeat of 404 (which it did not), the Athenians honored him publicly with a bronze portrait in the Agora – the first after the Tyrannicides (Figs. 5, 34; the Themistokles and Perikles, Figs. 37 and 56, were private commissions).

Many more honorary portraits were to follow Konon's, as the balance of power between city and individual began to shift inexorably in favor of

1 For comparison, imagine the effect of 25 *million* war dead on the United States, or 5 million on Britain or France; in modern times only Russian World War II losses even come close.

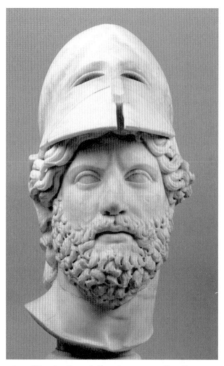

127. Head of an Athenian general or hero
(Roman copy); bronze original, ca. 350.
Marble; ht. 42 cm (16.5″). Berlin, Staatliche
Museen. The original would have been a
full-length statue.

the latter. The few copies that survive (Fig. 127: the originals are all lost) are
little more than clones of the Perikles (Fig. 56). When bestowing this signal
honor, the dēmos evidently took pains to ensure that its lucky recipients were
represented as ideal democrats, just like him.

Meanwhile, private citizens eagerly promoted their own democratic cre-
dentials, civic solidarity, and commitment to moderation, ostentatiously tun-
ing out the factionalism and litigiousness in which many of them, as voters,
jurors, and city functionaries, must eagerly have participated. As we have seen,
not only do the orators present a vivid image of the perfect "middling" Athe-
nian – prudent, intelligent, self-controlled, moderate, orderly, and so on – but
also the several thousand fourth-century Athenian gravestones that survive
throw this image (literally) into high relief. They showcase the family/oikos
as never before in Greek sculpture, but do so in a manner that now makes it
the nucleus of the democratic city.

Although (or perhaps because) the very act of erecting a costly gravestone
violated the strict egalitarianism of the Periklean period, the cast of charac-
ters on these gravestones is strikingly uniform, indeed quite depersonalized,
individualized only by inscriptions on the architrave (Fig. 128). These are
prosperous farmers and businessmen, a new middle class that had risen from

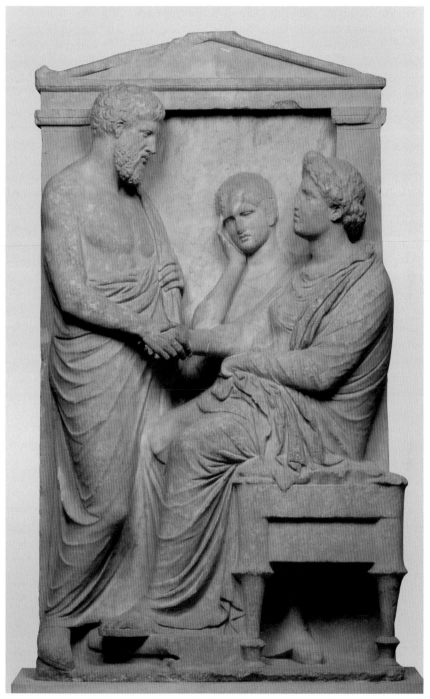

128. Gravestone of Thraseas and Euandria from the Kerameikos, Athens, ca. 350. Marble; ht. 1.60 m (5′3″). Berlin, Staatliche Museen.

the ruin of defeat, proud of its hard-won prosperity and perhaps somewhat anxious about maintaining it. Families are close-knit and tranquil; the men are thoughtful, dignified, well groomed, and tastefully dressed; the women mature and self-possessed; and the children obedient and well behaved. Only the occasional slave betrays a hint of emotion, by staring out listlessly from the ensemble or cradling his or her head dejectedly in one hand.

So these gravestones created what sociologists call an "imagined community" – *imagined* because most of its members never knew each other (Athens and Attica were too big for that) and a *community* because its members clearly conceived of it as real fraternity despite the actual inequality, exploitation, fragmentation, and dissension that prevailed in real life. Invoking a more profound reality behind the urban hubbub, they proclaimed a deep, horizontal comradeship sustained by the four Athenian charter myths explored in Chapter 2 and by a democracy that had withstood all assaults from both within and without. And because the cemeteries were situated directly along the roads radiating out from the city gates and the rural parishes or *demes*, these reassuring images were the first that anyone saw when approaching Athens or its satellite communities, and the last that any Athenian saw when leaving home.

Painted pottery, always sensitive to private concerns, presents a more nuanced picture. White-ground lekythoi disappear (Fig. 121: replaced by carved marble ones), as do, on red-figure, many time-honored departure and battle scenes – the Trojan War, Gigantomachy, and Centauromachy included. What remains is largely cultic, romantic, or fabulous, and Dionysos and Aphrodite – two great personal divinities and cosmic forces to whom everyone could relate – figure prominently.[2]

The bell-krater in Fig. 129 is a case in point. Athenian trade now focused on the northern shores of the Black Sea, the source of most of the city's grain, and everyone knew that the Amazons had once inhabited them. Many of these pots were exported to the Crimea and adjacent lands, part of a lucrative trade that also sparked interest in a peculiarly northern theme: the fight between the Arimasps and griffins. Popularized in an epic fantasy by Aristeas of Prokonnesos, the Arimasps reportedly lived between the Don and the Volga, and incessantly battled with the local griffins for control of their gold. As Prometheus had warned the hapless Io in Aischylos's *Prometheus Bound*:

> Now hear another
> Grim sight you must encounter. Beware the silent hounds
> Of Zeus, the sharp-beaked griffins; and beware the tribe
> Of one-eyed Arimaspian horsemen, on the banks
> Of the River of Wealth whose waters wash down gold.

On the vases, the Arimasps have two eyes and dress like Amazons in pseudo-oriental attire. The griffins – ancient symbols of power and wealth that even

2 Asklepios had no mythology as such, so the vase painters ignored him.

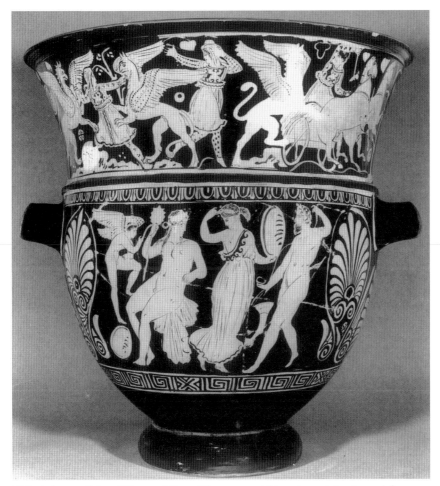

129. Arimasps fight griffins, and Eros, Dionysos, and his retinue. Athenian red-figure mixing bowl ("Falaieff" bell krater) attributed to the Griffin Group, ca. 350. Ht. 43 cm (16.9″). Paris, Louvre.

had appeared on the helmet of Athena Parthenos (Fig. 69) – combine lions' bodies with eagles' heads and wings.

Aristeas alleged that he met the Arimasps on a sightseeing tour of the Volga undertaken in a Dionysiac trance – in other words, stoned! Yet Dionysos and company (Eros now included) appear on Fig. 129 probably as much for their obvious relevance to the vessel's function as a wine bowl. From northern gold, they suggest, flow other pleasures too.

Dionysos rightly has been called the god of the fourth century, along with Aphrodite, whom we shall meet again shortly. Euripides had defined his character and powers for all time in his *Bacchai* of 406, and the wealth of images of him by late classical sculptors and painters amply attest to his enormous popularity. As in Fig. 110, in Fig. 129 the god, youthful, naked, and soft, sits gazing languidly at his entourage – an uncanny mixture of physical

effeminacy, mysterious allure, and subliminal power, just as the unsuspecting Pentheus sneeringly described him in Euripides' play:

> You are handsome, stranger, for women's taste –
> The goal, I see, that brings you here to Thebes.
> Your curls are long and cascade down your cheeks
> Seductively, so you're no wrestling man.
> And your complexion is so white that you
> Must keep it from the sun, and hunt indoors,
> Beguiling Aphrodite with your looks.

Meanwhile, a satyr and maenad caper about the god in carefree abandon. In such scenes the satyrs never have an erection and always behave themselves, whereas the women, absent-minded in their ecstasy, often let their garments slip from the shoulder, carelessly revealing a breast. For Dionysiac ecstasy (literally, "standing outside oneself") unashamedly bursts the confines of classical decorum:

> O Thebes, O nurse that cradled Semele[3]
> Be ivy-garlanded, burst into flower
> With wreaths of lush, bright-berried bryony,
> Bring sprays of fir, green branches torn from oaks,
> Fill soul and flesh with Bacchos' mystic power;
> Fringe and bedeck your dappled fawnskin cloaks
> With woolly tufts and locks of purest white.
> There's a brute wildness in the fennel wands –
> Reverence it well. Soon the whole land will dance
>> When the god with ecstatic shout
>> Leads his companies out
>> To the mountain's mounting height
>> Swarming with riotous bands
> Of Theban women leaving
> Their spinning and their weaving
> Stung by the maddening trance
>> Of Dionysos!

Dionysos was above all a god of carefree happiness, peace, and plenty – a welcome palliative for troubled times. He is omnipresent even when he is not represented personally. Pulsing through every living thing, he is the sap in the branch, the juice in the grape, and the wine in the cup (Fig. 130), the milk and honey in the cakes, and last but not least the blood and semen in the body. As Euripides' Bacchic chorus chants:

> The son of Semele, when the gay-crowned feast is set
> Is named among gods the chief;
> His gifts are joy and union of soul in dancing,
> Joy in music of flutes,
> Joy when sparkling wine at feasts divine

3 Dionysos's mother.

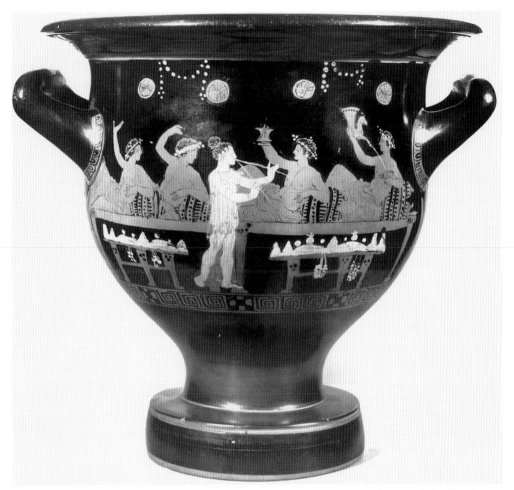

130. Symposion. Athenian red-figure mixing bowl (bell krater), ca. 350. Ht. 42.5 cm (16.75″). Vienna, Kunsthistorisches Museum. A flute girl entertains the young symposiasts, who recline in order of rank from left to right; at far right, the host pours wine from a fancy gold or silver drinking horn imitating the forepart of a griffin. Bunches of grapes hang from the food-laden tables in the foreground.

Soothes the sore regret,
Banishes every grief,
When the reveler rests, enfolded deep,
In the cool shade of ivy-shoots,
On wine's soft pillow of sleep.
. . .
Take me, O Bromios, take me and inspire
Laughter and worship! There our holy spell
And ecstasy are welcome; there the gentle band
Of Graces have their home, and sweet Desire.
Dionysos, son of Zeus, delights in banquets;
And his dear love is Peace, giver of wealth,
Savior of young men's lives, a goddess rare!

For the fourth century craved peace and plenty above all. When the Dexileos monument (Figs. 124–126) and the Konon (compare Fig. 127) were unveiled, in 393 or 392, peace was on everyone's mind and ambassadors were busy shuttling to and fro. Yet the fighting continued, and though it finally stopped in 386 at Persian instigation, another war with Sparta began only a few years later. This one lasted till 371, with another brief interruption in 375, again on Persian initiative, when the hopeful Athenians dedicated an altar and cult to Peace (Eirene) in the agora. In 371, when hostilities finally ceased, or in 362, when many of the Greek states signed a (predictably short-lived) Common Peace, the Athenians supplemented this altar with a bronze group of Eirene and Ploutos or *Peace Nurturing Wealth* by Kephisodotos, known in several fine Roman copies (Fig. 131). Now on a roll, they had even convinced much of their former empire to join a defensive alliance under their leadership (but not control), the Second Delian Sea League.

By this time the matronly Eirene's character was well established. In the eighth century, the poet Hesiod had given her an epithet, "blooming," and a genealogy, making her the daughter of Zeus and Themis (Custom) together with Law and Justice. In the fifth, Pindar and Euripides had glossed all this by calling her "child-nurturer" and (as we have seen) "wealth-bringer," and Aristophanes had put her on stage in his *Peace* of 421 together with two companions, the "harvest-breasted" Peace-and-Plenty and the "myrrh-sweet" Peacework, though none of them had speaking parts. In 388 his last extant comedy, *Wealth*, added Ploutos to the dramatic roster – though as the goddess Demeter's son, not Eirene's.

Kephisodotos registered much of this in his sculpture, not only by giving Eirene a scepter and Ploutos a brimming cornucopia, and by stressing the intimacy between the two, but also more subtly, through Eirene's hairdo, pose, and dress. For an alert spectator would notice that this caring mother goddess, with her long tresses and heavy, woolen Doric peplos (by then quite old-fashioned), strongly recalled Demeter, Ploutos's real mother, as visualized in the art of Periklean Athens. Figures such as the gorgeous, "harvest-breasted" young women of the Parthenon frieze, the Caryatids of the Erechtheion (see Fig. 111), and fifth-century vases (see Fig. 58) provide a wider context. On the other hand, the group's new intimacy and tenderness herald the complete realignment of Athenian sculpture soon to be achieved by Kephisodotos's own son, Praxiteles.

So Kephisodotos's point was twofold – and clearly directed at an "in" group of Athenians mindful and proud of their glorious past, who could connect and feel privileged thereby. Athenian commerce was flourishing, the good times had returned after fifty years of bad, and (as Dexileos's memorial, Fig. 124, had already intimated) sculpture itself also was making a fresh start with a Pheidian revival, the first "official" neoclassicism in Athenian and Western art. Mutually reinforcing, they proclaim an Athenian renaissance based not on imperialist aggression but on peaceful coexistence, cultural superiority, and commercial acumen. Meanwhile, Isokrates, Demosthenes, and others were busily trumpeting Athens's claims to cultural overlordship of Greece, and

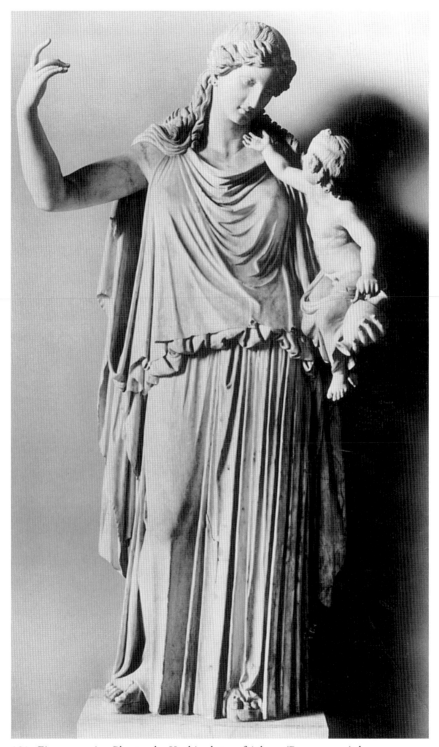

131. Eirene carrying Ploutos, by Kephisodotos of Athens (Roman copy); bronze original, ca. 370–60. Marble; ht. 2.01 m (6'7"). Munich, Glyptothek. Eirene's right arm, both of Ploutos's arms, and the jug are restored. Eirene originally held a scepter in her right hand and a cornucopia (together with Ploutos) in her left.

were actually describing its citizens as "mild," explicitly striving to repudiate an imperialist mindset that had brought nothing but disaster.

Yet, when the peace of 371 eventually was signed, the Thebans withdrew in a huff, and when the Spartans invaded to bring them to heel, they decisively defeated them, killing one of the two Spartan kings and 400 of the 700 Spartiates with him. The balance of power had shifted once again. Sparta's decline was now all but irreversible, a Theban hegemony had begun, and another round of conflicts was in the offing. The Messenians soon threw off the Spartan yoke, and the Arkadians seceded from the Peloponnesian League, federated, and dedicated their own monument at Delphi provocatively opposite Lysander's (see Fig. 122). These events also spawned a rash of tendentious personifications. The Thebans, for example, commissioned a Tyche (Fortune) carrying Ploutos, presumably to publicize their city's newfound preeminence and perhaps in passing to score a point off the Athenians as well. From Pausanias's description, it copied the Eirene closely. Such works continued to adopt the magnificent deportment and heavy, columnar draperies of the Pheidian style, pretentiously investing themselves in borrowed authority.

But what goes up can (indeed will) also come down, and Tyche in particular was a notoriously fickle goddess. The Thebans had nothing new to offer in place of Athenian culture or Spartan discipline, and when their charismatic leaders Pelopidas and Epaminondas were killed a few years later, they too soon found themselves overstretched, embattled, and eventually embroiled in an unwinnable war for control of Delphi: the so-called Third Sacred War of 355–46. The only real victor in this dreary conflict was a canny, ruthless newcomer, and certainly no democrat: King Philip II of Macedonia.

PHILOSOPHICAL ALTERNATIVES

Greek philosophers had long been involved in politics; only a few had disdained it entirely. In 386, Plato (ca. 429–347 B.C.), no friend to democracy, founded his Academy, about a mile northwest of Athens's Dipylon Gate, in an area sacred to the hero Akademos. He called it a *thiasos* or religious association, a clever move that protected him and his pupils from the charge of introducing new gods that had entrapped Sokrates. Endlessly ridiculed by the comic poets, it was not, as some have claimed, a philosophical "city outside the city," but a school for the training of statesmen and (he hoped) philosopher-kings. It eventually contained a gymnasion, a Mouseion (sanctuary of the Muses), a library, and residential facilities. Plato's *Republic*, published probably around 380, was its first textbook (see Box 1. *Plato's* Republic). Over a dozen fourth-century rulers and would-be rulers (most of them later vilified as tyrants) were educated there; and it was from there in 367 and again in 361 that Plato himself set out to school the Syracusan tyrant Dionysios II in statecraft – a fruitless task, as it turned out.

A head of Sokrates known in many Roman copies (Fig. 132) dates to this period and has been connected with a torn papyrus from Herculaneum

132. Head of Sokrates (Roman copy); bronze original, ca. 390–70. Marble; ht. 37 cm (14.6″). Naples, Museo Archeologico. The original would have been a full-length statue.

citing two eminent Athenian historians to the effect that "they [the Academy?] dedicated a bronze portrait mask of Sokrates, on which was written '[S?]otes made it,'" and "he [Plato?] told them [the Academy?] to dedicate at Athens a bronze portrait mask . . . beside the Mouseion. . . ." So was this mask dedicated in the Academy as some kind of a talisman: an ever-present reminder of philosophy's founding hero?

Figure 132 shows the great philosopher as Aristophanes, Xenophon, and Plato all describe him, and (presumably) as the mask worn by the actor who impersonated him in Aristophanes' *Clouds* had depicted him. He looks like the satyrs Silenos and Marsyas (see Figs. 110 and 129), with an ugly, lecherous countenance that totally belied the "great soul" within. This is the Sokrates of Plato's earlier dialogues such as the *Ion, Euthyphro, Charmides, Protagoras,* and *Meno*: the "gadfly" of Athens and ironic deflator of sophist and citizen alike. Some of the copies, however, intensify the expression by narrowing the eyes and pursing the lips, as if Sokrates were straining to conquer the satyric mask that the gods had allotted him. Unfortunately, there is no way to tell whether these touches are authentically fourth-century or are Roman embellishments.

So was this portrait simply trying to recreate the dead Sokrates' real face, using this clichéd comparison with a satyr as its model? Was it making

a pedagogical point, that the wise, benevolent teacher Silenos had been reincarnated in the individual that the Delphic oracle had called "the wisest man on earth"? Was it making a philosophical point, exploiting the disjunction between the satyric mask and Sokrates's true nature in a Platonic manner in order to emphasize the gulf between appearance and true reality, and the mendacity of the former? Or (finally) was it making a political point, challenging the fundamental values of the classical city, particularly the conviction that external appearance reflected inner character? For as Paul Zanker has remarked, "If the man whom the god at Delphi proclaimed the wisest of all could be as ugly as Silenos and still a good, upstanding citizen, then this must imply that the statue's patron was casting doubt on that very system of values. We have to look at this statue of Sokrates, with its . . . Silenos face against the background of a city filled with perfectly proportioned and idealized human figures in marble and bronze embodying virtue and moral authority."[4]

Alternatively, did it cover more than one of these bases, or even all of them together? We shall revisit this problem shortly.

When Plato died in 347, a Persian pupil of his, a certain Mithradates, commissioned a posthumous portrait of him from Silanion, a specialist in the genre; he set it up in the Academy, dedicating it to the Muses. Again, many copies survive of the head (Fig. 133), but none of the body. The pronounced forward tilt of the neck suggests that Plato was shown seated, like the bearded patriarchs of the Athenian gravestones (Fig. 128) and later philosophers.

Plato's portrait is easier to interpret than Sokrates's. His biographers describe him as handsome, modest, orderly, and dignified, and the comic poets ridicule his perpetually serious expression; his facial type also appears on the gravestones, complete with puckered brow and lined forehead. So Mithradates was presenting his master as a classic "middling" Athenian: prudent, restrained, self-controlled, moderate, orderly, and of course intelligent and thoughtful. Yet the specific setting of the Academy and the dedication to the Muses (patrons of the arts and of education) would have nuanced this reading somewhat. In the *Republic*, Sokrates singles out these and other key characteristics as essential for the philosopher, especially for one guiding a state:

> "Do you agree, Glaukon, that we have now been through a list of traits which all go together, and which the mind must have if it's to grasp reality fully and completely?"
>
> "Yes, certainly it must have them all."
>
> "Can you then possibly find fault with an occupation for the proper pursuit of which a man must combine in his nature a good memory, readiness to learn, breadth of vision, and versatility of mind, and be a friend of truth, justice, courage, and discipline?"
>
> "The god of Blame himself could find no fault here."
>
> "Grant, then, education and maturity to round them off, and aren't they the only people to whom you would entrust your state?"

4 *The Mask of Socrates: The Image of the Intellectual in Antiquity* (Berkeley and Los Angeles 1995): 39.

133. Head of Plato by Silanion of Athens
(Roman copy); bronze original, ca. 340.
Marble; ht. 35 cm (13.8″). Munich,
Glyptothek. Photo: D. Widmer, Basel. The
original would have been a full-length
statue.

This largely conventional catalogue of virtues suggests that Plato's portrait
(Fig. 133) was transgressing no boundaries – indeed that his and his followers'
vision of the ideal leader was at root deeply conventional, unlike their vision
of the ideal government. So perhaps the Sokrates (Fig. 132) did not present
him as a social revolutionary after all but merely as a latter-day Silenos, wise
and great-souled beneath his satyric mask.

At least one Hellenistic philosophical school did offer itself as an alter-
native to the polis, but in our period the only philosopher to do so firmly and
consistently was Diogenes the Cynic (414–323 B.C.; Fig. 134). This "Sokrates
gone mad" (as Plato called him), cantankerous, destitute, and living naked in
a barrel, proclaimed himself to be a "citizen of the world" (kosmos). According
to him, only the wise man can be free because he alone understands virtue; all
other men are slaves in fact, if not in law. Because the conventions of society
are arbitrary, the sage rejects them; private property, wealth, marriage, and
social status – the Greek city's social foundations – are irrelevant. His city is
the cosmos, and he is at home everywhere and nowhere.

Diogenes' portrait may postdate his death by many years, and when
he walked the streets he considerately wore a thong, but the statue's debt to

Sokrates (Fig. 132) and its emphatic rejection of civic convention (contrast, e.g., Figs. 58, 84, 88, 118, 128) are clear.

RETHINKING THE GODS

By 400, many Greeks would have felt very differently than their predecessors about the Olympian religion.

To begin with, many of them no longer believed that the stories of the poets (Homer and Hesiod in particular) were literally true, for they were blasphemous and self-contradictory. Reason dictated that gods do not fornicate and lie; imprison, fight, and cuckold each other; or die. Theognis had grumbled about all this already in the sixth century (see Chapter 1). In Euripides's *Iphigeneia among the Taurians*, the heroine declares that Artemis could never demand human sacrifice as the Taurians believed, for the goddess of purity (see, e.g., Figs. 51, 78) could not be hypocritical or evil; and in his *Herakles* the hero states flatly (demolishing Greek tragedy's very foundations and even – with typical Euripidean irony – his own existence):

> I don't believe the gods condone unlawful love.
> Those bondage stories are unworthy, too;
> I can't accept them; nor that any god
> Is tyrant of another. A true god
> Needs nothing. Those are poets' stupid myths.

So (second) the divine must be eternal, inexhaustible, omnipotent, omniscient, and self-sufficient, and therefore perfect, rational, and just. But both divine anthropomorphism and divine reciprocity are hard to reconcile with this package, because by definition a body is born, ages, and dies, and cannot be in two places at once; and how can a transcendent, impersonal, self-sufficient force that "needs nothing" take account of human needs or care for individuals? For above all, fourth century men and women wanted to *connect*. Hence the popularity of Dionysos, Aphrodite, and Asklepios (see Figs. 87 and 129): personal divinities offering satisfactions that the others could never match.

But (third) as a result, traditional religious practices – sacrifices, prayers, votive offerings, cult statues, and so on (see, e.g., Figs. 69 and 87–9) – remained acceptable, indeed more desirable than ever. For they both concretely expressed one's desire for a personal relationship with the gods, and also could serve a purer piety focused on divinity as such, whatever its form or needs. As Plato put it:

> Some of the gods [i.e., the sun, moon, and stars] we see clearly and honor
> them; but of the others, we set up likenesses or images, which we worship.
> And though these images are lifeless, we believe that the living gods are
> well disposed and grateful to us on this account.

So paradoxically, offerings of this kind now became both a duty and a quasi-symbolic gesture, because recognition of divinity as such entailed not only

134. Statuette of Diogenes the Cynic
(Roman copy); bronze original, ca. 300.
Marble; ht. 54.6 cm (21.5″). Rome, Villa
Albani. Only the head, torso, upper arms,
and right thigh are ancient.

that one must honor it, but also that if one had any brains at all, one could not take the form of these honors literally.

Greek artists – heirs to an entrenched tradition of anthropomorphism, dependent upon the Olympian religion for their livelihood, and servicing a largely nonintellectual clientele – could hardly devote themselves to addressing most of these concerns directly. As a result, most fourth-century images of the gods are resolutely conservative.

One could, of course, put old wine in new bottles, as at the Erechtheion and Bassai (see Chapter 5; Figs. 111–16). At the Arkadian town of Tegea around 340, the sculptor-architect Skopas tackled this task afresh. The temple that had housed the archaic idol of the city goddess, Alea Athena (Fig. 135), had burned to the ground in 395, and it took the Tegeans half a century to save enough money to replace it. Their diligence was amply rewarded. When

135. Statuette of Alea Athena from Tegea, ca. 500. Bronze; ht. 13 cm (5.1″). Athens, National Museum. Probably a version of the cult statue of Alea Athena by Endoios of Athens (ca. 525–500), which escaped the fire that destroyed the goddess's archaic temple in 395 and was installed in Skopas's replacement building around 330 (see Fig. 137).

Pausanias visited Skopas's temple five hundred years later he deemed it "far superior to all other temples in the Peloponnese on many grounds, especially for its size."

Following Iktinos's example at Bassai, Skopas chose the severe Doric order for the temple's exterior, but elongated the columns somewhat in order to make the building higher and more elegant. Its pedimental sculptures celebrated the exploits of Tegean heroes: the female boar-hunter Atalanta and the colonizer Telephos (Fig. 136). Their battered fragments show Skopas crafting a new heroic mode to fit the century's enhanced sense of personhood. Strongly muscled and with massive, cubic heads and craggy features, the figures seem to burst with energy, indomitably pursuing their goals. As at Bassai, carved porch metopes took up these themes and added more.

The temple's cella was more innovative and, following the example of the Erechtheion, far richer (Fig. 137; compare Figs. 111, 112). Here Skopas completely rethought his models, capitalizing on the much higher ceiling (50% higher) that the building's taller exterior columns and somewhat greater

136. Telephos, from the west pediment of the Temple of Alea Athena at Tegea, ca. 340–30. Carved probably by Skopas's workshop. Marble; ht. 31.4 cm (12.4″). Tegea Museum. Wounded by Achilles in the left thigh, Telephos has fallen to the ground – like Dexileos's opponent, Fig. 124.

size had given him. Eliminating Bassai's rear chamber and replacing its Ionic half-columns (see Fig. 115) with Corinthian ones, he pushed them back against the cella walls and (probably) mounted them on a continuous podium, whose crowning molding was located somewhat above eye level. The resulting space was both strongly unified and also less fussy and cramped than at Bassai, for these modifications both simplified it and tripled its usable volume. Finally, Skopas redesigned the Corinthian capital, eliminating its interior spirals and reinvigorating what remained.

But these brilliant innovations merely provided a frame and backdrop for the pious votives within, diligently listed by Pausanias. These included ancient trophies from the heroic exploits shown in the pediments and spoils from Tegea's past wars with Sparta, that former colossus now rapidly dwindling to second-rate status (Fig. 137). Finally came the archaic idol itself: An exquisite work of ancient piety at the heart of the entire ensemble, nested like a precious jewel in a magnificent and elegantly crafted setting.

While Skopas was busy with all this, others sought to establish a direct personal connection between divinity and attention-hungry worshiper. This

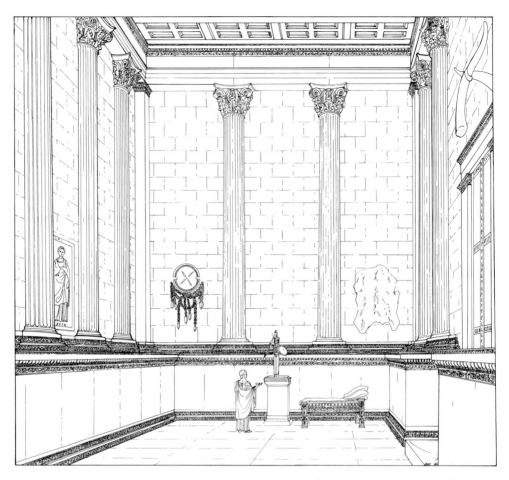

137. Reconstruction of the interior of Skopas's temple of Alea Athena at Tegea, ca. 330. Marble, with a wooden ceiling; ht. of room, 10.2 m (33′5″). Endoios's cult statue of Alea Athena (compare Fig. 135) stands at center. The votive offerings, listed by Pausanias, are (from left to right) a picture of Telephos's mother Auge; the shield of the Tegean heroine Marpessa and the chains that the Spartans had carried into Arkadia to enslave the Tegeans, but were forced to wear instead after their defeat; Athena's sacred couch; and the hide and tusks of the Kalydonian Boar, whose death at the hands of Meleager and Atalanta was shown on the temple's east pediment.

tactic worked amazingly well in the case of the caring healer-god Asklepios (Figs. 87, 138), whose cult was now mushrooming throughout Greece, but less so with Olympians such as Athena. The bronze Athena in Fig. 139 is clearly indebted to Pheidias, particularly to the Parthenos (see Fig. 69); she also once held a spear and shield in her left hand and a Nike in her outstretched right one. In order to stress her engagement with us, however, and her continuing benevolence toward us, she has abandoned the majestic, commanding posture of her Pheidian models. Instead, she relaxes her body and gently inclines her head in our direction, just like Asklepios. Such weakness in so masculine a deity is all but fatal. Athena was too tied in Athenian hearts to their years of greatness in the fifth century to bear such tinkering with in the fourth.

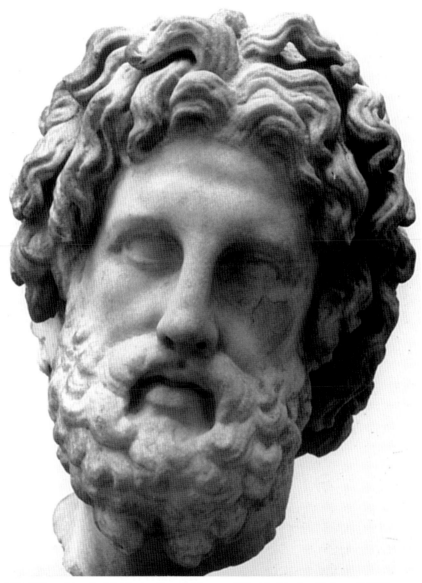

138. "Blacas" head of Asklepios from Melos, ca. 330. Marble; ht. 58.4 cm (1'11").
London, British Museum.

PRAXITELES STEPS IN

The sculptor who most successfully tackled these issues, however, was
Kephisodotos's son Praxiteles. Aphrodite, Dionysos, and their respective
entourages accounted for over a third of his recorded output, and his portraits
(often of women) equaled them in number. His marble Aphrodite of Knidos,
known in many large-scale copies (Fig. 140) and hundreds of miniatures, is
often hailed as the classic example of how to reconcile divine perfection and
self-sufficiency with the new demand for divinities that care. Together with

257

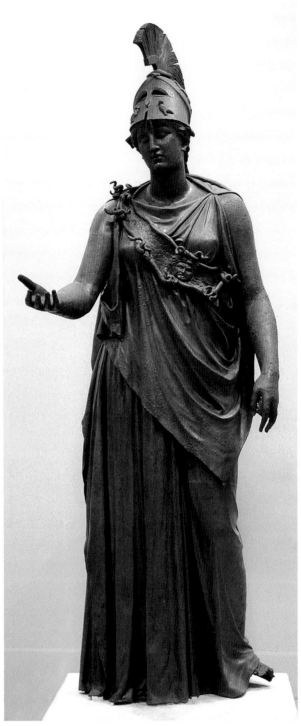

139. Athena from the Piraeus, ca. 350. Bronze; ht. 2.35 m
(7′7″). Piraeus Museum. Probably she held an owl in her
outstretched right hand, and a spear and shield in her left.

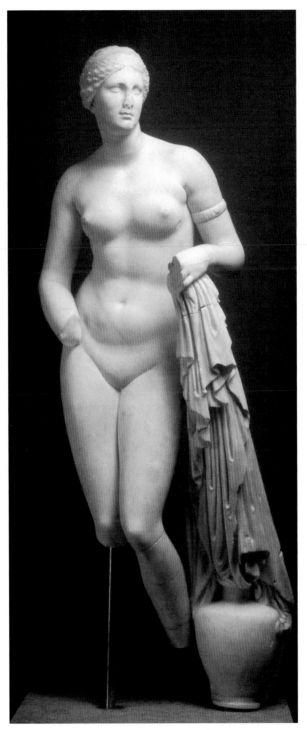

140. Aphrodite of Knidos by Praxiteles of Athens (Roman copy); original, ca. 350. Marble; ht. 1.62 m (5′4″). Munich, Glyptothek. The statue is a reduced version of Praxiteles' over-life-size original and deviates from it in minor details.

BOX 2. *PLINY ON THE KNIDIA* (NATURAL HISTORY 36.20–22)

Superior to all the works, not only of Praxiteles, but indeed in the whole world, is the Venus which many people have sailed to Cnidus in order to see. He made two statues and offered them for sale at the same time; one of them was represented with the body draped, for which reason the people of Cos, whose choice it was (since he had put the same price on both), preferred it, judging that this was the sober and proper thing to do. The people of Cnidus bought the rejected one, the fame of which became immensely greater. Later King Nicomedes wished to buy it from the Cnidians, promising that he would cancel the city's whole debt, which was enormous. They preferred, however, to bear everything, and not without reason. For with that statue, Praxiteles made Cnidus famous.

The statue's shrine is completely open, so that it is possible to observe the image of the goddess from every side; she herself, it is believed, favored its being made that way. Nor is one's admiration of the statue less from any side. They say that a certain man was once overcome with love for the statue and that, after he had hidden himself in the shrine during the nighttime, he embraced it, and that it thus bears a stain, an indication of his lust. There are other statues in Cnidus by illustrious artists, a Dionysus by Bryaxis and another Dionysus and an Athena by Scopas; and there is no greater testimonial to the quality of Praxiteles' Venus that, among all these works, it alone receives mention.

the Doryphoros (see Figs. 71, 72), it counts among the most influential images in the history of art [see Box 2. *Pliny on the Knidia*]. The entire history of the female nude in antiquity and thereafter is predicated upon it.

Housed on a windy crag high above the Mediterranean in a colonnaded rotunda that perhaps symbolized her universal power, the Knidia stood on a three-foot-high base and was an imposing seven Attic feet tall. We encounter the goddess just after her birth in the sea-foam off Cyprus, or perhaps during her journey through the Aegean. (Hence her cult title: Euploia or "Of the fair voyage.") She has just taken a bath and is about to put on her cloak, standing stark naked for the first time in major sculpture since the seventh century (contrast, e.g., Fig. 62).

The Knidia's cloak was colored purple; her hair-band would have been painted also, her jeweled armband inlaid with real stones, and her water-jar probably gilded.[5] Her lips were gently rouged and her eyes and eyebrows

5 Her headband and armband may have been love charms, but I cannot pursue the implications of this here.

painted as well; and contrary to over a century of scholarship, scrutiny of the Munich copy (Fig. 140) and some others has shown that Praxiteles' colorist, the great painter Nikias, discreetly indicated her pubic hair and genitals. Probably her body was lightly waxed so that the crystalline Parian marble would gently soak up and return the light, recalling the ethereal skin of the goddess herself. Perhaps it was tinted as well, to accent its major transitions.

Praxiteles probably intended his Aphrodite to be as definitive a statement in her own way as Polykleitos's Doryphoros (Figs. 71, 72): an icon of female perfection, a goddess in marble to match a hero in bronze. Not only was her finish exquisite (which is why the copies are so capricious, for no one would have been allowed to take molds of the original for reproduction), but also her proportions and pose were just as carefully contrived.

As with the Doryphoros, the Knidia's proportional scheme itself is lost, but the copies suggest some basic equivalences. The height of her head, for example, equals the distance from her chin to the level of her nipples, from nipple to nipple, perhaps from nipples to navel (her slight stoop has compressed her abdomen), and from navel to genitals. Praxiteles based her pose on the Doryphoros, but flexed her body a little at the waist; unified it by an S-curve that runs from head to toe; and created a strong contrast between her "closed" right side and "open" left one, to which she now turns her head. These subtle changes create a very particular relationship between spectator and goddess, as we shall see.

The Knidia's glance, the sources tell us, was "melting" and her smile was "proud, a grin that just parts the lips." Though the copyists failed to do justice to these subtleties, they do faithfully catch her averted head and sideways glance. This was quite new in the genre (compare the Parthenos, Fig. 69) and is one of the keys to the statue's meaning and impact. For whereas the naïve spectator would see only a beautiful, naked goddess, nonchalantly averting her head from him, an astute one would recognize that all this suggests a *second* visitor to the shrine: Someone off to the right at whom she looks and smiles. Her modest gesture and slight stoop suggest that she is responding to our gaze, but her sideways glance and smile invite him ever closer. The penny drops. Is our rival her irascible, implacable lover: the blood-soaked, man-slaughtering . . . Ares?!

This teasing strategy of simultaneous invitation and (quite decisive) rejection is precisely the strategy of the love triangle – a ploy well known to Greek tragedy (e.g., the *Agamemnon*) and comedy too. Like the goddess's sheer size and cultic setting, it affirms her independence from us, even as her nakedness and alluring posture hold out the tantalizing possibility of a relationship. We recognize this particular game at once. It is exactly that of the *hetairai* (literally, "female companions") or courtesans: those beautiful, independent, clever, and witty "women of the world" whom we met briefly in Chapter 4. And as it happens, Greek tradition held that one such hetaira, Praxiteles' own mistress Phryne, indeed modeled for the statue.

Phryne was among the handful of fourth-century "big ticket" hetairai. Superstars at the very top of their profession, they regularly inspired ruinous infatuation among the men they dated. One tell-all book on them even alleged

that Phryne became so rich that after Alexander razed the walls of Thebes to the ground in 335, she offered to rebuild them. The catch was that the Thebans had to erect the following inscription: "Alexander may have knocked these down, but Phryne the hetaira put them up again." They refused. And in Praxiteles's case, a number of anecdotes have Phryne playing exactly the same game with him as the Knidia does with us – a case of art copying life, or of life copying art?

According to one long-lived tradition, one infatuated Knidian even took all this literally [see Box 2. *Pliny on the Knidia*]. Confusing goddess and image, he tried to rape the latter, leaving an ugly stain on its thigh. Driven mad by the goddess, he then threw himself into the foaming sea below – the very element that had given her birth and provided her cult's sailor devotees with their livelihood.[6] Psychologists have had a field day with all this, but for our purposes it amply demonstrates this besotted individual's misunderstanding of the Knidia's true message and the magnetic attraction that she exercised on everyone who encountered her.

Yet not all the shrine's visitors were men. Because Aphrodite was literally the apotheosis of female sexuality, women frequently prayed and made dedications to her. The appeal of this Aphrodite-as-hetaira to "working girls" is obvious – and Knidos, a busy seaport on the cusp between the Aegean and Mediterranean proper, was prostitute heaven. But how did she speak to "ordinary" Greek women – chaste daughters and wives, but also desirable and desiring brides? Many of their dedications and prayers appeal for "affection" (*philia*) from men – the domesticated counterpart to the *erōs* inspired by the hetairai. From this perspective, the Knidia seems basically didactic. Embodied and active in the world, and caught bathing just like a mortal woman, she would have shown them how to kindle this affection. In behavior, deportment, and grooming they must acquire some of the skills of the hetaira, according to their age, station, and particular needs.

But the Knidia has also been described as "absentminded" and "aloof." There is some truth in this: The balance is a delicate one and depends upon how one evaluates the copies and texts. For not all the Olympians did relate to humans – at least, not all the time. The spectacular Hermes and Dionysos discovered in the temple of Hera at Olympia in 1877 (Fig. 141) is a case in point. It continues to inspire heated controversy. Is it an original by Praxiteles himself, as Pausanias thought (or was told); a work by his sons, pupils, or "school" (his grandson Praxiteles included); or a later copy or even free version of one of the master's lost works? Whatever the truth, it shows beyond dispute how these sculptors responded to the new fourth-century sense of divine self-sufficiency.

More than seven feet tall and standing on a four-foot high base, Hermes pays no attention to us at all. Although his body is absolutely frontal, his gaze drifts languidly toward the baby Dionysos, though their eyes do not meet. Dionysos's own attention is fixed upon a bunch of grapes (attested by Roman

6 The tale, a variant of the Pygmalion story grafted onto a variant of Hephaistos's attempt to rape Athena, has deep roots in Greek myth. Killjoys promptly tried to dismiss it as a salacious etiology or explanation after the fact to account for a flaw in the marble.

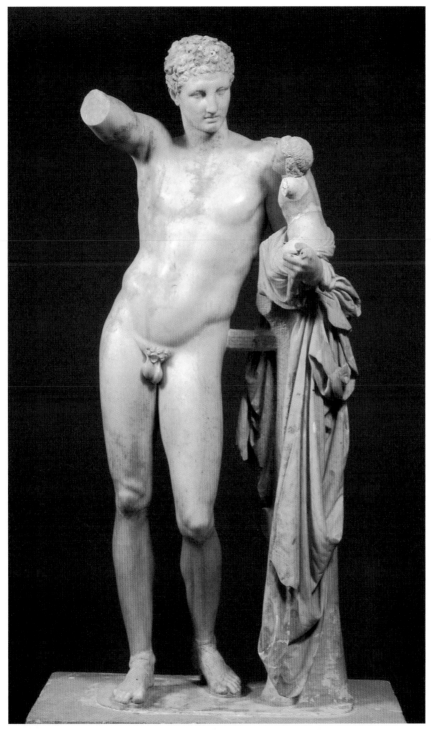

141. Hermes carrying the infant Dionysos, by Praxiteles or one of his pupils, ca. 340–300. Marble; ht. 2.15 m (7'). Olympia Museum. The god probably held a bunch of grapes in his right hand; parts of his legs are restored.

versions of the composition) once teasingly dangled before him by his divine mentor. Our own eyes travel endlessly round the oval path generated by these gestures and glances.

Though Praxiteles adapted his composition from Kephisodotos's Eirene (Fig. 131), its clever substitute of grapes for scepter and its weight shift from left leg to right makes it even more self-contained. In fact, where not confrontational it seems entirely closed. These two immortals are completely wrapped up in their own thoughts; they inhabit a dreamy Elysium far removed from our world and its cares. It is here that the sinuous Praxitelean S-curve, stronger even than the Knidia's (Fig. 140), reveals its full potential. It implicitly dematerializes the body by endowing it with a harmonious rhythm beyond our everyday experience, so that its response to gravity – its contrapposto – no longer furnishes the sole point of departure for the composition.

So like Plato's heavenly beings in his late dialogue the *Timaeus*, these two Olympians are now "able through their surpassing excellence to keep company only with themselves; they need no-one else, and are completely self-sufficient as acquaintances and friends." And as one of Aristotle's pupils shrewdly remarked, "it is eccentric to love god, for who can love what is remote and unknowable?" Soon, the philosopher Epikouros (341–270) was to formulate all this into a creed of wide appeal, affirming that "God dispenses no benefits; he is self-sufficient, heedless of us, indifferent to the world, untouched by rights or wrongs" and "that which is sublimely happy and immortal experiences no trouble itself nor does it inflict trouble on anything else, so that it is not touched by passion or partiality. Such things are found only in the weak."

So this was how one brilliant practitioner of the sculptor's art – Praxiteles himself? – ultimately solved the paradoxes of Greek anthropomorphic religion. As the gods withdrew into solipsistic self-sufficiency, all that remained for mortals was to contemplate their bliss, and to attempt as far as possible to imitate it here on earth.

DRAMATIC ECHOES?

It is time to shift focus and to return to the city – specifically to the western Greeks, who have received little attention so far in this book (see Fig. 30). From around 400, however, a vigorous output of red-figured vases thrusts them into the artistic limelight once more and enables us to revisit a theme from Chapter 2: the relation of text – specifically drama – and image.

Until the 420s, the south Italian and Sicilian cities had imported almost all their red-figured pottery from Athens, but then this trade began to collapse. This is hardly surprising, because when the Peloponnesian War began, the Spartans promptly threatened to execute any merchants from Athens caught sailing off their coast – a deterrent to even the most intrepid entrepreneur. Soon the flow of Attic imports all but dried up, and local red-figure schools emerged that in some cases were to endure till the end of the fourth century. Some of the pioneers were probably Athenian refugees from the great plague of 430–26 who successfully ran the Spartan blockade.

The western Greek pictorial repertoire overlaps with that of Athenian red-figure but is far from identical to it, and many vases were now made exclusively for the grave. Funerary scenes (visits to the tomb and so on: compare Fig. 121) are joined by a vast array of mythological ones that often seem to allude to death and the afterlife. Stories treated by the Athenian tragedians, especially Euripides, and scenes from comedy are particularly popular. The former are often connected with the following story from Plutarch's *Life of Nikias*, describing the aftermath of the Sicilian disaster in 413:

> Most of the Athenian prisoners perished in the quarries from sickness and their wretched diet . . . but a few were rescued because of their knowledge of Euripides, for it seems that the Sicilians were more devoted to his poetry than any other Greeks living outside the mother country. They learned even the smallest fragments of his verses from every stranger who set foot on the island, and took delight in exchanging these with one another. At any rate, there is a tradition that many of the Athenian soldiers who had returned home safely visited Euripides to thank him personally for the deliverance that they owed to his poetry. Some of them told him that they had been given their freedom in return for teaching their masters all they could remember of his words, while others, when they took to flight after the final battle, had been given food and water for reciting some of his lyrics.

This story shows that in 413, actual *texts* of Euripides had yet to reach Sicily, or at least were not readily available there – a situation that would soon change. In Athens the book trade was flourishing, and this "reading culture" soon swept the Greek world. Attic comedians mention books among the staples of the Agora (in the same breath as garlic, onions, and scent!), and in Plato's *Apology*, Sokrates remarks that Anaxagoras's *Physics* could be picked up there for a drachma. Xenophon even records an exchange between the philosopher and a bookworm who prides himself on buying absolutely everything available, from Homer and the poets to medical and even architectural treatises. Fifth-century Attic vases often show schoolboys and even girls reading from scrolls (Fig. 93), and on a part of the Pronomos krater not shown in Fig. 110, the poet Demetrios holds one while another leans against his chair.

By then, books were being exported to the Black Sea colonies, and in Aristophanes's *Frogs* of 405, Dionysos casually remarks that he had taken Euripides's *Andromeda* to sea with him. Later in the same play, which revolves around a poetry contest between Aischylos and Euripides, the chorus jokes that the whole audience has texts of their plays in hand. The revivals of Aischylean, Sophoklean, and Euripidean tragedy that started in 386 and of Aristophanic comedy in 339 could not have taken place without such texts. Indeed, by 330 so many bloated and inaccurate ones were in circulation that the statesman Lykourgos had official editions made (see Chapter 7). Aristotle (whose nickname as a student in Plato's Academy was "Bookworm") could not have written his *Poetics* without these texts, and in his *Rhetoric* he discusses at length the differences between texts written for oral delivery and those meant for reading only.

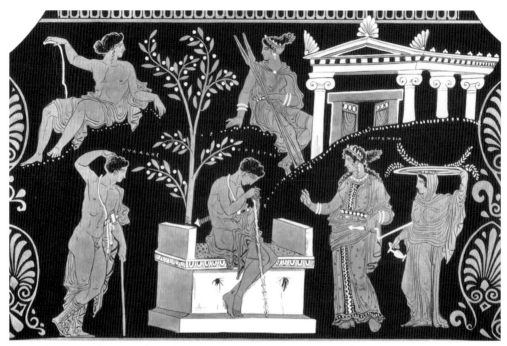

142. Iphigeneia, Orestes, and Pylades among the Taurians. Redrawing of an Apulian (south Italian) red-figure mixing bowl (krater) attributed to the Ilioupersis Painter, ca. 350. Ht. of picture, 24 cm (9.5″). Naples, Museo Archeologico. The scene probably illustrates Euripides' *Iphigeneia among the Taurians:* Iphigeneia, at center right, addresses Orestes (seated on the altar), while Pylades and (above) Apollo and Artemis look on.

As for the western Greeks, although all their classical-period literature has perished, the vases occasionally show men and women reading from scrolls, and a boom in theater-building there, in Macedonia, and in Ionia presumes the widespread diffusion of dramatic texts throughout these regions during the fourth century. At Syracuse, the earliest theater, where in the 460s Aischylos had presented his *Persians*, was a traditional rectangular/trapezoidal one (compare Thorikos, Fig. 18), but by the third century the new "clamshell" type (see Figs. 163–7) had prevailed.

So it is not surprising that fourth-century western Greek vase-paintings sometimes parallel literary texts quite closely. Whereas earlier Greek artists had represented traditional myths (see, e.g., Figs. 40, 41) rather than particular poetical versions of them, these pictures sometimes look suspiciously like book illustrations. Because the tales treated by the Attic dramatists, especially Euripides, are particularly popular, some see them as actual illustrations of western Greek tragic performances, and a few real optimists have even used them to reconstruct lost or fragmentary plays. So do the pictures in Figs. 142, 143 illustrate Euripides' *Iphigeneia among the Taurians* (for the plot, see Chapter 5, Box 1), the Iphigeneia myth in some generic, popular form, or something of both?

Before we decide, there is one observation to make. Whereas many comic scenes on western Greek vases clearly illustrate real plays, for they include the

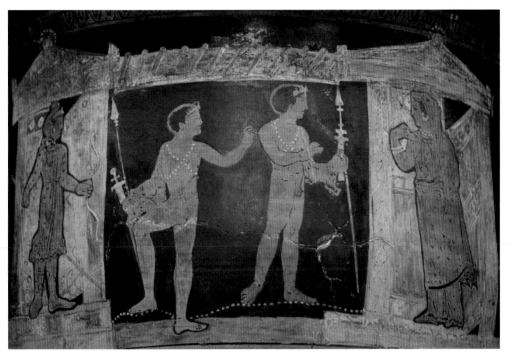

143. Iphigeneia, Orestes, and Pylades among the Taurians. Campanian (South Italian) mixing bowl (bell krater), ca. 320. Ht. 32 cm (12.6″). Paris, Louvre. The building resembles a fourth-century theatrical scene building, so the scene probably illustrates Euripides' *Iphigeneia among the Taurians:* Orestes and Pylades stand between Artemis (left) and Iphigeneia (right).

stage itself (see Fig. 144), none of the supposed tragic ones (Figs. 108, 142, 143) does so. This distinction seriously undercuts the latter's claim to illustrate real tragic performances.

The krater from which Fig. 142 is taken was made in the great south Italian city of Taras (modern Taranto), which boasted Orestes as one of its founders. Presumably chosen for this funerary vase because of the hero's impending death by sacrifice and then miraculous escape from it, the scene shows the first encounter between Orestes, Pylades, and Iphigeneia, all identified by inscriptions. Iphigeneia, sworn as Artemis's priestess to sacrifice all castaways to the goddess, addresses the captive Orestes, who is still incognito. Moved by sympathy for him, she offers to spare his life if he will take a letter to Argos telling her friends that she is alive and well. Orestes stoically insists that he should be the one to die and that Pylades, his friend and fellow captive, should take the letter. Iphigeneia eventually agrees, promises him a sumptuous burial in compensation (!), and goes into the temple to get the letter.

On the pot, the scene is rendered in "Polygnotan" stacked or bird's eye perspective (compare Figs. 51, 52), and the temple and its altar are rendered in "Agatharchan" orthogonal perspective (compare Fig. 108). Although the perspectives of temple and altar are blithely independent of one another, both items project vigorously from the picture plane (a requirement for theatrical scenery, as we have seen) and specify the locale quite adequately. In the upper

register, Artemis chats with Apollo as a laurel tree buds between them. In the lower one, Pylades stands at left while Orestes sits disconsolately on the altar, gruesomely speckled with blood. Iphigeneia, carrying the temple key, addresses him, accompanied by a slave girl who holds a jug and a large tray of branches.

Does the picture illustrate the play? At first sight, no. The hills, temple, tree, and presiding divinities evoke reality, not theatrical scenery. Moreover, whereas actors in the theater would be fully clothed, Orestes and Pylades are naked but for their cloaks and shoes, and still wear their swords – an impossibility if they are captives, as in the play. These features can be explained only if the painter wanted us to understand his picture primarily as a heroic encounter from the world of myth, not as a specific scene from Euripides' drama.

But even so, we still need the play (specifically, lines 467–642) to make sense of the picture. For the tale is unknown before Euripides. He may have invented it and (because the mythical world is preliterate) he surely introduced the device of the letter – a favorite gambit of his (compare his *Hippolytos*). According to tradition, Artemis had whisked Iphigeneia off to Taurica *to be a goddess*; here, however, she is clearly a priestess, as in the play (*Iphigeneia among the Taurians*, line 34). The temple's open doors show that she has just left it and sent her attendants back inside it (*IT* lines 467–71); the slave girl's water-jug refers to Iphigeneia's comment that she does not sacrifice the victims herself, but only sprinkles the lustral water over their hair (*IT* 622); and even Apollo's presence is explicable by Orestes' remark that it was the god's oracle that sent him to Taurica in the first place (*IT* 85–92).

Without these clues – indeed without knowing the play itself – the picture makes no sense, because Orestes was only a child when Agamemnon decided to sacrifice Iphigeneia, and according to the traditional version of the myth the two never met again thereafter. So those who had *not* seen or read the play simply could not have understood the picture. How, then, do we explain the latter's realistic setting? Presumably, as in the Shakespeare scenes popular with nineteenth-century artists, both painter and public wanted an illusion of reality, of real-life drama, not a representation of a representation.

Comedies (Fig. 144) were different, because – as the comic poet Antiphanes ruefully quipped (see the Introduction, pp. 18–19) – their plots were blatant fictions invented for the occasion. Getting the joke depended upon understanding the scene, for which the fantastical costumes and masks were essential. These items were typecast character by character, so that one could instantly recognize master, slave, cuckold, philanderer, wife, daughter, nanny, whore, and so on from the getup they wore. After all this, to include the stage and props was a no-brainer. They add to the fun, whereas a straightforward, everyday setting would only have dampened it. Indeed, these pictures do something more: They construct the viewer *as a theatergoer*, silently echoing that often boisterous interchange between cast and audience that ancient and modern comedy both thrive on. Like the comedies themselves, they emphasize their own particular status as fictions.

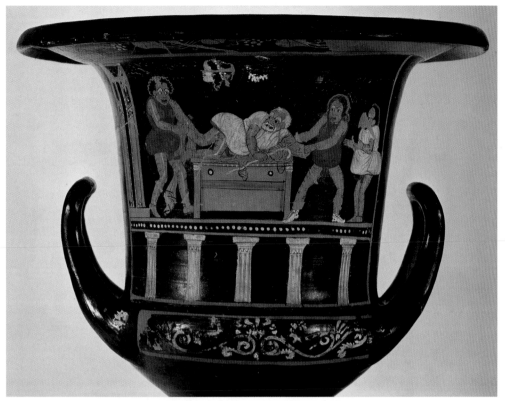

144. Scene from a comedy. Paestan (South Italian) mixing bowl (calyx krater) signed by Assteas, ca. 350. Ht. 37 cm (14.6″). Berlin, Staatliche Museen, Antikensammlung. On a wooden stage, two men pull a miser off his treasure-chest.

So Figs. 142 and 144 stand at the threshold of the rich western tradition of text illustration. In contrast to their Athenian predecessors of Figs. 10, 40, 41, 51, 119, and 120, which are the products of an essentially oral culture, they are *text-dependent*. They could not have come about without texts, and they presume a literate public.

But do the losses outweigh the gains? In Fig. 142, unless we know the plot, all we see is a typical suppliant scene with people standing around chatting in a rather boring way. Only the inscriptions make them individually identifiable, and even then the picture generates only puzzlement unless one knows the specifics of Euripides's play. The same is true of Fig. 144, where no inscriptions are included and the scene has never been identified. In both cases, only by knowing the plot in detail can we know more than the characters in the picture; match our knowledge against theirs; understand the crisis (*krisis*) that they face; and enjoy envisioning the result. Contrast, for example, Fig. 10, where the action is self-evident and the tension palpable even if one does not know that the warrior is Hektor; or Figs. 40, 41, 44, 45, 51, 119, and 120, where the traditional myth supplies everything we need, to the same effect.

A second Iphigeneia krater, painted in Campania a generation later (Fig. 143), goes even further. For the temple of Fig. 142 it substitutes a building

145. Iphigeneia, Orestes, and Pylades among the Taurians (Roman copy); original ca. 330. Detail of a fresco from the House of the Cithara Player at Pompeii; ht. of detail, ca. 1 m (3′4″). Naples, Museo Archeologico. Iphigeneia, partially visible at top right, emerges from Artemis's temple to interrogate the two bound captives, ready for sacrifice on the altar at right. The picture, most of which is badly damaged, probably copies a Greek fourth-century painting.

with a projecting porch at each end that looks suspiciously like the wooden scene-building of a typical fourth-century Greek theater (compare Fig. 108, possibly an excerpt from Euripides' *Medea*). The statue of Artemis stands in the left-hand porch, Iphigeneia in the right-hand one, and the naked Orestes and Pylades in between. The scene must refer to lines 989–1055 of the play, when Orestes has revealed his true identity to Iphigeneia and the two are plotting to steal the statue. Yet not only is the latter life-size and placed incongruously in front of the "temple" door (otherwise it would be invisible and the scene incomprehensible once more), but the two heroes are again naked, again wear swords (and now hold spears also), and stand on a bumpy ground line. This painter too could not bring himself entirely to abandon mythical "reality" and

146. Iphigeneia, Orestes, and Pylades among the Taurians (Roman copy); original ca. 330. Detail of a fresco from the House of L. Caecilius Iucundus, Pompeii; ht. 1.18 m (3′10″). Naples, Museo Archeologico. Iphigeneia emerges from Artemis's temple to interrogate the captive Orestes and Pylades. Orestes's elbow is visible at far left, showing that the picture, most of which is badly damaged, copies the same Greek original as that illustrated in Fig. 145.

the outdoors for the stage, but simply conflated them, with none too happy results.

These vases, however, leave one with a skewed impression of fourth-century painting. For this was the great age of Greek painting on wall and panel, of the master painters Euphranor, Nikias, Pausias, Apelles, and Protogenes. These works now are lost entirely except for some frescoes in Macedonian tombs and the inevitable Roman reproductions. To stick with the Iphigeneia legend (though the pictorial repertoire was of course vast and certainly not confined to Euripides or the theater), two battered Pompeian versions of

the same scene, Iphigeneia coming out of the temple to interrogate the bound Orestes and Pylades (*Iphigeneia among the Taurians* 467–9), give an inkling of just how grand these pictures could be (Figs. 145 and 146). Yet they also warn us not to take them too literally as copies, for Iphigenia's pose and clothing are different in each.

This still tentative adaptation of the pictorial repertoire to the status of text illustration presages the text-and-image compositions of the Hellenistic period and, eventually, the entire tradition of western book illustration from the Roman Empire onwards. But all this lies well beyond our horizons. It is time to turn to Macedonia, Philip, and Alexander.

CHAPTER 7

THE SHADOW OF MACEDONIA

FROM PEASANTS TO POTENTATES

Alexander invaded Asia in spring 336, and within ten years conquered not merely the entire Persian Empire but a good part of India as well. In summer 324, encamped in far-off Babylonia, he reminded his mutinous troops – fed up with his incessant campaigning – what his father, Philip II (reigned 359–36 B.C.: Fig. 147) had done for them:

> Macedonians! My father Philip gave you cloaks to wear instead of skins; he brought you down from the mountains to the plains; and he made you a match for the barbarians on your borders. He made you city dwellers and established the order that comes from good laws and customs. Because of him you became masters and not slaves. He annexed the greater part of Thrace to Macedonia, and by capturing the seaports, opened up the country to trade; he enabled you to work the mines in safety; he made you rulers of the Thessalians, who formerly paralyzed you with terror; and he humbled the Phokians and gave you an access to Greece that was broad and easy, not narrow and hard. The Athenians and Thebans, always lying in wait to attack Macedonia, he reduced so low that instead of our paying tribute to the Athenians and taking orders from the Thebans, we gave them protection. He entered the Peloponnese and settled affairs there, and his recognition as leader with full powers over the whole of the rest of Greece in the expedition against the Persians conferred glory less on himself than on you, the Macedonian people.

So how did this bunch of hillbillies, barely recognized as Greeks by the Greeks themselves, rise in one generation from a hardscrabble life on the margins to undisputed rule of Greece and, indeed, the civilized world?

147. King Philip II of Macedonia. Roman-period gold medallion from Tarsos (Turkey), A.D. 230. Diam. 6.7 cm (2.6″). Paris, Bibliothéque Nationale.

Nothing, of course, is ever that simple. Although evidence for Macedonian urbanism before Philip's reign is scanty, this is because some cities remain unexcavated (for example, Aigai/Vergina, the sixth- and fifth-century capital), and at others (for example Pella, the fourth-century and later capital), Hellenistic rebuilding has all but obliterated the earlier levels. Yet excavations at Aiani in Upper Macedonia have begun to reveal a polis, akropolis, and rich nekropolis complete with kouroi and korai that would have been fully at home in archaic Athens (compare Figs. 6, 13). The town flourished from the late sixth century onward, and numerous gold-rich tombs at Vergina, Sindos, Derveni, and elsewhere augment the picture.

From the reign of Alexander I (493–ca. 442), the Macedonian kings competed at Olympia and the other Greek "crown" festivals and issued a complex coinage on a variety of standards, ensuring convertibility with both the civic coinages of Greece and that of the Persian Empire (Fig. 148). King Archelaos (reigned 413–399) briefly turned Aigai into a cultural center, inviting the painter Zeuxis to redecorate his palace and the aged Euripides to jump-start its theater (he almost certainly wrote the *Bacchai* there). Several other prominent intellectuals followed suit, including perhaps the historian Thucydides and the great physician Hippokrates and his sons.

Yet even so, Alexander's main point holds. Most Macedonians remained herders and yeomen farmers, and it took Philip's energy and genius to organize them into the most formidable army in Europe and to turn Macedonia into a military and economic power like none other. Gaining the throne in 359 after northern barbarians had massacred his predecessor and 4,000 of his troops,

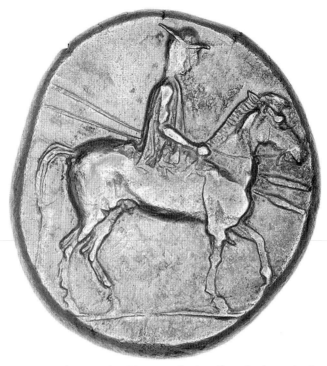

148. Macedonian rider. Silver tetradrachm (four-drachma piece) of Alexander I of Macedon, ca. 460. Diam. 2.3 cm (0.9″). American Numismatic Society, New York.

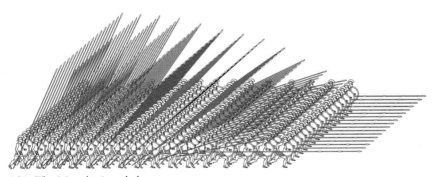

149. The Macedonian phalanx.

he raised a new army and armed it in a completely novel way: as a phalanx of pike-men (Fig. 149). In contrast to the Greek hoplite with his eight-foot thrusting spear and expensive bronze body armor (see Fig. 15), Macedonians now wielded eighteen-foot pikes or *sarissai* and wore very little armor at all.

Advancing like a giant porcupine, these pike-men could simply skewer their enemies before they got within striking range, and could dispense with fancy body armor for that reason. The massed pikes of the rear ranks, angled

275

above the heads of the front ones, even offered an effective shield against arrows. Hoplites, light-armed troops, and cavalry protected this human porcupine's vulnerable flanks.

Philip's reform spoke directly to Macedonia's strengths in men and horses. Whereas in the Greek cities men with the money to buy hoplite armor had always been a minority, and were fewer still in Macedonia, Philip could now utilize the mass of the peasantry as the backbone of his army. Moreover, he could capitalize upon the Macedonian aristocracy's passion for horse-breeding, riding, and hunting (Fig. 148) and turn them and his Thessalian allies into a formidable cavalry force by equipping them, too, with sarissai (albeit shorter ones). Meanwhile, by reorganizing his kingdom's administration, founding cities, exploiting nearby gold and silver mines, draining and cultivating the broad plain of Philippi (which he renamed after himself), and making land grants to his Thessalian and other Greek allies, he strengthened his kingdom and its army immeasurably. By 340, Macedonia had become the richest, largest, and strongest state in Europe.

As Philip's infantry and cavalry grew apace, the latter soon became his main striking arm. Charging in wedge formation, they sought to throw the enemy cavalry into disarray by the sheer fury of their assault. Reining in their horses at the last minute and stabbing at their opponents' faces, necks, and groins (for stirrups were still unknown, preventing one from couching one's lance like a medieval knight), the Macedonians would then drop their sarissai and go in with the sword, cutting their disorganized and (it was to be hoped) demoralized foes to pieces. Regrouping, they would then descend upon the enemy infantry from the rear, to devastating effect.

These tactics, combined with a mixture of bribes, threats, intrigues, timely alliances, astute diplomacy, and lighting military strikes, won Philip control of the whole of northern and central Greece by 345 and brought him into direct conflict with two of southern Greece's three major powers, Thebes and Athens. Demosthenes, Athens's greatest orator, attacked him relentlessly, appealed to Persia, and in 339 forged an Athenian–Theban alliance against him; Sparta, now in terminal decline, stayed aloof.

Yet Philip's new tactics, combined with a feigned retreat, won him the great battle of Chaironeia in central Boiotia on August 2, 338. His son Alexander, then only 17, led the decisive cavalry charge. Soon the entire Theban Sacred Band and a thousand Athenians lay dead on the field, and the rest, about thirty thousand in all, were fleeing from it in panic. Demosthenes (who took off with the rest) and other intelligent Greeks saw this battle as signaling the end of Greek freedom. Philip saw it as the beginning of a new era, for now he was going after Persia.

MACEDONIA: A DIFFERENT WORLD?

Between January 15 and late July 1962, Greek archaeologists conducting a rescue dig at Derveni near Thessaloniki in eastern Macedonia found seven tombs, five of them unplundered. Large stone chambers dating to the fourth

century B.C., they contained the biggest haul of classical Greek bronze and silver ever discovered. A recent study of this unique treasure has led to some important new conclusions.[1]

Deposited alongside quantities of jewelry, weapons, and utensils, the metal vessels were mostly for symposion use. They not only document the luxurious lifestyle enjoyed by some of the local elite even before Alexander's conquests (a far cry from Athenian democratic austerity), but suggest beliefs at work like those of the Orphic mystery cult ridiculed by Plato in the *Republic*: "The rewards that Mousaios and Orpheus provide for the just are juvenile indeed, for after they have got them to Hades, they have them recline, wreathed, at a banquet of the Blest and leave them drinking for all time, as if they thought that virtue's supreme reward was to be drunk for eternity." A charred papyrus from Tomb A's funeral pyre, which turns out to be part of an Orphic commentary; other Macedonian tombs filled with similar goods and/or frescoed with symposion scenes; and fourth-century gold tablets from Thessaly that describe Dionysiac mysteries promising heroization and life after death – all these items suggest that the excavators' initial suspicions were correct.

In two of the tombs, the ashes of the dead had been washed in wine and spices, wrapped in purple cloths, deposited in great metal volute-kraters (symposion vessels particularly associated with Dionysos), adorned with gold wreaths, and given coins to pay the infernal boatman, Charon, for their journey to the other side. This ritual is Homeric. In *Iliad* 24, Hektor is mourned, cremated, and buried in this manner, and in *Odyssey* 24, Agamemnon's ghost tells Achilles of his own funeral:

> But then, after the flame of Hephaistos had fully consumed you,
> Early at dawn we gathered your white bones together, Achilles,
> Into the unmixed wine and the unguent – a jar had your mother
> Given, of gold, two-handled: she said it had been Dionysos'
> Gift and that it was the work of the glorious craftsman Hephaistos.
> It is in this that your white bones lie now, brilliant Achilles.

As we shall see, this kind of Homeric emulation helped to shape the character and career of the greatest Macedonian hero of them all – Alexander.

One of these kraters (Figs. 150, 151), a huge vessel three Attic feet (90.5 cm) high, is the most elaborate ever found in the Greek world. At first thought to be either golden or gilded, and sometimes still erroneously described as such, it is actually made of bronze with a high tin content (almost 15%), with additions in silver. On its main frieze, a naked Dionysos lounges next to his beloved Ariadne, nonchalantly slinging his leg over her thigh while she decorously lifts her veil in the bridal gesture. Cavorting maenads, an imperious-looking Silenos, and a mysterious hunter wearing a single boot surround them. Sleeping maenads, a youth, and a Silenos adorn the vessel's

1 Beryl Barr-Sharrar, *The Derveni Krater: Masterpiece of Classical Greek Metalwork* (Princeton: American School of Classical Studies, 2008).

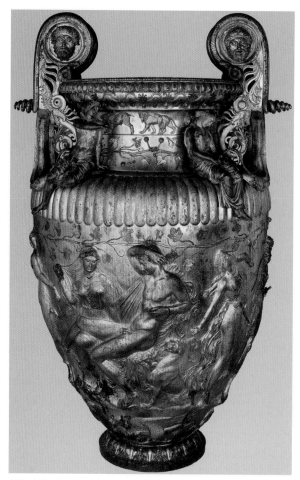

150. The Derveni krater. From Tomb B at Derveni
(Macedonia), ca. 370–50. Bronze; ht. 90.5 cm (3').
Thessalonike Archaeological Museum; for detailed credit see
p. 349. The krater contained the cremated remains of a man;
its main frieze shows Dionysos, Ariadne, and a hunter (the mad
king Lykourgos?), accompanied by Silenos and maenads.

shoulder, and masks of Herakles, the river god Acheloos, Hades, and Dionysos
embellish its handles. A riot of vine and ivy tendrils, animal friezes, snakes,
and moldings completes the ensemble. Inlaid in silver on the lip are the words
"[Property] of Astion son of Anaxagoras of Larissa."

The krater's type and figure style date it before the mid-fourth century,
but the middle-aged man and his wife interred inside it cannot have died
before about 330 or perhaps even later, because the coin found with them
was a posthumous gold issue of Philip II, who died in 336. No fewer than
twenty-three more bronze vessels and twenty silver ones were buried with
them, along with armor, weapons, a parade shield, and horse trappings for
the man and perfume jars, cosmetics, and jewelry for his wife. So perhaps the

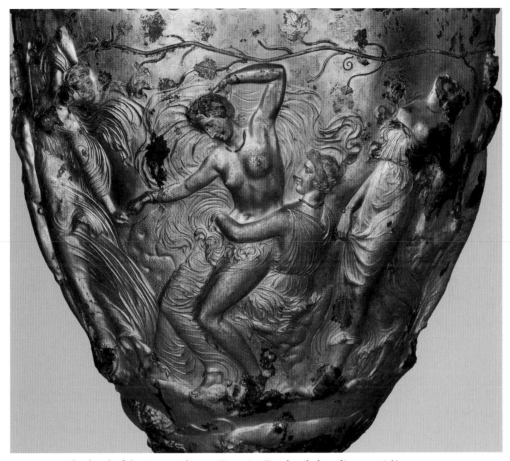

151. Maenads, detail of the Derveni krater, Fig. 150. For detailed credit see p. 349.

dead warrior was one of those Thessalian cavalrymen that Philip recruited for his new model army or Alexander took with him to Asia and demobilized as the great crusade drew to a close.

Based upon Athenian late fifth-century art (see Figs. 91, 104, 105, 110, 119, 120), the krater's main frieze not only celebrates Dionysos's deceptive looks and uncanny powers but also warns of the perils of resisting him – just like Euripides's *Bacchae* (written probably, we may recall, in Macedonia, and certainly performed there). For one of the maenads has slung a helpless naked baby over her shoulder, and the single-booted man is either Dionysos's sworn enemy Lykourgos or possibly Pentheus, who (as in the *Bacchae*) was first driven mad and then torn apart by the maenads for mocking and assaulting the god.[2]

2 The scene is not, however, an *illustration* of the *Bacchai*, where Ariadne, the satyr, and the woman with the baby have no place.

So either the Derveni krater was made for the tomb and then for some reason not used until a generation or two later, or it was made for a Dionysiac initiation ritual and subsequently reused for the tomb. Its imagery, which abounds with references to death, the Underworld, rebirth, and apotheosis (Ariadne's reward after Theseus jilted her and Dionysos discovered her), could support either interpretation. In any case, this flamboyant vessel and its sumptuous burial context take us into another world from contemporary Athens and its still red-figured pottery (and even further from Thebes or Sparta, for that matter). They remind us that northern Greek and Macedonian culture was very different from that of the south: baronial and Homeric to the core.

FROM PHILIP TO ALEXANDER

After his great victory at Chaironeia, Philip convened a conference at Corinth in order to codify his supremacy, to compel the Greeks to make peace, to corral them into an anti-Persian alliance, and to confirm him as "leader with full powers . . . in the expedition against the Persians," as Alexander later put it. He then returned to Macedonia and dispatched an advance guard to Asia, but in July 336 unexpectedly fell to an assassin's dagger in a palace intrigue.

Alexander, now twenty years old and recently estranged from Philip, was immediately suspected of orchestrating his murder. He promptly asserted control, identified the plotters, purged them (and others for good measure), and marched south into Greece. Terrified, the delegates at Corinth at once fell into line and hailed him supreme commander of the Persian war in his father's place. Returning to Macedonia, he then marched north as far as the Danube and west into deepest Illyria. Rumors of his death soon flew. The Thebans, seduced by Demosthenes with Persian gold, exploded into rebellion, but Alexander swiftly returned, stormed the city, persuaded the delegates at Corinth to declare it a traitor to the Greek cause, and destroyed it entirely but for the poet Pindar's house. Then he told the Athenians to hand over Demosthenes and his friends, but was persuaded to relent. These events left Greece in a state of shock. This was no callow and precocious teenager, but an autocrat even more ruthless than his father.

Who was this Alexander? Descended on his father's side from Herakles (who features prominently on his coinage, Fig. 152) and on his mother's side from Achilles, he had been educated by the great philosopher Aristotle, no less, and always kept a copy of the *Iliad* under his pillow. Like Achilles, he too was determined to be Best of the Achaeans: the best fighter, leader, and ruler of them all. He was fearless in battle, an expert warrior, a superb horseman, a military genius, a ruthless administrator, and a formidable drinker. He became King of Macedonia at age twenty and conquered Egypt, Persia, and the Near East at twenty-five and India at thirty. And he had little time for the fractious Greek city-states and their bickering politicians, especially if they failed to do his bidding.

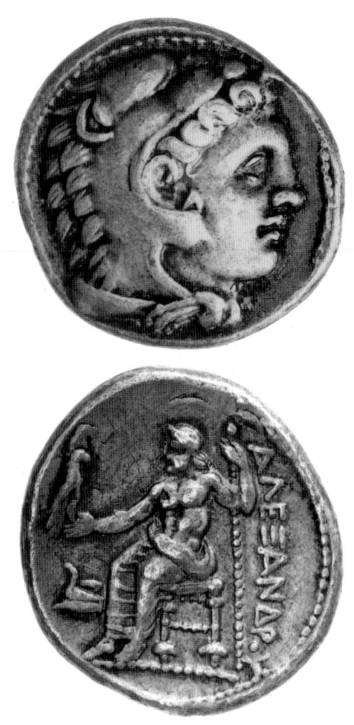

152. Herakles and Zeus. Silver tetradrachm (four-drachma piece) of
Alexander the Great of Macedonia, ca. 330. Diam. 2.1 cm (0.8″).
New York, American Numismatic Society.

Yet despite some glowing later reports of his Hollywood-like good looks, they actually left much to be desired. His neck was somewhat crooked, his eyes were "melting" (a trait he shared with the Knidian Aphrodite, Fig. 140!), his skin was fair like a woman's, and his chest was ruddy. His height was average (about 5 feet 5 inches); he would not or could not grow a beard; he wore his hair longish and styled in a kind of a cowlick or *anastolē*; he had a harsh voice; and he looked altogether "somewhat scary." And soon he was scarred by many wounds. An uncanny mixture of male and female, adult and adolescent, and aggression and allure, this boyish androgyne with his electrifying charisma soon galvanized his Macedonians to conquer the world.

Fortunately for Alexander, contemporary portraitists could easily sidestep some of these peculiarities, and clever ones could turn the rest to advantage. His height, complexion, and voice were no problem. For bronzes, marbles, paintings, and engravings were dumb; their scale and proportions could easily be manipulated; and their coloring was conventional – a burnished tan for men, and ivory-white for women. As to his lack of facial hair, Greek artists had long "youthened" their gods and heroes (see Figs. 51, 52, 72, 76, 101, 110, 136, 150, 151). His ancestors Heracles and Achilles had long shed their beards in this way, and in real life a few radicals had followed suit. So the avant-garde probably thought the king's smooth chin quite trendy. Furthermore, a clever artist could make his hair resemble the swept-back mane of the lion – king of beasts and paradigm of heroes – and could turn his crooked neck into a badge of heroic defiance (compare Fig. 136). Even his suspiciously feminine, melting gaze could be made to signal a longing for conquests new. Plutarch describes the outcome as follows:

> So Alexander ordered that only Lysippos should make his portrait. For he alone, it seemed, brought out his real character in the bronze and caught his essential genius (*aretē*). The others, in their eagerness to represent his crooked neck and melting, limpid eyes, were unable to preserve his virile and leonine demeanor.

Now this edict is clearly a fiction, invented at one of the Hellenistic courts or in Augustan Rome. Alexander certainly *preferred* Lysippos of Sikyon, the painter Apelles of Kos, and the gem-cutter Pyrgoteles to present his image to the world. Yet many others cast, carved, engraved, and painted him at no risk at all to life and limb (Fig. 153). Let us trace its history as the great crusade unfolded, for both of them propel us into a new world.

THE CRUSADE BEGINS

With Thebes ruined, Athens cowed, and Sparta isolated, Alexander's rear was now secure. He now turned on Persia (Map 4). Crossing to Asia in April 334, and not quite twenty-two years old, he took with him a good-sized army of about 30,000 infantry and 5,000 cavalry and an extraordinarily talented group of "Companions," all of whom would distinguish themselves in battle

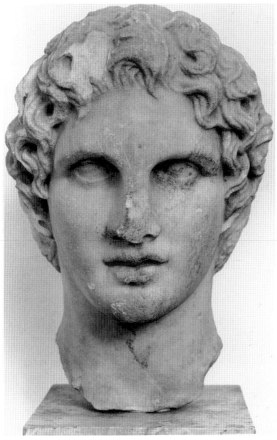

153. Alexander the Great, ca. 340–30. Marble; ht. 35 cm
(1′2″). Athens, Akropolis Museum.

and some of whom would outlive him and rule large tracts of the vast empire
that they would soon conquer. As Alexander neared the beach he hurled his
spear ashore, leapt after it in full armor, and declared Asia to be "spear-won
land." Now at the beginning of the Trojan War the hero Protesilaos had done
just this; the spear was an age-old symbol of heroic prowess (see Fig. 72); and
the ashen spear of Alexander's ancestor Achilles had been the mightiest weapon
at Troy. In Macedonia, however, the spear had acquired a special meaning.
"Spear-won land" was the king's personal property.

Next, Alexander and his companion Hephaistion went off to Troy to
sacrifice to Athena and to honor the graves of Achilles and Patroklos. The
campaign's tone was set. This was to be a new Trojan War, waged by Achilles's
descendant and successor for power and glory beyond human imagination.
Never mind that the Macedonian propaganda machine promoted it as a cru-
sade of revenge for the Persian invasions of Greece in 490 and 480: It was
really a war of conquest. For it soon emerged that Alexander wanted it all:
Asia, Africa, and Europe together.

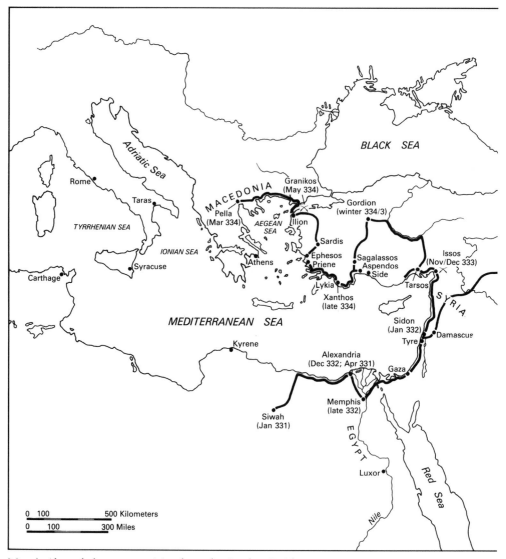

Map 4. Alexander's conquests. Map drawn by Candace Smith.

A month later, Alexander won his first great victory, smashing the armies of the western Persian satraps at the river Granikos. Typically, he then proceeded to commemorate his success in lavish fashion. He sent 300 suits of Persian armor to Athens for dedication in the Parthenon; had 14 gilt-bronze Persian shields hung under the Gigantomachy on the temple's eastern façade; and last but not least, hired Lysippos to make bronze statues of the 25 cavalry and 9 infantry who had fallen in the initial attack, with himself riding gloriously at their head. These he dedicated to Zeus at Dion under Mt. Olympos (see Box 1. *Pliny on Lysippos* (Natural History *34.61–5*)). Now this entire scene was fictitious, because Alexander had *not* led this first attack, which was

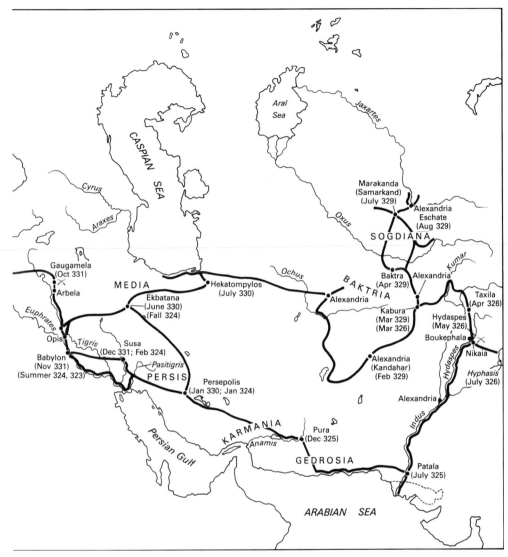

Map 4 (*continued*).

essentially a suicide mission, meant to throw the Persian army into confusion. Yet those on the home front – the families of the dead and those thousands still waiting to serve – would have got the point. King and army were indivisible, and Alexander cared.

In 334, Lysippos was in his fifties and already had thirty years' experience in producing bronzes of gods, heroes, athletes, generals, and even animals (see Box 1. *Pliny on Lysippos*). He was famed for his skill at rendering coiffure, physiognomy, anatomy, and movement. His works, we are told, seemed both alive and larger than life. For in addition to being a master of realistic detail, he had invented a novel system of proportions that made the body slimmer

BOX 1. *PLINY ON LYSIPPOS*
(NATURAL HISTORY *34.61–5*)

(61) Duris says that Lysippus of Sicyon was nobody's pupil. Originally a bronzesmith, he joined the profession after hearing a response from the painter Eupompus. When asked which of his predecessors he followed, Eupompus pointed to a crowd of people and said that it was Nature herself, not another artist, whom one should imitate.

(62) Lysippus was a most prolific artist, and made more statues than any other sculptor, among them an *Apoxyomenus* or *Man Scraping Himself with a Strigil* which M. Agrippa dedicated in front of his baths, and of which the emperor Tiberius was astonishingly fond ... (63) He is famed for his *Drunken Flute Girl*, his *Hounds and Huntsmen*, and particularly for his *Chariot of the Sun* at Rhodes. He also made many studies of Alexander the Great, beginning with one in his boyhood ... (64) He also made a *Hephaestion*, Alexander's friend, which some ascribe to Polyclitus, even though he lived a century earlier, and an *Alexander's Hunt* dedicated at Delphi, a *Satyr* now at Athens, and an *Alexander's Squadron* in which he rendered the portraits of the king's friends with the highest degree of likeness possible in each case; Metellus removed this to Rome after the conquest of Macedonia. He also made chariot groups of various kinds.

(65) Lysippus is said to have contributed much to the art of sculpture, by rendering the hair in more detail, by making the heads of his figures smaller than the old sculptors used to do, and the bodies slenderer and leaner, to give his statues the appearance of greater height. Latin has no word for the *symmetria* that he most scrupulously preserved by a new and untried system that modified the foursquare figures of the ancients; and he used to say publicly that whereas they had made men as they were, he made them as they appeared to be. A distinguishing characteristic of his is seen to be the scrupulous attention to detail maintained in even the smallest particulars.

(66) He left three sons who were his pupils, the celebrated artists Daippus, Boedas, and above all Euthycrates, who, however, imitated his father's toughness rather than his elegance, preferring to find favor through an austere style rather than a pleasing one.

than the Polykleitan ideal and the head slightly smaller, increasing the figure's apparent height (Fig. 154; compare Figs. 71, 72). As Cicero and Pliny tell us, "he used to declare the Doryphoros as his master – with total irony, of course" and "to say publicly that whereas his predecessors had made men as they were, he made them as they appeared to be."

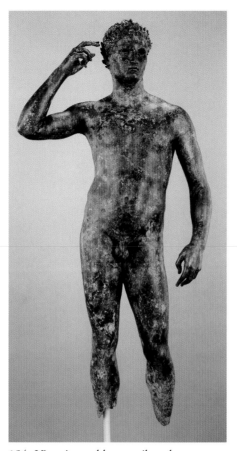

154. Victorious athlete, attributed to
Lysippos of Sikyon or a pupil, ca. 340–300.
Bronze; ht. 1.51 m (4′11′). Malibu: J. Paul
Getty Museum. The youth is adjusting his
crown (compare the Westmacott athlete,
Fig. 84); the crown seems to be of olive,
identifying him as an Olympic victor.

Alexander obviously found these innovations highly congenial. For one
thing, they made him seem taller, more imposing, and thus more powerful.
But in particular, as we have seen, he felt that only Lysippos could capture
his real character and excellence, even genius: his unique *ēthos* and *aretē*.
Deftly avoiding the trap of a merely superficial likeness, Lysippos aimed at
psychological realism, unmasking his subject's real character by judiciously
enhancing those features that promoted it and playing down distracting quirks
that obscured it. As he himself remarked, he sought to convey how people
actually *appeared* to others – how they looked as they moved, breathed, talked,
and so on – not simply to produce a crass one-to-one physical likeness.

Lysippos's work thus represented the ultimate triumph in Greek art of
a *per*ceptual approach over the old *con*ceptual one – of subjective appearance

287

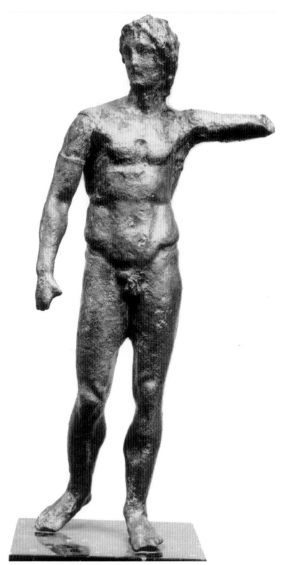

155. Alexander the Great (Hellenistic or Roman copy
after an original probably by Lysippos of Sikyon; so-called
Fouquet Alexander); original ca. 335–30. Bronze;
ht. 16.5 cm (6.5″). Paris, Louvre. Alexander probably
held a spear vertically in his outstretched left hand.

over both brute reality and abstract mental constructs (however sophisti-
cated and seductive), of *nomos* (culture) over *physis* (nature). He and Apelles,
the impresario of illusion and deception in painting, represent Greek art's
belated answer to Gorgias (see Chapter 5). Like the sophist, they realized that
the artwork's effect is in the eye of the beholder, whose subjective experi-
ence is all. Everything comes together in his mind, if the artist does his job
right.

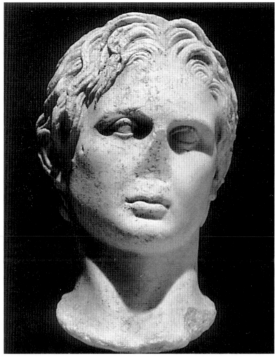

156. Alexander the Great (Roman copy after an original probably by Lysippos of Sikyon; so-called Schwarzenberg Alexander); original ca. 335–30. Marble; ht. 37 cm (14.6″). Munich, Glyptothek.

Lysippos's portraits of Alexander with the Spear are all lost, and their specific locations are not recorded, but numerous small bronzes from Macedonia, Asia Minor, and Egypt and a handful of Roman marble heads give some idea of their appearance (Figs. 155, 156). The bronzes stride imperiously forward, holding Alexander's trademark spear (now missing) upright in one hand, dominating his conquests like a new Doryphoros (Figs. 71, 72). The marbles stress his low-set, sulky mouth, high cheekbones, somewhat deep-set eyes, broad forehead, and leonine cowlick of hair or *anastolē*. These characteristics match Aristotle's own description of the lion-man in his *Nicomachean Ethics* and *Physiognomonics*,[3] actual preserved marble lions (Fig. 157), and Plutarch's explanation, quoted above, of why Alexander favored Lysippos's *leonine* or lionlike portraits above all others. As one early Hellenistic poet and fan of Lysippos approvingly remarked:

> Lysippos, Sikyonian sculptor, hand so bold,
> Keen smith, that bronze looks fire, which you have cast
> In Alexander's form. Blame not the Persian foe,
> For we forgive the cows who flee the lion.

3 Actually a treatise written by one of his pupils, but a good source nevertheless.

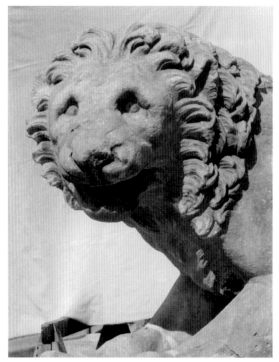

157. Funerary lion. Marble; ht. 1 m (3′4″). Piraeus
Museum. Compare the lion's mane (his so-called
cowlick or *anastolē*) with Alexander's, Fig. 156.

So Lysippos apparently hit upon a brilliant solution to the problem of representing the young, demanding warrior-king. Discreetly idealizing Alexander's striking but flawed physiognomy, he simply merged the genres of portrait and warrior-hero (Figs. 71, 72) into one, blending them with the charged iconography of the king of beasts (Fig. 157). His Alexander was a second Achilles, the very best of the Achaeans, a true lion among men. Compared with the mature, wise, even-tempered, and serene Perikles (Fig. 56), the perfect Athenian politician and icon of classical prudence, he throbs with youthful vigor. Bursting the narrow confines of the Greek city-state, even of the Macedonian kingdom, he gazes longingly out to far horizons, ever seeking conquests new.

DECISION IN SYRIA

After his triumph on the Granikos, Alexander swept down the Ionian coast and into central Asia Minor, cutting the famous Gordian Knot in the process, and then onto the Cilician plain to meet King Darius and the main Persian army at the river Issos (Map 4). It was now November 333. A monumental

reminiscence of this decisive battle survives in the famous Alexander Mosaic from the House of the Faun at Pompeii (Figs. 158, 159).

It shows the battle's climax. Alexander charges in from the left, leading his Companion cavalry. At center right, Darius stands high in his chariot, surrounded by his royal guard. The two foes meet at last, personifying everything that sundered their respective societies: the young Alexander, first among equals (his "Companions"), and the middle-aged Darius, perched atop his empire's rigid, pyramidal hierarchy. But unexpectedly, frustration rules. Fortune (Tychē), ever fickle, has thrust a Persian into Alexander's path, impaling him on the king's sarissa and immobilizing it. Darius, on the other hand, is fresh out of arrows; his quiver is empty, his bow useless. He can only gesture futilely toward his enemy. Meanwhile, a hedge of spears suddenly appears behind the Persian lines: are they friend or foe? Darius's charioteer, seeing the danger, whips up the horses and heads for the only exit, crushing two Persians like insects en route.

This monumental work – its figures are life-size – is a copy. Manufactured around 100 B.C., it was damaged in the earthquake that struck Pompeii in A.D. 62, patchily restored, and buried in the eruption of Vesuvius in A.D. 79. Yet it does not quite fit the space allotted to it; uses the classical Greek "four-color" technique (red, yellow, black, white, and their compounds); and finds clear echoes in several other Italian works of the late second century B.C. So it probably copies a painting brought to Italy as plunder after 146 B.C., when the Romans conquered Macedonia. This putative original painting ought to date to the 320s or 310s, when memories of the battle were still fresh. Its author is unknown. Was he Apelles, Alexander's favorite painter? Or Helena of Egypt, one of antiquity's few women artists, who painted a Battle of the Issos that ended up in the Forum of Peace at Rome? Or Philoxenos of Eretria, who Pliny says "produced a painting second to none for King Cassander, showing a battle of Alexander and Darius." (This was Kassandros son of Antipatros, the regent that Alexander left behind in Macedonia, though he took the royal title only in 303.)

Although the Mosaic is often hailed as a realistic masterpiece, scholars have long noticed that several compositional and iconographic blunders indicate that the mosaicist may have radically abbreviated his model (a colored sketch?) and partially misunderstood it too. In particular, the king's chariot is quite incoherent and a jagged fissure runs vertically through the composition at center, terminating in the comically crude helmeted head peeping out to the left of Darius's outstretched hand.

These imperfections apart, the Mosaic brilliantly explores three different aspects of Alexander's unique personality: his ferocity in battle, his charisma, and his military genius (Fig. 159). Moreover (like the oxen in Fig. 88), all the horses in the picture stare directly at us, turning us into eyewitnesses of the struggle and pressuring us to believe the message of the scene before us. A bible of the technologies of power, its relentlessly descriptive realism teaches us – as once it taught the young Kassandros? – the essential ingredients of Alexander's art of war.

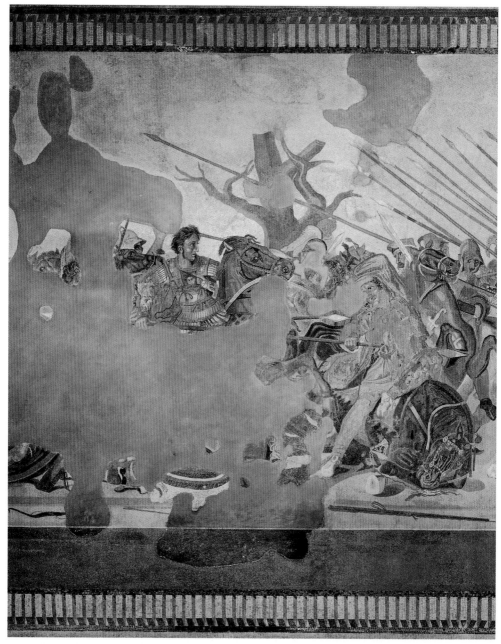

158. Alexander in battle against Darius (the so-called Alexander Mosaic: Roman copy after an original perhaps by Philoxenos of Eretria); original painting, ca. 330–20. Ht. of picture, 2.71 m (8′11″). Naples, Museo Archeologico. The Mosaic probably shows the Battle of Issos in 333. Alexander charges in from the left, but a Persian blocks him with his own body; meanwhile, Darius reaches out to Alexander while his charioteer whips up the horses to escape. In the foreground, a Persian tries to stop Darius's getaway horse from bolting, while in the background an array of spears signals the arrival of another Macedonian unit on the scene.

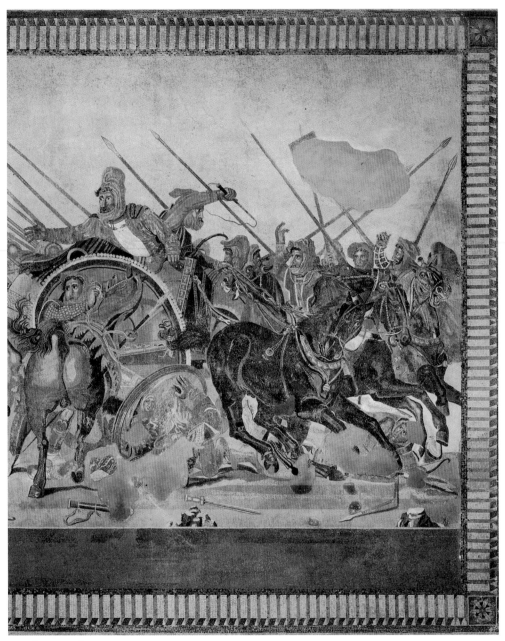

158 (*continued*)

Alexander's ferocity strikes us first and foremost. His appearance – his low-set, sulky mouth; razor-sharp nose; staring eyes; and unruly mane of black hair – is almost demonic. Though his mighty spear has skewered the hapless Persian before him like steak on a spit, he has eyes only for Darius, who gestures to him helplessly as his charioteer whisks him away. This motif

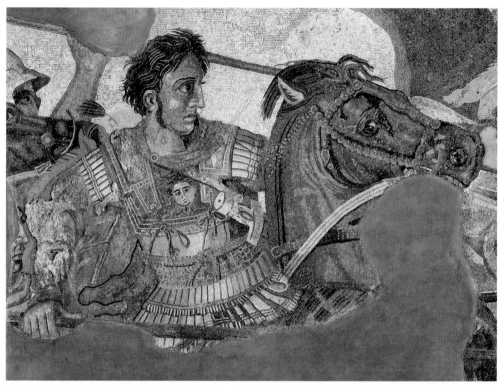

159. Alexander, from the mosaic, Fig. 158.

comes from popular Macedonian rape scenes like that of Persephone from Tomb I at Vergina (Fig. 160). It covertly feminizes the Persian king before the onslaught of his hypermasculine, thrusting opponent. All he can do is plead, but since he is a barbarian, Alexander cannot understand a word of it – not that he cares.

As to charisma, for proof of a man's personal magnetism one naturally looks to his followers. Their concerted action and steely gazes leave us no room for doubt. Alexander's charismatic leadership has welded them into an invincible fighting machine. Nothing can stand against them – certainly not the individually brave but collectively undisciplined Persians, led by a panicky, wild-eyed king in a chauffeur-driven chariot that crushes two of his own men like beetles.

Finally, Alexander's military genius – his mastery of the art of war – is signaled by the entire composition, especially if the spears in the background are Macedonian. It tells us that his success is based not only upon personal bravery and dashing leadership, but also upon his ability to control disparate and dispersed masses of men in maneuver. His tactical mastery has allowed him to penetrate the Persian line; to seek out Darius with an elite cavalry squadron; and to ensure that reinforcements arrive on time to clinch his success. Only Fortune can frustrate his plans, flinging a Persian in his way to immobilize his all-conquering spear and letting Darius escape by the skin of his teeth.

160. Hades abducts Persephone, ca. 336. Fresco; ht. 1 m (3′4″). Vergina (Macedonia), Tomb I within the Great Tumulus, in situ. The tomb may be that of King Philip II of Macedonia, assassinated in 336; compare the protagonists to Darius and his charioteer, Fig. 158.

Relentlessly didactic, this picture marks a watershed in both Greek history and Western art. Whereas the battle imagery of the Greek polis (see Figs. 25, 52, 58, 81, 103, 118, 121, 124) had vividly evoked the hoplite experience – the individual citizen warrior's wrenching departure from home, the physical prowess manifested in his naked body, his personal struggle with his foe, his heroic and divine protectors, and his often tragic end – the Mosaic's gritty, hard-hitting realism highlights the triumphs and tragedies of its two royal protagonists. Pitted against each other like a new Achilles and Hektor, they now duel for world domination in far-off Syria. Everyone else is anonymous,

a mere pawn in the great game of war. This is not classical intercity warfare but its Hellenistic successor: An affair of vast empires, disparate cultures, far-flung campaigns, professional armies, specialized units, customized weaponry, complex tactics, and generals directing events like players at a chessboard.

FROM SYRIA TO PERSIA

After Issos, Alexander moved down the Levantine coast, besieging and taking the great maritime cities of Tyre and Gaza on the way (Map 4). In November 332, he reached Egypt. After choosing the site for Alexandria-by-Egypt, the first of the many cities that were to anchor his name and fame in the landscape of empire, he set out across the Sahara desert to Siwah in order to consult the oracle of the god whom he increasingly acknowledged as his true father: Zeus Ammon. There, the priest obligingly greeted him as "Son of Zeus" and the god equally obligingly gave him the desired answers to his questions. Only Alexander heard them and he never divulged them, but the rumors soon flew. He was innocent of his father Philip's murder; he would rule the world; he would be invincible till he joined the gods; and he had chosen the site of his new city well.

Destined to become the "it" city of the third century and one of the great urban centers of the ancient world, Alexandria took decades to build. But its plan, devised by Alexander himself, the flamboyant architect Deinokrates, the dubiously named hydraulics expert Hyponomos, and the canny engineer Kleomenes (soon to be appointed governor of Egypt and to achieve notoriety as a ruthless administrator), was revolutionary. Since Hippodamos (see Figs. 31, 32), Greek town planning had advanced little. Alexandria boasted, for the first time ever, a sophisticated underground water and sewer system, and above ground, it was – or soon became – a planned City Beautiful, with harbors, gates, streets, public buildings, sanctuaries, temples, and palaces coordinated in an overall vision of breathtaking grandeur (Fig. 161).

Deinokrates used a spacious 1000-foot (330-m) master grid, with individual blocks measuring 300×150 feet: a 2:1 proportion. The city proper was basically rectangular – shaped like a Macedonian military cloak with its two southern corners rounded off. Cemeteries flanked it to east and west, and, later, the royal palaces and gardens adjoined it to the northeast, and the sanctuary of Sarapis to the southwest.

So Alexandria, every inch a royal capital, essentially was sandwiched between royalty and the gods. The main East–West street – the majestic, 100-foot-wide Canopic Way – traversed it from gate to gate, and another, equally wide, crossed it from north to south. The six grid squares in the town center, bisected by the Canopic Way, eventually housed the agora, the harbor market, and probably the law courts, gymnasion, Mouseion ("Place of the Muses" – the world's first university), and library. Such regularity soon prevailed throughout the Hellenistic world. It remained only to invent the arched gateway (first attested at Priene in 156) and the colonnaded street (in first-century Antioch). With these, the concept of the city beautiful was complete: A walled kosmos whose graceful arched gateways announced monumental, colonnaded

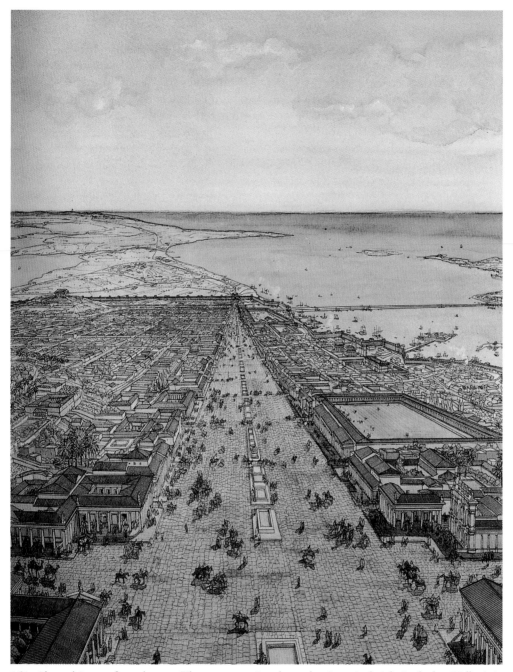

161. Alexandria seen from the east. The reconstruction shows the city at its height in the late Hellenistic period.

boulevards that defined a rationally controlled but eminently livable urban space. If only the modern West were so well served.

Meanwhile, the Egyptians were busy also. Plans were made to incorporate Alexander's image into the relief decoration of the great Pharaonic temple at Luxor. These reliefs (Fig. 162) give us a completely new perspective: that of the conquered. They stand in its innermost sanctum, the so-called Shrine of the Bark. Commissioned by the local priesthood to house the sacred boat used for Ammon's yearly voyage on the Nile, the shrine still stands. The temple was dedicated to the royal *ka* – the vital force transmitted, in an arcane and complex theology, from Pharaoh to Pharaoh via the ithyphallic Ammon-Ra Khamutef.

On the shrine's walls, Alexander appears over forty times, each time identified by hieroglyphic inscription and by the royal crowns he wears. As Pharaoh de facto he enters the temple; meets Ammon-Ra Khamutef, Mut, Khonsu, and other divinities; and leads the districts of Upper and Lower Egypt in sacrifice. The rendering is purely Egyptian and rigorously canonical. For Egyptian art was dedicated to the maintenance of *ma'at* or divine order, now supposedly reestablished by Alexander's conquest. It shows how much the Egyptian elite bought into Alexander's brave new world – at least in public.

In mid-April 331, Alexander left Egypt forever. After marching back up the Mediterranean coast, he crossed the Fertile Crescent to what is now northern Iraq (Map 4). There, at Gaugamela on October 1, he met Darius and the main Persian army, totaling well over 100,000 men (its cavalry alone numbered 35,000). The result was another smashing victory. Darius fled again, and Alexander moved swiftly south to occupy Babylon and the Persian royal centers of Susa, Persepolis, Pasargadai, and Ekbatana. He made Babylon his own capital, and in the Persian cities he found loot beyond his wildest dreams: more than 180,000 talents or almost 5,000 *tons* of un-coined bullion alone, equivalent to over *four hundred years'* revenue for the Athenian empire under Perikles. Any money worries Alexander may have had were now definitely over.

Alexander had already compelled those cities in his path that had minted their own coins to substitute his, and had opened some new mints of his own, but now, at Babylon, he used part of this immense treasure to produce a splendid series of 10-drachma coins along the lines of his existing royal coinage (see Fig. 152). Together with his gold issues featuring Athena and Nike, and his bronze ones with Herakles's head, bow, bow-case, and club, these advertised his sponsors, aims, and achievements more clearly than any verbal propaganda.

Henceforth, all monetary transactions of any significance in Asia and Africa would be carried out under the sign of Alexander. Just as his city foundations anchored his name and fame in the landscape of the universal empire (see Fig. 161; Map 4), these coins circulated them around and throughout it, somewhat as his court poets would have done if they had been any good. Unfortunately, they were awful. The praise-poetry of the free Greek city – Pindar's victory odes and their ilk (see Chapters 1 and 4) – could not easily serve this brash new autocratic world of empires, kings, and courtiers.

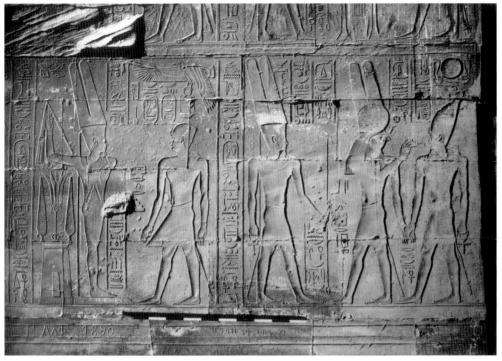

162. Alexander before the gods of Egypt, from Luxor, ca. 330–20. Sandstone; ht. 2 m (6′7″). Luxor (Egypt), Shrine of the Bark in the Temple of Ammon, Mut, and Khonsu, in situ. On the left, Alexander stands before Ammon-Ra Khamutef; on the right, Monthu introduces Alexander to Ammon.

BUT WHILE THE CAT'S AWAY...

After Alexander's departure, his regent Antipater kept Greece on a tight leash. In 331, however, King Agis of Sparta made a last-ditch bid for freedom. He attracted a number of allies, but Athens fatally stood aloof, dooming both the rebellion and him. (When Alexander heard of these Peloponnesian goings-on, he contemptuously called them "a war of mice.") For, by then, the fiery Demosthenes had taken a back seat to the cautious Lykourgos, a financial wizard who succeeded in building up the city's revenues to a respectable 1200 talents, even while orchestrating a comprehensive program of urban, religious, and cultural renewal.

So when, in 330, Demosthenes's great rival Aischines, a Macedonian stooge, attempted to deprive him of the crown voted him in 336 for his services to the state, Demosthenes, sensing that the public mood had swung to his side, struck back in fury. His speech *On the Crown* is a rhetorical masterpiece. If Lykourgan Athens is rightly characterized as the city's silver age in relation to Perikles' golden one (see Chapter 3), then *On the Crown* bears a similar relation to Perikles' *Funeral Speech*, delivered exactly a century before – except that now a new specter haunted the city: the specter of defeat.

Aischines' speech to the 501-man jury also survives. In it, he smears Demosthenes' legitimacy (under Perikles's Citizenship Law), honesty, morality, judgment, and patriotism, and (in a shrewd Catch-22 move) lambastes him less for opposing the Macedonians than for doing so feebly, fitfully, and foolishly, driving the city to ruin. Touching on Athens' charter myths and former glories (see Chapter 2), he concludes,

> So our city, the common refuge of all the Greeks, to which in former days used to come the embassies of all Greece, city by city, in order to find safety with us – our city is no longer contending for the leadership of Greece but for its own very soil . . . Do you not think that Themistokles and those who died at Marathon and Plataia, indeed the very tombs of your fathers, will groan aloud if the man who admits that he has plotted with barbarians against Greeks receives a crown?

Demosthenes hit back with everything he could muster. Brilliantly interspersing dramatic narrative with biting invective, he surveys the policies and events of the previous twenty years, showing that all that could have been done against the Macedonians had been done. Throughout, he plays down the years of quiescence since Chaironeia, hinting only that the city is slowly regaining its strength, and deftly turning Aischines' points against him:

> You cannot, men of Athens, you *cannot* have erred when you accepted the risks of war for the safety and freedom of mankind. I swear it by our forefathers who endured the danger at Marathon, who stood in battle array at Plataia, who fought in the sea-fights at Salamis and Artemision, and by all the brave men who lie in our public tombs, buried there by a country that deemed them all alike worthy of the same honor – *all of them*, I say, Aischines, not just the successful and victorious alone. So justice bids. For all of them fulfilled the duty of brave men. Their fortune was such as Heaven severally allotted them.

Even his jibes are wittier and sharper than Aischines':

> A project approved by the dēmos is going forward. Aischines is silent. A regrettable incident is reported. Aischines appears. He's like an old sprain or fracture: The minute you get under the weather it begins to act up.

So in the end Aischines, that "disreputable pen-pusher, that two-bit tragic actor," lost the case, not even receiving one-fifth of the votes cast – a blow that exposed him to penalty for frivolous prosecution. He fled to Rhodes, there to end his days as a professor of rhetoric.

Demosthenes' insults were timely. Tragedy and tragedians were in the air. One of Lykourgos's first acts upon gaining office around 336 had been to finish the new Theater of Dionysos, begun in the 340s. Not only was it huge – it could seat 17,000 people – but also it was revolutionary in design: clamshell-shaped, not rectangular (contrast Fig. 18). This is the theater visible today on the south slope of the Akropolis (Fig. 163), albeit several times

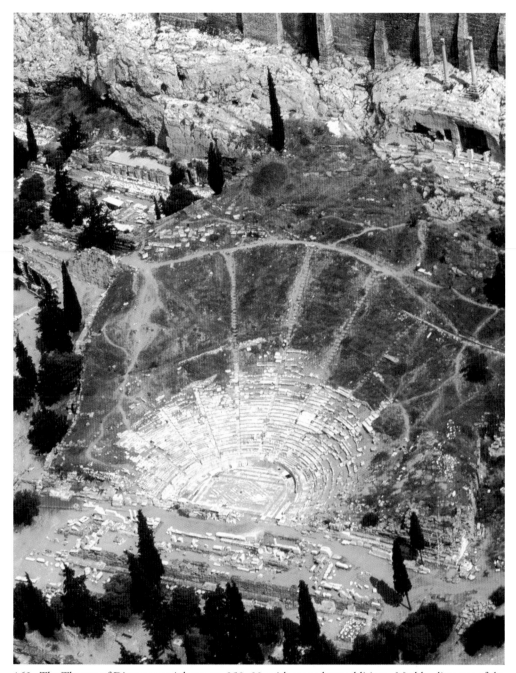

163. The Theater of Dionysos at Athens, ca. 350–30, with many later additions. Marble; diameter of the orchēstra, 23 m (75'6"); of the theater, 111 m (364').

remodeled in antiquity and heavily plundered since. It featured not only a two-tier auditorium, because a branch of the Street of the Tripods crossed it about four-fifths of the way up, but also a U-shaped orchestra and a winged scene building. The actors performed in the orchestra and on a low stage between the wings, entering and exiting from doors in the wings and rear colonnade, as on the vases (see Figs. 108, 143).

Why the new design? From the beginning of the century, the chorus's role had been shrinking until it merely provided dance interludes. Simultaneously, the actors had become superstars, often inserting virtuoso soliloquies into the plays in order to show off. Plato and Aristotle severely criticized these histrionic rants, and around 330 Lykourgos commissioned official editions of Aischylos, Sophokles, and Euripides that all future Athenian performances had to use, canonizing them for all time as classics of the genre – the "education to Greece" of Perikles' dreams. To underline the point, he ordered bronze portraits of the tragic trio for display in the new theater.

Marble copies of the Sophokles (Fig. 164) show him as a typical – indeed, classic – Athenian gentleman: prudent, intelligent, moderate, orderly, and self-controlled, with his arms firmly wrapped inside his cloak as Athenian etiquette dictated. This official "role" portrait (compare Figs. 56, 127, 128) suggests not that every Athenian can be a Sophokles, but that even the greatest Athenians should be men of the people: good, well-behaved democrats like ourselves. Without the inscription on its base, one might not have suspected that it represented a playwright and intellectual at all. Other, similar portraits of Miltiades, Thucydides (Fig. 165), Lysias, Xenophon, Sokrates (Fig. 166), and other great men of Athens's past, also preserved in Roman copies, may be products of the same Lykourgan program of nostalgia and renewal.

The Thucydides (Fig. 165) is all but indistinguishable from a thousand well-to-do, mature Athenians of the gravestones (compare Fig. 128). Here again we see the intellectual as good citizen, always ready to put his intelligence and vision at the service of the city, to provide it (in his case) with a "possession for ever" – with analysis and counsel whose efficacy would never fade. The potency of this image – a sculptural fantasy executed with consummate technique – can be judged by its blithe reappearance in countless history textbooks and editions of the great historian's work, supposedly as his true likeness.

The Sokrates (Fig. 166) achieves a similar "reality effect." Commissioned by the city – allegedly in regret at his execution – from Lysippos, it was set up near the Dipylon Gate, in the great assembly hall (Pompeion) for the Panathenaic procession. Two replicas in statuette form show him turning as if engaged in dialogue, his heavy body wrapped in a simple cloak, dispensing wise advice to a skeptical city.

Yet whereas Sokrates' earlier reincarnation (Fig. 132) had echoed Xenophon and Plato in contrasting his satyric looks and piercing intelligence, this one idealizes him, lengthening the face and smoothing out the crudities, so that the curved mustache, arching eyebrows, and domed skull create a rising movement that is focused and projected outward by the upward glance of the eyes. This is the visionary Sokrates of the *Republic* (see Chapter 6, Box 1) and the later Platonic dialogues, no longer merely the ironical deflator of

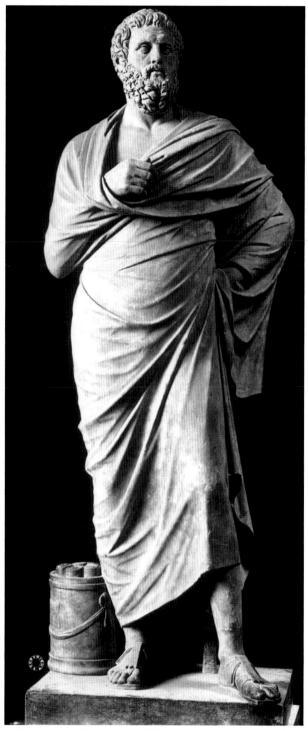

164. Sophokles (Roman copy); bronze original, ca. 334–24. Marble; ht. 2.04 m (6′7″). Vatican Museums.

165. Thucydides (Roman copy); bronze original, ca. 330. Marble;
ht. 61 cm (2'). Holkham Hall (England). The original would have
been a full-length bronze statue wearing a cloak (compare the
Demosthenes, Fig. 173).

citizen and sophist, but the discoverer of the Forms and planner of the ideal
city: as "great-souled" in his own way as that other visionary, Alexander (see
Fig. 156).

Together, these images set the seal on Athens's canonization of its past
that had begun at the beginning of the century with the Dexileos and Eirene
(Figs. 124, 131), and the official revivals of Aeschylean, Sophoklean, and
Euripidean tragedy that had started in 386. Thenceforth, especially after the
city's final defeat in 322 and conclusive loss of independence at Macedonian
hands, it increasingly would become what social historians call a "heritage"
society: classicism's bastion and taste's self-appointed arbiter in a world that
had changed forever.

To return to the Theater of Dionysos and fourth-century developments
in drama, its novel design both acknowledged their positive side (one can
easily imagine the actors striding forward to the center of the orchestra to
deliver their histrionics) and gave the audience a better view of them. Indeed,

166. Head of Sokrates (Roman copy after a
bronze original attributed to Lysippos of Sikyon);
original, ca. 330. Marble; ht. 37 cm (14.6″).
Paris, Louvre. The original would have been a
full-length statue wearing a cloak (compare the
Sophokles and Demosthenes, Figs. 164 and 173).

the clamshell form could even be defended as more democratic than the old
one, for now every spectator in a given row sat at exactly the same distance
from this focal point.

Even before its completion, the new theater became an instant classic,
inspiring imitations all over Greece. The most elegant of them sits just across
the Saronic Gulf in the sanctuary of the healing god Asklepios at Epidauros
(Fig. 167). There the sculptor-architect Polykleitos – a follower and probably
descendant of the great fifth-century sculptor – had been active since around
350, building the tholos (a sumptuous colonnaded rotunda of uncertain func-
tion), and now was tapped for the theater. Pausanias, describing them with
unusual warmth, even asks rhetorically, "What architect could rival Polykleitos
in harmony and beauty?"

For Polykleitos was not only an architect of extraordinary versatility but
also a mathematical genius. Highly complex in its proportions and boasting
an intricate black-and white marble floor of stunning beauty, his tholos rivaled
the Erechtheion (see Figs. 111, 112) in ornateness. As there, some (perhaps
all) of its moldings (Fig. 168) have cultic significance – another instance of
that "in-group" mentality that we uncovered in the case of the Eirene and
Knidia (see Chapter 6 and Figs. 131, 140).

167. The Theater at Epidauros, by Polykleitos the Younger, ca. 330. Marble; diameter of the orchēstra, 20.4 m (66′11″); of the theater, 117.9 m (387′). The upper tiers of seats are Hellenistic additions.

The theater (Fig. 167), on the other hand, is pure geometry. Its overall plan, computed in Peloponnesian cubits (19.3″ or 49 cm),[4] utilizes simple integral ratios. The orchestra's radius is 20 cubits, the lower auditorium's is 80 cubits (20 + 60), and the upper auditorium's is 120 cubits (20 + 60 + 40). The lower auditorium's gradient is 26.2° and the upper one's is 26.5°, an average slope of 1 in 2. It is no coincidence that these proportions, 1:2, 2:3, and 3:4, echo the perfect intervals of the octave, fifth, and fourth as Pythagoras had calculated them around 500 (see Fig. 23). For the quadrennial Epidaurian festival, the Asklepieia, certainly included musical contests, and large parts of Greek drama were sung also. As Polykleitos intended and Pausanias understood, his theater is pure harmony in stone.

Moreover, Polykleitos inscribed the circle of the orchestra within a regular pentagon, a well-known Pythagorean icon for health; its base runs along the front of the scene building, and its three other corners touch the bottom steps of the third, seventh, and eleventh staircases. And last but not least, he used the properties of this iconic pentagon to generate the seating plan itself. For the tiers of seats in the upper and lower auditoria (21 and 34) and their sum (55) conform to the only mathematical progression or algorithm that approximates the so-called Golden Section. This Section is mathematically irrational but – because of its simplicity – a culturally and aesthetically powerful proportion

4 I.e., one and one-half times the long Peloponnesian foot of 32.6 cm or 12.75 inches
 (the one that Libon had used at Olympia; see Chapter 2 and Fig. 42).

168. Coffers from the cella of the Tholos at Epidauros, by Polykleitos the Younger, ca. 340. Marble; width of recessed section, 55 cm (21.5″). Epidauros Museum.

constructed by means of the diagonals of the pentagon.[5] Its mathematical approximation, the so-called Fibonacci series, is plotted by adding each integer to the one after it, and develops as follows: 1, 1, 2, 3, 5, 8, 13, 21, 34, 55, 89, and so on.

So on one level Polykleitos's theater surpassed even Iktinos's Parthenon (see Fig. 60). It not only neatly reconciled rational and irrational, but also combined them with perfect harmonic proportions and even with the "classic" Pythagorean icon for health, the pentagon – the function of the entire ensemble. For it was at Asklepios's festival, attended by thousands of pilgrims, many of them seeking cures, that the theater came into its own. Of course, these correspondences do not strike us consciously. As with sculptural proportions (see Fig. 22), their effects are subliminal. We intuit them and feel better as a result.

Although the Epidaurian festival included athletic games, no statues of athletes were dedicated there; these clustered mainly at the great "crown" centers of Olympia, Delphi, Isthmia, and Nemea, and in the victors' respective

5 As explained in Chapter 2, the "Golden Section" is the section of a line in extreme and mean ratio, and is constructed by the intersection of the diagonals of the pentagon. If one of these diagonals, a line of length A, is divided in this way by another diagonal into two unequal parts b and c, A is to b as b is to c and vice versa (A : b :: b : c).

Although geometrically and aesthetically satisfying, mathematically the ratio is irrational: 1:1.6180339887. . . .

cities. The Lysippic Getty Bronze (Fig. 154), found in the Adriatic Sea off Italy, shows how far the genre had progressed since Polykleitos (see Fig. 84). Life-size, naked, and looking out boldly over our heads, he raises his right hand to adjust a now-lost crown of (probably) wild olive on his head, and perhaps carried another attribute – a palm branch? – in his left. If truly of olive, this crown would make him an Olympic victor; presumably his feet remained on his now-missing base when he was brutally wrenched from it during the Middle Ages and taken by ship up the Adriatic Sea, perhaps for recycling in the Venetian arsenal.

A version of Polykleitos's bronze of the boy-boxer Kyniskos (Fig. 84), which also stood at Olympia, the Getty athlete was probably a runner, for his ears are not cauliflowered as a boxer's would be, and his body is slim and lithe. In contrast to Fig. 84, his head is now a portrait and no longer meekly bows in respect to the gods. He too recalls Aristotle's Great-Souled Man (see Chapter 6), "who claims much and deserves much; . . . an extreme in regard to his claim, but the mean by reason of its rightness." Especially concerned with honor, the Great-Souled Man is the best of men, disdains trivia, competes only for the top prizes, and acts in a superior fashion, so he may appear haughty and even somewhat hybristic. So much for classical reserve and the athletic victor's traditional deference before men and gods.

FROM HERO TO GOD

We left Alexander in 330, victorious, unimaginably rich, and undisputed ruler of Greece and western Asia. This must have been the moment when he asked his court painter Apelles to paint a colossal portrait of himself to dedicate in the temple of Artemis of Ephesos, offering him the vast sum of 20 gold talents for his efforts.[6] For Artemis Ephesia was the great goddess of Asia, and her temple, burned by a lunatic in 356 and still only partly rebuilt, was her foremost shrine in the Greek world. (When finished, it became one of the Seven Wonders of the World.) The picture is of course lost, but was famed for the realism of the thunderbolt Alexander held, which seemed to flash like a searing fire. Apelles was renowned as a master of "luster," of the illusion of glint and sparkle, and here he used it to stunning effect.

By equipping the king with a divine attribute, Apelles broke decisive new ground, but replicas of his Alexander Thunderbolt-Bearer are extremely elusive. The favorite candidates are an engraved gemstone signed by a certain Neisos, now in St. Petersburg (Fig. 169), and a fresco from the House of the Vettii at Pompeii.

The gem (Fig. 169), a splendid red carnelian, shows a youthful, naked, diademed king, complete with Alexander's trademark cowlick. He carries Zeus's aegis on one arm and Zeus's thunderbolt in his outstretched hand,

6 At just over 1,100 lbs or 516 kg, this was about half the amount of gold Phidias had used on the drapery of the Athena Parthenos (see Fig. 69) and was enough to finance a good-sized temple.

169. Alexander the Great with diadem, thunderbolt, aegis, and eagle. Engraved gemstone signed by Neisos, perhaps echoing Apelles's painting at Ephesos of Alexander with the Thunderbolt, ca. 300–250. Red carnelian; ht. 4.5 cm (1.77″). St. Petersburg, Hermitage Museum. This is a negative image or *intaglio*, cut into the stone; when stamped into soft wax or clay, it would produce a positive (i.e., left–right reversed) image in relief.

and Zeus's eagle sits at his side. The fresco shows an enthroned king with thunderbolt and scepter. Yet it comes from a room decorated with the loves of Jupiter. So it probably represents the king of the gods in his youth, not Alexander, but still might echo an Alexander type.

Whichever image one chooses, it is clear that Apelles's Thunderbolt-Bearer simultaneously invented a new type of ruler portrait; provoked some harsh criticism; and started a controversy that lasted until the end of antiquity. Lysippos, for example, acidly remarked: "*I've* given the king a spear, his true and proper weapon. Time can never take *its* glory away." With this comment, he was attacking the propriety of endowing *living* mortals with divine attributes and thus according them de facto divine status. His own response was probably those swaggering images of Alexander looking up to the sky (Fig. 170), which some early Hellenistic poet cleverly glossed as follows:

> This brazen image seems to look at Zeus and say:
> "You take Olympos! Me let earth obey!!"

Apelles's Thunderbolt-Bearer is usually labeled "Alexander as Zeus." Yet this cannot be expressed in Greek, and the picture cannot reflect an actual Alexander cult, for the only hint of divine honors during his lifetime comes from Athens in 323, two hundred miles away and seven years later. Moreover, although the king clearly believed that he was the son of Zeus-Ammon, he consistently deflated attempts to kowtow to his supposed divinity: "Good human blood here, not the ichor of the gods!" And even more tellingly: "Thunder? No, I don't want to frighten my friends!"

So Apelles cannot have shown Alexander "as Zeus," still less as an actual recipient of cult. His "godlike" image and its Hellenistic successors are the stuff not of cult but of encomium. Their proper literary equivalents are praise-poetry and panegyric. Their language is that of simile and metaphor, of *comparison*, employed by the Greeks since Homer to extol men of superhuman – even godlike – achievements and power. Alexander's court historian Kallisthenes had already invested him with thunderbolt and aegis, alleging that even the waves prostrated themselves before him, and soon "his court poets were opening Heaven to him, boasting that Hercules, Dionysus, Castor, and Pollux would give place to the new deity." Alexander did not disappoint them. In Afghanistan he captured the Rock of Aornos, which allegedly Herakles had assaulted in vain, and in India he reached Dionysos's birthplace at Nysa, then advanced far beyond it.

So Apelles's Alexander Thunderbolt-Bearer praised the king as god*like*, as a Zeus on earth, as the superhuman master of the *Blitzkrieg*. If one wanted to believe that he was actually Zeus's son, to recognize him as a demigod, even to honor him as a special kind of god on earth, that was one's own affair. Nothing in the image demanded it, but nothing actually forbade it either. That is precisely the power, ambivalence, and flexibility of images.

Many wild parties later, one of which burnt Persepolis to the ground, Alexander set off in pursuit of the luckless Darius (Map 4). It was now early June 330. The chase was short. Cornered near the Caspian Sea, Darius was

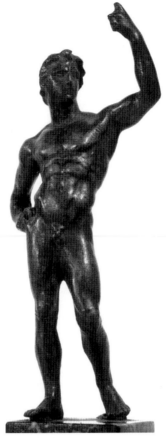

170. Alexander the Great
(Hellenistic or Roman copy after
an original probably by Lysippos;
so-called Nelidow Alexander);
original ca. 330–20. Bronze; ht.
10 cm (3.9″). Cambridge (MA),
Sackler Museum. Alexander
probably held a spear vertically in
his raised left hand.

murdered by his few remaining followers. Alexander, now his legitimate successor by right of conquest, formally assumed the diadem of empire: a simple white ribbon tied around his head. He then proceeded east into Afghanistan – ancient Baktria – to complete the campaign. This took longer than expected. Although he prudently married a local princess, Roxane, resistance was strong, and Macedonian tactics and equipment proved ill suited to the hit-and-run warfare of the Afghan mountains and the central Asian steppe. (As the experiences of the British in the nineteenth century, the Russians in the twentieth, and NATO in the twenty-first have shown, little has changed in the meantime.)

But eventually Alexander prevailed, and, in 326, he marched down the Khyber Pass to the river Indus, which he crossed in early spring. This advance took him decisively beyond the boundaries of the ex-Persian empire: his ambitions were greater still. He then occupied the great city of Taxila on the river's eastern side, not far from the modern Pakistani capital of Islamabad. According to Greek geographical orthodoxy, he was now only a few hundred miles from the world's end (compare Map 2).

Crossing the first branch of the eastern fork of the Indus in May 326, he met Porus, the rajah of that part of India, in battle (Map 4). Porus had three secret weapons at his disposal: 200 mighty elephants armed for war; a squadron of huge, four-horse chariots; and a corps of archers equipped with fearsome, six-foot longbows. But just before the battle Zeus intervened by sending the first big thunderstorm of the monsoon. It mired elephants, chariots, and archers in mud, tipping the odds in Alexander's favor. His victory is commemorated on a rare and remarkable series of silver five-shekel pieces from Afghanistan and a hoard buried near Babylon in 323, the last year of his life.

On the obverse (Fig. 171, top), Alexander, lance in hand and mounted on his horse Boukephalas, pursues Porus, seated on his elephant along with his mahout. The encounter, which never actually took place,[7] uncannily resembles the Alexander Mosaic (see Fig. 158). Now, however, Porus, sitting up front, turns back to stab at Alexander with his spear. A huge man almost seven feet tall, he was made of sterner stuff than Darius, which was why, after he surrendered, Alexander graciously made him viceroy of India.

On the reverse (Fig. 171, bottom), the king stands in full armor, complete with spear and scabbard. Crowned by Zeus's messenger, a flying winged Victory (missing on Fig. 171, bottom, because the engraver struck the coin off center, but present on other examples), in his right hand he holds the thunderbolt, no less – an accessory now justified by Zeus's timely storm. He is Zeus on earth, just as Apelles had painted him at Ephesos. Indeed, is this tiny image our best guide to Apelles's lost picture? One wonders, especially because it seems unlikely that this undistinguished die-engraver invented it himself. Two related issues of silver two-shekel coins show the key detachments of Porus's now-defeated army: his elephants, chariots, and archers.

If it is not a fake (some think so), the gold issue that completes this series was discovered in 1993 but published only in 2005 (Fig. 172). A double daric struck on the Persian standard, it comes from a huge early medieval treasure found at Mir Zakah in Afghanistan, along with several of the silver five-shekel pieces. It shares two enigmatic monograms, Ξ (Xi) and BA, with the silver issues, so it must have been minted together with them, before 323 and the burial of the Babylonian hoard. On the reverse a huge, muscular elephant ambles along, whereas the obverse (Fig. 172) carries a stunning image

7 Lucian, *How to Write History* 12, establishes it as a fiction; even so, Oliver Stone made a memorable scene of it in his movie *Alexander the Great* (2004).

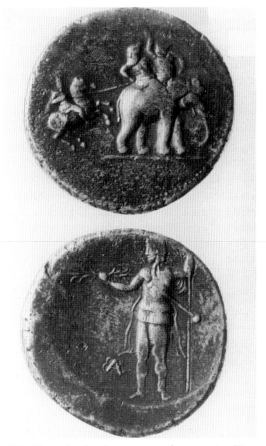

171. Alexander the Great pursues the retreating King Porus; Alexander with thunderbolt and Nike. Silver "Porus" medallion (five-shekel piece) from Babylonia, ca. 325. Diam. 3.2 cm (1.3″). London, British Museum.

that can only be Alexander himself, wearing an elephant-skin, Ammon's horn peeking out from under it in front of his ear, and Zeus's scaly aegis: emblems of invincibility, omnipotence, and divinity.

Perhaps designed by Alexander's court engraver, Pyrgoteles, this is the only likeness of him that – if genuine – is firmly datable to his lifetime. With its bulging brow, huge eyes, massive nose, and "sneer of cold command," it shows us the face of the conqueror. (Did anybody ever dare ask him where he got that hat?) Not surprisingly, his successors would soon craft their own portraits of Alexander, by then enthroned among the gods, along very similar lines.

Did Alexander himself mint these coins? His name is absent; the silver ones with their flat flans, low relief, and poor, off-center striking (Fig. 171) are quite different from his own imperial money (see Fig. 152); and the gold one (Fig. 172) shows him, unequivocally, as superhuman. For only giants can wear

elephant skins and only gods can sprout horns. So did one of his governors in Baktria or India – even Porus himself – produce them? Or were they struck in Babylon, where many of them were found? Who are the enigmatic Xi and BA? And is the gold one even genuine? There's an old saying that archaeology does not solve problems but merely creates new ones. This new discovery proves the rule.

After installing Porus as viceroy of India, Alexander pressed on eastward, convinced that the world's end lay near (Map 4). But his men had had enough. They had marched almost eight thousand miles in eight years – still the longest military campaign in human history. Incessant rain – the relentless Indian monsoon – had been pounding them for over seventy days. Many were sick. Rumors flew of huge kingdoms beyond the Indus, and vast armies spearheaded by hordes of the dreaded elephants. On the easternmost branch of the Indus the army mutinied and refused to march any further. Like Achilles, Alexander retired to his tent to sulk for three days. Then, emerging to take the omens, he pronounced them unfavorable. The great crusade was at an end.

After sailing down the Indus, massacring the Indian tribes as he went, and crossing the murderous Gedrosian desert, Alexander returned to Babylon at the beginning of 323. Various sources describe him at this time as asking the Greeks to worship him as a god. The request met with some ribald responses, but the Athenians seems to have replied with a grudging resolution to erect a statue to him as God Invincible and perhaps an altar and cult as well. But once again Fortune – ever fickle – intervened.

On May 30, 323, the god suddenly developed a fever and soon fell into an intermittent coma. On June 10 he died, just a few days shy of his thirty-third birthday. In eleven short years he had changed the face of the ancient world, had created the largest empire yet seen upon this planet. Perhaps his most fitting epitaph is his own last words. When asked to whom he would leave his conquests, he is said to have replied, "To the strongest; for a great funeral contest will follow my death."

History's spotlight now turns to those lesser men who now battled for Alexander's legacy of empire. More than two million square miles of the earth's surface were now Macedonian. With the colossus now among the gods, how long and in what form would his achievement endure?

EPILOGUE

When news of Alexander's demise reached Greece, one wit remarked that he could not be dead, or the whole world would be stinking of his corpse. Athens and many other cities promptly exploded into rebellion. Antipater, Alexander's regent in Macedonia and de facto governor of Greece, soon crushed it and condemned Demosthenes and its other ringleaders to death. Pursued by Antipater's agents, Demosthenes fled, committing suicide as they closed in for the kill.

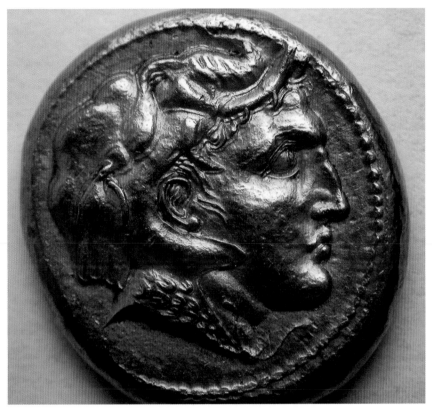

172. Alexander wearing an elephant skin, Ammon's horn, and aegis; elephant. Gold medallion (double daric) from Mir Zakah (Afghanistan), ca. 325, if not a modern forgery. Diam. 2.25 cm (0.9″). London, private collection.

Although the Greek cities were to experience intervals of independence until the final imposition of Roman rule in 31 B.C., Greek freedom as such was now history. In 304 King Demetrios Poliorketes, given divine honors by the Athenians, even proclaimed Athena his elder sister and wintered together with his harem in the Parthenon. And, as we have seen, by no coincidence a new era was dawning in Greek art as well.

But the Athenians should have the last word. In a fleeting moment of liberty in 280 they finally erected a statue of the great Demosthenes (Fig. 173), showing him alone and tense in those nail-biting seconds before beginning to speak. In a last flash of defiance, they glossed it with the following inscription denouncing their Macedonian oppressors:

> Would that your strength had matched your will, Demosthenes:
> A Macedonian Ares ne'er had ruled the Greeks.

So we have come full circle. When raging Ares had destroyed the young Kroisos two hundred and fifty years before (see Fig. 13), he had silenced only one

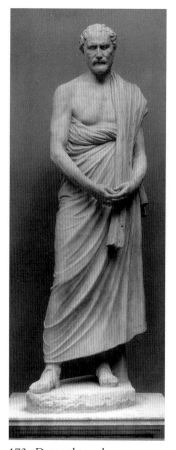

173. Demosthenes by
Polyeuktos of Athens (Roman
copy); bronze original, 280.
Marble; ht. 2.02 m (6′7″).
Copenhagen, Ny Carlsberg
Glyptotek. The original stood in
the Athenian Agora near the
Tyrannicides, Figs. 5 and 34.

of the city's ever-lengthening roster of heroes. Athens would soon produce
plenty more: Harmodios, Aristogeiton, Themistokles, Kimon, Perikles,
Chairedemos, Lykeas, Dexileos, and many others now forever nameless (see
Figs. 50, 25, 34, 37, 56, 58, 81, 103, 118, 124). But now the butcher of
Olympos had scored a bulls-eye. He had killed the voice of Greek freedom
itself.

GLOSSARY

(Greek words are italicized)

Aegis (Greek *aigis*) scaly vestment fringed with snakes and usually bearing a ***Gorgoneion*** at
 its center, worn by Athena and Zeus

Agōn contest

Agora meeting place, assembly place, market place, city center

Akropolis "high city," high place, citadel

Akrotērion (pl. *akrotēria*) floral or figural embellishment crowning the corners and apex of a
 pediment

Amazonomachy battle between Greeks and Amazons

Amphora (pl. *amphorai*) two-handled jar for wine or oil

Anastolē cowlick; hair brushed upward and to the sides from a central parting

Archaic old; generic modern term for art produced in Greece from ca. 700 to 480 B.C., before
 the classical style

Aretē (pl. *aretai*) bravery, courage, prowess, personal excellence, genius; later, moral virtue

Bretas primitive image or idol, usually of a god

Canon see ***Kanōn***

Caryatid female figure used as an architectural support

Cella the cult room of a temple

Centauromachy battle between Greeks and Centaurs

Chiaroscuro Italian term for light and shade, color gradation, color perspective; see also
 skiagraphia

Chiasmos (Latin chiasmus) arrangement resembling the Greek letter *chi*, χ; in rhetoric,
 inversion of the second of two parallel clauses (e.g., "she went to London; to Paris went
 he"); in art, antithetical arrangement of limbs and/or muscles in the form of a *chi*, χ;
 a.k.a. (after its Italian equivalent) **contrapposto**

Chitōn linen shift or tunic, usually girdled at the waist

Chous children's juglet used at the Athenian festival of the Anthesteria

Classic "of a certain class" or "in a class of its own"; something that sets a standard

Contrapposto see ***chiasmos***

317

Daric a Persian monetary unit of about 8 grams of gold, worth about 18–20 silver ***drachmai***
Dēmokratia democracy
Dēmos the people, the citizen body
Doryphoros spearbearer
Drachma (pl. *drachmai*) a monetary unit; in Athens, 4.3 grams of silver, and a standard day's
 wage for a skilled craftsman

Eirene (Greek *eirēnē*) peace
Entablature the architrave, frieze, and cornice of a building
Erastēs (pl. *erastai*) "lover"; the senior partner in a homoerotic relationship
Erōmenos "beloved"; the junior partner in a homoerotic relationship
Erōs love
Ēthos character, disposition
Etiology the origins of current events, customs, and rituals

Geometric art created in a largely or wholly abstract style, produced in Greece between ca.
 900 and 700 B.C.
Gorgoneion decapitated head of the Gorgon Medusa
Gymnasion "naked place"; gymnasium
Gynaikeion the women's quarters in a Greek house

Habrodiaitos "having a luxurious lifestyle"; a hedonist
Hades the Underworld; hell
Helot (Greek *heilōtēs*) serf; indigenous, unfree people subject to the Spartan state
Herm (Greek *hermēs*) stone pillar equipped with a phallus and surmounted by a bearded
 head, in later times not necessarily of the god Hermes
Hetaira (pl. *hetairai*) female companion, "courtesan"; a high-class prostitute
Himation woolen cloak
Homoios "equal"; a freeborn Spartan citizen or Spartiate
Hoplite (Greek *hoplitēs*) heavily armed infantryman serving in the ***phalanx***
Hybris "outrage"; arrogance, insolence, violence, injury, rape
Hybristēs arrogant, insolent, or violent person; rapist
Hydria three-handled water jar

Ilioupersis sack of Troy (by the Greeks)
Isonomia "equal-law"; equality before the law; equal rights
Isonomos equal before the law
Ithyphallic sporting an erection

***Kanōn*/Canon** rule, standard, proportional system
Kithara a stringed instrument, bigger and heavier than the **lyre**, usually played by profes-
 sionals
Kitharode (Greek *kitharoidos*) a professional ***kithara***-player
Korē (pl. *korai*) girl, maiden, or a statue of one
Kosmos adornment, order, cosmos, universe
Kōthōn Spartan drinking mug
Kouros (pl., *kouroi*) youth or a statue of one
Krater (Greek *kratēr*) two-handled mixing bowl for wine, punch bowl
Krisis moment of decision, crisis
Kudos charisma, talismanic power, mana
Kylix drinking-cup

Lekanis bowl, dish, basin, pan

Lēkythos oil flask

Loutrophoros ritual vessel for water used in purification ceremonies

Lyre (Greek *lyra*) a stringed instrument, lighter than the ***kithara***, often played by amateurs

Maenad (Greek *mainas*) madwoman; female devotee of Dionysos

Metope (Greek *metōpē*) forehead; a panel, sometimes painted or carved, separating the **triglyphs** of a Doric frieze

Nekropolis "city of the dead"; cemetery

Nemesis righteous anger, retribution

Nikē (pl. *Nikai*) victory, or a personification of one

Nomos convention, custom, law, "culture" (as opposed to ***physis***)

Oikos (pl. *oikoi*) house; household; family

Oinochoē wine jug

Oligarchy (Greek *oligarchia*) "rule of the few"; rule by a clique

Omphalos navel-stone, sacred to Apollo

Orchēstra dancing floor, orchestra

Order one of the three Greek architectural styles: Doric, Ionic, and Corinthian

Orthogonal receding line, usually at right angles to the **picture plane** and parallel to the ground, which in perspective seems to rise or fall toward the horizon or vanishing point

Ostracism (Greek *ostrakismos*) banishment by popular vote for ten years

Paean (Greek *paian*) cult hymn to Apollo

Panhellenic (Greek *panhellēnikos*) "all-Greek"; anything known, believed, or practiced throughout the Greek world; a place frequented by all Greeks

Pankration combination of boxing and wrestling, one of the most popular of Greek combat sports

Parthenos (pl. *parthenoi*) maiden, virgin, unmarried girl; epithet of Athena

Pathos (pl. *pathē*) feeling, emotion

Pediment gable, on temples sometimes carved

Peplos a long woolen gown, usually girdled

Phalanx dense battle formation of heavy infantry or **hoplites**

Physis nature

Picture plane the surface on which a picture is painted; the front plane of the foreground of a picture

Ploutos wealth

Polis (pl. *poleis*) city, city-state

Pornē (pl. *pornai*) prostitute, whore

Rhythmos rhythm, meter, pattern, composition

Sarissa (pl. *sarissai*) a Macedonian pike

Satyr (Greek *satyros*) attendant of Dionysos, usually goatish and **ithyphallic**

Severe style the first phase or generation of the classical, ca. 480–50 B.C.

Sfumato literally, "smoky"; the slurring of transitions in a sculpture to create a vague or impressionistic effect

Shekel a Near Eastern monetary unit of about 8.4 grams of silver, or two ***drachmas*** worth

Skiagraphia "shadow-painting"; painting making use of shading or gradations of light and shade

Skyphos deep, two-handled drinking cup

Sōtēr savior

Spartiate A freeborn Spartan citizen or **homoios**

Stamnos a two-handled wine or oil jar, like a wide-mouthed **amphora**

Strigil a body-scraper, usually of bronze

Symmetria "measuring together"; proportion, commensurability of parts, a proportional system or **canon** (see **kanōn**)

Symposiast (Greek *symposiastēs*) participant in or guest at a **symposion**

Symposion (pl. *symposia*) drinking party

Talent (Greek *talanton*) a heavy weight; in coin, 6,000 **drachmai** or 25.86 kilograms/57.02 lbs of silver or gold

Technē (pl. *technai*) skill, know-how, technique, facture, technology, craft, art, occupation, profession, textbook

Thiasos a cult organization; Dionysos's retinue of **satyrs** and **maenads**

Tholos round temple or shrine

Triglyph (Greek, *triglyphon*) tripartite architectural element separating the **metopes** of a Doric frieze

Tychē fortune, chance, luck

Tyranny (Greek *tyrannis*) unconstitutional rule, one-man rule, dictatorship

CHRONOLOGY: SOME IMPORTANT EVENTS AND DATES

N.B. Because the Greek year began in midsummer, and events often cannot be assigned to one particular half-year or the other, some dates may differ by a year from those you may find in other books.

1. MYTH AND LEGEND

Giants attempt to depose the Olympian gods; the Gigantomachy

Labors and other deeds of Herakles (Figs. 14, 29, 46, 47, 49, 119); deeds of Theseus (Figs. 75, 76); Theseus and Herakles attack the Amazons; Amazons invade Greece; the Athenian Amazonomachy (Figs. 39, 70, 101)

Wedding of Peirithoos and Deidameia; the Centauromachy (Figs. 45, 65, 66, 116)

Pelops and Oinomaos (Fig. 44)

Oedipus; the Seven Heroes attack Thebes; death of Antigone

Judgment of Paris (Fig. 109)

The Trojan War (Figs. 10, 28)

The Greeks return home; Aigisthos and Klytaimnestra murder Agamemnon (Fig. 40); Iphigeneia and Orestes (Figs. 142, 143, 145, 146) take revenge (Fig. 41); wanderings of Odysseus

Dorian invasion of the Peloponnese

2. THE END OF THE BRONZE AGE; THE DARK AGE; THE EARLIEST CITY-STATES

Date	Political events	Cultural developments
Twelfth c.	Sack of Mycenae and other Mycenaean palaces	Greek "Dark Age" begins (palace civilization, literacy, luxury crafts, etc. disappear); Greece increasingly isolated from the rest of the Mediterranean

Date	Political events	Cultural developments
Eleventh c.		Protogeometric period (the Iron Age) begins; iron technology introduced from Cyprus
Tenth c.		Sporadic contacts with the Near East
Ninth c.		Geometric period begins; contacts increase with the Near East, and resume with Italy and the West
Eighth c.	Earliest Greek-city states; Sicilian Naxos and Syracuse, the first western Greek colonies, founded (734 and 733); Greek colonization begins in Italy (720)	Olympic games (supposedly from 776); literacy revives in Greece; Homer supposedly composes the *Iliad* and *Odyssey*, and Hesiod the *Theogony* and *Works and Days*; "orientalizing" art appears in Greece

3. THE ORIENTALIZING AND ARCHAIC PERIODS (TO CA. 500)

Seventh c.	Kingdom of Lydia founded; Greek colonization begins in North Africa and the Black Sea; tyrants take power in Corinth and elsewhere; earliest phalanx battles (Fig. 15)	Archaic period begins. Black-figure vase-painting; first marble kouroi and korai; earliest Greek lyric poetry; Archilochos, Sappho, Alkaios (Fig. 17), and Mimnermos
Sixth c.	Cyrus the Great founds the Persian Empire (550s); conquers Lydia (547), Ionia (540s), and the nearby islands (520s). Peisistratos tyrant at Athens (547–27), then Hippias; Harmodios and Aristogeiton murder Hippias's brother Hipparchos (514); Spartans expel Hippias from Athens (510); Athenian democracy founded (508)	First stone temples; earliest Greek coinage; Thespis invents tragedy (530s); red-figure vase-painting begins (520s); Pythagoras and followers flee from Samos to Italy (522); first Tyrannicide monument in the Athenian Agora (508)

4. THE FIRST HALF OF THE FIFTH CENTURY AND THE RISE OF ATHENS

490s	Ionians revolt from Persia (499); Athenians and Eretrians come to help; Ionian revolt collapses (494); Persians sack Eretria, and Athenians and Plataians defeat them at Marathon (490; Fig. 103)	Hekataios of Miletos; Aischylos stages his first tragedy (499); theater at Thorikos (Fig. 18); Pindar begins to write lyric poetry; Phrynichos's *Fall of Miletos* (492)
480s	Persians invade Greece (480); battles of Thermopylai and Salamis; sack of Athens; Carthaginians invade Sicily, defeated at Himera (480)	Athenian Treasury at Delphi (Fig. 75); latest archaic sculpture at Athens

Date	Political events	Cultural developments
470s	Greeks defeat the Persians at Plataia and Mykale, and Persians withdraw from Greece (479); Greek counteroffensive begins, and Athens founds Delian League (478); Themistokles (Fig. 37) ostracized from Athens (472)	Classical period begins. Simonides' Plataian elegy; temple of Aphaia at Aigina begun (Fig. 26); Athenians erect replacement Tyrannicides in the Agora (477; Fig. 34); Kimon builds Theseion at Athens, frescoed by Mikon; Pindar's *First Olympian Ode* (476); Aischylos's *Persians* wins dramatic contests (472); temple of Zeus at Olympia begun (ca. 470; Fig. 42); Hippodamos of Miletos replans Piraeus (Fig. 31); Polygnotos frescoes Lesche of the Knidians at Delphi; Pheidias's career begins
460s	Kimon defeats Persians at the battle of Eurymedon (467), and then helps Sparta crush the helot and Messenian revolt; Ephialtes and Perikles (Fig. 56) reform the Athenian Areiopagos (462); Kimon ostracized (461)	First dramatic victory by Sophokles (Fig. 164) over Aischylos (467); Anaxagoras arrives in Athens; Pheidias's Athena Promachos (?)
450s	Long Walls built from Athens to Piraeus (458) (Map 3); Spartans defeat Athenians at Tanagra and Athens conquers Boiotia (457); Athenian expedition to Egypt annihilated, and Delian League treasury moved to the Akropolis for safety (454); Perikles's Citizenship Law (451); Athens signs peace with Persia (450)	Aischylos's *Oresteia* wins first prize (458); temple of Zeus at Olympia (Fig. 42) completed; death of Aischylos (456); Euripides stages his first tragedy (455); Panainos, Polygnotos, and Mikon fresco the Painted Stoa in the Agora; Parmenides visits Athens

5. THE SECOND HALF OF THE FIFTH CENTURY AND THE FALL OF ATHENS

Date	Political events	Cultural developments
440s	Athenians lose Boiotia (447); Perikles crushes Euboian revolt; Athens signs Thirty Years Peace with Sparta (446); Perikles's annual election to the generalship begins (443); revolt of Samos (440)	Protagoras visits Athens; Perikles inaugurates Athenian building program (449); work begins on the Parthenon (Figs. 60, 69) and Telesterion at Eleusis (447); Pindar's last ode (446); Sophokles's *Antigone*; Polykleitos's *Doryphoros* (Fig. 71)
430s	Perikles crushes Samian revolt (439); revolt of Potidaia (432); Peloponnesian War begins, and the Spartan King Archidamos invades Attica (431); plague strikes Athens (430)	Parthenon (Fig. 60, 69) completed but for its pediments (438); Pheidias prosecuted for embezzlement, flees to Elis, and begins his Zeus at Olympia (438); Propylaia begun (438; Fig. 102); Anaxagoras prosecuted and exiled for impiety (437); Erechtheion (Fig. 111) begun (?); Parthenon pediments (Figs. 61-3)

Date	Political events	Cultural developments
		completed and work on Propylaia and possibly Erechtheion stopped (432); Perikles's Funeral Speech (431); Herodotos recites parts of his *Histories* at Athens; Sokrates (Fig. 132) begins teaching at Athens
420s	Annual Spartan invasions of Attica through 425; Perikles dies of the plague (429); Kleon captures 120 Spartiates at Sphakteria, and Athens triples the imperial tribute (425); Kleon and Brasidas killed in battle (422); Peace of Nikias (421); Alkibiades elected general (420)	Sophokles's *King Oedipus*; Euripides's *Hippolytos* (428); Gorgias visits Athens (427); temple of Athena Nike (Fig. 102) begun (426); Thucydides (Fig. 165) exiled from Athens (424), begins to research his history of the war; Aristophanes's *Clouds* (423) and *Peace* (421); cult of Asklepios introduced to Athens (420); Kresilas's Perikles (Fig. 56); marble gravestones (Fig. 100) resume at Athens; Paionios's Nike at Olympia (Fig. 106)
410s	Spartans defeat Alkibiades and his coalition at Mantineia (418); Athenians destroy Melos (416), invade Sicily, besiege Syracuse, and exile Alkibiades (415); Spartans declare war, occupy fort of Dekeleia (413); Sicilian expedition annihilated (413); short-lived oligarchic coup in Athens (411)	Temple of Apollo at Bassai; Euripides' *Trojan Women* (415) and *Iphigeneia Among the Taurians* (413); Aristophanes' *Birds* (414), *Lysistrata* (411), and *Frogs* (405)
400s	Recall of Alkibiades and his second exile (407); battles of Arginusai (406) and Aigospotamoi (405); siege and surrender of Athens, demolition of Long Walls (Map 3), and installation of the Thirty Tyrants (404); restoration of the Athenian democracy (403)	Erechtheion completed (406; Fig. 111); Sophokles dies (406); Euripides leaves Athens, dies in Macedonia (406); his *Bacchai* staged in Macedonia (405); Zeuxis frescoes the Macedonian King Archelaos's palace at Aigai; Lysander's Aigospotamoi monument (Fig. 122) and other dedications (403)

6. THE FIRST HALF OF THE FOURTH CENTURY AND THE RISE OF MACEDONIA

Date	Political events	Cultural developments
390s	Trial and execution of Sokrates for impiety (399); Greek cities ally against Sparta (396); battle of Corinth, and Persian fleet under Konon defeats Spartans off Knidos (394); Konon rebuilds Long Walls	Temple of Alea Athena at Tegea burns (395); Lysias's *Funeral Speech*, gravestone of Dexileos (Fig. 124), and Konon's honorary portrait in the Agora (394); Plato (Fig. 133) begins to write Socratic dialogues
380s	Sparta signs the King's Peace, hands Ionia back to the Persians (386)	Aristophanes's *Wealth* (388); Athenians canonize Aischylos, Sophokles, and

Date	Political events	Cultural developments
		Euripides; Plato founds the Academy (386) and writes the *Republic*
370s	Second Athenian Confederacy; war with Sparta resumes (378); Thebans defeat Spartans at Leuktra (371)	Kephisodotos's Eirene and Ploutos (371? Fig. 131); Praxiteles's career begins
360s	Theban hegemony; Thebans and Athenians defeat Sparta at Mantineia (362)	Lysippos's career begins; Arkadian dedication at Delphi; Tholos at Epidauros (Fig. 168) begun by Polykleitos the Younger
350s	Philip II (Fig. 147) king of Macedon (359); Athens at war with Philip, and Athenian Confederacy breaks up (357); Alexander the Great (Fig. 153) born (356); Phokians take Delphi, provoke Third Sacred War (355)	Praxiteles's Knidian Aphrodite (Fig. 140)? Demosthenes (Fig. 173) begins to attack Philip in the Athenian Assembly, often opposed by Aischines

7. THE SECOND HALF OF THE FOURTH CENTURY AND THE CONQUESTS OF ALEXANDER

Date	Political events	Cultural developments
340s	Philip wins Third Sacred War and signs peace with Athens (346)	Death of Plato (347); Silanion's portrait of Plato (Fig. 133); Aristotle tutors Alexander in Macedonia (343). Theater of Dionysos (Fig. 163) and theater at Epidauros (Fig. 167) begun, latter by Polykleitos the Younger; Skopas designs new temple of Alea Athena at Tegea (Fig. 137)
330s	Philip defeats Athens and Thebes at Chaironeia (338). Philip assassinated, succeeded by Alexander (336). Alexander destroys Thebes (335), invades Asia, and defeats Persians at the Granikos (334) and Issos (333; Fig. 158), conquers Egypt (332), visits Siwah, founds Alexandria (Fig. 161), defeats Persians at Gaugamela (331), and takes Babylon, Susa, and Persepolis, pursuing King Darius, whose followers murder him near the Caspian Sea (330)	Athenians canonize Aristophanes (339); earliest Alexander portraits by Lysippos (Fig. 155), Apelles, and Pyrgoteles; Lysippos's portrait of Sokrates (Fig. 166). Aristotle begins teaching in Athens, founds Lyceum (335). Lykourgos controls Athenian finances, completes Theater of Dionysos (Fig. 163), erects bronze portraits of Aischylos, Sophokles (Fig. 164), and Euripides. Demosthenes's *On the Crown* (330); Aischines flees into exile
320s	Alexander invades Baktria (329) and India (326), defeats King Porus on the Hydaspes (Fig. 171), and reaches the eastern branch of the Indus (326), where his army mutinies; he sails down the Indus, returns to Persia (324), and dies at Babylon (323). Abortive Greek rebellion; murder of Demosthenes (322)	Apelles's Alexander Thunderbolt-bearer at Ephesos (cf. Fig. 169); Lysippos's later Alexanders (Fig. 170); "Porus" medallions (326; Figs. 171–2); Hellenistic period begins. Death of Aristotle (322)

Date	Political events	Cultural developments
310s	Alexander's generals and successors fight for hegemony; Macedonians install Demetrios of Phaleron as tyrant of Athens (316)	Demetrios bans Athenian funerary extravagance, marble gravestones included (316)
300s	Wars of the Successors continue; Demetrios expelled from Athens and democracy temporarily reestablished (306)	

BIOGRAPHICAL SKETCHES

Note: All dates are B.C. Names in **bold** indicate persons discussed in the list.

Aischylos Athenian tragedian, ca. 525–456. Aischylos fought at Marathon (490) and probably also at Salamis (480). He staged his first tragedy in 499 and won his first victory in 484. Of his 70–90 plays, only seven survive: *The Persians* (472; funded by **Perikles**), *Seven Against Thebes* (467), *Suppliants, Prometheus Bound* (attribution disputed), and the *Oresteia* trilogy (458): *Agamemnon, The Libation-Bearers* or *Choephoroi,* and *The Furies* or *Eumenides* (see Chapter 2, box 2). At the end of his life he retired to Sicily.

Alexander III, "the Great" Macedonian king, 356–23 (reigned 336–23). See Figs. 153, 155, 156, 158, 159, 162, 169–72. Son of King **Philip II** of Macedonia, and educated by **Aristotle**, Alexander fought at Chaironeia (338) and gained the throne upon his father's murder in 336. In 334 he invaded the Persian Empire (see Map 4), defeating the western satraps on the river Granikos (334) and King Darius on the river Issos (333); after taking Egypt (332), he founded Alexandria and visited Ammon's oracle at Siwah. After defeating Darius again at Gaugamela (331), he pursued him to the Caspian Sea, where a courtier murdered him. In 329–7 he conquered Baktria (Afghanistan) and in 326 invaded India, defeating King Porus on the River Hydaspes (Indus); his army then mutinied and he returned to Babylon via the Indus and the Gedrosian Desert (325). Still planning further conquests, he died in 323, leaving his empire "to the strongest."

Alkibiades Athenian politician, 451–04. Brought up by **Perikles**, and elected general in 420, Alkibiades led an anti-Spartan coalition to defeat at Mantineia (418). The architect of the Athenian invasion of Sicily (415), he was recalled to face trial for sacrilege, but fled to Sparta (414), where he advised the Spartans on how to defeat Athens. Leaving Sparta under a cloud, he intrigued unsuccessfully with the Persians. After the oligarchic coup at Athens (411), he was elected general by the Athenian fleet, which he led to victory at Kyzikos (410). Returning to Athens in 407, he fled to Thrace after **Lysander** defeated a subordinate of his at Notion (406); in 405, his warning to the Athenian fleet at Aigospotamoi fell on deaf ears. Taking refuge with the Persians, he was murdered at the behest of the Thirty Tyrants and **Lysander**.

Anaxagoras Philosopher from Klazomenai in Asia Minor, ca. 500–428. Anaxagoras settled in Athens around 455, where he became a friend of **Perikles** and wrote his one book, *On*

the Kosmos. Exiled in 437 for impiety, he retired to Lampsakos, where he died a decade later.

Apelles Painter from Kolophon in Ionia, active ca. 350–290. Apelles worked for **Philip II** of Macedonia and then for **Alexander the Great**, whose favorite painter he became; his works included an **Alexander** Thunderbolt-Bearer at Ephesos (see Fig. 169), an **Alexander** in Battle, and **Alexander** with the Dioskouroi, Nike, Triumph, War, and Fury at Alexandria. He perhaps painted the last of these for Ptolemy I Soter of Egypt (reigned 323–283), at whose court he also painted his famous Calumny. His Aphrodite Anadyomene, rising from the sea and wringing out her hair, became as famous as **Praxiteles**' Knidian Aphrodite (Fig. 140), partly because, according to one tradition, the great hetaira **Phryne** inspired it.

Aristophanes Athenian comic poet, ca. 455–386. Universally rated the greatest fifth-century Athenian comic poet, Aristophanes staged his first comedy in 427; his extant plays are *Acharnians* (425), *Knights* (424), *Clouds* (423; revised in 416), *Wasps* (422), *Peace* (421), *Birds* (414), *Lysistrata* and *Women at the Thesmophoria* (411), *Frogs* (405), *Women in the Assembly* (392), and *Wealth* (388).

Aristotle Philosopher from Stageira in Thrace, 384–22. Aristotle entered **Plato**'s Academy in 367, remaining until the latter's death in 347; he then settled in Assos and in Mitylene on Lesbos, researching biology, until asked by **Philip II** of Macedonia to tutor **Alexander** (343). In 335, he returned to Athens and founded the Lyceum, but anti-Macedonian feeling forced him out in 323; he died in Chalkis a year later. Of his voluminous writings, only texts assembled by his pupils from lecture notes and research projects survive, including the *Metaphysics, Nicomachean Ethics, Physiognomics, History of Animals, Rhetoric, Poetics, Politics*, and *Constitution of Athens*.

Croesus Last king of Lydia, reigned ca. 560–46. After subduing the Greek cities of Ionia, Croesus made Lydia (in Western Asia Minor) briefly the chief power in the eastern Mediterranean. A pious and fabulously wealthy philhellene, he made lavish dedications at Greek sanctuaries, including Delphi, Delos, and Ephesos. Attempting to check the rising power of King Cyrus of Persia, he was defeated and his capital, Sardis, was sacked (546). Accounts of his end differ: either he was killed in the fall of Sardis; or he was burnt to death on a pyre; or he survived to become Cyrus's chief adviser.

Demosthenes Athenian orator and politician, 384–22. Fig. 173. Entering politics in 355, Demosthenes soon recognized the Macedonian threat and devoted himself to countering it. Unable to check **Philip II**, he fought at Chaironeia (338) and narrowly escaped being handed over to **Alexander** in 335. In 330, his great rival Aischines unsuccessfully sought to deprive him of the crown awarded him for his services to the state. Prosecuted in 323 for taking bribes from **Alexander**'s renegade treasurer Harpalos, he went into exile, but was recalled after **Alexander**'s death to help lead the ensuing revolt. When it failed, he fled again, and committed suicide as Macedonian agents closed in. His surviving works include the *Philippics* (351, 344, 341), the *Olynthiacs* (349), the *Funeral Oration* (338), *On the Crown* (330), numerous other speeches (both political and legal), and some letters.

Euripides Athenian tragedian, ca. 485–06. Euripides staged his first tragedy in 455, winning third prize; his first outright victory came only in 441. Of some ninety plays, nineteen survive, including *Medea* (431), *Hippolytos* (428), *Trojan Women* (415), *Herakles, Iphigeneia Among the Taurians*, and *Orestes* (408), *Iphigeneia at Aulis* (406), and *Bacchae* (406). In 406 he retired to the court of King Archelaos I of Macedonia, where his *Bacchae* was performed posthumously. A controversial figure, famously parodied by **Aristophanes** in the *Frogs* (405), he won only four victories at the Dionysia, against 13 by **Aischylos** and 18 by **Sophokles**.

Gorgias Virtuoso rhetorician and sophist from Leontinoi in Sicily, ca. 485–380. Gorgias's visit to Athens in 427 introduced sophistic rhetoric to the city; he is parodied in **Plato**'s *Symposion* and critiqued in his *Gorgias*. His extant works include an *Encomium of Helen*, a *Defense of Palamedes*, and part of a *Funeral Oration*.

Herodotos Historian from Halikarnassos in Asia Minor, ca. 484–20. Widely traveled in Greece, Asia, and Egypt, and often regarded as the "Father of History," Herodotos recited parts of his *Histories* (a wide-ranging account of East–West relations focused on the Persian Wars) in Athens, possibly in the 440s and 430s. The *Histories*, in nine books, survive intact.

Hippodamos Town planner and theorist from Miletos, active ca. 480–40. Hired to replan Piraeus probably in the 470s (Fig. 31), Hippodamos perhaps was also responsible also for planning Miletos (destroyed in 494) and **Perikles**'s colony at Thurioi in Italy (443); a tradition that he also planned Rhodes (408) is not credible on chronological grounds. **Aristotle** summarizes and critiques his book on the ideal city, now lost, in his *Politics* (see Chapter 2, Box 1).

Iktinos Athenian architect, active ca. 450–10. Selected in 449 to design the Parthenon (Fig. 60) together with Kallikrates and Karpion, Iktinos wrote a book on the temple, now lost. He also worked on the Telesterion at Eleusis and, after 426, designed the temple of Apollo Epikourios at Bassai in Arkadia (Figs. 114–15).

Kimon Athenian politician and general, ca. 510–451. The son of Miltiades, the victor of Marathon (490), Kimon fought with distinction at Salamis (480). In 478 he was one of the architects of the Delian League; commanded its operations in the northern Aegean in the following years; and defeated **Themistokles** in an ostracism (472). In 467, he destroyed the Persian fleet at Eurymedon in Asia Minor and used the spoils to rebuild the south wall of the Akropolis (Fig. 59). In 462, he led a force to aid the Spartans against the Messenians, but soon was asked to leave, and in 461 was ostracized. In 451, he returned, arranged a five-year truce with Sparta, and then left to fight the Persians on Cyprus, where he died.

Lysander Spartan admiral and general, ca. 440–395. Appointed to command the Spartan fleet in 408, Lysander gained the support of the Persian prince Cyrus and defeated the Athenian fleet at Notion (406), a victory that led to **Alkibiades**'s exile from Athens. In 405 he destroyed the Athenian fleet at Aigospotamoi, for which he received divine honors from the Samians – an ominous precedent. After dissolving the Athenian empire, he forced Athens to surrender (404) and installed an oligarchy there: the infamous Thirty Tyrants. Briefly the most powerful man in the Aegean, he strove to increase Sparta's power in Asia Minor and Greece but was killed invading Boiotia in 395.

Lysippos Sculptor from Sikyon in the Peloponnese, ca. 390–10. A virtuoso bronzeworker famed for his skill and prodigious output (see box, Chapter 7), Lysippos specialized in athletes (compare Fig. 154), heroes, divinities, and portraits (Fig. 166), eventually becoming **Alexander**'s favorite sculptor (compare Figs. 155, 156, 170). Apparently he wrote no treatise, but his three sons and numerous pupils continued his work (Fig. 154), dominating Peloponnesian sculpture for two generations and securing important commissions at the courts of **Alexander**'s successors.

Mikon Athenian painter, active ca. 475–50. Apparently a protégé of **Kimon**, Mikon dominated Athenian painting after the Persian Wars. Among his most famous works were his Theseus cycle in **Kimon**'s Theseion at Athens (after 476) and his Amazonomachy and Battle of Marathon in the Painted Stoa (Stoa Poikile) at Athens, funded by **Kimon**'s brother-in-law Peisianax, and painted in collaboration with **Polygnotos**.

Parmenides Philosopher from Elea in Italy, ca. 510–440. **Plato** used Parmenides's visit to Athens in his sixty-fifth year as the basis for his *Parmenides*, and also discussed his

philosophy in the *Sophist*. Large parts of his philosophical poem on the Way of Truth survive; it was highly influential, especially upon his pupil Zeno.

Parrhasios Painter from Ephesos in Asia Minor, active ca. 430–390. Famed for his subtlety of line, and a rival and competitor of **Zeuxis**, Parrhasios wrote a treatise on painting, now lost; he appears as the prototypical painter in **Xenophon**'s *Memorabilia of Sokrates*. His works included a "rose-fed" Theseus and other heroes, and an unflattering image of Demos; he also designed the embellishment of the shield of **Pheidias**'s Athena Promachos.

Perikles Athenian politician and general, ca. 495–29. Fig. 56. Too young to fight in the Persian Wars, Perikles first achieved prominence by sponsoring **Aischylos**'s *Persians* in 472. After prosecuting **Kimon** in 462, he and Ephialtes carried a drastic reform of the Areiopagos council, the final step in the consolidation of Athenian democracy. Soon he dominated Athenian politics; his law limiting Athenian citizenship was passed in 451, and his building program in 449. In 446, he crushed the revolt of Euboia, and from 443, after the ostracism of his last major opponent, he held the generalship uninterruptedly till 430, when resentment at his conduct of the Peloponnesian War briefly forced him from power. In 438, a charge of embezzlement failed, but did succeed in ensnaring his friend **Pheidias**. He died of the plague in 429. None of his speeches survives, though **Thucydides** purports to give versions of three of them in his history.

Pheidias Athenian sculptor, ca. 495–25. Best known for his gold and ivory colossi of Athena Parthenos (Fig. 69) and Olympian Zeus, Pheidias was recognized throughout antiquity as Greece's greatest sculptor and foremost interpreter of the divine. According to Plutarch, he also oversaw **Perikles**'s building program, the Parthenon sculptures (Figs. 54, 55, 60–68, 78) presumably included. Exiled for embezzlement in 438, he spent his last years in Olympia, making the Zeus.

Philip II Macedonian king, 382–36. Fig. 147. Gaining the throne in 359, after northern barbarians had killed his predecessor and many of his troops, Philip reformed the Macedonian army, strengthened his kingdom, and soon began to expand west and south. Despite **Demosthenes**'s efforts to stop him, by 346 he dominated the whole of northern Greece; in 338 he decisively defeated the Athenians and Thebans at Chaironeia in Boiotia, becoming master de facto of mainland Greece. In 337, a conference at Corinth anointed him to lead a crusade against Persia, but the expedition had barely begun when in 336 a disaffected aristocrat assassinated him.

Phryne Courtesan (hetaira) from Thespiai in Boiotia, ca. 380–10. Best known as **Praxiteles**'s mistress and the model for his Aphrodite of Knidos (Fig. 140), Phryne also supposedly inspired **Apelles**'s Aphrodite Anadyomene, and reportedly offered to rebuild the walls of Thebes after **Alexander** destroyed them in 335. **Praxiteles** made portraits of her in all three major media (marble, bronze, and gold), the third of which she dedicated at Delphi.

Pindar Lyric poet from Boiotia, ca. 518–438. Pindar's extraordinary talent was recognized early, when at age 20 the Thessalian ruling family asked him to celebrate an athletic victory (*Pythian Ode* 10); thereafter commissions for victory odes, hymns, dirges, and other occasional pieces poured in from all over the Greek world. Of this huge output, only his four books of odes for victors at the great "crown" festivals (Olympian, Pythian, Isthmian, and Nemean) have survived intact.

Plato Athenian philosopher, ca. 429–347. Fig. 133. A pupil and devotee of **Sokrates**, Plato turned to writing Socratic dialogues after the latter's execution in 399. In 386, he founded the Academy (see Map 2), outside Athens, to educate future politicians and others in philosophy, and traveled twice to Syracuse to school the city's tyrants, but without success. His many extant works include the *Apology* (**Sokrates**'s speeches in his own defense), *Protagoras, Crito, Gorgias, Meno, Phaedo, Republic, Symposion, Parmenides,*

Timaeus, Sophist, Laws, and a number of letters, not all genuine. His best and most famous pupil was **Aristotle**.

Polygnotos Painter from Thasos in the northern Aegean, active ca. 475–50. Polygnotos's most important works were the huge panoramas of Troy Taken and the Underworld in the Lesche (clubhouse) of the Knidians in Delphi, and (with **Mikon** and at his own expense) the paintings in the Painted Stoa (Stoa Poikile) at Athens, for which he received Athenian citizenship. His relationship with **Kimon**'s sister Elpinike was notorious.

Polykleitos Sculptor from Argos, active ca. 450–10. A specialist in bronze, Polykleitos was most renowned for his Doryphoros (Spearbearer: Figs. 71–2) and for his Diadoumenos (athlete binding a victory fillet round his head), but also produced other bronzes of heroes and athletes (compare, e.g., Fig. 84, probably the boy-boxer Kyniskos). His book *The Canon* (Rule) inspired three generations of pupils, who followed his precepts "like a law" (Pliny) and dominated Peloponnesian sculpture until the appearance of **Lysippos**.

Praxiteles Athenian sculptor, ca. 390–26. A pupil and (presumably) son of Kephisodotos (see Fig. 131), and best known for his work in marble, Praxiteles specialized in marble statues of the younger gods, especially Aphrodite (Fig. 140), Dionysos (Fig. 141), and their entourages, and in bronze portraits, mostly of women. His most famous work was his naked Aphrodite of Knidos (Fig. 140), supposedly based on his mistress **Phryne**; after his death his sons inherited his clientele and continued his work.

Protagoras Sophist from Abdera in Thrace, ca. 490–20. Widely traveled, a brilliant lecturer, and generally regarded as the greatest of the sophists, Protagoras visited Athens several times, where **Perikles** invited him to write a constitution for his colony at Thurioi (443). According to one tradition, the Athenians later condemned him for impiety but (unlike **Sokrates**) he fled the city. **Plato** attacked his relativism in the *Theaetetus*, and in the *Protagoras* he holds **Sokrates** more or less to a draw.

Pythagoras Thinker and cult leader from Samos, ca. 550–500. Pythagoras migrated to Kroton in Italy around 520 (perhaps to escape the Persian occupation of Samos), where he founded a sect that remained politically and philosophically influential in Italy through the late fourth century. A sage and shaman, he supposedly discovered the concordant (perfect) intervals of the musical scale (Fig. 23) and built a philosophy and cosmology around them.

Skopas Sculptor and architect from Paros, active ca. 370–30. A specialist in marble and in statues of the younger gods, Skopas worked on the colossal tomb of King Maussolos of Halikarnassos (died 353) – the original Mausoleum – and designed the temple of Alea Athena at Tegea (Fig. 137), whose pedimental sculptures (Fig. 136) are often attributed to him also.

Sokrates Athenian philosopher, 469–399. Figs. 132, 166. Supposedly trained as a sculptor, Sokrates began teaching only in the 430s; in the 420s he served courageously as a hoplite in the Athenian army, and just as courageously stood up to both the dēmos (406) and the Thirty Tyrants (404) when his conscience demanded it. In 399 the Athenians condemned him to death in part for elevating this "inner voice" above the city's gods, though his inquisitional tactics in the Agora and the fact that Kritias and other pupils of his had been members of the Thirty probably were equally to blame. He wrote nothing, and how far his views can be extracted from the dialogues of his greatest pupil, **Plato**, has been endlessly debated.

Sophokles Athenian tragedian, ca. 495–06. Fig. 164. After defeating **Aischylos** at his debut in the dramatic competitions of 468, Sophokles gained seventeen more victories in the Dionysia, producing over 120 plays, of which only 7 survive: *Ajax, Antigone, King Oedipus, Elektra, Women of Trachis, Philoktetes* (409), and *Oedipus at Kolonos* (staged posthumously in 401). He was also active in Athenian public life: a treasurer of Athena in 443; a general alongside **Perikles** at the revolt of Samos in 441; the host of Asklepios's

sacred snake in 420 (which earned him the posthumous cult title of Dexion, "The Receiver"); and a member of the emergency committee of advisers appointed after the destruction of the Sicilian expedition in 413.

Themistokles Athenian politician and general, ca. 524–459. Fig. 37. In 493, as *archōn* or chief magistrate, Themistokles began the development of Piraeus as Athens's port, and in 483 carried the motion to use a rich silver find at Laurion to build a fleet – but allegedly for use against Aigina, not Persia. In 480 he commanded the Athenian forces against the invading Persians and was instrumental in engineering the evacuation of the city; at Salamis his feigned retreat was largely responsible for the Greek victory. After the Athenians' return to the city in 479 his guile bought them enough time to rebuild their walls in the face of Spartan opposition. At the 476 Olympics he was lauded by the assembled spectators. During these years he came increasingly into conflict with **Kimon**, who defeated him in an ostracism in 472. He spent the rest of his life in exile, ending up as Persian governor of Magnesia on the Meander.

Thucydides Athenian general and historian, ca. 460–395. Fig. 165. Elected general in 424, Thucydides failed to save the city of Amphipolis in Thrace from the Spartan Brasidas and was exiled from Athens, returning only in 404 when the war was over. His authoritative history of it, in eight books, was unfinished at his death, stopping abruptly in late 411; **Xenophon** and others later completed and expanded it.

Xenophon Athenian mercenary general and historian, ca. 430–360. An upper-class Athenian cavalryman and Spartan sympathizer, Xenophon associated with **Sokrates**, probably fought in the later stages of the Peloponnesian War, and served the Thirty Tyrants (404–3). In 401 he enlisted as a mercenary with Cyrus, pretender to the Persian throne, and when the latter was killed near Babylon and his generals executed, he led the surviving 10,000 Greek mercenaries back to the Aegean. In the 390s, he served in the Spartan army (which earned him exile from Athens) and then retired to an estate near Olympia and finally to Corinth. His surviving works include the *Anabasis* (*March of the Ten Thousand*), *Hellenica* (a continuation of **Thucydides**'s history), *Defense Speech* (*Apology*) and *Memorabilia of Sokrates, On Household Management* (*Oeconomicus*), *Education of Cyrus, Spartan Constitution*, and books on horsemanship and hunting.

Zeuxis Painter from Herakleia in Italy, active ca. 430–390. Famed for his naturalistic use of shading, and a rival and competitor of **Parrhasios**, Zeuxis visited Athens around 430, and decorated the palace of Archelaos I of Macedonia between 413 and 399. Notoriously, he composed his Helen by asking the most beautiful girls of Kroton to strip and combining their best features (see Fig. 9).

REFERENCES

Preliminary note: Although a few of the Greek and Latin texts referenced here have not been translated into English, most of them are conveniently available in the dual-text volumes (Greek-English; Latin-English) of the Loeb Classical Library, published by Harvard University Press, Cambridge, Massachusetts. When this is the case, I have *asterisked the citation. Many important ancient literary sources on Greek art and architecture are translated in Pollitt's *Art of Ancient Greece: Sources and Documents*. In these cases, I have noted his page number(s) in parentheses after the citation.

INTRODUCTION

"Possession for ever": *Thucydides, *The Peloponnesian War* 1.22.

Definitions of and explanations for the classical: Jas Elsner, in James Porter (ed.), *Classical Pasts* 271 (see also Porter's introduction to this volume); Whitley, *Archaeology of Ancient Greece* 269–70; H. W. Janson and Antony F. Janson, *A History of Art* (sixth edition, Upper Saddle River 2004) 106; Pollitt, *Art and Experience in Classical Greece* 1–14; B. S. Ridgway, *Fifth-Century Styles in Greek Sculpture* (Princeton 1981) 3–14; C. H. Hallett, "The Origins of the Classical Style in Sculpture," *Journal of Hellenic Studies* 106 (1986): 71–84; Jeremy Tanner, *The Invention of Art History in Ancient Greece* (Cambridge 2006): Chs. 1, 2.

Plato on measure and commensurability: *Philebos* 64E; Perikles on the Athena Parthenos's gold: *Thucydides 2.13.5.

Maidens of Kroton: *Pliny, *Natural History* 35.64; *Cicero, *de Inventione* 2.1.1 (Pollitt, *Art of Ancient Greece* 150–51). Zeuxis's contemporaries Gorgias and Xenophon both allude to the stunt: *Encomium of Helen* 18; *Memorabilia of Sokrates* 3.10.2.

Art transcending life: Alkidamas, *On the Sophists* 27; *Isokrates, *Evagoras* (9) 75; *Theophrastos, *Characters* 3.12. Live models: *Xenophon, *Memorabilia of Sokrates* 3.11 (the courtesan Theodote models for a painter); *Athenaios, *Deipnosophistai* 13.590 (Phryne, Praxiteles, and Apelles); cf. *Pliny, *Natural History* 35.87 (Pankaspe and Apelles)(Pollitt, *Art of Ancient Greece* 158–63).

Comic and tragic plots: Antiphanes fragment 191 ed. and tr. J. M. Edmonds, slightly adapted, as quoted by *Athenaios 6.222a.

Progress in *technē*: *Thucydides 1.71.3; *Inscriptiones Graecae* 1^3.766.

CHAPTER 1

"Frogs around a pond": *Plato, *Phaedo* 109B.

Agamemnon and Briseis: *Homer, *Iliad* 1.244. Phokylides on the polis and Nineveh: *fragment 4 ed. Douglas Gerber, tr. Nicholas Cahill. Kroisos: *Inscriptiones Graecae* 1³.1240. *Mimnermos: fragment 2, ed. Gerber, tr. Richmond Lattimore. Cultural bonds: *Herodotos 8.144. *Archilochos: fragments 19 and 114, ed. Gerber. *Phokylides: fragment 12, ed. Gerber. Dress: *Thucydides 1.6.

Elite and middling: Ian Morris, "The Strong Principle of Equality and the Archaic Origins of Greek Democracy," in Josiah Ober and Charles Hedrick (eds.), *Demokratia: A Conversation on Democracies, Ancient and Modern* (Princeton 1996): 19–48.

Spartans and helots: *Xenophon, *Hellenica* 3.3.6. Sparta and Athens as interdependent antitypes: *Thucydides 1.10, with Marshall Sahlins, *Apologies to Thucydides: Understanding History as Culture and Vice Versa* (Chicago 2004). Kōthōn: Kritias, *Spartan Constitution* fragment 34, as quoted by *Athenaios 11.483B.

Foreshortening: *Pliny, *Natural History* 35.56 (Pollitt, *Art of Ancient Greece* 125). "Reality effect": Roland Barthes, *The Rustle of Language* (tr. R. Howard, New York 1986): 141–54.

Sappho and Alkaios: *Aristotle, *Rhetoric* 1.17, 1367a. Role portraits: J. J. Pollitt, *Art in the Hellenistic Age* (Cambridge 1986): 59.

Early theaters and performances: Unfortunately, at present (2007) the evidence is published only in German: see the superbly illustrated exhibition catalog edited by Suzanne Moraw and Eckehardt Nölle, *Die Geburt des Theaters in der griechischen Antike* (Mainz 2002). On gestures, see Alan Boegehold, *When a Gesture Was Expected. A Selection of Examples from Classical Greek Literature* (Princeton 1999).

Pindar on Zeus: *Isthmian Ode* 5.53; *Pythian Ode* 2.49–52 (tr. C. M. Bowra). Plato on measure: *Philebos* 64E. Alkmaion: frag. 4, ed. Herman Diels. Pythagoras the sculptor: *Diogenes Laertius, *Lives of the Philosophers* 8.47 (Pollitt, *Art of Ancient Greece* 43–6). Theognis and Aischylos on Zeus: *Theognis 373–80, tr. Gerber; *Agamemnon* 174–83, tr. Philip Vellacott.

Xerxes' proclamation: James G. Pritchard (ed.), *Ancient Near Eastern Texts Relating to the Old Testament* (Princeton 1969), p. 316 no. 4. Phrynichos: *Herodotos 6.18–22.

Phylakidas: *Pindar, *Isthmian Ode* 5.34–53, tr. C. M. Bowra. Veins, etc.: Guy Métraux, *Sculptors and Physicians in Fifth-Century Greece* (Montreal 1995). The Aigina temple: This discussion is based on unpublished work by two German scholars, Norbert Eschbach and Raimund Wünsche, and upon my own series of articles entitled "The Persian Invasions of Greece and the Beginning of the Classical Style: An Archaeological Study," forthcoming in the *American Journal of Archaeology* 112 (2008). Suffering, victor, and vanquished: *Aristotle, *Poetics* 11, 1452b11; *Lysias 2.24.

Atossa, etc.: *Aischylos, *Persians* 159–68, 753–60, 816–31, tr. Philip Vellacott.

CHAPTER 2

For Simonides' Plataian elegy see Deborah Boedeker and David Sider, *The New Simonides: Contexts of Praise and Desire* (Oxford 2001), with text and translation; Lawrence M. Kowerski, *Simonides on the Persian Wars: A Study of the Elegiac Verses of the "New Simonides"* (New York 2005).

Hippodamos of Miletos: *Aristotle, *Politics* 2.5.1–2 (1267b22). Piraeus: *Aristophanes, *Knights* 813–15; cf. *Plutarch, *Themistokles* 19 (with a jab at Aristophanes).

Freedom: Kurt Raaflaub, *The Discovery of Freedom in Ancient Greece* (Chicago 2004). Funeral speeches: Nicole Loraux, *The Invention of Athens*; and Athenian "myths of identity": Hornblower, *The Greek World* 127–30. Plataian Oath: *Diodoros 11.29.3. Tyrannicides: *Athenaios 15.695 (songs); *Thucydides 6.54 (Aristogeiton's alleged "middling" status); *Lucian, *Teacher of Rhetoric* 9 (style); *Plato, *Symposion* 182A (Pollitt, *Art of Ancient Greece* 43). Athletics and eros: *Theognis 1335–6.

Character and tragedy: *Aristotle, *Art of Poetry* 6, 1450a14–23. Perikles: *Thucydides 2.40. Themistokles' portrait: *Plutarch, *Themistokles* 22.

The Theseion, Amazons, etc.: *Pausanias 1.17 (Pollitt, *Art of Ancient Greece* 142–3); *Aischylos, *Persians* 824–8; *Eumenides* 685–90 (tr. Robert Fagles); cf. David Castriota, *Myth, Ethos, and Actuality: Official Art in Fifth-Century* B.C. *Athens* (Madison, WI 1992); Barringer and Hurwit (eds.), *Periklean Athens and Its Legacy* 63–102.

Kimon's expulsion by the Spartans: *Thucydides 1.102; cf. *Plutarch, *Kimon* 17. Olympia: *Pausanias 5.10 and 13 (Pelops), with *Pindar, *Olympian Ode* 1. Plato on measure: *Philebos* 64E. Spartan brides-to-be: *Plutarch, *Lykourgos* 15.3. Heraia: *Pausanias 5.16. On Herakles' bow and club, see Beth Cohen, "From Bowman to Clubman: Herakles and Olympia," *Art Bulletin* 76 (1994): 695–715.

Meno's question: *Plato, *Meno* 70A. Teaching *aretē*: *Pindar, *Olympian Odes* 9.100; 10.20; Herakleitos, in Stobaeus 4.40.23 (= Herakleitos frag. 119, ed. Herman Diels).

Underworld and *Marathon*: *Pausanias 10.31.5–8, 1.15.4 (Pollitt, *Art of Ancient Greece* 127–40). Simonides: see notes to the beginning of this chapter. Eion epigrams: *Aischines 3.183.

Aischylos's epitaph: *Elegy and Iambus* ed. and tr. J. M. Edmonds, 420 no. 4.

CHAPTER 3

Imports and wealth: Hermippos frag. 63, tr. C. M. Edmonds; Thucydides 2.38. Perikles Funeral Speech: *Thucydides 2.34–46; and the plague, id. 2.47. Sophokles's "Ode to Man": *Antigone* 331–75, tr. E. F. Watling. Anaxagoras's book: *Plato, *Apology of Sokrates* 26D. Aristophanes on Sokrates: *Clouds* 98–104, 355–61.

Perikles's citizenship law: *Aristotle, *Constitution of Athens* 26.4; *Plutarch, *Perikles* 33; etc.; and Athenian autochthony, Loraux, *Children of Athena*. Parthenon frieze: See especially Jenifer Neils, *The Parthenon Frieze* (Cambridge 2001), with Barringer and Hurwit (eds.), *Periklean Athens and Its Legacy* 147–62 on the cavalry reform; my remarks on the frieze and the Athenian project of Athenian self-ennoblement are indebted to an unpublished paper by Richard Neer. Promise of immortality: *Plutarch, *Perikles* 18.

Perikles and his character: *Thucydides 2.65, tr. Rex Warner; *Plutarch, *Perikles* 5; cf. Pollitt, *Art of Ancient Greece* 69.

Antigone: see *Demosthenes 19.247; *Aristotle, *Rhetoric* 1.13–15, with, e.g., Jean Anouilh, *Antigone* (1942); Bertold Brecht, *Antigone* (1948); Judith Malina, *Antigone* (1967); Miro Gavran, *Creon's Antigone* (1990); Mac Wellman, *Antigone* (2001); Seamus Heaney, *The Burial at Thebes* (2004).

Athenian good taste and courage: *Thucydides 2.38 and 40, tr. Rex Warner.

The Periklean Akropolis: See now the definitive guide by Jeffrey Hurwit, *The Akropolis in the Age of Perikles* (Cambridge 2004); and in particular, Neils (ed.), *The Parthenon*, especially Barbara Barletta's doubts that the frieze was an afterthought and Lothar Haselberger's discussion of the temple's "refinements" (though attributing the decisive step along "the way of seeming" to Mnesikles and his Propylaia, built immediately after the Parthenon: see Figs. 59, 102). Deviations ("additions and subtractions"): *Vitruvius 3.3.11 and 13,

5.7.7, 6.2.4, with 3.4.5 on sagging horizontals. Athens vs. Sparta: *Thucydides 1.10, tr. Rex Warner.

Plato on measure: *Philebos* 64E.

Athenian pride: *Thucydides 2.41. Athena and Athens: *Solon frag. 2, tr. Gilbert Highet; *Aischylos, *Eumenides* 996–1002, tr. Richmond Lattimore.

"Sight of the unseen": Sextus Empiricus, *Adversus Mathematicos* 7.140. "Prudence under stress": *Aischylos, *Eumenides* 520. Loving Athens and the *dēmos:* *Thucydides 2.43; *Aristophanes, *Knights* 732–40ff; *Plato, *Alkibiades* I, 132A; *Gorgias* 481D–E.

Pausanias and the Parthenon: *Pausanias 1.24.5–7. Quintilian and Pheidias: *Institutio Oratoria* 12.10.10 (Pollitt, *Art of Ancient Greece* 222–3). The building's later history and the "Elgin Marbles" controversy: Mary Beard, *The Parthenon*; William St. Clair, *Lord Elgin and the Marbles* (rev. ed., London 1998); Dorothy King, *The Elgin Marbles. The Story of the Parthenon and Archaeology's Greatest Controversy* (London 2006).

New restoration of the Doryphoros: Currently published only in Italian: Vincenzo Franciosi, *Il "Doriforo" di Policleto* (Naples 2003).

The Canon: *Pliny, *Natural History* 34.55; *Lucian, *de Saltatione* 75; Philo Mechanicus, *Belopoeica* 4.1, p. 49, 20; Galen, *de Temperamentis* 1.9; *de Placitis Hippocratis et Platonis* 5; etc. (Pollitt, *Art of Ancient Greece* 75–9). Sokrates and the bookworm: *Xenophon, *Memorabilia* 4.2.1–10ff. Thales: *Diogenes Laertius 1.33.

CHAPTER 4

Eponymous Heroes and mobilization: *Aristophanes, *Peace* 1183.

Theseus and Athens: *Euripides, *Suppliants* 349–53; cf. Henry J. Walker, *Theseus and Athens* (New York and Oxford 1995); Sophie Mills, *Theseus, Tragedy, and the Athenian Empire* (Oxford 1997).

Parrhasios: *Pliny, *Natural History* 35.69 (Pollitt, *Art of Ancient Greece* 154).

Tomb of Kritias: Scholiast to Aischines 1.39, no. 82 ed. Mervin Dilts.

Scrutiny: *Aristotle, *Constitution of Athens* 55.3.

Family memorials, etc.: see especially Christoph W. Clairmont, *Classical Attic Tombstones* (8 vols., Kilchberg 1993–5), cataloging them by the number of figures (singletons in vol. 1, pairs in vol. 2, etc.); Garland, *The Greek Way of Death*; Ian Morris, *Death-Ritual and Social Structure in Classical Antiquity* (Cambridge 1992): chs. 4–6; Thomas W. Gallant, *Risk and Survival in Ancient Greece* (Stanford 1991). For a fuller discussion of Hegeso see Stewart, *Art, Desire, and the Body* 124–9.

Koroibos family inscriptions: *Inscriptiones Graecae* ii^3.1079, 6008, 6859.

Family reunited in death: *Aischylos, *Agamemnon* 1555; *Sophokles, *Antigone* 897–9, tr. E. F. Watling.

Men in Greek art: see, e.g., Bérard (ed.), *City of Images*; Stewart, *Art, Desire, and the Body*; and the synopses in Boardman's *Athenian Red Figure Vases* and *Greek Sculpture* (both).

Victor and vanquished: *Lysias 2.24.

Kudos: *Pindar, *Olympian Odes* 4.8–12 (tr. C. M. Bowra) and 5.7–8; cf. Leslie Kurke, "The Economy of Kudos," in Carol Dougherty and Leslie Kurke (eds.), *Cultural Poetics in Archaic Greece* (Cambridge 1993): 131–63; also R. R. R. Smith, "Pindar, Athletes, and the Early Greek Statue Habit," in Hornblower and Morgan, *Pindar's Poetry, Patrons, and Friends* 83–139.

The symposion and its art: François Lissarrague, *The Aesthetics of the Greek Banquet* (Princeton 1990); for the erotica, see Martin F. Kilmer, *Greek Erotica* (London 1993); Boardman, *Athenian Red-Figure Vases: The Classical Period* figs. 182, 224, etc.

Socratic symposia: *Plato, *Symposium*; *Xenophon, *Symposium*; the quotation is from ch. 9.7.

Women in Greek art: see, e.g., Eva Keuls, *The Reign of the Phallus: Sexual Politics in Ancient Athens* (New York 1985) (feminist); Sian Lewis, *The Athenian Woman: An Iconographic Handbook* (London 2002) (sociological-biographical); Bérard (ed.), *A City of Images* (representational subsystem); and Stewart, *Art, Desire, and the Body* (gendered viewer/consumer). Susan I. Rotroff and Robert D. Lamberton, *Women in the Athenian Agora* (Princeton 2006), evaluate some of the archaeological evidence.

Women and the *gymnasion*: *Plato, *Republic* 5, 452a–b.

The Muses (and Apollo): Boardman, *Athenian Red Figure Vases* figs. 23, 144, 206, 262; Boardman et al. (eds.), *Lexicon Iconographicum Mythologiae Classicae*, s.v. Mousai/Musae.

Building Z and brothels: See Ursula Knigge, *The Athenian Kerameikos: History, Monuments, Excavations* (Athens 1991): 88–95, Figs. 79–86; Davidson, *Courtesans and Fishcakes* 72 (plan and reconstruction), 83–91; Alexis frag. 203, Xenarchos frag. 4, and Philemon frag. 4 ed. J. M. Edmonds, as quoted in *Athenaios 6, 258b and 13, 568f–569b. Hetairai and pornai: See Leslie Kurke, *Coins, Bodies, Games, and Gold* (Princeton 1999): 175–219.

Women's athletics, Sparta, and mirrors: These paragraphs are adapted from my *Art, Desire, and the Body* chs. 6 and 8.2, with all relevant references.

Desire and the bride: *Sophokles, *Antigone* 879–94, tr. E. F. Watling.

Phaidra as a bird: *Euripides, *Hippolytos* 828–9.

Children: see especially Jenifer Neils and John H. Oakley, *Coming of Age in Ancient Greece: Images of Childhood from the Classical Past* (New Haven and London 2003), and on the Anthesteria, S. H. Lonsdale, *Dance and Ritual Play in Greek Religion* (Baltimore 1993): 123.

Slaves: See *[Xenophon], *Constitution of Athens* 1.9–11; *Xenophon, *Oeconomicus* 10.11–12. The remarks on Hegeso and her slave-girl are adapted from my *Art, Desire, and the Body* 127–9, with all relevant references.

CHAPTER 5

Evacuation and plague: *Thucydides 2.16–17, 48–54, tr. Rex Warner; cf. *Sophokles, *King Oedipus* 24–30, 1528–30, tr. E. F. Watling. The typhoid diagnosis comes from the teeth of three of the ca. 150 skeletons in a pit revealed by the excavations in the 1990s for the Athens Metro and dated to the early 420s by the context pottery (now on display in the Kerameikos Museum). See L. Parlama and N. Stampolides, *The City beneath the City: Antiquities from the Metropolitan Railway Excavations* (Athens 2000): 264–5, 271–3, 351–6, Figs. 1, 8–10, and nos. 383–90; and for the diagnosis, see Manolis J. Papagrigorakis and others, "DNA Examination of Ancient Dental Pulp Incriminates Typhoid Fever as a Probable Cause of the Plague of Athens," *The International Journal of Infectious Diseases* 10 (2006): 1–9, with rebuttal and reply on pp. 334–40. I find this diagnosis particularly poignant because at the age of two I contracted typhoid during a postwar epidemic in England, but (obviously) survived.

"Your empire is a tyranny": *Thucydides 2.63, cf. 3.37 (Kleon). Athens and Sparta: *Thucydides 1.70; cf. 1.74 (Athenian reply) and 1.144 (Perikles on the victors of Marathon and Salamis).

Kalllimachos: *Herodotos 6.109.

The Nike temple parapet: On the date see Peter Schultz, "The Date of the Nike Temple Parapet," *American Journal of Archaeology* 106 (2002): 294–5. Traditionally it has been dated a decade later, and one scholar has placed some slabs as late as 395.

Rhetoric: Gorgias, *Helen* 18–19. Wimpy youths: *Aristophanes, *Clouds* 1009–23. Scene painting; Agatharchos, Anaxagoras, and Demokritos on perspective: *Aristotle, *Poetics*

4, 1449a18; *Vitruvius 7, preface 11 (Pollitt, *Art of Ancient Greece* 145–6). Apollodoros and Zeuxis: *Pliny, *N. H.* 35.60–65; *Plutarch, *de gloria Athenensium* 2 (*Moralia* 346A) (Pollitt, *Art of Ancient Greece* 146–53).

Sokrates objects: *Plato, *Republic* 10, 602c–d; attack on sculptors: *Sophist* 235e.

Parrhasios: *Pliny, *Natural History* 35.67–9; *Quintilian 12.10.4; *Xenophon, *Memorabilia of Sokrates* 3.10.1–5; *Athenaios 12, 543C–F (Pollitt, *Art of Ancient Greece* 153–6). Craft as "limited slavery" (i.e., working for others): *Aristotle, *Politics* 1.5.10, 1260b1.

The Erechtheion: *Pausanias 1.26.5–27.2.

Apollo the plague god: *Homer, *Iliad* 1.44–52, tr. Richmond Lattimore; and the protector, *Pausanias 8.41.7–9 (Bassai). The Bassai temple: Federick A. Cooper, *The Temple of Apollo Bassitas* (4 vols., Princeton 1992–6).

Corinthian capital: *Vitruvius 4.1.8–10 (Pollitt, *Art of Ancient Greece* 193) attributes it to the sculptor Kallimachos. The Corinthian column that supported the Athena Parthenos' outstretched right arm is the other contender for primacy; it was added in the late fifth century, when the arm began to bend under the Nike's weight. Aischylos on cult images: Porphyry, *de Abstinentia* 2.18.

Chairedemos and Lykeas: *Inscriptiones Graecae* 1³.1190.42 (Lykeas; a rare name, so surely the same person); 1191.250 (Chairedemos). The comic poet Phrynichos (not the earlier tragedian), frag. 20 (ed. J. M. Edmonds), attacks Lykeas and some known oligarchs as "big apes"; the battle of Kynossema occurred in 411, while the oligarchs were still in power (*Thucydides 8.104–6).

Athenian women forced to work like slaves: *[Demosthenes] 57.42, 45.

Xenophon and Aigospotamoi: *Hellenica* 2.2.3; and the Spartan reply to the Thebans and Corinthians: *Hellenica* 2.2.20.

CHAPTER 6

Chaironeia and the end of Greek freedom: *Pausanias 1.25.3. "Education to Greece": *Thucydides 2.41.

Following Polykleitos "like a law": *Pliny, *Natural History* 34.55 (Pollitt, *Art of Ancient Greece* 75).

Lysias's Corinthian eulogy: *Lysias 2.18, 69–80 (selections).

Magnificent and great-souled men: Aristotle, *Nicomachean Ethics* 4.2–3 (selections). On the ideal fourth-century Athenian, see Ian Morris, "The Strong Principle of Equality and the Archaic Origins of Greek Democracy," in Josiah Ober and Charles Hedrick (eds.), *Demokratia: A Conversation on Democracies, Ancient and Modern* (Princeton 1996): 19–48, at pp. 21–4; and especially Roisman, *The Rhetoric of Manhood*.

Arimasps and griffins: *Aischylos, *Prometheus Bound* 803–6, tr. Philip Vellacott. Dionysos: *Euripides, *Bacchae* 104–19, 376–85, 412–20, 453–9 (tr., in part, Philip Vellacott).

Peace and Wealth: *Hesiod, *Theogony* 901–3; *Pindar, *Olympian Ode* 13.6; *Euripides, *Bacchae* 419; *Aristophanes, *Peace* and *Wealth*. Kephisodotos's statue: *Pausanias 9.6.2 (Pollitt, *Art of Ancient Greece* 83).

Athenian cultural superiority and "mildness": *Isokrates, *Antidosis* 20, 300; *Areopagiticus* 20, 67; *Panathenaicus* 56, 121.

Tyche at Thebes (and the Eirene): *Pausanias 9.16.1–2, cf. 1.8.2 (Pollitt, *Art of Ancient Greece* 83–4).

Sokrates's portrait: Herculaneum papyri (*PHerc*) 1021 column 2. Plato's appearance: *Diogenes Laertius 3.26, 28, cf. Richter, *Portraits of the Greeks* 182; the perfect philosopher: *Plato, *Republic* 6, 487a. Diogenes as "Sokrates gone mad": *Diogenes Laertius 6.45.

Euripides, Plato, and the gods: *Euripides, *Iphigeneia in Tauris* 386–91; *Herakles* 1341–6; *Plato, *Laws* 11, 931A.

Pausanias on Tegea: *Description of Greece* 8.46–7.

On the Knidia, see especially Kristen Seaman, "Retrieving the original Aphrodite of Knidos," in *Atti della Accademia Nazionale dei Lincei: Rendiconti* 9.15.3 (Rome 2004). The statue's glance and smile: *Lucian, *Imagines* 6; *[Lucian], *Amores* 13 (Pollitt, *Art of Ancient Greece* 85–6). Phryne and Thebes: *Athenaios 13, 591d. "Absentminded" and "aloof": Brunilde S. Ridgway, *Fourth-Century Styles in Greek Sculpture* (Madison 1997): 263.

Divine self-sufficiency: *Plato, Timaeus 34B; *[Aristotle], *Magna Moralia* 2.11.7, 1208b31; Epikouros, in *Diogenes Laertius 10.139; *Seneca, *de Beneficiis* 4.4.1.

Athenian prisoners and Euripides: *Plutarch, *Nikias* 29, tr. Ian Scott-Kilvert. Books and reading: Eupolis fragment 304 ed. and tr. J. M. Edmonds; Nikophon fragment 9 ed. and tr. Edmonds; *Plato, *Apology* 26D; *Xenophon, *Memorabilia* 4.2.1–10ff (book collector) and *Anabasis* 7.5.14 (Black Sea trade); *Aristophanes, *Frogs* 52 (Dionysos), 1114; *Aristotle, *Rhetoric* 3.12.1–3, 1413b12 (poetry for reading); *Plutarch, *Moralia* 841f (Lykourgos). On vases with scrolls, etc., see Frederick Beck, *Greek Education* (London 1964): figs. 4, 15, and *An Album of Greek Education* (Sydney 1975): pls. 13–15, 69–75.

Vases and drama: For a range of opinions, see A. D. Trendall and T. B. L. Webster, *Illustrations of Greek Drama* (New York 1971); Oliver Taplin, *Comic Angels and Other Approaches to Greek Drama through Vase-Paintings* (Oxford 1993); Jocelyn Penny Small, *The Parallel Worlds of Classical Art and Text* (Cambridge 2003); Oliver Taplin, *Pots and Plays: Interactions Between Tragedy and Greek Vase-Painting of the Fourth Century* B.C. (Los Angeles 2007); and (unfortunately available only in German), Luca Giuliani's *Bild und Mythos: Geschichte der Bilderzählung in der griechischen Kunst* (Munich 2003).

CHAPTER 7

Philip: *Arrian, *Anabasis of Alexander* 7.9.

Eternal feasting in heaven: *Plato, *Republic* 2, 363c–d. Homeric burial: *Iliad* 24.707–804; *Odyssey* 24.71–6 (tr. Rodney Merrill).

Alexander and Lysippos: *Plutarch, *On the Fortune or Virtue of Alexander* 2.2 (*Moralia* 335A–B); for Alexander's personal appearance and portraits see Pollitt, *Art of Ancient Greece* 90, 94, 98–100; Stewart, *Faces of Power: Alexander's Image and Hellenistic Politics* (Berkeley 1993); on the Alexander Mosaic see also Ada Cohen, *The Alexander Mosaic: Stories of Victory and Defeat* (Cambridge 1997).

Lysippos and his predecessors: *Cicero, *Brutus* 86, 296; *Pliny, *Natural History* 34.65 (Pollitt, *Art of Ancient Greece* 98–9). Cattle and the lion: *Poseidippos 65 (*The Greek Anthology* 16.119).

Aischines versus Demosthenes: *Aischines 3.134, 259; *Demosthenes, *On the Crown* 208–9.

Fourth-century acting: *Plato, *Republic* 3, 396–7; *Aristotle, *Rhetoric* 1403b. "Education to Greece": *Thucydides, *The Peloponnesian War* 2.41. Etiquette and posture: *Aischines 1.25; *Demosthenes 19.251.

"Possession for ever": *Thucydides, *The Peloponnesian War* 1.22. Sokrates: *Diogenes Laertius, *Lives of the Philosophers* 2.43. "Great-Souled Man": *Aristotle, *Nicomachean Ethics* 4.3.3–8, 1123b12–15.

Epidauros tholos and theater: *Pausanias 2.27.5 (Pollitt, *Art of Ancient Greece* 195). Unfortunately, the theater's proportions are examined only in a (very difficult) article in German: Lutz Käppel, "Das Theater von Epidauros," *Jahrbuch des deutschen archäologischen Instituts* 104 (1989): 83–106. On health and the pentagon, see *Lucian, *A Slip of the Tongue in Greeting* 5.

"Great-Souled Man": see above.

Lysippos and Apelles: *Plutarch, *On Isis and Osiris* 24 (*Moralia* 360D); cf. * *The Greek Anthology*
16.120 (Asklepiades, ca. 280 B.C.) (Pollitt, *Art of Ancient Greece* 100, 161–2). Alexander
and the gods: *Plutarch, *Alexander* 28; Kallisthenes in *Polybios, *Histories* 12.12b3;
*Arrian, *Anabasis of Alexander* 4.8.3 and 10.6–7; *Curtius 8.5.8 (the quotation). On
the gold Alexander medallion see Osmund Bopearachchi and Philippe Flandrin, *Le
Portrait d'Alexandre le Grand: Histoire d'une découverte pour l'humanité* (Paris 2005).
"God invincible": *Hypereides, *Against Demosthenes* frag. 7, cols. 31–2.

Demosthenes: *[Plutarch], *Lives of the Ten Orators: Demosthenes* (Plutarch, *Moralia* 847A)
(Pollitt, *Art of Ancient Greece* 112).

SELECTED BIBLIOGRAPHY
AND FURTHER READING

CLASSICAL GREEK ART AND ARCHAEOLOGY: SURVEYS

Boardman, John. 1996. *Greek Art.* London and New York. Fourth edition.
Osborne, Robin. 1998. *Archaic and Classical Greek Art.* Oxford and New York.
Pedley, John. 2002. *Greek Art and Archaeology.* Upper Saddle River, NY. Third edition.
Whitley, James. 2001. *The Archaeology of Ancient Greece.* Cambridge.

CLASSICAL GREEK ART AND ARCHAEOLOGY: REFERENCE

Campbell, Gordon (ed.). 2007. *The Grove Encyclopedia of Classical Art and Architecture.* Oxford.
 2 vols.

CLASSICAL GREEK ART AND ARCHAEOLOGY:
MEDIA AND TOPICS

1. General

Barringer, Judith M., and Jeffrey M. Hurwit (eds.). 2005. *Periklean Athens and Its Legacy: Problems and Perspectives.* Austin.
Bérard, Claude (ed.). 1989. *A City of Images: Iconography and Society in Ancient Greece.* Princeton.
Boardman, John. 1999. *The Greeks Overseas. Their Early Colonies and Trade.* London and New York.
Carpenter, Thomas H. 1991. *Art and Myth in Ancient Greece.* London.
Cohen, Beth (ed.). 2000. *Not the Classical Ideal. Athens and the Construction of the Other in Greek Art.* Leiden.
Jaeger, Bertrand (general ed.). 1981–99. *Lexicon Iconographicum Mythologiae Classicae.* Zürich.
Nevett, Lisa. 1999. *House and Society in the Ancient Greek World.* Cambridge.
Pollitt, Jerome J. 1972. *Art and Experience in Classical Greece.* Cambridge
Pollitt, Jerome J. 1974. *The Ancient View of Greek Art.* New Haven.
Pollitt, Jerome J. 1990. *The Art of Ancient Greece, Sources and Documents.* Cambridge.
Stewart, Andrew. 1997. *Art, Desire, and the Body in Ancient Greece.* Cambridge.

2. Regions, Sites, and Buildings

Andronikos, Manolis. 1984. *Vergina: The Royal Tombs*. Athens.

Beard, Mary. 2003. *The Parthenon*. Cambridge, MA.

Boardman, John. 2000. *Persia and the West*. London.

Cahill, Nicholas. 2002. *Household and City Organization at Olynthus*. New Haven.

Camp, John McK. 1984. *Ancient Athenian Building Methods*. Princeton.

Camp, John McK. 2001. *The Archaeology of Athens*. New York.

Coulton, J. J. 1977. *Ancient Greek Architects at Work*. Ithaca, NY.

Drougou, Stella, and Chryssoula Saatsoglou-Paliadeli. 2006. *Vergina: The Land and Its History*. Aghios Dimitrios.

Ginouvès, René. 1994. *Macedonia: From Philip II to the Roman Conquest*. Princeton.

Hurwit, Jeffrey. 2004. *The Acropolis in the Age of Pericles*. Cambridge.

Karageorghis, Vassos (ed.). 2002. *The Greeks beyond the Aegean: From Marseilles to Bactria*. New York.

Korres, Manolis. 1995. *From Pentelicon to the Parthenon*. Athens.

Lawrence, A. W. 1996. *Greek Architecture* (rev. ed. by R. A. Tomlinson). Cambridge.

Miller, Margaret C. 1997. *Athens and Persia in the Fifth Century B.C.: A Study in Cultural Receptivity*. Cambridge.

Neils, Jenifer (ed.). 2005. *The Parthenon: From Antiquity to the Present*. Cambridge.

Pedley, John. 2005. *Sanctuaries and the Sacred in the Ancient Greek World*. Cambridge and New York.

Pugliese Carratelli, G. (ed.). 1996. *The Western Greeks*. Venice.

Schoder, Raymond V. 1974. *Wings over Hellas: Ancient Greece from the Air*. Oxford.

Travlos, J. 1970. *A Pictorial Dictionary of Ancient Athens*. London.

3. Sculpture

Boardman, John. 1985. *Greek Sculpture: The Classical Period*. New York.

Boardman, John. 1995. *Greek Sculpture: The Late Classical Period*. New York.

Grossman, Janet B. 2003. *Looking at Greek and Roman Sculpture in Stone. A Guide to Terms, Styles, and Techniques*. Malibu, CA.

Higgins, Reynold. 1967. *Greek Terracottas*. London.

Lawton, Carol. 2006. *Marbleworkers in the Athenian Agora*. Princeton.

Mattusch, Carol. 1988. *Greek Bronze Statuary. From the Beginnings through the Fifth Century B.C.* Ithaca, NY and London.

Mattusch, Carol. 1996. *Classical Bronzes*. Ithaca, NY and London.

Richter, G. M. A. 1984. *The Portraits of the Greeks* (abridged and revised by R. R. R. Smith). Ithaca, NY.

Rolley, Claude. 1986. *Greek Bronzes*. London.

Steiner, Deborah T. 2001. *Images in Mind: Statues in Archaic and Classical Greek Art and Thought*. Princeton.

Stewart, Andrew. 1990. *Greek Sculpture: An Exploration*. New Haven.

4. Painting and Pottery

Boardman, John. 1989. *Athenian Red Figure Vases: The Classical Period*. New York.

Clark, Andrew J., Maya Elston, and Mary Louise Hart. 2002. *Understanding Greek Vases: A Guide to Terms, Styles, and Techniques*. Malibu.

Lissarrague, François. 2001. *Greek Vases: The Athenians and Their Images*. New York.

Lydakes, Stelios. 2004. *Ancient Greek Painting and Its Echoes in Later Art*. Los Angeles.

Robertson, C. M. 1993. *The Art of Vase-Painting in Classical Athens*. Cambridge.

Sparkes, Brian, and Lucy Talcott. 1977. *Pots and Pans of Classical Athens*. Princeton.

Trendall, Arthur D. 1989. *Red-Figured Vases of South Italy and Sicily*. New York.

5. Luxury Arts and Crafts

Boardman, John. 1970. *Greek Gems and Finger-Rings*. London.

Jenkins, G. K. 1972. *Ancient Greek Coins*. New York (2nd ed., London 1990).

Kraay, Colin M. 1976. *Archaic and Classical Greek Coins*. Berkeley and Los Angeles.

Williams, Dyfri, and Jack Ogden. 1994. *Greek Gold: Jewelry of the Classical World*. London and New York.

CLASSICAL GREEK CIVILIZATION

1. General

Boardman, John, Jasper Griffin, and Oswyn Murray (eds.). 2001. *The Oxford Illustrated History of Greece and the Hellenistic World*. Oxford.

Garland, Robert. 1990. *The Greek Way of Life: From Conception to Old Age*. Ithaca, NY.

Golden, M. 1990. *Children and Childhood in Classical Athens*. Baltimore.

Hornblower, Simon (ed.). 1998. *The Oxford Companion to Classical Civilization*. Oxford.

Hornblower, Simon, and Anthony Spawforth (eds.). 1996. *The Oxford Classical Dictionary*. Third edition. Oxford and New York.

Humphries, Sarah C. 1993. *The Family, Women, and Death: Comparative Studies*. Second edition. Ann Arbor.

Just, Roger. 1989. *Women in Athenian Law and Life*. London and New York.

Kinzl, Konrad (ed.). 2006. *A Companion to the Classical Greek World*. Malden, MA.

Llewellyn-Jones, L. 2002. *Women's Dress in the Ancient Greek World*. London and Swansea.

Loraux, Nicole. 1986. *The Invention of Athens: The Funeral Oration in the Classical City* (translated by Alan Sheridan). Cambridge, MA.

Miller, Margaret C. 1997. *Athens and Persia in the Fifth Century B.C.: A Study in Cultural Receptivity*. Cambridge.

Osborne, Robin. 1987. *Classical Landscape with Figures: The Ancient Greek City and Its Countryside*. London.

Patterson, Cynthia. 1998. *The Family in Greek History*. Cambridge, MA.

Pomeroy, Sarah. 1975. *Goddesses, Whores, Wives, and Slaves. Women in Classical Antiquity*. New York

Porter, James (ed). 2005. *Classical Pasts: The Classical Traditions of Greece and Rome*. Princeton.

2. History, Politics, Economics

Allen, Lindsay. 2005. *The Persian Empire*. Chicago and London.

Boardman, John, Jasper Griffin, and Oswyn Murray (eds.). 2001. *The Oxford Illustrated History of Greece and the Hellenistic World*. Oxford.

Boedeker, Deborah, and Kurt A. Raaflaub (eds.). 1998. *Democracy, Empire, and the Arts in Fifth-Century Athens*. Cambridge, MA.

Finley, Moses I. 1985. *Democracy Ancient and Modern*. London.

Hornblower, Simon. 2002. *The Greek World, 479–323 B.C.* Third edition. London and New York.

Osborne, R. 2000. *The Athenian Empire*. London.

Pomeroy, Sarah, et al. 2004. *A Brief History of Ancient Greece*. Oxford.

Rhodes, P. J. 2005. *A History of the Classical Greek World*. Malden, MA and Oxford.

Schaps, David M. 2003. *The Invention of Coinage and the Monetization of Ancient Greece*. Ann Arbor.

Wohl, Victoria. 2002. *Love among the Ruins. The Erotics of Democracy in Classical Athens*. Princeton.

3. Literature

Boardman, John, Jasper Griffin, and Oswyn Murray (eds.). 2001. *The Oxford Illustrated History of Greece and the Hellenistic World*. Oxford. (Chapters on lyric, drama, historiography.)

Easterling, P. E. (ed.). 1997. *The Cambridge Companion to Greek Tragedy*. Cambridge.

Easterling, P. E., and Bernard M. W. Knox (eds.). 1989. *The Cambridge History of Classical Literature. Vol. 1. Greek Literature*. Cambridge.

Goldhill, Simon. 1986. *Reading Greek Tragedy*. Cambridge.

Hornblower, Simon, and Catherine Morgan (eds.). 2007. *Pindar's Poetry, Patrons, and Friends*. Oxford.

Kennedy, George A. 1994. *A New History of Classical Rhetoric*. Princeton.

Lardinois, André, and Laura McClure (eds.). 2001. *Making Silence Speak: Women's Voices in Greek Literature and Society*. Princeton.

4. Thought, Values, and Desires

Brunschwig, Jacques, and Geoffrey E. R. Lloyd. 2000. *Greek Thought: A Guide to Classical Knowledge*. Cambridge, MA, and London.

Cairns, Douglas. 1993. *Aidos: The Psychology and Ethics of Honour and Shame in Ancient Greek Literature*. Oxford.

Cohen, David. 1991. *Law, Sexuality, and Society. The Enforcement of Morals in Classical Athens*. Cambridge.

Davidson, James. 1997. *Courtesans and Fishcakes. The Consuming Passions of Classical Athens*. London.

Dover, Kenneth. 1974. *Greek Popular Morality in the Time of Plato and Aristotle*. Berkeley and Los Angeles.

Dover, Kenneth. 1989. *Greek Homosexuality*. Second edition. Cambridge, MA.

Faraone, Christopher A., and Laura K. McClure (eds.). 2006. *Prostitutes and Courtesans in the Ancient World*. Madison.

Guthrie, W. K. C. 1971. *The Sophists*. Cambridge.

Hall, Edith. 1989. *Inventing the Barbarian. Barbarians in Greek Tragedy*. Oxford.

Hall, Jonathan. 2002. *Hellenicity. Between Ethnicity and Culture*. Chicago.

Hartog, François. 1988. *The Mirror of Herodotus. The Representation of the Other in the Writing of History*. Berkeley.

Lloyd, Geoffrey E. R. 1999. *Magic, Reason and Experience. Studies in the Origins and Development of Greek Science*. Indianapolis.

Lloyd-Jones, Hugh. 1971. *The Justice of Zeus*. Berkeley and Los Angeles.

Long, Anthony A. 1999. *The Cambridge Companion to Early Greek Philosophy*. Cambridge.

Loraux, Nicole. 1993. *The Children of Athena. Athenian Ideas about Citizenship and the Division between the Sexes*. Princeton. Translated by Caroline Levine.

North, Helen. 1966. *Sophrosyne: Self-Knowledge and Self-Restraint in Greek Literature*. Ithaca, NY.

Rademaker, Adriaan. 2005. *Sophrosyne and the Rhetoric of Self-Restraint*. Leiden. (*Mnemosyne* Supplement 259.)

Roisman, Joseph. 2005. *The Rhetoric of Manhood. Masculinity in the Attic Orators*. Berkeley, Los Angeles, and London.

5. Mythology, Religion, Ritual, Festivals, Sport

Burkert, Walter. 1985. *Greek Religion*. Cambridge, MA.

Buxton, Richard. 1994. *Imaginary Greece. The Contexts of Mythology*. Cambridge.

Buxton, Richard. 2004. *The Complete World of Greek Mythology*. New York.

Cole, Susan G. 2004. *Landscapes, Gender, and Ritual Space: The Ancient Greek Experience*. Berkeley.

Easterling, P. E., and J. V. Muir (eds.). 1985. *Greek Religion and Society*. Cambridge.

Garland, Robert. 2001. *The Greek Way of Death*. Ithaca, NY.

Golden, Mark. 1998. *Sport and Society in Ancient Greece*. Cambridge.

Johnston, Sarah Iles (ed.). 2004. *Religions of the Ancient World. A Guide*. Cambridge, MA, and London.

Miller, Stephen G. 2004. *Ancient Greek Athletics*. New Haven.

Parker, Robert. 2005. *Polytheism and Society at Athens*. Oxford.

Pedley, John. 2005. *Sanctuaries and the Sacred in the Ancient Greek World*. Cambridge and New York.

Phillips, David J., and David Pritchard. 2003. *Sport and Festival in the Ancient Greek World*. Swansea.

Swaddling, Judith. 1999. *The Ancient Olympic Games*. Austin.

Zaidman, Louise. 1992. *Religion in the Ancient Greek City*. Cambridge and New York.

6. Warfare

Hanson, Victor Davis. 1989. *The Western Way of War. Infantry Battle in Classical Greece*. Berkeley.

Hanson, Victor Davis. 2005. *A War like No Other: How the Athenians and Spartans Fought the Peloponnesian War*. New York.

Lendon, J. E. 2005. *Soldiers and Ghosts. A History of Battle in Classical Antiquity*. New Haven.

Van Wees, Hans. 2004. *Greek Warfare. Myth and Realities*. London.

GREEK CIVILIZATION: WEB SITES

http://www.perseus.tufts.edu/ A vast digital library of ancient texts and images, with many links, including:

http://www.stoa.org/diotima/ Materials for the study of women and gender in the ancient world.

SOURCES OF ILLUSTRATIONS

Alinari/Art Resource, New York: 80

American Numismatic Society, New York: 148, 152

Anderson/Art Resource, New York: 164

Antikenmuseum Basel und Sammlung Ludwig: 19 (photo by Claire Niggli, BS 415)

Erin Babnik: 16, 22, 23, 59 (after a plan by Manolis Korres), 72 (after reconstructions by Vincenzo Franciosi), 96 (after Ursula Knigge, *The Athenian Kerameikos* figs. 89 and 165), 149 (after a drawing by Peter Levi); Maps 1–3

Beryl Barr-Sharrar: 150, 151

Bibliothéque Nationale de France (Cabinet des Médailles et Antiques): 147

Bildarchiv Preussischer Kulturbesitz/Art Resource, New York: 1, 24 (photo by Barbara Grünewald), 86 (photo by Jutta Tietz-Glagow), 94, 127, 128, 144

Osmund Bopearachchi: 172

A. Brückner, *Der Friedhof am Eridanos*: 125 (with additions by Lynn Cunningham and Erin Babnik)

Chuzeville, Paris: 53

Ernst Curtius and Friedrich Adler, *Olympia*: 42 (vol. 1, pl. 10)

Deutsches Archäologisches Institut, Athens: 4 (photo by Hermann Wagner, DAI Olympia 832), 70 (photo by Eva-Maria Czakó, DAI Piraeus 149), 74 (photo by Gösta Hellner, DAI 1972/3003), 87 (photo by Eva-Maria Czakó, DAI NM 4656), 92 (photo by Hermann Wagner, DAI NM 3840), 100 (photo by Eva-Maria Czakó, DAI NM 5466), 118 (photo by Hans-Rupprecht Goette, DAI NM 2001/691), 124 (DAI Kerameikos 15534), 135 (photo by Gösta Hellner, DAI NM 6121), 153 (photo by Gösta Hellner, DAI Akropolis 2368), 157 (photo by Franz Willemsen, DAI Piraeus 134); all rights reserved.

Deutsches Archäologisches Institut, Rome: 34 (Schwanke photo, DAI 1984.3300), 81 (Koppermann photo, DAI 1962.0696), 132 (Felbermeyer photo, DAI 1936.0896)

Jean-Yves Empereur, *Alexandria Rediscovered* (New York, George Brazillier, Inc., 1998): 161 (p. 47; reconstruction by J.-P. Golvin, reproduced by permission of Georges Brazillier)

Alison Frantz Photographic Collection, American School of Classical Studies at Athens: 54, 104, 105

Adolf Furtwängler, *Aegina, das Heiligtum der Aphaia*: 27 (pl. 36).

Adolph Furtwängler and Karl Reichhold, *Griechische Vasenmalerei*: 39 (pl. 116), 91 (pls. 36, 37), 109 (pl. 30), 110 (pl. 143), 142 (pl. 148)

347

Hans Goette: 31 (after an original plan by Wolfram Hoepfner and Ernst-Ludwig Schwandner)

Greek Ministry of Culture, 1st Ephoria: 77

Hirmer Fotoarchiv, Munich: 5, 13, 15, 30, 58, 83, 88, 89, 101, 120, 121

Wolfram Hoepfner: 32 (from Wolfram Hoepfner and Ernst-Ludwig Schwandner, *Haus und Stadt im klassischen Griechenland*: 41, fig. 33)

The J. Paul Getty Museum, Villa Collection, Malibu, California: 117, 154

Fritz Krischen, *Die griechische Stadt*: 115 (pl. 40)

Kunsthistorisches Museum, Vienna: 95, 130

Kunstmuseum Basel: 9

Marie-Lan Nguyen/Wikimedia Commons: 143

Erich Lessing/Art Resource, New York: 51, 158, 159

A. Loxias, Athens: 6, 21, 22, 26, 28, 29, 37, 43–47, 49, 50, 55, 56, 62–68, 71, 73, 75, 78, 106, 114, 123, 126, 134, 139, 141, 160, 163, 167

Martin von Wagner Museum der Universität Würzburg: 108 (photo K. Oehrlein)

Craig and Marie Mauzy: 60

Metropolitan Museum of Art: 20 (56.171.38; Fletcher Fund 1956), 97 (bequest of Walter C. Baker, 1971)

Munich, Staatliche Antikensammlung und Glyptothek: 17, 131 (photo by Christa Kopperman)

Museum of Fine Arts, Boston: 25 (Frances Bartlett Donation, 1912), 40, 41 (William Francis Warden Fund), 98

National Maritime Museum, London: 2 (© National Maritime Museum)

Ny Carlsberg Glyptotek, Copenhagen: 85 (photo by Ole Haupt), 173

Oriental Institute of the University of Chicago: 162

N. Papachatzis, *Pausaniou Hellados Periegesis*: 122 (vol. 5, p. 327, after a drawing by K. Iliakis)

Phoebe Apperson Hearst Museum of Anthropology and the Regents of the University of California: 7 (8–4308, 8–5468; photo by Therese Babineau), 35, 36 (8–4581; photo by Therese Babineau)

Frederik Poulsen, *Greek and Roman Portraits in English Country Houses*: 165

Martin Price: 171

Réunion des Musées Nationaux de France/Art Resource, New York: 38, 52, 129, 155

Carson Sieving: 18

Candace Smith: 69, 137 (after plans and elevations by Jari Pakkanen)

Solow Art and Architecture Foundation, New York: 93

The State Hermitage Museum, St. Petersburg: 169 (© The State Hermitage Museum)

Trustees of the British Museum, all rights reserved: 33, 48, 57, 76, 82, 84, 99, 107, 113, 116, 119, 138 (© Trustees of the British Museum, all rights reserved)

University of California at Berkeley, Nemea Excavations: 11

University of California at Berkeley, Visual Resources Collection: 12, 14, 61, 103, 140, 145, 146, 168, 170

Vatican Museums: 3, 90

D. Widmer, Basel: 133

All uncredited photographs are the author's.

Detailed photo credits required by museum vendors and others

20. Terracotta amphora (jar), ca. 490 B.C.; Late Archaic, attributed to the Berlin Painter. Greek, Attic. Terracotta, H 15 15/16 in. (41.50 cm). The Metropolitan Museum of Art, Fletcher Fund 1956 (56.171.38). Image © The Metropolitan Museum.

25. The Chicago Painter. Pitcher (oinochoe) with Greek warrior attacking a Persian archer. Greek, Classical Period, about 450 B.C. Place of manufacture: Greece, Attica, Athens. Ceramic, red figure. Height: 19.3 cm (7 5/8 in.); height with handle: 24 cm (9 7/16 in.). Museum of Fine Arts, Boston. Francis Bartlett donation of 1912. 13.196.

40. The Dokimasia Painter. Mixing bowl (calyx krater) with the killing of Agamemnon. Greek, Early Classical Period, about 460 B.C. Place of manufacture: Greece, Attica, Athens. Ceramic, red figure. Height: 51 cm (20 1/16 in.); diameter: 51 cm (20 1/16 in.). Museum of Fine Arts, Boston. William Francis Warden Fund. 63.1246.

97. Bronze mirror with a support in the form of a draped woman, mid-fifth century B.C. Classical, Greek, Argive. Bronze, H 15 15/16 in. (40.41 cm). The Metropolitan Museum of Art, Bequest of Walter Baker, 1971 (1972.118.78). Photograph © 1998, The Metropolitan Museum of Art.

98. Woman cooking, watched by a girl. Greek, Archaic period, 500–475 B.C. Place of manufacture: Greece, Boiotia, Tanagra. Terracotta. Height: 10.7 cm (4 3/16 in.). Museum of Fine Arts, Boston. Museum purchase with funds donated by contribution. 01.7788.

150. Elias Eliades, photographer; © Beryl Barr-Sharrar.

151. Elias Eliades, photographer; © Beryl Barr-Sharrar.

INDEX